Passion in Venice

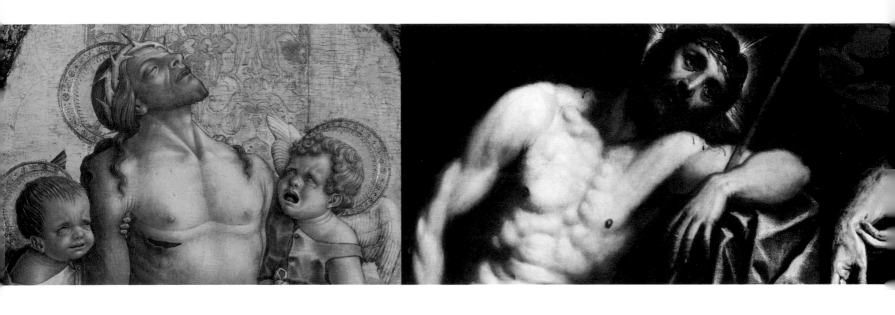

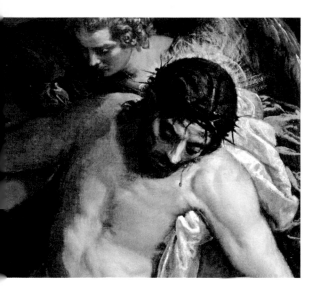

Passion in Venice
Crivelli to Tintoretto and Veronese

The Man of Sorrows in Venetian Art

Edited by Catherine Puglisi and William Barcham

Essays by Catherine Puglisi and William Barcham, and Xavier Seubert

MUSEUM OF BIBLICAL ART
MOBIA 𝓰

Museum of Biblical Art, New York
in association with D Giles Limited, London

This catalog accompanies the exhibition *Passion in Venice: Crivelli to Tintoretto and Veronese* on display at the Museum of Biblical Art from February 11–June 12, 2011
© 2011 Museum of Biblical Art

First published jointly in 2011 by GILES
An imprint of D Giles Limited
4 Crescent Stables, 139 Upper Richmond Road,
London SW15 2TN, UK
www.gilesltd.com

and Museum of Biblical Art
1865 Broadway (at 61st Street),
New York City,
NY 10023, USA
Phone: 212-408-1500
Fax: 212-408-1292
info@mobia.org
www.mobia.org

No part of the contents of this book may be reproduced, stored in a retrieval system, or transmitted in any form or by any means, electronic, mechanical, photocopying, recording, or otherwise, without the written permission of the Board of Trustees, Museum of Biblical Art, New York, and D Giles Limited.

The exhibition was curated by Catherine Puglisi, Professor and Chair of the Department of Art History, Rutgers University of New Jersey, and William Barcham, Professor in the Department of the History of Art at the Fashion Institute of Technology, the State University of New York.

Edited by Catherine Puglisi and William Barcham

Contributions by Catherine Puglisi, William Barcham, and Xavier Seubert

Catalog Design: Anikst Design, London
Produced by D Giles Limited, London
Printed and bound in Hong Kong

Front cover illustration:
Paolo Veronese (1528–1588)
The Dead Christ Supported by Angels, 1563–1565
Oil on canvas, 221 × 250.5 cm (87 × 98.6 in.)
National Gallery of Canada, Ottawa, inv. 3336

Contributions by:

LL	Liana Lupus
LP	Leigh-Ayna Passamano
MD	Michael DeNiro
CO	Colette Obzejta
AV	Alexandra Venizelos
CK	Catherine Kupiec
KS	Kathleen Sullivan
CW	Christina Weyl
IV	Ivannia Vega-McTighe
MMW	Maria Agnese Chiari Moretto Wiel
MY	Melissa Yuen
CM	Colette Moryan
KM	Kira Maye
KF	Kimberly Fisher

Major support for MOBIA's exhibitions and programs has been provided by the American Bible Society and by Howard and Roberta Ahmanson.

Support for the catalog has been provided, in part, by the Robert Lehman Foundation.

Additional support for *Passion in Venice* has been provided by the Samuel H. Kress Foundation and The Gladys Krieble Delmas Foundation.

This program is supported, in part, by public funds from the New York City Department of Cultural Affairs, in partnership with the City Council.

Passion in Venice is made possible with public funds from the New York State Council on the Arts, celebrating 50 years of building strong, creative communities in New York State's 62 counties.

Contents

Foreword

The exhibition *Passion in Venice: Crivelli to Tintoretto and Veronese*, which occasioned the publication of this catalog, was a very special undertaking for the Museum of Biblical Art (MOBIA). When it was first proposed to us, I joked that MOBIA and this exhibition were a match made in heaven—no biblical pun intended.

On a slightly more serious note, investigating the iconography of the Man of Sorrows does indeed provide a perfect lens through which to reveal MOBIA's overall mandate, as it encompasses many of the wonderfully contradictory elements of what we define as biblical art. The image has its textual basis in the Bible (Isaiah 53:3) yet does not make an appearance in art until around 1200 AD. While its iconography is clearly non-narrative, the image is mostly associated with the narrative of the Passion. The Man of Sorrows thus illustrates the non-linear route that images travel, from their source in the books of the Bible through their relationship with various aspects of devotion to their fulfillment as artistic compositions.

And speaking of travel, the other and equally interesting story this exhibition tells is the journey of the Man of Sorrows from the Orthodox East to the mercantile West, as personified by "La Serenissima"—the Republic of Venice. With their usual aplomb, the Venetians appropriated the image and transformed it to embody the power and glory of the Republic, legitimized, as it were, by its roots in the Byzantine East.

Looking together at these two paths, brilliantly sketched by guest curators Catherine Puglisi and William Barcham, we glimpse the power of images, the complexity of stories told by religious art. And learning these stories above and beyond appreciating the indisputable aesthetic beauty of the images is, after all, the value and virtue of MOBIA. For bringing our mandate into sharp and beautifully crafted focus, and giving MOBIA the opportunity to feature their research, I thank our guest curators. For their generosity in funding the exhibition, I thank the Gladys Krieble Delmas Foundation, the Samuel H. Kress Foundation, the Robert Lehman Foundation, and the New York City Department of Cultural Affairs, as well as our long-term principal supporters, Roberta and Howard Ahmanson and the American Bible Society. Last but not least, I thank my superb staff who made the exhibition, and this handsome volume, a reality.

Ena Heller
Executive Director

Acknowledgments

The realization of this exhibition is owed to many, many different institutions and individuals, and we are grateful to all. Several foundations have generously supported our endeavor with funds, and we are very pleased to acknowledge the help of the Gladys Krieble Delmas Foundation, the Samuel H. Kress Foundation and the Robert Lehman Foundation. Save Venice has been instrumental in assisting us with matters on the ground in Venice; and under the guidance of Michelle Marincola, the Conservation Center of the Institute of Fine Arts, New York University, generously undertook to restore the tabernacle lent by the Alfred and David Smart Gallery of the University of Chicago. Lastly, the two curators wish to thank their individual institutions for support toward travel to Venice, which has been essential for research and for the implementation of this exhibition: Catherine Puglisi is grateful to the Research Council of Rutgers University, and William Barcham to the Teaching Institute of the Fashion Institute of Technology, SUNY.

Of course, without the participation of the more than two dozen American collectors and institutions, there would be no exhibition at all. First, we are obliged to the several collectors who have parted with their works to enrich our show; their generosity is very deeply appreciated. Our institutional lenders were likewise generous; in particular, where we were made visits, spoke with curators and staff and shared our plans for the exhibition, numerous kindnesses accompanied the hours everyone gave us. It is our pleasure, therefore, to thank the following: Ronni Baer, Alex Barker, Peter Barnet, Fran Barulich, Andrea Bayer, George Bisacca, Barbara Drake Boehm, E. Peters Bowron, Christine Brennan, Sue Canterbury, Martin Chapman, Alan Chong, Elisabeth Cornu, Angelica Daneo, Andria Derstine, Nicolette Dobrowolski, James Draper, Rhoda Eitler-Porter, Anne Guillemet-Lebofsky, Anne Halpern, Erin Hartsock, Gretchen Hirschauer, Deborah Jackson, Greg Jecman, Catherine Jenkins, William LaMoy, Anne Leonard, Teresa Lignelli, Richard Lingner, Charles Little, Alison Luchs, Louis Marchesano, Patrice Mattia, Jesse McNab, Thom Morin, John Nolan, Nadine Orenstein, Mary Pixley, Janine Pollock, Sean M. Quimby, Amanda Ricker, Ruth R. Rogers, Betsy Rosasco, Jon Seydl, Innis Shoemaker, Will South, Freyda Spira, Morgan Statney, David Steel, Jennifer Tonkovich, Mark Tucker, William Voelkle, Nicole Wankel and Jeffrey Wilcox.

Our colleagues abroad were unfailingly helpful, and we were indeed fortunate to work with almost all of them face to face and enjoy their hospitality. Stephen Gritt and Chris Etheridge spent hours with us in Ottawa; Dillian Gordon and Rachel Billinge were quick with emails, and Dillian Gordon was more than generous in sharing information about the London panel. Our dealings with Italy spanned several summers and many visits, and we thank Davide Banzato, Roberta Battaglia, Don Silvano Brusamento, Don GianMatteo Caputo, Dennis Cecchin, Matteo Ceriana, Milena Dean, Don Rino Giacomazzi, Rossella Granziero, Pietro Lucchi, Gilda Mantovani, Maria Agnese Chiari Moretto Wiel, Franco Novello, Giuseppe Pavanello, Franca Pellegrini, Annalisa Perissa Torrini, Franco Posocco, Chiara Torresan and the late Monsignor Antonio Niero.

Many friends and colleagues willingly answered questions, offered advice, accompanied us on visits to out of the way places, introduced us to people we did not know, and generally made us feel that our undertaking was more than worthwhile. We are indebted to all listed below, each one knowing how and how much we have counted on their assistance: Francesco Aceto, Ann J. Adams, Denise Allen, Maria Elisa Avagnina, Sara Bellis, David Boffa, Lucio Bonora, Linda Borean, Jonathan Brown, Ellen Brueckner, Caroline Bruzelius, Andrew Butterfield, Mauro Carboni, Francesca Cavazzana Romanelli, Roberto Contini, Alan Darr, Peter Dent, Marco Favetta, Massimo Favilla, Holly Flora, Alessandro Franchini, Paola Gambarota, Giovanni Gentili, Judy Guston, Sara Harrington, Alessandra Hoffer, Colum Hourihane, Elizabeth Hudson, Elizabeth Ivy, Andrew

Kirkman, C. Douglas Lewis, Andrew Lins, Emilio Lippi, Mauro Lucco, Liz Makrauer, David Malone, Giordana Mariani Canova, Robert Matthews, Mons. Antonio Meneguolo, Anita Moskowitz, Caroline Murphy, Maria Giuseppina Muzzarelli, Giovanna Nepi Scirè, Alison Oscar, Maurizio Pellegrin, Giovanni Pizzorusso, Lynn Ransom, Gary Rendsburg, Ruggero Rugolo, Xavier Salomon, John Sawyer, Frits Scholten, Mario Sensi, Lorenza Smith, Julia Sybalsky, Helena Szépe, Paul Tabor, Nicholas Terpstra, Wendy Thompson, Erik Thuno, Jennifer Tonkovich, Christian Trottmann, Huub van der Linden, Giovanni Villa and Emanuela Zucchetta.

The graduate students enrolled in the Exhibition Seminar at Rutgers University in fall 2009 contributed valuable insights in our weekly discussions about the history and development of the Man of Sorrows, and we are grateful for their collaboration on the research and writing of entries for the catalog. We also thank Yael Gabbay, Aresty Research Assistant at Rutgers, for attending to practical and technical matters.

We would like to single out for acknowledgement our entire advisory committee, with special thanks to Keith Christiansen, Helen Evans, Tiziana Franco, Frederick Ilchman, Stefania Mason, Andrea Nante, Giandomenico Romanelli and Federica Toniolo, all of whom opened doors, stepped in when necessary, showed us the ropes and furnished all kinds of friendly and professional assistance. Individuals whose help has further enriched the exhibition and catalog include our co-contributor, Xavier Seubert, and our colleagues Lilian Armstrong, Sergio Benedetti, Susan Boynton, Melissa Conn, Laura Giles, Anne Varick Lauder, Liana Lupus, Norman Muller, Debra Pincus and Carl Brandon Strehlke.

Finally, we acknowledge with deep gratitude Ena Heller, the Director of MOBIA, who has supported this project from the start and provided strong encouragement throughout, and we thank the staff, especially Lisa Dierbeck, Ute Keyes, Tricia Pongracz, Adrianne Rubin, Megan Whitman and Kate Williamson, for their expert and tireless assistance in the planning and realization of the exhibition and its catalog.

Catherine Puglisi and William Barcham

Venice and Its Territories during the Renaissance

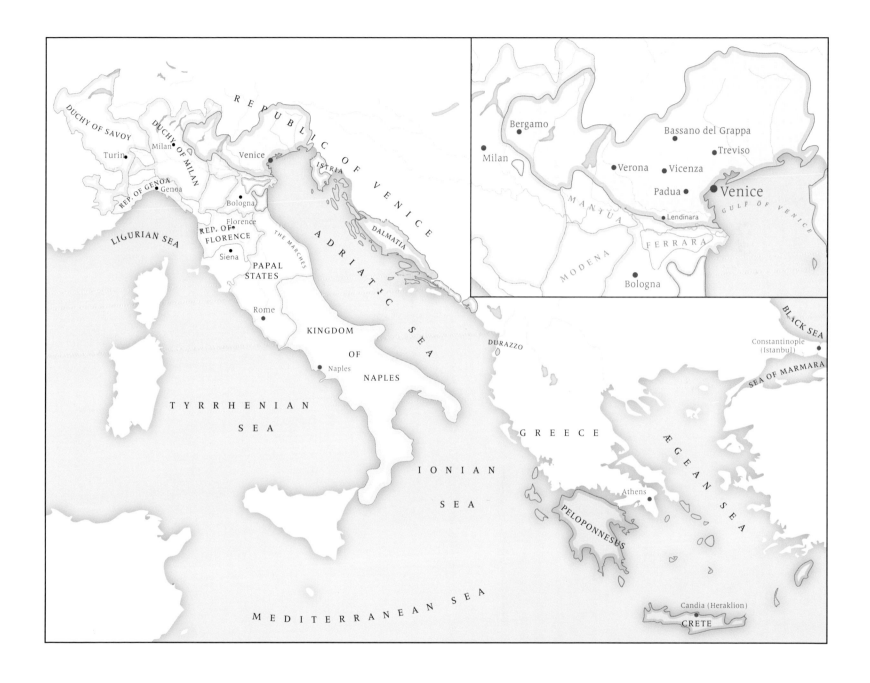

The Man of Sorrows in Venetian Art

TO THE MEMORY OF DONALD POSNER

1. Anonymous
Mosaic Icon with the *Akra Tapeinosis*, late thirteenth–early fourteenth century
Basilica di Santa Croce in Gerusalemme, Rome

Who is the "Man of Sorrows," and why is MOBIA spotlighting the subject in Venetian and Veneto art? The artistic traditions of Venice and its region are among the greatest in Europe, but they alone did not privilege the subject. Oftentimes called the *Imago pietatis*, this image of the Dead Christ was ubiquitous in the West from *c*.1300 to *c*.1650, its pervasiveness apparently militating against our focus. Yet a lens that concentrates sharply on a single milieu and a cultural tradition whose values and beliefs remained relatively stable facilitates our comprehension of this complex figure more easily than a kaleidoscopic prism, that, while offering multiple views, could also distort. *Passion in Venice* sketches a biography only of the Venetian chapter in the life story of an image. Any biography must acknowledge, however, that its subject will transform and adjust across time, and the *Imago pietatis* did just that, undergoing a complex historical development over the centuries, as the vast literature on the theme makes plain.[1] What's more, responding to devotional requirements together with artistic changes, the Man of Sorrows was modified to suit shifting settings (altars, tombs, private homes), triggering transformations that in turn generated multiple connotations. Drawing primarily from the rich holdings of American institutions, *Passion in Venice* relates specific episodes in the story of our figure. This introductory essay develops several of them.

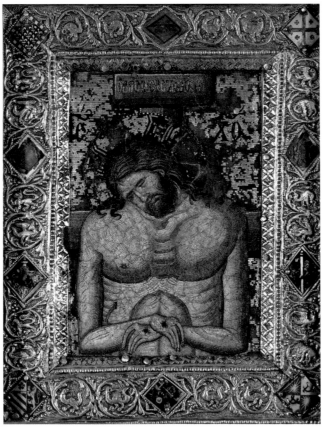

Fig. 1

The Man of Sorrows originated as a simple figure before appearing in Venetian art: a frontal but truncated image of the Dead Christ represented vertically and shorn of the Crucifixion narrative (fig. 1). The Christian savior is paradoxically upright and perpetually within reach; his eyes are closed and his head tilts to his proper right (the viewer's left). Apparently anticipating resurrection, he does not, however, recount it. Christ is beyond narrative and time. Emerging by *c*.1200 from the ritualized liturgy of Orthodox Christianity, the state religion of the Byzantine Empire, this figure appeared in sacred manuscripts of the Orthodox Church and on its portable icons and small sculptures, extant examples of that early period depicting the Dead Christ as limned in the first sentences of this paragraph.[2] Referred to as *Basileus tes doxes*, or King of Glory, the figure is also known in Byzantine art as *Akra Tapeinosis*, or Utmost Humility.

The image had penetrated Western Europe by *c*.1260–1280, its transmission likely abetted by Venetian artists.[3] First seen in the Veneto in manuscript illuminations, it then appeared on local altarpieces, panel paintings and stone sculptures. The figure elongated: artists protracted Christ's chest downward to include his thorax and incorporated his arms, crossing them compliantly over his abdomen (fig. 2).[4] Secondary figures and/or supplementary details sometimes took their place alongside Christ in enlarged compositions (fig. 3). Altering and expanding in the West, the Man of Sorrows manifested a capacity to change, even a talent for variety, as it attracted more and different

Fig. 2

Fig. 3

2. Anonymous
Man of Sorrows (within initial T),
early fourteenth century
Parchment
Roman Missal, Codex LXXXVI,
folio 177r
Biblioteca Capitolare, Cividale
del Friuli

3. After original attributed to
Maestro di Sant'Anastasia
*Man of Sorrows with Mary and
John,* early fourteenth century
Street shrine, Riva del Garda

framing effects.[5] Nonetheless, the paradigmatic formulation of the *Imago pietatis* remained stable for a long period, certainly until *c.*1350–1370. With time, however, many physical details either modified or dwindled in importance: half-length increased to three-quarter or full length, closed eyes sometimes opened, the head shifted from one side to the other and the arms spread outward. Yet not every lone and forlorn Christ portrays a Man of Sorrows. The *Ecce Homo*, deriving from the story in John 19:5, depicts a submissive and sometimes solitary Christ, and the Mocking of Christ recounts chapters from Mark, Matthew and John. Christ on the Cold Stone (not mentioned in the Bible) again presents a stationary and doleful savior, but he is alive, as he is in the Agony in the Garden, where angels may support him as they often do in representations of the Man of Sorrows. Importantly, the *Imago pietatis* does not depict spiritual rapture or the afflictions of flagellation, derision and crucifixion nor does it describe lamentation and burial, all of which denote sequential actions. The works in *Passion in Venice* banish incident and reject temporality, the visionary superseding the actual. Finally, because the subject depicts an earthly event—death—but does so within the framework of human impossibility—verticality—only Christ is the Man of Sorrows.

Despite its complex metaphysical equivocalities, the figure is comparatively simple to recognize and to explain verbally (at least for the Venetian tradition), yet its classification, or taxonomy, is not easily sorted out. The designations most often used today—"Man of Sorrows" (or its modern vernacular equivalents) and the Latin *Imago pietatis*—are almost interchangeable, though specialists employ the latter more often than do the interested public. Our brief terminological investigation begins with "Man of Sorrows," the phrase that is a translation of *Vir dolorum* in chapter 53, verse 3, of the Book of Isaiah as it appears in the Latin Vulgate, the fifth-century Bible credited to Saint Jerome (cats. **1** and **2**).[6] Foreseeing Israel's much desired deliverance, Isaiah characterizes its savior as a Suffering Servant (chapters 40–55), describing him famously in 53:3:

> He is despised and rejected of men, a man of sorrows [*vir dolorum*], and acquainted with grief: and we hid as it were our faces from him; he was despised, and we esteemed him not.[7] [King James Version]

Emerging in the late Roman Empire, the Latin term *Vir dolorum* stems from the Isaianic phrase that originated well before (circa sixth century BC), thus preceding the artistic image labeled "Man of Sorrows" by nearly two thousand years.[8] The questions arise as to when and why the Latin verse penned by an early Church Father but deriving from an ancient Semitic language was affixed onto a late medieval artistic figure. Surprisingly, and in the face of all that has been written on our subject, these questions have not been posed, but the issue of nomenclature has not been ignored either.[9] First, "Man of Sorrows" (or its corresponding vernacular expressions) is not a historic label for the works in this exhibition or their counterparts. Renaissance and Baroque documents and inventories, seventeenth- and eighteenth-century sales catalogs, and nineteenth-century museum files never, to our knowledge, use this classification for a work of art.[10] It seems the term for the figure in art descends from German art historical writing. Publishing his seminal article on the subject in 1927, Erwin Panofsky cited three slightly earlier studies, two French and one German. Emile Mâle (1908) and Gabriel Millet (1916) used only *Christ de pitié* for the figure, a designation known in the early fifteenth century.[11] Panofsky's title repeats the word *Schmerzensmann* from a 1922 German dissertation, and the word and its vernacular equivalents have since been part of art historical vocabulary.[12]

Does the Isaianic term "Man of Sorrows" suit our upright Dead Christ? The Book of Isaiah has been called the Fifth Gospel and the seer himself defined as "more evangelist than prophet."[13] By *c.*1250–1300, when the figure of the Man of Sorrows emerged in Italy, the identification of Christ with Isaiah's Suffering Servant was centuries old. The evangelist Mark writes that the son of man must suffer (27:31), and in his Epistle to the Philippians (2:7–8), Saint Paul explicitly refers to Christ as the Servant.[14] Much later, in a commentary on Christ's descent into hell in order to liberate the righteous, the popular early fourteenth-century tract entitled the *Meditationes vitae Christi* ("Meditations on the Life of Christ"), written by a member of the Franciscan Order, advises readers to

> *Go to Isaiah* [our italics], and he will describe him [Christ] to you as he had seen him, in the spirit of prophecy. Whom else could he have been talking about, when he called him a man of sorrows, knowing what it is to be weak.[15]

One modern critic of the biblical text, questioning Jesus' understanding of his own humanity, employs the phrases "self-awareness as Messiah/Suffering Servant" and "the Isaianic Servant who dies yet lives."[16] But despite this rich and centuries-old Christian tradition that Jesus fulfilled Isaiah's prophecy, the modern designation "Man of Sorrows" apparently has no historical justification as a name for works such as those in this exhibition. Yet the singularity of the term fits the exceptionality of the figure, and surely this correlates with a discussion around the Man of Sorrows that has been following in the wake of Panofsky's now famous article of 1927: that is, exactly what kind of image is it?[17] Given that Christ himself is a mystery for those believing in his divinity and that his essence uniquely blends the human and the godly, a metaphorical term befits an image amalgamating the two. Furthermore, and as has often been pointed out, because Isaiah's verses identify the Israelite Servant as *a* man of sorrows to whom *all* reacted and from whom *all* hid their faces, the savior was at once both specific and collective. This twofold dynamic rendered the verse exceptionally potent for Christians, as Christ was *a* man brutally treated in life and shunned at death, but then *universally* revered as a redeemer.[18]

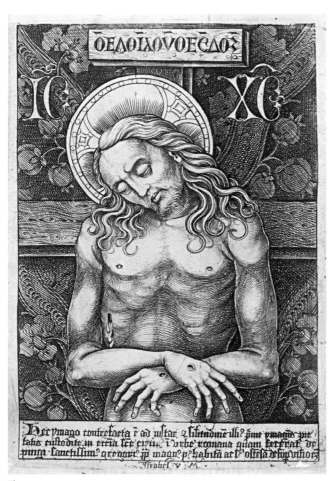

Fig. 4

4. Israhel van Meckenem
Imago pietatis, *c*.1495–1500
Kupferstichkabinett,
Staatliche Museen zu Berlin

Whereas Man of Sorrows or *Vir dolorum* exploits prophetic traditions, *Imago pietatis* qualifies an *imago* (a picture) evoking *pietas* (pity).[19] The phrase apparently gained currency in the late fifteenth century as the result of an engraving (fig. 4) by the German printmaker Israhel van Meckenem (*c*.1440/45–1503) showing the famous Byzantine micromosaic icon of *c*.1300 that had been revered in the church of Santa Croce in Gerusalemme, Rome, since its arrival there *c*.1385 (fig. 1).[20] The Carthusian Order resident at Santa Croce claimed the icon as the vision Pope Gregory the Great (Gregory I, r. 590–604) had enjoyed while praying for a heavenly sign that would allay the doubts of a skeptic over the nature of the Eucharist (cat. **34**). Van Meckenem's text at the bottom of his print verbally identifies the icon in the genitive case, *ymagis pietatis*, an image expressing Gregory's pity for the suffering Christ.[21] Having already publicized the association of icon and vision through the fifteenth century, the Carthusians then promoted van Meckenem's engraving for the Jubilee Year of 1500 with the hope of attracting to their church pilgrims craving divine absolution.[22] Within a few years, the picture of Gregory's vision—that is, the Man of Sorrows in Santa Croce—was often juxtaposed with the phrase *Imago pietatis* in prayer books and prints, at times excluding the pope's name from the pious context but promising worshipers thousands of years of indulgence for release from Purgatory if they addressed prayers to the *Imago pietatis*.

Popular as the term was by 1500, the simple word *pietas* and its related forms had long been familiar names for many works like those in *Passion in Venice*. Jean, Duc de Berry, owned images called *Christ de pitié*, and Italian businessmen also employed the word *Pietà*.[23] Francesco di Marco Datini (*c*.1335–1410), the well-known "Merchant of Prato" of Iris Origo's classic biography, received news from an associate that he might acquire "a *Pietà*—that is, [a picture of] our Lord rising from the tomb, with Our Lady beside Him, and the whole background in fine gold."[24] Datini did not visualize a painting of Jesus on Mary's lap (as one would nowadays) but one similar to what Silvestro dei Gherarducci produced in nearby and contemporary Florence (cat. **9**). Given the reciprocal relationship between Christ and his devotees—his *pietas* for humanity and its *pietas* towards him—it is not surprising that the word adhered to the mute pictorial exchange between the Christian savior facing mankind and mankind facing him.[25]

"Man of Sorrows" and *Imago pietatis* both appeal as empathetic terms. So too does our third phrase—*Cristo passo*. It is used today exclusively in Venice and the Veneto, and as far as we know, no other region in Europe employs such an individual name for the subject, a term divorced from the local vernacular of biblical prophecy and from forms of *pietas*. This linguistic phenomenon and its regional distinctiveness supply one of the several rationales underlying the geographical and cultural focus of our exhibition.[26] *Passo* is the Italian form of the Latin *passus*, past participle of the verb *patior* (to suffer or undergo), which by the mid-thirteenth century characterized Christ's suffering on the cross as, for instance, in the *Dies irae* of the Requiem Mass, a Latin text once attributed to the Franciscan Tommaso of Celano but now given to Joachim of Fiore (Gioacchino da Fiore):[27]

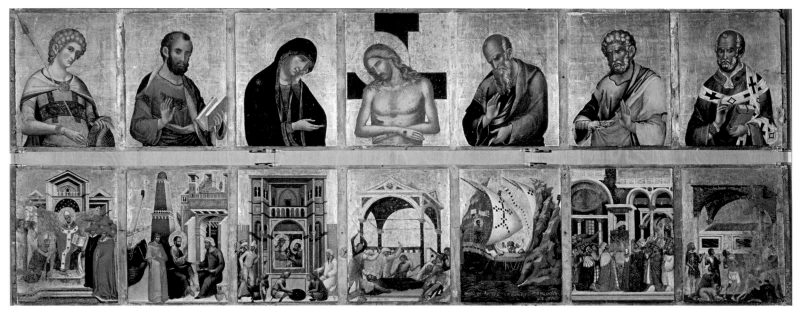

Fig. 5

5. Paolo Veneziano
Pala feriale, 1345–1348
Tempera on panel
Museo di San Marco, Venice

Quaerens me sedisti lassus /
redemisti crucem passus /
tantus labor non sit cassus. [You sat down wearied while seeking me /
Having suffered on the cross you redeemed me /
may your effort not be lost.]

Early in the next century, Dante inflected *passus* to refer to Christ on the cross in the *Paradise* of his *Divine Comedy*.[28] In neither case, however, does the word modify Jesus' name as an adjective. To our knowledge, the Italian *Cristo passo* first turns up labeling works of art in early fifteenth-century Venetian documents: in 1422, for example, the widow Agnesina della Stoppa left a will itemizing, among other articles, a *Cristo passo de alabastro*, an alabaster figurine of the Dead Christ who suffered.[29] That this is *our* image of Christ is clear because figure and designation appear jointly on a Paduan drawing of a generation later (cat. **17**).

Aside from the possible origins, dates and meanings of our three names, questions arise about the relevance of each. Although apparently a modern label for a work of art, the term "Man of Sorrows" surely resonated centuries ago as the laity listened to sermons in Mendicant churches and gazed upon paintings and sculptures of Christ, especially in times of famine and plague. The Franciscan Order in particular promoted the figure of the anguished Jesus, and in a period when many people memorized long passages of sacred scripture, above all verses recited aloud during Holy Week, presenting Christ as the prophet Isaiah's Suffering Servant must have been deeply affecting.[30] *Imago pietatis*, on the other hand, carries little of the theological authority inherent in Isaiah's millennial text. Perhaps that very lack of visionary power made the words compelling to tired, illiterate pilgrims who, while seeking absolution for the hereafter, needed clemency in the here and now. Judging from the crowds that reportedly reacted to the Santa Croce icon when linked with the phrase, the two worked miraculously well together. Finally, *Cristo passo* became a learned designation in the Veneto, finding its way into wills and inventories drafted by educated notaries, onto a drawing associated with one of the eminent fifteenth-century Paduan scribes

(cat. **17**), and into the writings of Marin Sanudo, the erudite Venetian patrician who was both biblio-phile and historian.[31] Venice and the Veneto have retained the designation *Cristo passo* to this day.

Beyond language, the historic individuality of the Venetian Man of Sorrows lies in the very early links the region enjoyed with the Byzantine Empire, where the *Akra Tapeinosis* originated. Initially a fishing village precariously poised on mud flats in a windswept lagoon at the northwestern tip of the Adriatic Sea, Venice developed as an outpost of the Orthodox capital, Constantinople, and its intense and long-standing commercial, diplomatic and artistic relations with that city secured it, as a matter of course, a series of advantages.[32] Shipping lanes joining the two cities led to the burgeoning of Venice's maritime economy and mercantile might, to such an extent that by *c.*1430 the Venetian State encompassed the Veneto mainland lying westward toward Milan, the hill towns and Dolomite Mountains in the north, lands lying southward to the Po River and numerous ports and islands in the eastern Mediterranean Sea. But Venice had already become powerful long before, and in 1204 its forces participated in the invasion of Constantinople, its former mother city, controlled it for several years and then acquired Byzantine lands in Greece, among them parts of the Peloponnesus and the island of Crete.

The Byzantine legacy in Venice is evident in the golden mosaics of San Marco and in the famous *Pala d'oro*, the great ensemble of nearly 100 cloisonné enamels encrusted with almost 2,000 precious stones that sits on the high altar of that church. But it is evident too in the fact that local depictions of the *Imago pietatis* are among the earliest in Italy and resemble the Orthodox *Akra Tapeinosis* stylistically.[33] Byzantine influence had a critical impact in 1343–1345 when Paolo Veneziano, today considered the "father" of Venetian painting, produced the *Pala feriale*, or "daily altarpiece" (fig. **5**), a large work composed of fourteen panels that enveloped the *Pala d'oro* as a protective cover. The Man of Sorrows reigns at the top center of Paolo's *Pala feriale*, with three saints flanking him on each side, and stories from the life and legend of Saint Mark, the city's patron saint, filling the seven scenes on the bottom register. Though bleeding profusely, Paolo's Man of Sorrows is golden, and the figure signals the influence of Palaeologan art, the Byzantine artistic style then dominating Constantinople.

Paolo's serene and lyrical Christ sensitively modernized Byzantine convention in Venice, employing fluid alternations of light and shadow to create a pictorially radiant and three-dimensional torso. As an official image, moreover, his figure exerted enormous artistic power in the city, its authority due to its prime position on the *Pala feriale* and to the site of the altarpiece itself. Prior to the early nineteenth century, San Marco was not the Venetian episcopal seat it is today but the Ducal Chapel—that is, the State church linked both physically and administratively to the Ducal Palace where the Doge, head of government for life, lived and worked, and where all Venetian officials gathered for their deliberations and councils. San Marco embodied the union of Church and State, a place resonating with "Venetian spirituality" (if one can characterize faith by geography and culture). Excluding the ten or so feast days every year on which the *Pala feriale* was raised to reveal the resplendent *Pala d'oro* beneath, Paolo's touching Man of Sorrows was permanently visible on the high altar and determined the local interpretation of the figure for the rest of the century and into the next (cat. **3**). No other early formulation of the subject in Western Europe—apart from the Santa Croce icon (fig. **1**)—played an equally influential role.

A second outcome of the *Pala feriale* was its impact on the placement of the Man of Sorrows atop many later Veneto polyptychs.[34] The type snowballed, so to speak; a number of imposing Veneto golden altarpieces originating in the fourteenth and fifteenth centuries were similarly capped

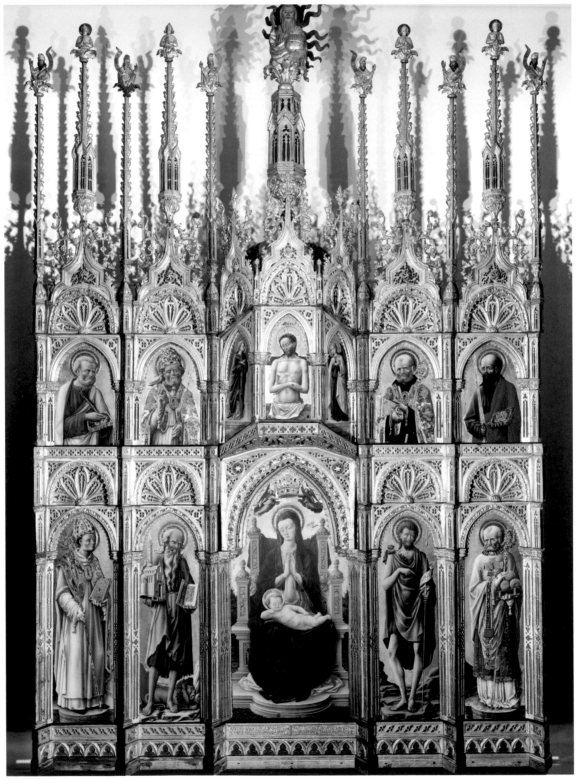

Fig. 6

Man of Sorrows in Venetian Art

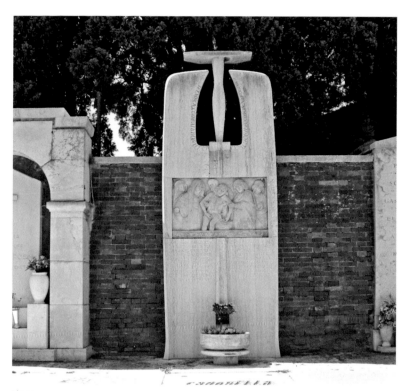

Fig. 7

6. Antonio and Bartolomeo
Vivarini
Certosa Polyptych, 1450
Tempera on panel
Pinacoteca Nazionale, Bologna

7. Carlo Scarpa
Capovilla tomb, 1943–1944, with
fifteenth-century relief of the
Man of Sorrows, Cemetery, Isola
di San Michele, Venice

by the *Imago pietatis* (fig. **6**). The figure's consistent position on large works is striking, particularly when contrasted with Tuscan examples, where the figure customarily appears at the center of the predella, the bottom section of the wood framework enclosing the altarpiece (cat. **9**). As in Tuscany, the Veneto arrangement gave visual form to the nature of the Eucharist because—following Church doctrine affirmed by the Fourth Lateran Council in 1215—Christ's "body and blood are truly contained in the sacrament of the altar under the forms of bread and wine."[35] But the Veneto display also suggested more: as the priest, his back to the congregation while celebrating Communion during Mass, lifted his arms high above the consecrated altar in order to elevate the Body and Blood of Christ, he not only emulated Christ on the cross but also drew attention to the Man of Sorrows crowning the altarpiece.[36] Site, liturgy and gestural drama coalesced and assumed a distinctive Veneto spiritual resonance.

The Man of Sorrows assumed an elevated position on Venetian tombs as well, and thus afforded all social classes the opportunity to benefit from frequent exposure to the figure in church.[37] One example is Pietro Lombardo's tomb for Doge Pasquale Malipiero, *c*.1467, in Santi Giovanni e Paolo.[38] The effigy lies in the eternal sleep of death on his bier, but above, in the crowning lunette, the Man of Sorrows, his arms spread wide, miraculously rises from a sarcophagus and offers believers the promise of resurrection at the end of time. Devotees standing in the church nave could find comfort for their deep anxieties about death in Lombardo's figure high on the wall, across from Giovanni Bellini's painted Man of Sorrows atop his contemporary Saint Vincent Ferrer Polyptych.[39] This enduring funerary tradition was sustained even five hundred years later when Carlo Scarpa, the great modern Venetian architect, incorporated a fifteenth-century relief portraying the Dead Christ into the 1940s gravestone of the Capovilla Tomb on the island cemetery of San Michele in Isola (fig. **7**).[40]

In addition to altarpieces and tombs, small ecclesiastical objects presented the Man of Sorrows to celebrants and attendants at Mass and to lay groups such as sacrament confraternities. Liturgical vessels and implements afforded priests an intimate exchange with the image, as when—in the cathedral of Treviso—they grasped the sculpted and gilt Man of Sorrows on the cover of a pyx containing wafers to be consecrated (cat. **26**). The chalice holding the sacred wine or the paten onto which the priest placed the consecrated Host could equally display the image; one example of the latter shows the Dead Christ with the Virgin Mary and Saint John the Evangelist crafted in 1486 for the pastor of San Giovanni in Bragora, Venice (fig. **8**).[41] When the wafer lay in the center of the dish, substance and image conjoined in spiritual unity. The vestment worn by the officiating priest could also repeat the image, as evinced by Michele Giambono's painted depiction of a vestment adorned with the *Imago pietatis* (fig. **9**).[42] One notable extant example of the type is a splendid chasuble with a prominent Christ in the Chalice embroidered in gold threads on the back, which echoes the miracle of transubstantiation performed at the altar.[43]

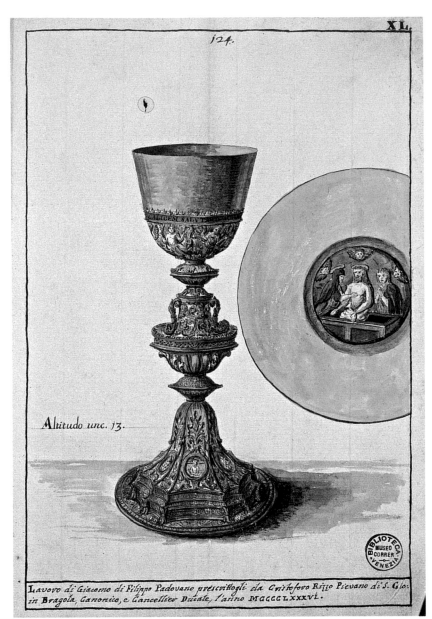

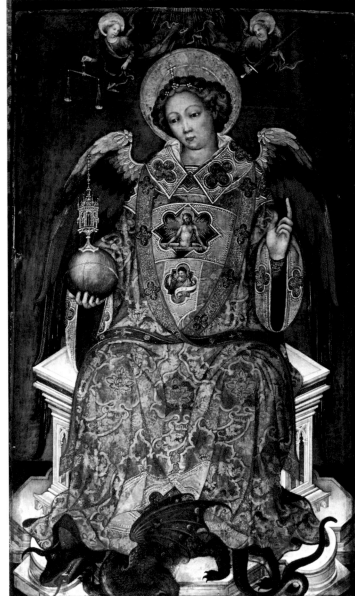

Fig. 8

Fig. 9

8. Jan Grevembroch
Watercolor of chalice and
paten by Giacomo di Filippo
Padovano (1486)
*Varie Venete curiosità sacre e
profane*, 1755, Ms. Gradenigo-
Dolfin 65-I, folio XL
Biblioteca Correr, Venice

9. Michele Giambono
Archangel Michael, c.1440
Tempera on panel
Bernard Berenson Collection,
Villa I Tatti, Settignano

While reciting the liturgical prayers, the priest read from his missal propped up on the altar, a scene portrayed in the *Mass of Saint Gregory* (cat. **34**). An illumination of the Man of Sorrows at key places in the text would cue the celebrant to invoke Christ's redemptive sacrifice, for example at the opening prayer of the Canon of the Mass in a fourteenth-century missal from Cividale (fig. **2**), or of the Collect on Wednesday of Holy Week or the Feast of the Five Wounds, both instances found in a Franciscan missal of the same century.[44] The celebrant and others privileged with access to the high altar of San Marco also gazed upon the figure in the sumptuous Sacramentary of San Marco, the missal displayed on solemn days in the liturgical calendar, as on the first Sunday in Advent when the Introit to the Proper of the Mass presented a richly illuminated folio with the Man of Sorrows at the center of the top border joined by Mary, John, the Evangelists, and the patron saints of Venice.[45] Also enriching the altar of San Marco was the pair of gilded silver candlesticks donated to the Ducal Chapel by Doge Cristoforo Moro (r. 1462–1471). The base of one of the massive candlesticks shows the Man of Sorrows in high relief, framed within an ornate Gothic aedicule, flanked by Mary and John in their own small shrines, and accompanied by a larger saintly assembly, all expressing the same devotions as on the *Pala feriale* and in the Sacramentary of San Marco. Moro's gift inspired civic pride for generations, as confirmed by an imaginary seventeenth-century dialogue between a Venetian and his foreign guest who singled out the priceless candlesticks for high praise.[46]

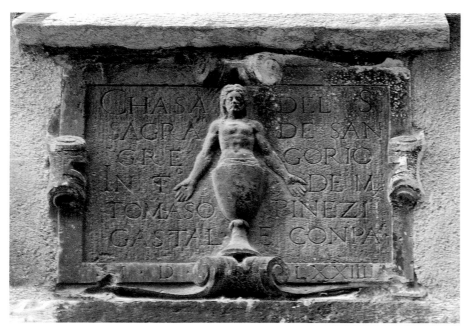

Fig. 10

10. Anonymous
Christ in the Chalice, 1573
Outdoor stone relief
Calle del Mezzo, Dorsoduro 136,
Venice

From the beginning of the sixteenth century ordinary Venetian men and women had increasing opportunities to venerate and exalt the Man of Sorrows as lay members of confraternities whose mission was to care for the Holy Sacrament.[47] The majority of these societies, the *Scuole del Santissimo Sacramento* or *del Corpus Domini*, were founded in the first third of the century, well before the Council of Trent met from 1545 to 1563 to institute Church-wide reform and define Catholic doctrine in response to Protestant dissent. In fact, the principles asserted at the twenty-third session in 1551 regarding the Eucharist had long been in practice in Venetian sacrament confraternities.[48] Prior to Trent, the sacrament was generally reserved not on the high altar but in its own chapel, whose maintenance and adornment fell to the local *scuola*. The Man of Sorrows claimed a place in the *scuola*'s chapel decorations and confraternal furnishings but never played a role on the large canvases painted for lateral walls owing to the symbolic meaning of the image.[19] Alone or with angels, the figure might appear as an illuminated miniature on the frontispiece of the *mariegola* or confraternal statute book (cats. **40** and **41**), as a gilded carved figure atop processional standards (cats. **42** and **43**), or as a bronze relief on the pax tablet offered for the Kiss of Peace at Mass (cats. **30–32**). Inventories of the communal property of the *scuole* list among their possessions still other items: an altar frontal, a curtain for the altarpiece of the chapel (both painted with the *Cristo passo*), and pieces of furniture decorated with the sculpted figure, including a balustrade, a lectern, and the bench where the members gathered in the church.[50] Even the confraternal meetinghouse, like one near San Gregorio, could be adorned with a stone relief signaling the function within (fig. **10**).[51]

Although sacrament confraternities were hardly exclusive to Venice, two features set them apart in the Republic from their counterparts elsewhere in Italy: first, their charters required the approval of the Council of Ten, a key governmental executive body, and second, they enjoyed an unusual degree of independence in the management of daily church business without priestly intervention.[52] The Venetian State had long exerted direct control over its own ecclesiastical affairs and encouraged lay piety in order to achieve this. Visually asserting the link between the State and the corporate piety of sacrament confraternities, a miniature of the Lion of Saint Mark, the emblem of the city as well as the Evangelist's attribute, decorates the border on the opening page of a *mariegola* of one Venetian *Scuola del SS Sacramento* (fig. **11**) and is aligned with the host and chalice; below these, both male and female members of the *scuola* kneel in adoration of a sculpted Christ in the Chalice raised on a pedestal.[53] As pictured here, average Venetians devoted to the sacrament worked collectively for a common purpose and in so doing shaped their identity within society. Unlike *scuole* bearing saintly and professional dedications in Venice and elsewhere, sacrament confraternities in the city were united by the Eucharist, its universality engaging every neighborhood and *sestiere*, or district.

The civic pride underlying Venetian Eucharistic piety emerged forcibly in the late sixteenth century when the Church in Rome attempted to impose reforms promulgated by the Council of Trent. Ordering pastoral visits by high ecclesiastics charged with inspecting churches in the Republic, the Vatican sent investigators to examine the fitting reservation of the sacrament on the

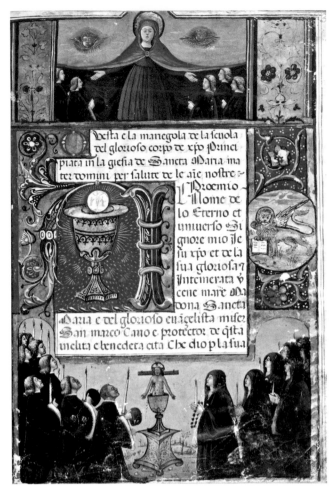

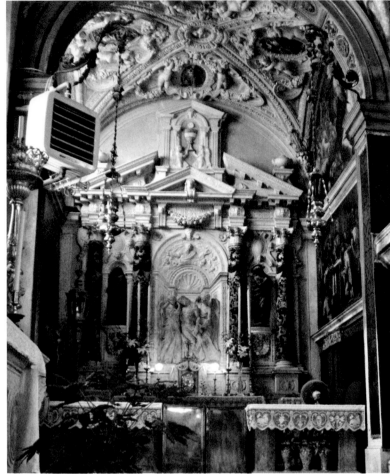

Fig. 11

Fig. 12

11. Anonymous
Madonna della Misericordia (above),
Christ in the Chalice and Confraternity Members (below), 1512
Vellum
Mariegola, Confraternity of the Holy Sacrament, Santa Maria Mater Domini, folio 3r
The Art Museum, Princeton University

12. Chapel of the Holy Sacrament, 1578–1581
San Zulian, Venice

high altar. Several Venetian sacrament confraternities embraced the recommendations of Trent and obediently moved the sacrament.[54] But even those *scuole* that retained an independent Eucharistic chapel were stirred by the renewed devotion of the time and vied to redecorate their sacrament altars. In the small parish church of San Zulian, or San Giuliano, where the sacrament chapel stands to the left of the high altar, the *scuola* initiated lavish renovations in 1578 (fig. **12**).[55] The Veronese sculptor Girolamo Campagna carved a monumental marble relief of the Dead Christ with Angels for the magnificent host tabernacle, and his modern interpretation of the traditional image soon found imitations in other media (cat. **55**). Local authorities adamantly upheld the privilege of the confraternities at San Zulian and elsewhere in order to maintain the traditional local position of the sacrament altar, and they warned visiting prelates from outside the city against undermining lay piety in the *Scuole del Santissimo Sacramento*. The confraternities were essential to the sustainability of the city's churches.[56]

Just as the image of the Man of Sorrows stimulated Venetian popular piety within the sacrament confraternities, it spread through Veneto cities and towns by means of the *Monti di Pietà* that flourished in the second half of the fifteenth century.[57] Conceived by the Observant branch of the Franciscan Order, a *Monte di Pietà* was a banking institution that relied on collective monies—as did the sacrament confraternities—but for the purpose of making small loans to the worthy poor. The *Imago pietatis* became the *Monte*'s official logo, probably at the instigation of Bernardino da Feltre (1439–1494), a man intimately acquainted with the image from his Veneto birthplace, his Paduan training, and his Franciscan vocation. Bernardino acted as prime mover of the banking enterprise and created or revitalized more than thirty such loan foundations in the Veneto and elsewhere between 1484 and his death. In order to raise the necessary capital to support the system, Bernardino and other Observant friars preached regularly and led processions brandishing the *Monte* banner painted with the Man of Sorrows, thereby linking charity and credit to Christ's

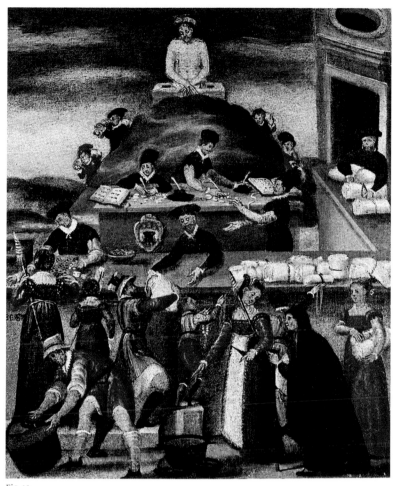

Fig. 13

13. Giambattista Bertucci
*Bank and Pawnshop of the
Monte di Pietà*, c.1500–1515
Oil on canvas
Banca di Romagna, Faenza

Passion. A sixteenth-century canvas demonstrates how these institutions ran: anyone seeking a loan consigned a pledge, or *pegno*, to the lay personnel in the bank in exchange for a small sum of money (fig. **13**). A *monte*, or hill, rising behind the donors, borrowers, and bureaucrats, signifies a mound of communal wealth; at the summit the Man of Sorrows also rises, but from the tomb. Surely a visual paradox for the modern observer: banking on the one hand, and Christ's redemptive body on the other. Emphasizing the abject humility and suffering that Christ freely bore, the *Imago pietatis* offered the pious a compelling model of compassion for urban philanthropy, not only on the processional banners of the *Monti* but also on the banks' façades, in account ledgers and statute books (cat. **18**), and even on doorknobs, cabinet drawers, and other bureaucratic accessories.

Many further opportunities existed for the public or private veneration of the Man of Sorrows. Reliefs sculpted with the *Imago pietatis* might greet the traveler from a shrine along a lonely country road (fig. **3**), or beckon the urban dweller from the imposing portal of a Venetian church (fig. **14**).[58]

At home the individual could turn to the figure for prayer and meditation by opening an illuminated Book of Hours, reading a spiritual manual printed in Venice, or gazing upon an inexpensive devotional print tacked to the wall.[59] Artists and artisans, many now anonymous, made most of these images, but for three centuries the Man of Sorrows also inspired major works of art in Venice and its empire. Beginning in the early Renaissance, nearly every great artist associated with that school interpreted the image time and again. Indeed, no other European region can boast so many important painters and sculptors replicating the subject so often. Michele Giambono depicted the Man of Sorrows six times; Giovanni Bellini and his family workshop ten times, without counting drawings; the Vivarini atelier, more than a dozen; Carlo Crivelli—working outside the region but insisting upon his Venetian origins in his signature—depicted the figure more often yet; Lorenzo Lotto, also a Venetian active abroad, painted it at least three times, as did his contemporary Palma il Vecchio; the Bassano clan created a slightly higher number of germane works; Paolo Veronese painted almost ten figures of the Man of Sorrows, and Palma il Giovane produced about twenty-five painted and drawn versions of the subject. Leading painters alone produced more than 100 paintings and drawings of the *Imago pietatis* between c.1430 and c.1620. This total does not include the many celebrated sculptors and printmakers who also depicted the Man of Sorrows, nor does it take into account two extraordinary canvases: an easel picture attributed to Giorgione and Titian, and a mural by Tintoretto. In the dramatic *Dead Christ Supported by an Angel* of c.1510 which Titian probably completed after Giorgione's death, Christ's palpably physical body fills the foreground and covers most of the angel, whose vibrant face and transfixing gaze are juxtaposed with Jesus' pallid, lifeless head.[60] Seventy years later, in a votive painting for the Senate Chamber in the Ducal Palace, Tintoretto portrayed the awesome vision of a full-length and blood-soaked Christ with five angels amidst the clouds.[61] The site and vast size of Tintoretto's mural underscore the official veneration accorded to the image, continuing a tradition that went back to late-medieval Venice and Paolo

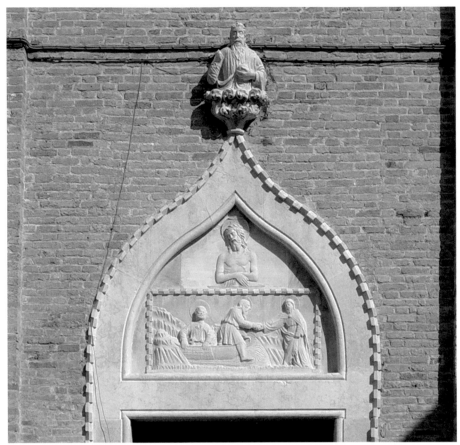

Fig. 14

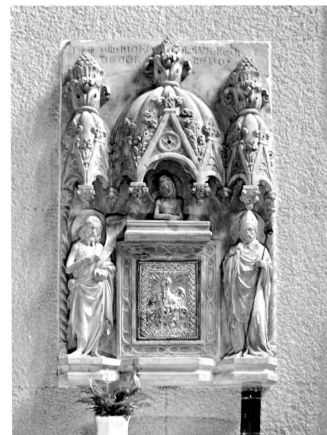

Fig. 15

14. Anonymous
*Man of Sorrows, c.*1475
Façade relief
Sant'Andrea della Zirada,
Venice

15. Niccolò da Cornedo
Sacrament Wall Tabernacle,
1440
Limestone
Parish Church, Cornedo

Veneziano's Man of Sorrows on the high altar of San Marco. Finally, early seventeenth-century artists active in Verona executed numerous small works on the theme on both slate and copper. No pictorial tradition in Europe can compete with this Venetian and Veneto record.

Several works in the exhibition merit special comment. Sadly lacking its forearms and thereby prompting our speculation as to its possible original appearance and setting, the magnificent marble relief from Dayton (cat. **29**) bears an attribution to Cristoforo Solari that needs to be tested and discussed. Close in date to the Dayton work but carved in lower relief in Istrian stone, a material widely used in Venice, is a newly discovered panel attributed to the Venetian sculptor Antonio Rizzo (cat. **28**). Another sculpture, restored for this occasion, is the polychromed wall tabernacle from Chicago that presents a small figure of the Man of Sorrows over the door to the sacrament repository, a position notably respected in the Veneto (cat. **33**). In recent years a few local churches in and around Vicenza have renovated their fifteenth-century wall tabernacles (fig. **15**), reviving a type of sacrament receptacle once found throughout the region but later replaced by tabernacles set on the altar. Also restored, and brought out of storage from the Princeton University Art Museum, is the gripping late fifteenth-century *Dead Christ Supported by Two Angels* (cat. **21**), a relief in papier-mâché, its material betraying its replication for a "mass market."

The prototype for the Princeton design derives from the great Florentine sculptor Donatello, whose influential bronze relief of the Dead Christ with Angels (fig. **16**) on the high altar of Sant'Antonio was cast in 1449.[62] Moderno's pax tablets (cats. **30–32**), and a bronze plaquette (cat. **20**) are only a few of the numerous Venetian and Veneto works that reflect local responses to Donatello's radical transformation of the late-medieval Man of Sorrows into a classically conceived figure grieved by *spiritelli*, the infant angels he invented after antique prototypes.[63] But Giovanni Bellini best understood and developed Donatello's interpretations of the theme in his many panels. While drawing upon the Byzantine tradition, he also introduced Renaissance innovations, conceiving an idealized yet naturalistic Christ at times seen before sunlit landscapes.[64] At other times he dramatically set Jesus' pallid but Herculean body against a darkened space, as in the *Man of Sorrows*

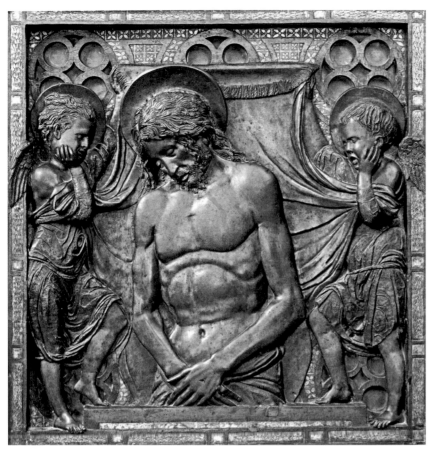

Fig. 16

16. Donatello
*Man of Sorrows with Two
Angels*, 1448–1449
Gilt bronze relief
High Altar, Basilica di
Sant'Antonio, Padua

with Four Angels (fig. **17**), where individualized and graceful *spiritelli* tenderly prepare the Christian savior for his Resurrection beyond the grave. Bellini's variations on the *Cristo passo* are among the most profound ever painted and, along with Donatello's, and those of Andrea Mantegna (fig. **18**), established new criteria for the modern Man of Sorrows.

A late fourteenth-century painted panel from London is presented in the exhibition with its recent attribution to the early Veneto artist Jacobello del Bonomo (cat. **3**); his radiant Christ closely approaches Paolo Veneziano's authoritative figure on the *Pala feriale*. Bonomo's work introduces a small group of fifteenth-century panels that, although now displayed in their respective museums as independent paintings, once belonged to large altarpieces. The priceless silver pyx lent by the Cathedral Treasury of Treviso (cat. **26**), which is still used for special feasts in the liturgy, is an outstanding example among the various exquisitely crafted Veneto liturgical vessels that adopted the *Imago pietatis* for its Eucharistic associations. Also dating from the late fifteenth century is the delicate miniature in the statute book of the *Monte di Pietà* of Padua, which is here associated with the work of Antonio da Villafora, one of the city's leading illuminators (cat. **18**). The *Man of Sorrows* from the Scuola Grande di San Rocco, recently identified as by Vittore Belliniano, offers a striking synthesis of traditional imagery harking back to the origins of the figure in Venice but overlaid with the latest artistic techniques of the sixteenth century (cat. **44**). Normally displayed in the magnificent upper hall of the Scuola amidst Tintoretto's biblical cycle, the canvas belongs to the only Venetian lay confraternity in continuous existence since the end of the fifteenth century. Working later in the same century, Battista Franco produced a series of images of the Dead Christ with Angels (cats. **46–48**), a drawing, an etching, and a related painted panel discovered among the anonymous works in the David and Alfred Smart Museum during preparation for the exhibition.

Works from elsewhere interspersed among the Venetian objects in the exhibition provide a contrasting view of how the Man of Sorrows was portrayed outside Venice. Two prints by Albrecht Dürer, who had first-hand knowledge of Venetian art from his travels, underline his original and influential interpretations of the subject (cats. **35** and **36**), and exemplifying a type of virtuoso carving typical of the North, the curious boxwood head from San Francisco couples a skull and Christ's face, which uniquely conceals a full-length Man of Sorrows released by a spring (cat. **37**). Still other works illustrate cults and devotions that, like the Man of Sorrows, reflect late-medieval veneration of Christ's Passion, but attained popularity largely outside of Venice, such as the *Holy Face, Veil of Veronica*, and *Mass of Saint Gregory* (cats. **34, 38** and **39**), or veneration of the Instruments of the Passion, intensely observed in Verona and other Italian locales. The theme of the *Ecce Homo*, which at times inspired a close-up portrayal of the suffering Christ akin to the Man of Sorrows, is represented by two works: the first from Oberlin and the second produced in porcelain in the eighteenth century (cats. **60** and **61**), close in date to George Frideric Handel's famous setting of Isaiah 53:3 for alto voice, included here in an early printed edition from the Morgan Library (cat. **62**).

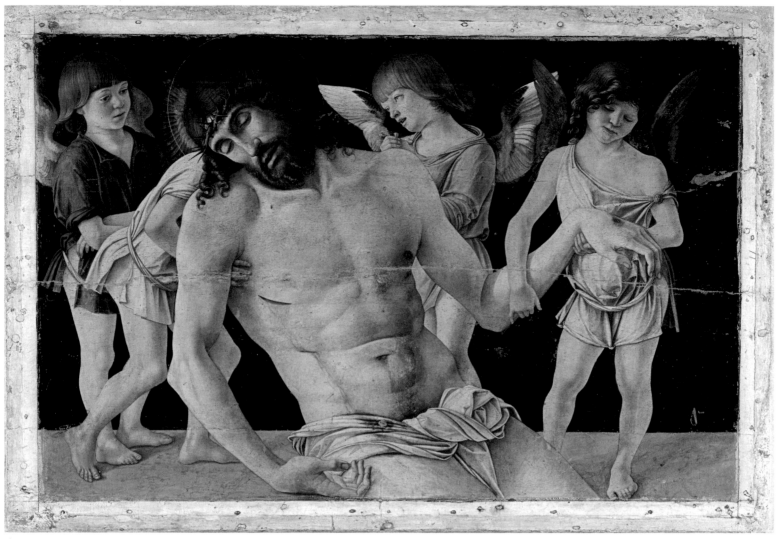

Fig. 17

17. Giovanni Bellini
Man of Sorrows with Four Angels,
c.1470
Tempera and oil on panel
Musei Comunali, Rimini

18. Andrea Mantegna
Man of Sorrows with Angels, *c*.1500
Tempera on panel
Statens Museum for Kunst,
Copenhagen

19. Bill Viola
Emergence, 2002
Color High-Definition video

A brief epilogue to our array of early images of the Man of Sorrows comprises three modern works revealing the lasting fascination induced by the image. Edouard Manet and Paul Cézanne were drawn to the figure primarily for aesthetic reasons but were nonetheless inspired by religious prototypes like those on view here (cats. **63** and **64**).[65] Today a secularized and widespread use of both the phrase and the image of the Man of Sorrows appears in a variety of contemporary contexts created by authors, musicians, and even film and video makers, all confident that their audiences are sufficiently familiar with the term to understand its application. For example, the distinguished British novelist Barry Unsworth alludes to the Man of Sorrows to describe a subtle aura of sensual appeal attached to his protagonist's counterfoil in *Pascali's Island*.[66] American crime writer Donna Leon calls on her readers' empathy for the engaging Venetian detective Commissario Brunetti by likening him to "a man of sorrows and afflicted with grief" when he is yet again exasperated and exhausted by an obstructive colleague.[67] In the American folk song "Man of Constant Sorrow," attributed to Richard Burnett and recorded by Bob Dylan, the protagonist sings of his lifelong woes, which are echoed in a third-person refrain, an arrangement recalling Isaiah's description of the Suffering Servant.[68] Even where the phrase itself is not used, imagery of the Man of Sorrows nonetheless presumes viewers' associations with its artistic tradition. Thus, in the Italian neorealist film *Rome: Open City* (1945), Roberto Rossellini's scene of torture portrays the leader of the Resistance in the guise of the suffering Christ—blood streaking his face and nude torso, the shadow of a cross cast on the wall behind him—and so imbues the wartime sacrifice of modern Italians with hallowed meaning. Such common human themes of pain, loss, and grief suffuse Bill Viola's videos in his series "The Passions" from 2003, two of which draw on traditional

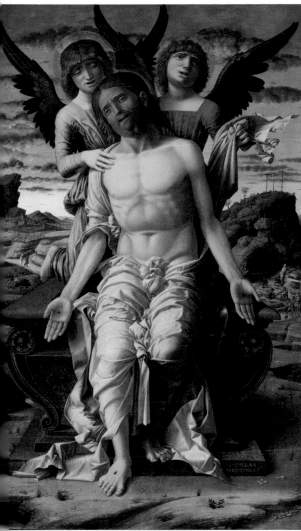

Fig. 18

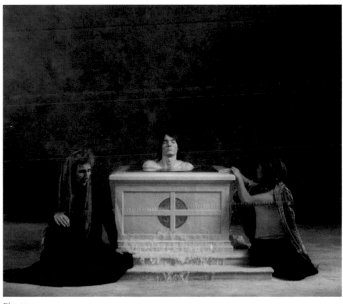

Fig. 19

sacred imagery of Christ's death. Viola's large-screen video *Emergence* (fig. **19**) presents three actors in a contemporary staging inspired by Renaissance painting and directly referring to the Madonna and Mary Magdalene lamenting Christ's death and witnessing his rising from the tomb; his *Man of Sorrows* (cat. **65**), showing only a man's head and shoulders and echoing early Byzantine prototypes, is less tied to sacred history but more generally personifies the human condition. The works in *Passion in Venice* eloquently visualize earthly suffering but interpret it through the Christian hope of redemption embodied in the Man of Sorrows, a figure that sustained faith and piety across three centuries of art in Venice and the Veneto.

Catherine Puglisi and William Barcham

1 The literature is indeed vast, but see Panofsky 1927, Schiller 1971, Belting 1980–1981, Ringbom 1984, Pallas 1965, Ridderbos 1998, and for the early Venetian story, Puglisi and Barcham 2006.

2 Among the most famous early Byzantine images of the figure are the painted bilateral icon in Kastoria (Evans and Wixom 1997, 125–126, cat. 72), the illuminations on fols. 65v and 167v in the Gospels of Karahissar (Colwell and Willoughby 1936, I, 118–120, and II, 176–180, pl. XXXIV, and 349–351, pl. CVI), and an early steatite carving (Kalavrezou-Maxeiner 1985, I, pl. 95, and II, pl. 48).

3 Several hypotheses for the transmission can be proposed, a subject the authors will explore in subsequent publications.

4 Byzantine representations also began to include Christ's arms in the imagery; cf. the Santa Croce micromosaic icon (fig. 1), for which see Bertelli 1967 and Evans 2004, 221–223, cat. 131.

5 Epley 2008 (professor of Behavioral Science at the Graduate School of Business, University of Chicago) uses the term "framing effects" to characterize how descriptions or narratives are outlined or perceived. Nagel 2000, 50, refers to "pictorial staging," perhaps not synonymous with framing effects but related; see his stimulating discussion, 49–82.

6 The issue of vernacular translations of *Vir dolorum* in early modern Bibles remains to be studied.

7 Childs 2001, 410: "It is hardly necessary to remind the reader that this passage is probably the most contested chapter in the Old Testament."

8 The bibliography on Isaiah is immense, but see Childs 2001, 289–291, on chapters 40–55 (Second Isaiah), where the arguments for assigning this section to an author of the sixth century BC are summarized.

9 Belting 1981, 1–5, proposes "Passion Portrait,"— "with its associations and affiliations to the pictorial staging of the Passion," a likeness "of a corpse touched by suffering."

10 We are grateful to several colleagues for helping us verify this: Linda Borean, Roberto Contini, Michel Hochmann and Stefania Mason.

11 See Panofksy 1927; also Mâle 1908 and Millet 1916. See Guiffrey 1894–1896, 19, 23, 227, 236, 294, for the figure in fifteenth-century inventories of Jean, Duc de Berry, as "une Pitié or une Pitié de Nostre Seigneur"; and O'Meara 2001, 260, for a payment of 1383 by the Duke of Burgundy for a tondo with "un ymage de

Nostre Seigneur dedens le sepulcre et l'ange qui le soutenoit," surely a work showing what today we would call a Man of Sorrows with an Angel.

12 Löffler 1922. Von Dobschütz 1899, 294, uses *Mann des Leidens*.

13 Sawyer 1996, 1; we are much indebted to Professor Sawyer for his advice.

14 "But he [Christ] made himself of no reputation, and took upon him the form of a servant, and was made in the likeness of men; And being found in fashion as a man, he humbled himself, and became obedient unto death, even the death of the cross." See Eissfeldt 1965, 336: "vicarious suffering by the innocent is man's highest good, which in Jesus' suffering and death is made a reality bringing salvation."

15 John of Caulibus 2000, 273–274. See the late Gothic Italian glass tablet of the Man of Sorrows (cat. **7**) with a short Latin inscription culled from that very excerpt and confirming the medieval connection between Isaiah 53:3, Philippians and our image of Christ.

16 For the Suffering Servant, see Craig 1944 and McCormick 1994, 69–92. See Childs 2001, 420–423, for Isaiah 53 and the New Testament, and for the Suffering Servant and Christian theology.

17 The debate deriving from Panofsky over whether the Man of Sorrows is a devotional image or a cultic image has continued for decades; the authors will address this issue elsewhere.

18 Childs 2001, 414.

19 Du Cange 1845, 248: *miseratio, misericordia*. Translated as "piety" or "pity" by various authors writing on the subject, but the two English words do not carry the same meaning; the classical Latin *pietas*, devotion and compassion, is not synonymous with the medieval *pietas*.

20 For the icon (today in the museum adjacent to the basilica), see note 4 above. Despite ongoing assertions that it was responsible for the figure's diffusion, the Man of Sorrows was already well established in Italy by *c*.1385. For van Meckenem's print, see Evans 2004, 556, cat. 329.

21 See the English prayer roll in Finaldi 2000, 164–165, cat. 64, with the English words *ymage of pyty* written directly below the Man of Sorrows; the phrase had already migrated from Latin into English by 1500.

22 See the illumination on fol. 179r in a Book of Hours in the Morgan Museum and Library (ms. M.1052) for an association of 1483 between the image and Pope Gregory.

23 See note **11** above. The Spanish Retable of Saint

Mark, *c*.1350 (New York, the Morgan Library and Museum) represents the Man of Sorrows with the inscription PIETAS CRI.

24 Origo 1963, 239.

25 For *pietas*, see Belting 1990, 172–173.

26 The phrase creates perplexity today even in adjacent Emilia and Romagna; see Cortelazzo 2007, sub vocem *passo*.

27 Vellekoop and Alvarez 1978, as in Gy 1996, 179.

28 We are deeply indebted to Emilio Lippi, director of the Biblioteche e Musei Comunali di Treviso, for his help in resolving the challenges posed by *Cristo passo*. See Battaglia 1984, "Passo." Dante, *Paradiso*, XX, 103–105: "D'i corpi suoi non uscir, come credi,/ Gentili, ma Cristiani, in ferma fede/ quel d'i passuri e quel d'i passi piedi." Thomas Bullfinch (1796–1867), Dante's famous American translator, wrote "They quitted not their bodies, as thou deem'st,/ Gentiles but Christians, in firm rooted faith,/ This of the feet in future to be pierc'd,/ That of feet nail'd already to the cross."

29 Venice, Archivio di Stato, Cancelleria inferiore, Notai, b. 24, fol. 27v, n. 201, as in Sorelli 1984, 102, n. 35.

30 For the Franciscans and the Man of Sorrows, see Cannon 1999, and Puglisi and Barcham 2008. For historical background on why the subject would have appealed so strongly in the later Middle Ages, see Ariès 1977, Delumeau 1978 and Delumeau 1983; and for the fourteenth century generally as a tragic period, see the readable and reliable work by Tuchman 1978.

31 See Sanudo, *Diarii*, XXIV, col. 63 (1517), and ibid., XXXIV, 98 (1523). See Gilbert 1976, 513, for the mention in 1522 of a painting "cum una testa de Christo passo" in the will of Giampietro Stella, Cancelliere Grande of Venice.

32 Nicol 1999.

33 See Neff 1999 for two relevant illuminations in the *Supplicationes variae* (Florence, Biblioteca Medicea Laurenziana), and d'Arcais and Gentili 2002, 130–131, cat. 14, for the panel in the Museo Provinciale, Torcello.

34 For paintings by Paolo's workshop in Piove di Sacco (now Padua, Museo Diocesano) and the National Gallery of Spalato, see Guarnieri 2006, 85, fig. 66, and d'Arcais and Gentili 2002, 170–171, cat. 33.

35 For the decree on the doctrine of transubstantiation, see Tanner 1990, I, 230.

36 This was an act itself begun in the late Middle Ages; cf. Sensi 2008, esp. 283–287. Pope John XXII (d. 1334) invoked the suffering of Christ in his pronouncement regarding the elevation of the host during the consecration; see Paulus 1922–1923, 2, 233, who cites an

Office by John for the praise of the suffering of Christ ("Leidens Christi") for which many indulgences were granted (according to the Franciscan Johann von Winterthur's chronicle of 1340). For more on John XXII, see Gy 1996, esp. 181–182 for the prayer *Anima Christi, Sanctifica me*.

37 For a brief summary of fourteenth-century tombs, see cat. **5**.

38 For Lombardo's relief dated *c*.1467–1470, see Zava Boccazzi 1965, 113–117.

39 On late-medieval attitudes towards death, see the classic study by Ariès 1977.

40 The relief presents a composition that extends the Man of Sorrows into the narrative of the Lamentation by incorporating additional figures in a design closely related to drawings by Jacopo Bellini (Paris, Musée du Louvre) and Giovanni Bellini (Florence, Galleria degli Uffizi). For Scarpa's tomb in *recinto XX* of the cemetery, see Los 2001.

41 The Man of Sorrows decorates the foot of the chalice from Sant'Eufemia now in the Museo Diocesano, Venice; see Grevembroch 1755, vol. II, pl. XL.

42 For Giambono, see cat. **19**; the artist's Saint Michael in fig. 9 wears a deacon's vestment.

43 For the late fifteenth–early sixteenth-century chasuble in the Duomo of Motta di Livenza (outside Treviso), see *In Hoc Signo* 2006, 311, and 362, cat. I.71.

44 See the Franciscan Missal, Princeton University Library, Garrett 39, fols. 123r, 383r, for which see Puglisi and Barcham 2008, 45, and 61, notes 35–36.

45 Venice, Biblioteca Nazionale Marciana, ms. Lat. III, 111 (=2116), fol. 7r, for which see Puglisi and Barcham 2006, 420–421, for bibliography.

46 Niccolò Doglioni (1662), in *Documenti per la storia* 1886, 256–263, especially 262. For the candlesticks, see *Tesoro di San Marco* 1971, 185–186, cats. 181–182, pls. CLXXXV–CLXXXVII.

47 For a description of confraternal responsibilities, see cats. **40** and **41**.

48 The bishops at Trent affirmed the "sound and genuine doctrine of the venerable and divine sacrament of the Eucharist" and insisted that the "sublime and venerable sacrament be celebrated with special veneration and solemnity every year on a fixed festival day, and that it be borne reverently and with honor in processions through the streets and public places." The Council also recognized "the custom of reserving the Holy Eucharist in a sacred place" and "the practice of carrying [it] to the sick and of carefully reserving it for this purpose in churches." http://www.ewtn.com/library/COUNCILS/TRENT13.HTM.

49 For Venetian sacrament chapels, see Cope 1979; and for their pictorial decoration and furnishings, see Hills 1983 and Worthen 1996.

50 These objects were listed in inventories of the *mariegole* of San Tommaso, San Cassiano, and Corpus Domini (Biblioteca del Museo Civico Correr: ms. Cl. IV, 44; ms. CL. IV, 203; ms. CL. IV, 210).

51 As noted by Marcon 2007, 285, a stone relief of Christ in the Chalice on the exterior of San Polo, facing the *campo* of that name, attests to the intervention of the sacrament confraternity in renovating the tabernacle.

52 On the Venetian *scuole*, see Brown 1996.

53 For the Princeton *mariegola*, see cat. **41**. For the political implications of the Lion of Saint Mark, see Brown 1988, 19.

54 At San Marziale, the sacrament confraternity decided that, since many other parishes were busy redecorating their chapels, they would do likewise, and they also moved the sacrament to the high altar; the same decisions were recorded in the *mariegole* of Santa Sofia and San Tommaso. For all three, see Biblioteca del Museo Civico Correr, ms. Cl. IV, 22 (San Marziale), ms. CL. IV, 131 (Santa Sofia), and ms. CL. IV, 44 (San Tommaso). See also Hills 1983, 37.

55 For the chapel, see Mason 1976.

56 See Tramontin 1967, and Hills 1983, 38. The Venetian State also guarded its prerogatives in the determination of its own ecclesiastical affairs against interference from Rome; see Prodi 1990.

57 Opened in all the principal cities of the Veneto, the institution was barred from Venice by the government, whose economy depended upon Jewish moneylenders; for the *Monte*, its links to the Franciscans, and its adoption of the Man of Sorrows as a logo, see Puglisi and Barcham 2008, with earlier bibliography.

58 For the relief, the original of which dates to the Trecento and is now in the Museo Civico, Riva del Garda, see Castelnuovo and de Gramatica 2002, 684–685, cat. 109. For the relief at Sant'Andrea della Zirada, see Rizzi 1987, 414, no. 53, fig. SC53.

59 For Books of Hours, see cats. **12–15**; and for a devotional woodcut, see cat. **56**. Numerous examples can be found in Venetian printed books, for which see D'Essling 1908.

60 See Pignatti and Donahue 1979, 50–51, cat. 10.

61 See Sinding-Larsen 1974, 99–108, pls. XXXII–XXXIII.

62 On the Santo altar, see Johnson 1999, with earlier bibliography; and Gilbert 2007, 18–20, who has hypothesized that the bronze relief with the Dead Christ adorned the rear, but such a reconstruction ignores where the Man of Sorrows was customarily placed on Veneto altars.

63 For this new type of angel, see Dempsey 1996 and Dempsey 2001.

64 See Belting 1996 for his provocative analysis, and *Giovanni Bellini* 2008 for several of the panels. Regrettably, conservation issues precluded the loan of a *Man of Sorrows* by Giovanni Bellini.

65 See also James Ensor, *Man of Sorrows*, Ghent, 1891; and Odilon Redon's series of the "noirs," large charcoal drawings from the mid-1890s often depicting the suffering Christ with eyes opened or closed and with the crown of thorns; see Wildenstein 1992, I, 192–207.

66 Barry Unsworth, *Pascali's Island*, New York, 1980, 64–65. The Englishman Bartlett is described as assuming willy-nilly the guise of a Man of Sorrows, which not only holds sexual appeal but "seems to be the fashion for contemporary heroes." Michael A. Greenberg's recent novel *A Man of Sorrows* (San Jose, CA, 2001) never explains the choice of title; presumably it pertains to the protagonist's miraculous healing powers that subject him to persecution.

67 Donna Leon, *Doctored Evidence*, London, 2004, 77.

68 The song was first published in Burnett's 1913 Songbook and was included on the 1962 album "Bob Dylan." See also British singer Bruce Dickinson's lyrics for his song "Man of Sorrows" (*Accident of Birth*, 1997) evoking an image that frightens a boy—the Victorian Antichrist, Aleister Crowley—in church.

Isaiah's Servant, Christianity's Man of Sorrows, and Saint Francis of Assisi

The Christian church considered the Old Testament Book of Isaiah to be the fifth gospel. For the early Church, the prophet Isaiah—before all other prophets—was believed to be prophesying Christ. For Christians, the most well-known instance of Isaiah's prophecy is chapter 53, popularly known as the *Suffering Servant Song*:

> He was despised and rejected by others;
> a man of suffering and acquainted with infirmity;
> and as one from whom others hide their faces
> he was despised and we held him of no account.
>
> Surely he has borne our infirmities
> and carried our diseases;
> yet we accounted him stricken,
> struck down by God, and afflicted.
>
> But he was wounded for our transgressions,
> crushed for our iniquities;
> upon him was the punishment that made us whole,
> and by his bruises we are healed. (Isaiah 53:3–5, New Revised Standard Version)

Beginning with the early Christians and still resonant for believers to this day, these verses were often thought to refer to the Christ who suffered and died on the cross. The foundational use of Isaiah in the construction of a Christian consciousness in the early writings of Christianity has led to the understanding that Christ himself very likely considered chapter 53 as prophesying his personal destiny.[1] Beyond its use in the Hebrew and Christian scriptures, the Book of Isaiah took on great importance in the liturgy and in personal meditation and devotion (often focused on images), especially in the books of meditation which, although existing earlier, reach an initial maturity in the thirteenth century.[2] This essay examines the association of the image of Christ as "Man of Sorrows" with certain texts from the prophet Isaiah and elucidates why this image was important to Franciscans in deciphering the life of Saint Francis of Assisi.[3] Looking to two fifteenth-century works by Michele Giambono, the essay also argues that in this artist medieval Franciscan theology found a visual champion.

Our consideration of how early Christians found Isaiah's text to be a prophesy for Christ is best understood in relation to a devotional image painted by Michele Giambono (fl. *c*.1420–1462), *Archangel Michael*, dating to *c*.1440 (fig. 9). Giambono depicts a seated Michael enthroned with two angels hovering above him: one angel holds a set of scales symbolizing the weighing of souls at the Last Judgment, the other a sword indicating Saint Michael's position as head of the heavenly army. Beneath his feet, Michael crushes the dragon from the Book of Revelation, symbolizing the defeat of the devil.[4] In these few symbols the whole problematic of human salvation from a Christian perspective is intimated: how does humanity, fallen from grace, regain the heavenly place and its life-giving relationship with God? Humanity, in its sin, is powerless to do this, but, as the iconography of Giambono's painting suggests, the relationship can be restored.

Giambono depicts Michael not in his usual military armor but dressed in a sumptuously brocaded, diaconal dalmatic and crossed stole. Dressing in this manner liturgically expresses a certain quality of service to God and humanity. On the breastplate of Michael's dalmatic are two registers of images. The lower, smaller register shows a Hebrew prophet holding a prophetic script and pointing upward to indicate the figure in the register above: an image of Christ standing in a

sarcophagus as the Man of Sorrows.[5] Behind him stands a cross emitting triumphal rays of light. Michael holds a globe in his right hand, reminiscent of the earth or universe and his power over it. Surmounting the globe is a gold monstrance with a crystal case center and a Gothic finial, appropriate for enthroning the consecrated bread of the Catholic Mass. In this work, Eucharistic presence pervades the cosmos.

The loss of paradisal relationship with God through sin, occasioned by Adam and Eve eating from the Tree of the Knowledge of Good and Evil as reported in the Book of Genesis, is believed to have been restored through a prophetic fulfillment in Christ given for humanity; he is portrayed in the second image at once dead and living. In Giambono's *Archangel Michael*, the Eucharist, symbolized by the monstrance, extends the effect of this fulfillment to the cosmos, for the Eucharist is the symbolic continuation of the power of this sacrifice through the meal of fellowship. Humanity, destined to fall in the scales, is restored to relationship with God through the enigmatic figure of the Man of Sorrows. And Michael, the avenging angel, once commissioned to drive the damned into everlasting darkness, becomes the archservant, the deacon, at the cosmically redeeming Eucharistic banquet. For medieval Christians, this was the fulfillment of what was believed to be Isaiah's prophecy of Christ.

From the thirteenth century onward, books of meditation were inspired by and modeled on several Franciscan works. Two works with particular resonance were the *Lignum vitae* or *Tree of Life* by Saint Bonaventure of Bagnoregio (1221–1274), the thirteenth-century Minister General of the Franciscan Order, and the *Meditationes vitae Christi* or *Meditations on the Life of Christ* by John of Caulibus, the fourteenth-century Franciscan spiritual director.[6] These works presented a pathos-laden, chronological description of Christ's Passion, based on scriptural texts, with the underlying purpose of inviting the reader to imagine the plight of the suffering Christ and contemplate his or her own role in the unfolding drama. The reader or listener was led step by step into the stream of salvation history and encouraged to be accountable for his or her life, especially a life of sin.

As historian Denise Despres has so astutely articulated, a sympathetic journeying with Christ was insinuated onto the disparate facts of the life of the sinner and beckoned him or her to conversion into the life of Christ.[7] Being transformed into Christ was the endpoint of the *imitatio Christi*, the imitation of Christ. Sympathetic meditation fashioned an interior openness in the sinner for receiving forgiveness and being reinstated in relationship to God through the Sacrament of Penance. The Sacrament of the Eucharist, whether through reception of communion or viewing the elevated/enthroned host during its consecration at Mass, completed this process: the interior shaping of the sinner in the form of Christ, through meditation and penance, was now filled with Christ's reality. This is the logic of Christian conversion that Giambono's *Archangel Michael* makes visible.

James Marrow traces the developments, expansions, and distortions of the emotionally restrained and scripturally anchored books of meditation mentioned above. The concern with pathos-laden and tender descriptions of the life of Christ was in place by the end of the twelfth century. But as time advanced, the pathetic element was emphasized more and inventive embellishment of the scriptural texts became standard. Part of this process was a type of biblical exegesis in which New Testament Passion narratives were expanded through an inventive incorporation of prophetic texts from the Old Testament, which were seen as anticipating the scenes in New Testament descriptions of Christ's Passion.[8]

Though other passages in Isaiah are historically associated with Christ as the Man of Sorrows, Isaiah 1:6 and 63 in particular, Isaiah 53 is most closely connected with this image, largely because verse 3 introduces the term "man of sorrows."[9] Isaiah establishes that the servant is unattractive and despised from birth. This condition is exacerbated by the subsequent abusive treatment and

mockery of his contemporaries. He is crushed to death by ignominy. In Isaiah 53 the servant is righteous and without sin and yet "it was the will of the Lord to crush him with pain" (Isaiah 53:10). The servant Isaiah describes takes on the appearance of those estranged from God, as they are described in Isaiah 1:6 and 63. He became the reality and appearance of estrangement: "he has borne our infirmities and carried our diseases; yet we accounted him stricken, struck down by God and afflicted" (Isaiah 53:4).

According to Isaiah, the servant is born into and lives the existence of estrangement in order that those who are truly afflicted (and who have caused their own affliction) may be healed. Yahweh places their condition upon the servant so that they may not be crushed by what they have become through their own choice: "All we like sheep have gone astray, we have all turned to our own way, and the Lord has laid on him the iniquity of us all" (Isaiah 53:6). Yahweh restores the servant after his death so that he may occasion the healing of many:

> Therefore I will allot him a portion with the great,
> and he shall divide the spoil with the strong;
> because he poured out himself to death,
> and was numbered with the transgressors;
> yet he bore the sin of many,
> and made intercession for the transgressors. (Isaiah 53:12)[10]

The Church applied these passages to Jesus' Passion and death. For instance, in describing Christ, the Christological hymn in Saint Paul's letter to the Philippians (2:5–11) articulates an unthinkable contrast when it says that Christ was in the form of God and yet took the form of a slave. For Paul, to be in slavery is variously to be under the Law and to be in sin and subject to death, that is, to be truly human. And although we do not know whether or not the servant's death was voluntary—as was Christ's—they both end in a death which is beneficial for the many.

There is no point-for-point parallel between Isaiah's servant and Christ (in fact there are more discrepancies), but the images they share of being unsound and misshapen and suffering death for the sake of the many would have led ineluctably to comparison of the two.[11] Such comparison was encouraged by the use of the Isaianic text in the Divine Office and lectionary for the Eucharistic liturgies, like the first reading for the Good Friday Liturgy, the day Jesus is crucified and dies.

With the connection of the Man of Sorrows to the vision of Saint Gregory, described in the introductory essay, the image became associated with the Eucharist in the West.[12] Theologically the association was logical: the Eucharist is the means by which the servant/Christ heals the many; it is how the healing power of the sacrifice of his death emanates from that single historical point to the many for countless generations. From a Christian perspective, this is how the world is transformed into the Kingdom of God.

The Eucharistic association is delicately implied in Giambono's *Man of Sorrows* of c.1420–1430 (fig. **20**).[13] The unsightly Christ stands erect in his marble sarcophagus displaying his wounds. The Crucifixion, indicated by the cross in the background, is past. Christ is thoroughly marked by death and yet seems alive.[14] This resurrected Christ strangely remains within death. The anomaly has radical theological implications that Giambono beautifully captured. The marble sarcophagus, which recalls the altar on which the Eucharist is consecrated, connects the altar with Christ's death. The Eucharistic species of bread and wine become for Catholics, in the course of the liturgical commemoration of the Crucifixion, the healing and life-giving power of the risen Christ, given

Fig. 20

20. Michele Giambono

*Man of Sorrows with Saint
Francis*, c.1420–1430
Tempera and gold on panel
The Metropolitan Museum of
Art, New York

for the many. The magnificently embroidered shroud alludes to an altar linen, whether this be a corporal, altar cloth or antependium. This life within death, as both historical fact and liturgical commemoration, is portrayed here with imaginative clarity.

The inclusion in Giambono's *Man of Sorrows* of an image of Saint Francis of Assisi expands the central understanding. Saint Francis miraculously received the stigmata, the wounds of Christ, in 1224 while on Mount La Verna, where he had a vision of the crucified Christ enfolded in Seraph wings.[15] Saint Bonaventure writes: "Divine Providence had shown him a vision of this sort so that the friend of Christ might learn in advance that he was to be totally transformed into the likeness of Christ crucified, not by the martyrdom of his flesh, but by the enkindling of his soul."[16] Ann Astel, quoting Hans Urs von Balthasar, speaks of Bonaventure's understanding of the journey of Francis as a *via pulchritudinis* (way of beauty). The self-emptying of Christ, which results in the image of the despicable servant and the form of a slave, is what restores beauty or right relationship with God to the cosmos. Saint Francis' imitation of Christ through his self-emptying, absolute poverty resulted in his becoming body and soul an image of the Crucified. As Astel explains:

Bonaventure discovered a remedy for the restoration of the world's microcosmic and macrocosmic beauty in a Franciscan poverty that extended itself to the complete embrace of the Crucified and thus to communion with the self-emptying Lord of the Eucharist. Even as the stigmata sealed the union of Francis with Christ in body and soul, the Eucharist made it possible for others to share in that same harmony (*convenientia*), proportionality, and light (*claritas*).[17]

The *Legenda maior*, Bonaventure's life of Saint Francis, orchestrates, through the description of the mystical journey of Francis, the transformation of a human being into the life of Christ.[18] Books of meditation extended this orchestration to the Church beyond the Franciscan Order. Conforming oneself internally to the form of Christ through meditation reached a repeated fulfillment by receiving Christ himself in the Eucharist. Saint Francis therefore became a model for this process in his devotion to both the Crucified and the Eucharist.[19] Giambono's *Man of Sorrows* visually implies Francis' devotion and *imitatio Christi*.

Furthermore, in *Man of Sorrows* the lines of red blood connecting the bodies and the wounds of the crucified Christ and Saint Francis indicate a direct communication of life between the two. No Eucharistic species are present, only the body of Saint Francis, who is transformed by the encounter into the complete image of the crucified Christ. Saint Francis, and not bread and wine, is transubstantiated into the reality of Christ. He has become in this image both the crucified Christ and the Eucharist he loved so well. Bonaventure and the Franciscans offered Saint Francis to the world as the model of transformation into Christ. Giambono celebrates this by giving us an icon as a threshold into that world. We have here a multifaceted fulfillment of Isaiah's prophecy as the Christians of the Middle Ages saw it. Saint Francis, one might say, is the goal of the images of the Man of Sorrows. He is a prime example of transformation into Christ and of how the Man of Sorrows is life for the many.

Xavier John Seubert, OFM, STD
Thomas Plassmann Distinguished Professor of Art and Theology
St. Bonaventure University

1 Sawyer 1996, 1–20. Childs 2004 articulates the use of Isaiah from its Hebrew and Christian beginnings through Postmodernism. See also Old 1999, Wilken 2007, McKinion 2004, and Elliott 2007.

2 Stadlhuber, 1950.

3 The *Supplicationes variae* offers an early example of how Franciscans made use of this image; Evans 2004, 471–472. Franciscan association with the Man of Sorrows would have begun early in the thirteenth century in Constantinople; Brooke 2006, 202–217.

4 Revelation 12:7–8: "And war broke out in heaven; Michael and his angels fought against the dragon. The dragon and his angels fought back, but they were defeated, and there was no longer any place for them in heaven." Unless otherwise indicated, all scriptural citations are taken from the New Revised Standard Version (NRSV) of the Bible.

5 Puglisi and Barcham will explicate the prophet and his biblical verse in a forthcoming publication.

6 Marrow 1979, 9–13, and especially Roest 2004, 472–514. There are several versions of the *Meditationes* in Italian and Middle English. There is controversy among scholars as to the original author, who may have been a woman. The *Meditationes* originated in Franciscan circles and John of Caulibus authored the first Latin version. See McNamer 2010.

7 Despres 1989, 19–22.

8 Marrow 1979, 5–9.

9 Ibid., 459–468.

10 Westermann 1969, 256–269.

11 Morna D. Hooker, "Philippians," in Soards 2000, 500–510. For the comparison, Janowski and Stuhl-macher 2004, Beckwith 1996, and Bellinger and Farmer 1998.

12 Puglisi and Barcham in this catalog, page 13, and Rubin 1991, 121–125.

13 Evans 2004, 484–485.

14 Belting 2005, 86–109, and Büchsel 2003.

15 Armstrong, Hellmann and Short 1999, 263–265.

16 Ibid.

17 Astel 2006, 99.

18 Armstrong, Hellmann and Short 2000, 525–683. Brother Elias, the Minister General of the Franciscan order at the time of the death of Francis describes his life and appearance in terms of Isaiah 53; see Armstrong, Hellmann and Short 2000, 490.

19 Astel 2006, 99–135.

Catalog

Notes to the Reader

Measurements are given in centimeters (in millimeters for prints, drawings and manuscripts) and inches; height precedes width, followed by depth where applicable.

All entries are written by the co-curators of the exhibition except where signed; see key below for initials:

LL	Liana Lupus
LP	Leigh-Ayna Passamano
MD	Michael DeNiro
CO	Colette Obzejta
AV	Alexandra Venizelos
CK	Catherine Kupiec
KS	Kathleen Sullivan
CW	Christina Weyl
IV	Ivannia Vega-McTighe
MMW	Maria Agnese Chiari Moretto Wiel
MY	Melissa Yuen
CM	Colette Moryan
KM	Kira Maye
KF	Kimberly Fisher

Abbreviated references are used in the notes to the essays and catalog entries; for full citations, see the Bibliography.

1

Bible in Latin
Venice: Franciscus Renner of Heilbronn and
Nicolaus of Frankfurt, 1475

Folio 254r, 27 × 19.5 cm.
Rare Bible Collection at MOBIA, New York

Open at folio 254r to show the phrase *virum dolorum,* "man of sorrows," in the Latin text of
Isaiah 53:3, this is the first Bible printed in Venice. The cities of Italy were quick to adopt
the revolutionary printing technique developed by Gutenberg between 1452 and 1455
and were the first in Europe to welcome itinerant German printers, after a handful of
towns in German lands.[1] In 1464 Conrad Sweynheym and Arnold Pannartz brought a
press to Subiaco, near Rome, and issued Italy's first printed book: the short and
immensely popular Latin grammar compiled by Donatus in the fourth century. By 1467
they had moved to Rome and were ready to tackle far more ambitious projects. Not long
after March 15, 1471, they issued, in Latin, Italy's first printed Bible. Venice was the next
Italian city to host a printing press. It was owned and operated by two brothers from
Speyer in the Rhineland-Palatinate, Johann and Wendelin, known locally as Giovanni
and Vendelino da Spira. Initially, the *Serenissima*, as Venice called itself, had granted
Johann an exclusive right to print within its borders, but when his monopoly lapsed on
his death in 1470, a host of printers converged upon the city and made it the most
important printing center in Italy. Franz Renner of Heilbronn was among the first
publishers to take advantage of the new business opportunities in Venice. He worked
there from 1471 to 1483 and was associated with Nicolaus of Frankfurt between 1473 and
1477. The 1475 Latin Bible they produced together was the first in a series of four (two
folios and two quartos) issued by the Renner press over a period of eight years. Based on
the 1471 Roman edition, it was printed in a beautiful small Gothic type with the usual
abbreviations for Latin endings and common words, with tildes replacing the letter *n,*
etc.[2] The initial capitals were left blank to be filled by a calligrapher. LL

1 Steinberg 1996, 30–34.
2 Heitzmann and Santos Noya 2002, D 39.

Quis credidit auditui nr̄o: LIII
⁊ brachiū dn̄i cui reuelatū est ! Et
ascēdet sicut v̂gultū corā eo.⁊ sicut
radix d̄ terra sitiēti. Nō ē spēs ei neqȝ decor.
Et vidim9 eū ⁊ nō erat aspectus :⁊ desidera-
uim9 eū despectū ⁊ nouissimū viroȝ: vir̄ do
loȝū ⁊ sciētē infirmitatē. Et quasi abscōdit9
vult9 eius ⁊ despect9 : vnde nec reputauim9
eū. Vere languoȝes nostros ipse tulit :⁊ do
loȝes nostros ipe portauit. Et nos reputaui
mus eū q̄si lepsū :⁊ pcussū a deo ⁊ hūiliatū.
Ipse aūt vulneratus ē ꝓpt iniqtates nr̄as:
attritus ē ꝓpter scelera nr̄a. Disciplina pacis

uim9 eū despectū ⁊ nouissimū viroȝ: vir̄ do
loȝū ⁊ sciētē infirmitatē. Et quasi abscōdit9

Cat. 1, detail

2

Bible in Italian
Venice: Francesco Brucioli, 1541

Folio 274r, 26.1 × 17.5 cm.
Rare Bible Collection at MOBIA, New York

The Bible was first printed in Latin, by Gutenberg around 1455, then in German by
Johann Mentelin probably in 1466.[1] Italian was the third language to have a printed
Bible. Issued in Venice by Wendelin of Speyer in 1471, the Italian Bible had been
translated from the Latin Vulgate by Niccolò Malermi (c.1422–1481). In the early 1530s,
Antonio Brucioli (c.1490–1566), a Florentine humanist who was living in Venice as an
exile, produced a new Italian version of the Bible based, as he claimed, on the original
Hebrew and Greek texts. Modern research has proved that Brucioli had little knowledge
of either Hebrew or Greek and had used mainly the Latin translations of Pagninus and
Erasmus.[2] But for all its limitations, his work was far more accurate than Malermi's. A
first folio edition was printed in Venice in 1532 and this was followed by two quartos in
1538 and 1539. A second folio, on display in this exhibition, was produced in August 1541
in the Venetian shop of Brucioli's brothers. Beautifully printed in Roman type with
historiated initials at the beginning of each book and chapter, it was dedicated to King
Francis I of France. After his early stay in Lyons in 1522 Brucioli was leaning towards the
Reformation and he was twice tried for heresy in Venice in his later years. In 1555, his
Bible translation was placed on the infamous Index of forbidden books and ceased to be
reprinted in Italy. It was reissued and revised in Geneva and remained the favorite
version of the Italian-speaking Protestants until the publication of the Diodati version in
the early 1600s. The photograph shows a detail of folio 274r including the phrase *huomo di
dolori* ("man of sorrows") in Isaiah 53:3. LL

1 Steinberg 1996, 20.
2 De Hamel 2001, 237–238.

del mezo fuo,purificateui uoi che portate i uafi del Signore.Perche non cō fretta uſcirete, & con fuga non caminerete,pche camina auāti à uoi il Signore, & congregaui l'Iddio di Iſrael.Ecco ſara prudente il ſeruo mio,fia eſaltato,& ſara inalzato, & ſara ſublime grande= mente.Come ſi ſono marauigliati, ſopra di te molti, coſi piu corrotto di huomo l'aſpetto ſuo,& la forma ſua piu de figliuoli de gli huomini.Coſi ſtillera àmolte genti,ſopra quello chiuderanno i R e la bocca loro,pche quegli à quali nō ſi è narrato loro,uiddono, & que= gli che non udirno inteſono. Predice la paſſione di Chriſto. Cap. 53.

A Hi credette à l'audito noſtro,& à chi è riuelato il braccio del Signore? Et aſceſe come uirgulto auanti à eſſo,& come radice da la terra ſecca, nó for= ma à quello, ne decoro, & uedemmo quello, & non è aſpetto, ne deſide= rammo quello.E' diſprezato,& abietto degli huomini, huomo di dolori, & che è eſperto delle infermita , & come aſcondente la faccia da eſſo, dif= prezato, & non reputammo quello.Certaméte eſſo portò i noſtri languo= ri,& ſoſtenne i dolori noſtri,& noi reputammo quello piagato,percoſſo da Iddio, & hu= miliato.Et eſſo è ferito pe noſtri peccati,è percoſſo per le noſtre iniquita,la gaſtigatione p la pace noſtra ſopra quello, & con il liuido ſuo fu ſanita è noi, Tutti noi come pecore er= rammo,ciaſcuno à la uia ſua cì ſiamo uoltati,& il Signore fece peruenire à quello il pecca= to di tutti noi.E' oppreſſo,& è afflitto,& nó aprirra la bocca ſua,come agnello al macello fia códotto,& come pecora auanti à toſatori ſuoi è muta, & nó aprirra la bocca ſua. Da la chiuſura,& dal giudicio è tolto,& chi narrera la generatione di ꝗllo?perche è tagliato da la terra de uiuenti,per la preuaricatione del popolo mio,fu piagato. Et dette con gl'impii la ſepoltura ſua,& col ricco,fra morti ſuoi, auuegna che nó faceſſe rapina, ne inganno ne la bocca ſua.Et il Signore uolſe percuotere quello,fecelo amalare, ſe poneſſe per il pecca= to l'anima ſua,uedra il ſeme, prolunghera i giorni, & la uolonta del Signore per la mano ſua fia proſperata.Da la fatica de l'anima ſua uedra,ſara ſatio,ne la ſcientia ſua,ſi giuſtifiche= ra il giuſto,ſeruo mio à molti, & eſſo portera le iniquita loro.Per queſto daro à ꝗllo parte

ma à quello, ne decoro, & uedemmo quello, & non è aſpetto, né deſide= rammo quello.E' diſprezato,& abietto degli huomini, **huomo di dolori,** & che è eſperto delle infermita , & come aſcondente la faccia da eſſo, dif=

Cat. 2, detail

3

Jacobello del Bonomo (fl. 1370–1390), attributed to
Man of Sorrows with Two Censing Angels,
late fourteenth century

Tempera on arched poplar panel, 52.3 × 30 cm. (20.86 × 11.81 in.)
National Gallery, London, NG 3893

Presenting our earliest Man of Sorrows from the Veneto, this panel was once the central pinnacle of a polyptych and played the same role in its pictorial ensemble as that of numerous other paintings of the region depicting the *Imago pietatis*.[1] The figure was shown at the top center of an altarpiece more often in the northeast of Italy than anywhere else in Europe. Paolo Veneziano, the father of Venetian art, had initiated the practice on the *Pala feriale* for the high altar of San Marco, Venice, in the 1340s (fig. **5**), and two outstanding early fifteenth-century Veneto polyptychs sustaining the custom are those by Battista da Vicenza (1404) and Jacobello del Fiore (*c.*1415).[2] The Veneto tradition of placing and viewing the Man of Sorrows at the summit of altarpieces lasted well into the early sixteenth century (fig. **6**; cats. **22** and **23**). Accordingly, the London figure should be envisioned crowning a splendidly gilded polyptych with either the Virgin and Child or the Coronation of the Virgin below and various saints flanking Mary on the left and right.

Following Paolo Veneziano's *Man of Sorrows*, the London figure is golden in hue, serene in nature and appears asleep more than dead, lacking any hint of the agony Christ endured on the cross. The artist also sought grace and refinement, creating an hourglass-shaped body lyrical in its cadences and typical of the period. Christ is a sequence of supple rhythms calibrated by three horizontal forms: the sarcophagus at the bottom from which he rises, the crossbar seen from below defining his broad chest, and the superscription atop whose golden letters ostensibly mock but actually glorify his majesty. Christ's nipples and the droplets of blood oozing from his wounds are painted in relief. Two censing angels dressed in Byzantine-like brocades hover on the upper left and right and swing thuribles as if deacons at Mass, thereby emphasizing the Eucharistic significance of the Man of Sorrows. Christ's elaborately tooled halo is richly ornamented like a crown, incorporating a cruciform design encrusted with thick dabs of paint to simulate jewels, which creates the surface elegance and stylishness characterizing many late Gothic images of the Man of Sorrows in the Veneto.

1 Dillian Gordon and Rachel Billinge of the National Gallery, London, have informed us that they have restudied the panel and ascertained its role as the pinnacle of a polyptych, and Gordon very generously offered a draft of her entry on the painting that will appear in Gordon 2011. See also Davies 1988, 118, and *National Gallery* 1995–1996, 349. For Bonomo, see Curzi 2000, 42–46. Finaldi 2000, 152, cat. 59, states that the work "would have been found in a wealthy household," but this is unlikely given the presence of the censing angels.
2 For Battista's work in Sant'Agostino outside Vicenza, see Lucco 1989–1990, vol. 1, fig. 181. Jacobello painted his polyptych also for a church dedicated to Sant'Agostino but in Teramo; see Andrea De Marchi and Tiziana Franco, "Il Gotico internazionale: Da Nicolò di Pietro a Michele Giambono," in Curzi 2000, 58–69; and Eugeni 2008, 19.

4

Anonymous Northern Italian artist
Man of Sorrows,
late fourteenth or early fifteenth century

Pen and brown ink, brown wash and touches of red on linen
91 × 77 mm. (3.58 × 3 in); laid down on paper, 180 × 136 mm. (7.08 × 5.35 in.)
The Morgan Library and Museum, New York, inv. 1981.78

Not seen publicly for years, this delicate and rare drawing of the Man of Sorrows on linen has touches of brilliant red depicting the wounds and modeling the sarcophagus. The tiny figure was likely made for private devotions, or possibly as the model for a more finished image to serve the same purpose. Its dimensions are surely too small to suppose that it was employed liturgically in church, though paintings on altar cloths or draperies are known.[1] The size and support of the Morgan work argue for modest beginnings, since linen was less expensive than panels at the time and so would have been used for poorer patrons and/or in humble circumstances, but perhaps it was intended for use during Lent. This is relevant in the context of our exhibition as there are historical links between cloth images and Franciscan patronage, and between cloth images and the Veneto.[2]

Years ago this drawing bore an attribution to Lorenzo Monaco, a leading Florentine artist active between *c.*1390 and 1425 and a member of the Camaldolese Order (hence his surname, which means "monk" in Italian).[3] Like Silvestro dei Gherarducci (cat. **9**), Lorenzo was both a manuscript illuminator and a panel painter; he executed drawings with pen and brown ink and colored washes and portrayed the Man of Sorrows at least six times: in a fresco, on three separate panels, on a predella and as an illuminated initial.[4] Despite such grounds for associating the Morgan figure with Lorenzo, little stylistic justification connects the design on the fabric with him, his Florentine circle or indeed Tuscany at all. Comparison with the artist's autograph versions of the Man of Sorrows discloses that this figure has a much softer physiognomy, a less elongated torso, and a suppler body type akin to numerous northern Italian or Umbrian counterparts of the era. Perhaps the best visual association that can be made is with the similarly graceful curvature of Christ on the London panel (cat. **3**) whose long and attenuated fingers, spindly arms, and flowing locks all agree in type with those of the Morgan drawing; even the view into the sarcophagus is analogous. We propose that this little devotional figure raptly engaged the attentions of a northern Italian Franciscan or devotee of the Order.

1 These few sentences are dependent upon Bosshard 1982; Seifert 1991, 27; Wolfthal 1989, 1–5; and Dubois and Klaassen 2000, but the fact that they discuss mostly later examples makes it plain that the survival of such small, early linen works as this drawing is rare indeed. See Parshall 2005, 62–68, cat. 2, for a (perhaps) Venetian cloth of the second quarter of the fifteenth century, and 118–121, cat. 24, for a southern German or Austrian altar cloth of 1420–1430. For more on painting on cloth in the north of Italy, see *Arte Lombarda* 2008.
2 Wolfthal 1989, 5. See also cat. **24** for another small work on linen.
3 The drawing entered the Morgan Library from the collection of Janos Scholz; see Scholz 1976, cat. 3; and Scholz 1980, cat. 130, for the attribution to Monaco. For Monaco, see *Painting and Illumination* 1994, 220–306, and Laurence B. Kanter in *Dizionario Biografico* 2004, 399–401.
4 Eisenberg 1989, 82, 99–100, 117–118, figs. 18, 136, 169; and *Painting and Illumination* 1994, 265, fig. 106, and 296–298, cat. 39.

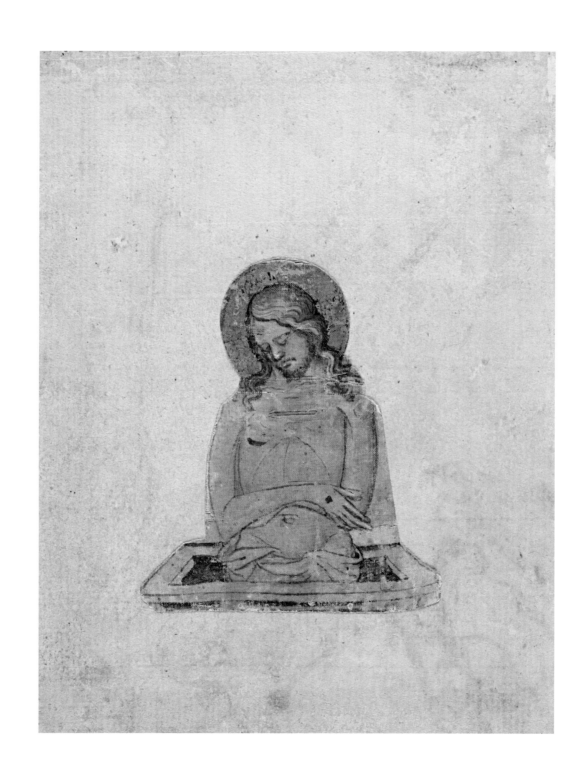

5

Tino di Camaino (*c.*1280–1337)
*Imago pietatis, c.*1330–1335

Marble bas-relief, 25.4 × 20 × 4.1 cm. (9.8 × 7.87 × 1.6 in.)
Private collection

Working in Siena, Pisa, and Florence until *c.*1323, when he journeyed south to Naples, Tino became famous producing monumental tombs for ecclesiastics, nobles, and royalty. This little figure shows the impact of his art even when small in size.[1] Christ's broad physique and rich drapery folds establish perfect balance with the refined stone-cutting in relief. The work's quality in fact surpasses that of Tino's comparable *Imago pietatis* ornamenting a bilateral stone triptych of *c.*1334 (Siena, Salini Collection).[2] The Christ here is more splendidly modeled, and his diagonally inclined head and mournful expression powerfully suggest the words of Isaiah 53:3. Similarly configured, the two figures also resemble nearly all Italian representations of the Man of Sorrows pre-dating *c.*1350–1370. Half-length, head turned to his proper right, arms or hands crossed over his stomach, face bearded, and locks flowing onto the shoulders, the *Imago pietatis* altered little on the peninsula before mid-century, though distinctions between artistic styles and variations in function abounded.

Given its diminutive size, Tino's work likely ornamented a private devotional panel.[3] And produced in Naples, it also represents a subject that flourished on tombs and sarcophagi in the city across the middle of the century, numerous examples existing in San Domenico Maggiore, San Lorenzo Maggiore, and elsewhere in the area.[4] Contemporary stone reliefs of the *Imago pietatis* also survive on tombs in Tuscany: in Florence, for example, the monuments of Archbishop Aliotti Tedici, Francesco Pazzi, Gualterotto de' Bardi, and the Baroncelli and Bardi di Vernio families comprise a group locating the Man of Sorrows at the base.[5] In the Veneto the epicenter of the trend was Verona, and its tombs position the Dead Christ higher up, as in Naples; the monuments include the sepulchers of Guglielmo Castelbarco, *c.*1319–1320 (Sant'Anastasia), Cangrande I, mid-1330s (Santa Maria Antica), and Saint Agatha, 1353 (Cathedral).[6] But aside from identifying where and when the *Imago pietatis* prospered *c.*1330–1370, it is equally crucial to insist upon other aspects regarding its existence at the time. First, the figure enjoyed a vigorous artistic life decades before the famous Byzantine mosaic arrived in Santa Croce in Gerusalemme, Rome, in the 1380s (fig. **1**); second, the Eucharistic function of the Man of Sorrows was clearly not its only or primary one. Finally, when seen in conjunction with other configurations of the subject depicted in Naples and elsewhere, this work confirms the figure's generally Italian character before regional disparities multiplied up and down the peninsula later in the century.

1 Seidel 2005 and Baldelli 2007, 385, 388, fig. 476.
2 Kreytenberg 2001, Baldelli 2007, 389, fig. 479, and 423, cat. 51b, and Francesco Aceto in Bellosi 2009, 96–98.
3 Seidel 2005, 630.
4 For the tomb of Giovanna d'Aquino in San Domenico, see Vitolo 2008, figs. 127–128; for the many monuments in San Lorenzo, see Mormone 1973, 40 (cat. XXIV), 42–44 (cats. XXVI–XXVIII), 48–49 (cats. XLI, XLIII), figs. 39–40, 46, 48, 52, 60–61, 100, 102, and Enderlein, 76–89, figs. 26, 30. For the tomb of Ludovico d'Artus in San Francesco in Sant'Agata dei Goti, see Vitolo 2008, figs. 129–130; for the sarcophagus of Nicola Baraballo in the Museo di San Martino, Naples, see Middione 2001, cat. 1.8a; and for the tomb of Giacomo Martano in the Cathedral of Caserta Vecchia, see *Duomo di Napoli* 2002, fig. 93.
5 See Butterfield 1994 and Kreytenberg 1998: Tedici is in Santa Maria Novella, the others in Santa Croce.
6 Napione 2009, figs. 18 (Castelbarco), 52, 60 (Cangrande I), 104, and 107 (Saint Agatha).

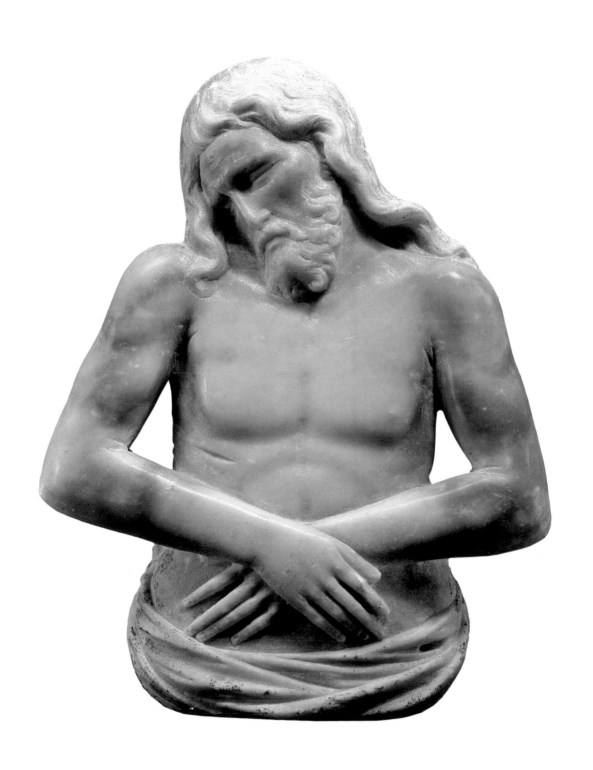

6

Anonymous central Italian artist
Man of Sorrows with Dominican Monk and Flagellant,
mid-fourteenth century

Gilt copper with champlevé enamel, 10.4 × 7.9 × 0.2 cm. (4.09 × 3.1 × 0.07 in.)
Inscribed (at bottom): SOTIETATIS • S • DOMINICI; (at left): FN; (at right): PB
The Metropolitan Museum of Art, New York, inv. 1982.480
Gift of Georges Seligmann, in memory of his wife, Edna, his father, Simon Seligmann,
and his brother, René

This small plaque reflects the important role the Dominicans played alongside the Franciscans in the early promulgation of the Man of Sorrows in the West.[1] At lower left, a Dominican friar clasps his hands in prayer and looks up at the looming figure of Christ in order to intercede for the man at right, whose bare back, hood, veil, and scourge (hanging from his wrist) identify him as a flagellant. Mortification of the flesh was widely practiced in the late Middle Ages and enabled the devotee, through physical pain, to experience and thus imitate Christ's suffering.[2] Huge public flagellant processions encouraged by the Dominicans swept across central and northern Italy in 1260 and reached Venice too. Although quickly outlawed by the Church for political reasons, flagellant sects periodically resurfaced in the ensuing century.[3] The practice of self-flagellation persisted in lay confraternities (*dei battuti*), and the inscription below the scene, translating as "Society of Saint Dominic," suggests that the plaque was probably created for a member of a flagellant confraternity dedicated to the saintly founder of the Dominican Order.[4]

The plaque presents the Man of Sorrows with arms extended, a portrayal seen in other Tuscan images from the fourteenth century but adopted only later in Venice.[5] Rising from the tomb as a three-quarter-length figure, Christ opens his arms as if to shelter the two diminutive figures kneeling at either side.[6] Streaks of dried blood on his arms stain his golden body, which is set against a blue background studded with stars symbolizing his five wounds. Christ is flanked by the lance and sponge, Instruments of the Passion, whose veneration conferred indulgences upon the faithful, as Pope Innocent VI (d. 1362) had pronounced in the fourteenth century.[7] The dark blue background and red decorative border of the plaque were created with enamel fired into recessed spaces in the copper plate, and the features of Christ, the friar, and the flagellant were incised. Gilding illuminates and ennobles the body of Christ in a visual and material glorification of the Redeemer that is repeated in the later Metropolitan Museum of Art's panel in *verre églomisé* (cat. **7**). Perhaps originally set into a frame, the plaque served private devotions.[8] LP

1 See Cannon 1998, 29–30.
2 Barbara Drake Boehm, in Evans 2004, 483–484, cat. 293.
3 See Henderson 1978, 155–156. At the end of the fourteenth century, Venetian authorities expelled Giovanni Dominici, Vicar General of the Reformed Dominicans, from Venice for his support of the Bianchi flagellant movement; see Gilbert 1984, 110.
4 The initials "FN" on the left may stand for "Frater Noster" ("our brother"), and those next to the flagellant read "PB", whose meaning is unknown; see Wixom 1983, 22.
5 For another example, see the detached fresco of the Man of Sorrows in The Cloisters, the Metropolitan Museum of Art attributed to the Tuscan artist Niccolò di Tommaso (fl. 1343–1376), inv. 25.120.241.
6 But see the very different formulation, also Tuscan and of the later fourteenth century, by Silvestro dei Gherarducci, cat. **9**.
7 Barbara Drake Boehm, in Wixom 1999, 151, cat. 177.
8 Barbara Drake Boehm, in Evans 2004, 483–484, cat. 293.

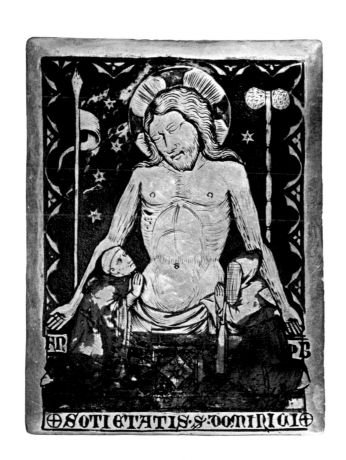

7

Anonymous Italian artist

*Man of Sorrows, c.*1400

Verre églomisé, framed, 19.9 × 13.8 × 2.1 cm. (7.48 × 5.4 × .8 in.);
glass panel, 13.2 × 8.3 cm. (5.19 × 3.26 in)
Inscribed: HUMILIAVIT SEMET IPSUM
The Metropolitan Museum of Art, New York, inv. 17.190.845
Gift of J. Pierpont Morgan, 1917

An exquisite example of a work in *verre églomisé*, this fragile panel is only one of the approximately sixty works to survive of the many produced in this medium during the late medieval and early Renaissance periods in Italy.[1] Theophilus' twelfth-century treatise, *De diversus artibus*, relates that the *églomisé* technique was prevalent in the Late Antique period but had declined by the fifth century; it was revived in fourteenth-century Italy, especially around centers of glass production such as Venice.[2] The most precise description of the revived technique comes from Cennino Cennini's *Il Libro dell'Arte*, perhaps written in Padua in 1398, at around the time this panel was produced.[3] Cennini describes the "process for working on glass, indescribably attractive, fine and unusual, . . . a branch of great piety, for the embellishment of holy reliquaries." He lays out the steps, beginning with the cutting and treatment of the glass and the application of a sheet of gold leaf, that precede the engraving. The figures are then drawn with a sharp needle:

> As if you were using a pen; for the whole is done with the point . . . The darkest tone which you can produce will come by allowing the point of the needle to go down quite to the glass; the half-tones will come when it does not quite penetrate the gold; this is delicate work. It must all be done unhurriedly, and with great delight and pleasure.[4]

The Franciscans may be linked with *verre églomisé* panels; their Rule exhorts members to "observe the poverty, humility and holy gospel of our Lord Jesus Christ," and the text inscribed on the bottom of the Metropolitan Museum of Art's panel, which translates as "He humbled Himself" (Philippians 2:8), would have surely found a receptive audience in the Order (see p. **12**).[5] Here Christ's humility, evocatively expressed by his solitude, is exalted by the medium itself, and the brilliance of the delicately worked gold would have inspired "great delight and pleasure" in the heart of the viewer. A similar panel in the Museo Civico, Turin, suggests the popularity and efficacy of this composition.[6] MD

1 Swarzenski 1940, 56; this number may have since increased.
2 Pettenati 1978, esp. xvii and xx; cf. Swarzenski 1940, 63.
3 Ibid., xxi–xxii; Cennini 1998 (Brunello's foreword) posits only that the treatise was composed "at the end of the fourteenth century," but Pettenati 1978 points out the presence of a "Paduan lexicon" in the text, suggesting a dating during Cennini's Paduan residency, which had begun by 1398. Cennini's proximity to Venice would imply a familiarity with the workshops producing *églomisé* panels; see Honey 1933, 377.
4 Cennini 1998, Ch. CLXXII, 182–85.
5 Habig 199, 64 (Chapter 12 of the Rule of 1223); see also Dobrzeniecki 1971, esp. 5–6. A *verre églomisé* reliquary diptych with the Man of Sorrows amidst Franciscan devotions belongs to the Metropolitan Museum of Art, New York (inv. 17.190.922).
6 Pettenati 1978, no. 11.

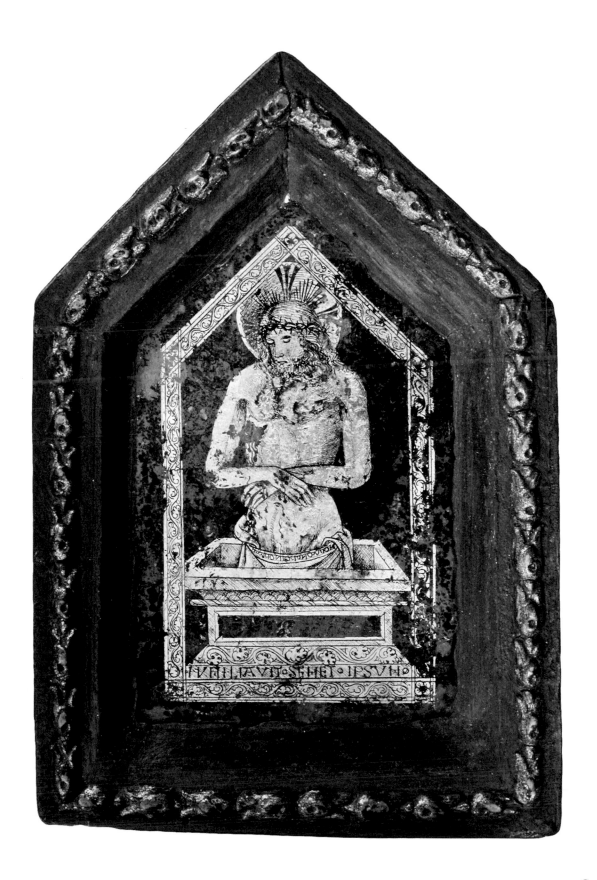

8

Niccolò di Ser Sozzo (fl. *c.*1330–1363)
Gradual single leaf: Initial C with Christ as
*the Man of Sorrows, c.*1350

Parchment, 189 × 141 mm. (7.44 × 5.55 in.)
Free Library of Philadelphia, Philadelphia, Lewis E M 69:9

This single leaf bears the musical setting of the liturgical text for the Feast of Corpus Christi and was illuminated by Niccolò di Ser Sozzo, the Sienese painter and miniaturist who decorated a series of graduals, or chorus manuscripts, for the Collegiata of San Gimignano and the Cathedral of Siena.[1] Graduals contained the chants of the Mass for principal feast days; early productions were generally small in size and used by one or two cantors, but later counterparts grew larger so that augmented choirs, developing because of an increase in the ability to read music, could see from afar.[2] Large historiated letters, such as the *C* containing the Man of Sorrows here, served as chapter headings to mark the beginning of a new musical piece; they helped focus the attention of the choir and, importantly, sparked an individual singer's memory for a particular chant if he stood too far away to read.[3]

As the celebrant entered the sanctuary for the Mass on the Feast of Corpus Christi, the Latin verses sung for the introit often derived from Psalm 81 (Vulgate 80), whose opening lines, *Cibavit eos ex adipe frumenti* ("And he fed them with the fat of the wheat"), emphasize the Eucharistic meaning of the ritual. The psalm was interpreted to allude to the nourishing aspect of the Eucharist, "the fat of the wheat," and assures the penitent of divine benediction and redemption. The first letter of *Cibavit* was usually illuminated with a miniature, at times depicting the Elevation of the Host and at others the Last Supper, but the *Imago pietatis* was also a preferred image.[4] Niccolò's torso-length Christ is framed within the initial and appears against a blue background isolating him both temporally and spatially. An important Venetian example of the Man of Sorrows within the initial *C* of the same introit decorates a gradual painted by Cristoforo Cortese, the greatest illuminator of fifteenth-century Venice, who lived a half-century later than Niccolò di Ser Sozzo. Cortese's figure on fol. 58v of Ms. Lat. III, 18 (=2284) in the Biblioteca Marciana, Venice, shows a shorter, half-length Christ whose arms are likewise crossed but who emerges from a sea of hosts, each apparently inscribed with a cross, thereby underscoring the Eucharistic function of the chant (fig. **8.1**).[5] CO

1 For the artist, see the entry by Gaudenz Freuler in *Dizionario Biografico* 2004, 823–826.

2 Muir 2002, 68.

3 Boehm 2009, 31.

4 Rubin 1991, 204–208.

5 For this Carthusian gradual from Sant'Andrea del Lido, dating perhaps to the 1430s, see Susy Marcon, "Cortese Cristoforo," in *Dizionario Biografico* 2004, 176–179, esp. 178. Niccolò di Ser Sozzo also represented the Man of Sorrows in an initial *D* (Milan, private collection), for which see De Benedictis 2002, 303, and 312, fig. 240; the only notable difference between his two images is the more defined modeling on Christ's torso in the Free Library sheet. For the initial *C* with the Man of Sorrows (in the tomb) that opens the prayer for the Feast of Corpus Christi in a Venetian Servite missal of *c.*1410–1420 attributed to Niccolò di Giacomo (Biblioteca Nazionale Marciana, Ms. Lat. III, 120 [=2478], fol. 192v), see Massimo Medica in *Tramonto del medioevo* 1987, cat. 33.

Fig. 8.1 Cristoforo Cortese, attributed
Man of Sorrows (within initial *C*),
early fifteenth century
Parchment
Venetian Gradual, Ms. Lat. III, 18 (=2284),
folio 58v
Biblioteca Nazionale Marciana, Venice

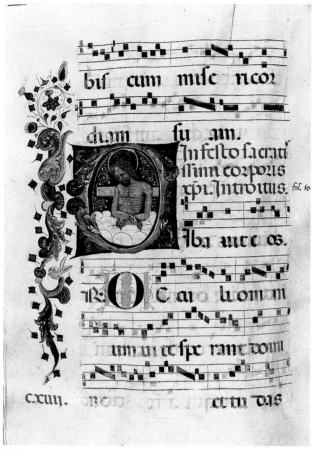

Fig. 8.1

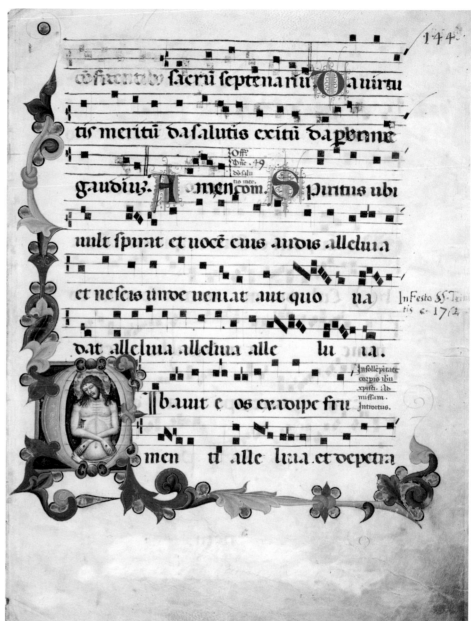

9

Silvestro dei Gherarducci (1339–1399), attributed to
*Man of Sorrows with the Virgin Mary, Saint John
and a Donor, c.1365*

Tempera on panel, 30.47 × 63.13 cm. (11.99 × 24.85 in.)
The Denver Art Museum, Denver, CO, Gift of Samuel H. Kress Foundation,
inv. 1961.154

Traditionally attributed to Jacopo di Cione, this panel more likely came from the hand of Silvestro dei Gherarducci, a much appreciated painter of both panels and manuscript illuminations who was a monk at the Camaldolese monastery of S. Maria degli Angeli, Florence.[1] Although Gherarducci is credited with painting a large altarpiece for his church, the attribution of its panels has alternated over the years between him and the Cione workshop. The Denver panel was certainly intended for the predella of an important altarpiece (that is, the section at the base that frames a row of smaller paintings), and its figures are consistent both with those Gherarducci painted elsewhere and those in his manuscript illuminations.[2] Here, as in other works in this exhibition, Mary and John flank the Man of Sorrows, but in this instance they venerate from a distance rather than support him.[3] The kneeling figure in prayer is surely the patron of the work, who, given his attire, was most probably a tertiary or lay member of a religious order outside the monastic community, perhaps one tied to S. Maria degli Angeli itself.

Tuscan images of the Man of Sorrows contrast sharply with their counterparts from the Veneto, a distinction that can be illustrated by comparing this work with the London panel (cat. **3**). Its fuller forms, typical of Florentine art, contrast with the elegant refinement of the Veneto painting; Mary and John appear larger than Christ, a representation unimaginable in corresponding panels of northeastern Italy. Just as the difference in style between these two works reflects their separate artistic traditions, so do their formats conform to regional conventions. As part of a polyptych, each painting of the Man of Sorrows would have been positioned on the central vertical axis of its respective altarpiece; exceptions to this rule are few. Following the Tuscan tradition of placing the figure in the middle of the predella, the Denver panel is horizontal in shape.[4] In contrast, the London *Man of Sorrows* sat at the apex of an altar complex, as was the custom in the Veneto, and so its crown-like role is articulated by a vertical format.[5] The two paintings thus responded differently to the altar: whereas the sacred efficacy of the Denver *Man of Sorrows* lay in its physical proximity to the altar table, that of the London panel benefited when the celebrant drew attention to the pinnacle high above the altar by lifting his arms while elevating the Holy Sacrament during consecration and thereby emulating the raising of Christ on the cross.

1 See Shapley 1966, 33–34, for the traditional attribution.
2 For the Denver panel as by Gherarducci, see Gaudenz Freuler in *Painting and Illumination* 1994, 124–176 (130, fig. 44), and Freuler 1997, 292–293 and 339, plate XXXVI; and for the panel of the *Crucifixion* (New York, The Metropolitan Museum of Art, Lehman Collection; inv. 1975.1.65), as the principal work of the S. Maria degli Angeli altarpiece, see Boskowitz 1972 and Pope-Hennessy 1987, 68–70, cat. 32. In re-creating the altarpiece for S. Maria degli Angeli, Florence, Boskowitz 1972, 37–39, placed the Denver panel on its predella, a reconstruction that Pope-Hennessy 1987, 68–70, considered convincing and which is repeated in Freuler 1997.
3 See cats. **18** and **30–32**.
4 Simone Martini's Pisa or Saint Catherine Altarpiece of 1319 (Pisa, Museo Nazionale di S. Matteo) is a very early example of this tradition, which extended well into the next century.
5 The Man of Sorrows makes a singular appearance on a Venetian predella of the late fourteenth-century polyptych ascribed to the so-called Maestro della Dormitio Virginis di Murano, a work that once sat on the high altar of Santi Maria e Donato, Murano, and covered the now destroyed silver *paliotto*; see Guarnieri 2006, 41–42, and 81, fig. 56.

THE EUCHARISTIC ECCE HOMO
ANDREA ORCAGNA
FLORENCE, ACTIVE c. 1343 – c. 1368
KRESS COLLECTION

10

Anonymous Veronese painter
Reliquary Triptych,
first half fifteenth century

Tempera on wood, gold ground; central panel, painted surface
52.4 × 37.5 cm. (20.6 × 14.76 in.); left and right panels, painted surfaces
54.6 × 16.5 cm. (21.49 × 6.49 in.) and 54.6 × 15.9 cm. (21.49 × 6.25 in.), respectively
The Metropolitan Museum of Art, New York, Rogers Fund, 1909,
inv. 09.104

This wonderfully rich triptych offers an insight into the meditations, hagiography and theology engaging the faithful in early fifteenth-century northern Italy.[1] Eleven of the sixteen scenes represent episodes from Christ's life and endorse late medieval devotional practices originating in the *Meditationes vitae Christi* ("Meditations on the Life of Christ"), an account of Jesus' life once ascribed to Saint Bonaventure but now assigned to the fourteenth-century Franciscan John of Caulibus.[2] John rendered the gospel narrative immediate and real, seeking to inspire attachment to Christ's humanity by means of concrete imagery and narrative detail. Later writers expanded upon his text, among them Ludolphus of Saxony, a Carthusian monk who died in 1378.[3] Artists had already begun realizing the *Vita Christi* in paint, the most famous cycle being Giotto's in the Scrovegni Chapel, Padua, of *c.*1305. The Metropolitan triptych, also a northern Italian series of images, followed it by a century, just decades after Ludolphus' death.

Several characteristics distinguish the triptych. First, the arrangement of the scenes seems counter-intuitive to the modern viewer expecting the enactment of Jesus' life on the two wings to observe the usual Western sequence running from left to right; that is, with the Flight into Egypt following the Annunciation, and so forth. But painted versions of the *Vita Christi* did not always observe narrative progression. The larger central panel depicts Salvation at the top (the prophetic John the Baptist, the Triune God, and Saint Michael Slaying the Dragon), the Passion in the center, and the Pietà and *Imago pietatis* at the bottom.[4] The pairing of Christ's recumbent corpse with the vertical Man of Sorrows clarifies that the two subjects were devotionally distinctive. Both, however, are associated with the triptych's function as a reliquary: twelve tiny cavities, which once held saintly relics, are carved along the bottom. The Man of Sorrows was regularly linked with this purpose on a work of art, the most famous example being the famed Byzantine micromosaic icon of *c.*1300 in Santa Croce in Gerusalemme, Rome, encased in a reliquary enframement (fig. **1**).[5] Other relevant examples abound; one of these, also a reliquary triptych from Verona, is now in the parish church of Arbizzano outside the city.[6]

1 Zeri 1986, 79–80, and Baetjer 1995, 67.
2 *John of Caulibus* 2000, and Ragusa and Green 1961.
3 Bodenstedt 1944 and Ransom 2011.
4 Michael Slaying the Dragon was the central image in Veronese's great *Petrobelli Altarpiece*, cat. **50**. See Moretti 2009, 90–97, for a panel by Roberto Oderisio (active in Naples, late fourteenth century) also showing the Pietà in conjunction with the Man of Sorrows in the pointed arch above.
5 Bertelli 1967 and Evans 2004, 221–22, cat. 131.
6 It was formerly in S. Antonio al Corso, Verona; see Rognini 1985, 141.

11

Anonymous Bohemian miniaturist
Crucifixion and Man of Sorrows, c.1425–1450

Vellum, single leaf, 310 × 211 mm. (12.25 × 8.25 in.)
The Morgan Library and Museum, New York, inv. M.936

In this northern manuscript leaf, the combination of the large miniature of the Crucifixion with a small roundel of the Man of Sorrows typifies the design of Canon pages in early fifteenth-century Bohemian missals and is a pairing also found in both Italian Books of Hours and Venetian paintings (cat. **13**).[1] Although considered Austrian in the past, the leaf displays the graceful forms, harmonious coloring, and sinuous rhythms that characterize illuminated manuscripts firmly identified as Bohemian, particularly those from Prague.[2] This "Beautiful Style," as it was aptly named, enjoyed favor at the cosmopolitan Bohemian court under Wenceslas IV (r. 1378–1419), a great patron of manuscript illumination.[3] Nearly a century earlier, c.1355–1360, his father, Emperor Charles IV (r. 1346–1378), had commissioned a diptych with the Man of Sorrows from the Italian artist Tomaso da Modena to serve as the altarpiece of the richly decorated Chapel of the Holy Cross in Karlštejn Castle, where the imperial crown jewels and a collection of Passion relics were housed.[4] A few years later, court artist Master Theodoric painted on the altar wall above Tomaso's diptych a large Crucifixion, beneath which he inserted a triptych whose central image repeated the Italian painter's Man of Sorrows. The Bohemian manuscript leaf couples these two images again and in a relationship that perhaps evoked associations with the illustrious royal chapel.

The miniaturist's portrayal of the three-quarter-length Man of Sorrows with hands crossed on his abdomen recalls Tomaso's traditional formulation in the Karlštejn diptych but shows Christ cradling in his arms two of the Instruments of the Passion, the scourge and the flail (or palm?).[5] As in many northern images, the Lord's eyes are open, and with a piteous expression he implores the devotee's compassion.[6] Christ's delicate proportions and swaying stance echo those of the figures in the full miniature above, and the round format of the image is repeated in the *rinceau* ornament of the border, whose blue, green, and salmon-colored blossoms accentuate the dominant colors in the miniatures. Further enriching the leaf are the gold halos and the decorative lozenge pattern forming the backdrop to the Crucifixion.[7] AV

1 Bohemia comprises the present-day Czech Republic and the Silesian region of Poland; the Canon of the Mass includes the sacred prayers recited during the consecration of the Eucharist.
2 Traces of gold on the miniature suggest that it faced text on the opposite page; see William Voelkle in *Parler und der Schöne Stil* 1978, 425, and Pirker-Aurenhammer 2002, 35. As noted by Voelkle in the Morgan curatorial files, similar examples can be found in the Missal of Zbyněk of Hasenburg (the Archbishop of Prague) of 1409 (Vienna, Österreichische Nationalbibliothek, Codex 1844), and in the Missal from St. Vitus' Altar in Prague, *c.*1413 (Brno, State Archive).
3 For the "Beautiful Style," see Gerhard Schmidt in *Prague* 2005, 105–111, and for Wenceslas IV, see Schmidt 1977, 56.
4 For Tomaso da Modena, see Gibbs 1989, 181-189 and 286-288, n. 17. For Charles IV, art at the Bohemian court, and stylistic trends generally in Bohemia, see Schmidt 1977, 43–55, Jiří Fajt in *Prague* 2005, 3–16, and Barbara Drake Boehm in ibid., 75–78.
5 Earlier images of the Man of Sorrows with the Instruments show them around him, but by the end of the fifteenth century Christ himself often holds them; see Schiller 1971, 208–209.
6 See Gerhard Schmidt in *Prague* 2005, 110–111.
7 For more information on the border designs, with their striking resemblances to those of the Master of the Gerona Martyrology, see Pfändtner 2006, 301–316, and Frinta 1964, 283–306.

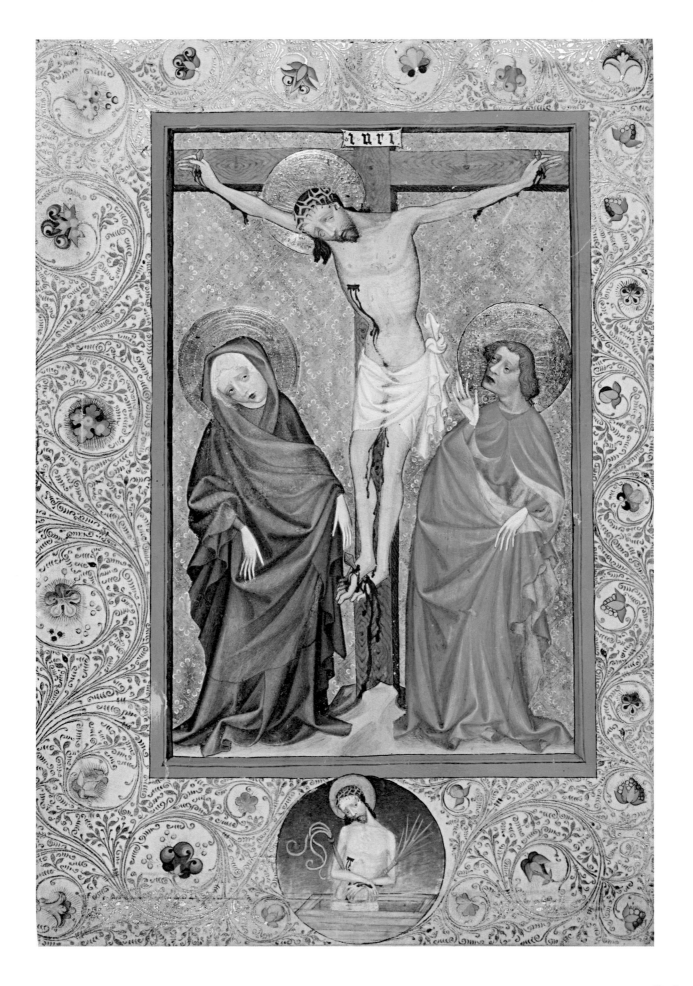

12

Anonymous French miniaturist
Book of Hours, Use of Nantes, c.1450–1475

Folios 99v–100r, 108 × 60 mm. (4.25 × 2.36 in.)
Margaret Clapp Library, Wellesley College, Wellesley, MA
Guy Warren Walker Collection, MS 81 WM–1

13

Anonymous Tuscan miniaturist
Book of Hours, Use of Rome,
early fifteenth century

Folios 201v–202r, 115 × 80 mm. (4.5 × 3.1 in.)
E.S. Bird Library, Syracuse University, Syracuse, NY, MS 5

14

Anonymous Neapolitan miniaturist
Book of Hours, Use of Rome, c.1485–1499

Folio 50r, 129 × 182 mm. (5 × 7.1 in.)
The Free Library, Philadelphia, Lewis E 120

15

Liberale da Verona (*c*.1445–1527/29)
Book of Hours, Use of Dominican Order, c.1475–1480

Folios 91v–92r, each 107 × 92 mm. (4.2 × 3.6 in.)
The Free Library, Philadelphia, Lewis E 118

These four Books of Hours, each including an image of the Man of Sorrows, originated in the fifteenth century, from which time many extant illustrated and handwritten devotional texts date. Their generic title derives from and defines their function, for their prayers and psalms were read at predetermined hours of the day called Matins, Lauds, Prime, Terce, Sext, None, Vespers and Compline. Three of the books here are Italian and one is French. All small and portable, they served their wealthy owners for private devotions and meditation. Books of Hours were often illuminated, that is, embellished with brightly colored images highlighted with gold. Some illuminations are independent miniatures whereas others fill enlarged and decorated initials opening a section of text; still others ornament the margins of their respective pages or folios.[1] Virtually all illuminated Books of Hours contain images of Christ's Passion; our selection shows the Man of Sorrows occupying one full-page illumination and part of another (cats. **12** and **15**) and decorating two initials (cats. **13** and **14**).

The French Man of Sorrows contrasts sharply with its three Italian counterparts. The figure occupies the top two-thirds of a full-page miniature filling one half of a bifolium, a double-leaf spread that was painted late in the century and inserted into the earlier

1 Wieck 1988, passim.
2 For other fifteenth-century representations depicting angels supporting the Man of Sorrows from behind, see Panofsky 1927, figs. 22–23, 25, and, for a related French illumination of *c*.1420, fig. 33.

Cat. 12

manuscript. Christ is supported by an angel and encircled by Instruments of the Passion (see also cat. **24**).[2] Behind rise the three crosses of Golgotha, a pictorial accompaniment new to the history of our subject in the fifteenth century.[3] Christ's bloodstained hands dangle downward, responding as it were to the Infant Jesus in the bottom segment of the folio raising his bleeding palms upward to his Passion portrayal, the two sets of blood-soaked hands highlighted by two similarly colored blossoms in the border decoration on the right. The baby Christ is in the arms of a Dominican friar positioned atop a blue and silver escutcheon with six *fleurs-de-lis* identifying the manuscript's late fifteenth-century owner, who belonged to the St. Gilles family of Brittany.[4] Perhaps one of its members, a spiritual advisor or confessor to the patron of the manuscript, the friar points to the facing folio where Saint Catherine of Alexandria, with her wheel, and Saint Sebastian, shot with arrows, appear above and below in settings and compartments analogous to those opposite. The Man of Sorrows dominates the full spread and offers the saints the exemplum for their torments, or *Passio*. Intercessors and perhaps saintly patrons of the St.-Gilles family, Catherine and Sebastian were themselves models for the manuscript reader.

The three Italian prayer books present the Man of Sorrows differently from the Wellesley *Book of Hours*. One of the three originated in Naples, the other two in Tuscany, yet all position the Man of Sorrows in relation to Psalm 51 (Vulgate 50), one of the 150 biblical "songs" associated with David. The psalms are traditionally divided into groups, the most famous being the Penitential Psalms, which customarily appear in a Book of Hours; recited during Lent, they express sin and repentance. Vulgate 50, the best known of the seven Penitential Psalms and usually called the *Miserere* for its third Latin verse, is used during the canonical day and plays a part in several liturgical offices.[5] These three prayer books, like many others, show the Man of Sorrows in relation to verse 17 of the *Miserere*: *Domine labia mea aperies et os meum adnuntiabit laudem tuam* ("Lord, thou wilt open my lips, and my mouth shall declare thy praise").[6]

Ms. 5 from Syracuse University (cat. **13**) places the Man of Sorrows within the *D* of *Domine labia* opening the Office of the Passion commemorating Christ's death. Its facing illumination depicts the Crucifixion, a standard image initiating the Office, with the spear and sponge on the sides of the cross and a skull below. The Man of Sorrows is pictorially foreshadowed on fol. 105r by an identically configured bust-length skeleton, which similarly fills the letter *D* (fig. **13.1**) but initiates Psalm 116 (Vulgate 114) beginning

3 One of the most famous examples is Mantegna's panel in Copenhagen (fig. **18**).
4 Information culled from the curatorial files at the Margaret Clapp Library; folios 99–100 are not contemporary with the rest of Wellesley's 81 WM-1 but were produced late in the century. The locality of Pointe St.-Gilles lies not far from Brest in Brittany. We are very grateful to Lilian Armstrong for discussing all four mss. with us.
5 See Wieck in *Liturgy* 2001, 498–502.
6 Wellesley 81 WM-1 shows the figure on a folio inserted immediately before the Penitential Psalms.

Fig. 13.1 Anonymous Tuscan artist, early fifteenth century
Office of the Dead, Ms. 5, folio 105r

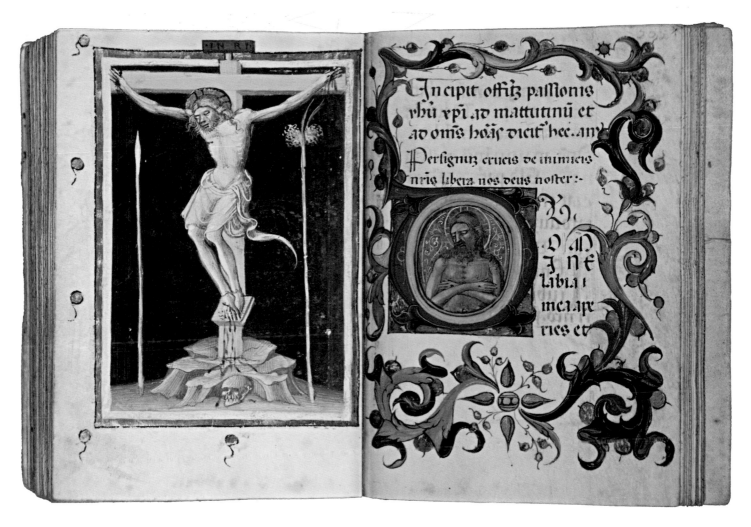

Cat. 13

Fig. 13.1

the Office of the Dead: *Dilexi quoniam exaudet Dominus vocem orationis meae* ("I have loved because the Lord will hear the voice of my prayer"). The skeleton opens private devotions to the deceased, whereas the Man of Sorrows introduces the text for the Good Friday services when the manuscript owner venerated Christ. Once attributed to an anonymous Tuscan artist, the illuminations of Syracuse ms. 5 have recently been given to Bartolomeo di Fruosino (1366/69–1441), who was responsible for illustrations in codices of Dante's *Divine Comedy* and whose style is associated with that of Lorenzo Monaco, a leading Florentine painter between *c.*1390 and 1425.[7]

One of the two Books of Hours from the Free Library depicts the Man of Sorrows again within the *D* of *Domine labia* (cat. **14**), and the other shows the figure in an independent miniature facing the same verse (cat. **15**); in each case the psalm introduces Matins of the Office of the Cross. The Neapolitan manuscript surrounds the text with a rich floriated border, and its miniaturist positioned the Man of Sorrows against Instruments of the Passion, a configuration surprisingly similar to the upper half of the design of the almost contemporary *Madonna Noseda* in this exhibition (cat. **24**). Despite the two very different devotional contexts, an analogous pictorial setting frames the figure during the same years of the Renaissance at the geographical extremities of the Italian peninsula.

The last example, a very beautiful *Man of Sorrows with Two Angels*, is now generally attributed to Liberale da Verona, although it has also been linked with Girolamo da Cremona; both were northern Italian painters working alongside one another in Siena, where this manuscript probably originated.[8] Like others works in this exhibition (cats. **6** and **12**), the associations and/or patronage of Lewis E 118 are Dominican. Backed by a cross with the crown of thorns, Christ sits on the edge of his tomb, and a delicately rendered, serene landscape stretches behind. The miniature is in fact devoid of affective drama, Liberale having chosen for his Christ a quasi-classical style recalling Andrea Mantegna's art, particularly his Man of Sorrows on a small drawing likely prepared for a crucifix.[9] Yet, after returning to Verona in 1476, Liberale painted panels of a contorted Man of Sorrows accompanied by several anguished figures, works resonating with an emotional fervor totally absent from the Philadelphia miniature.[10]

7 Bollati 2007; for this artist generally, see Barbara Drake Boehm in *Painting and Illumination* 1994, 307–317, and Katia Zambrelli in *Dizionario Biografico* 2004, 64–67.

8 *Painting in Siena* 1988, 298–299; *Leaves of Gold* 2001, 100–101, and Hans-Joachim Eberhardt in *Dizionario Biografico* 2004, 378–387 (384). Federica Toniolo in *Dizionario Biografico* 2004, 310–315, related the ms. to Girolamo (314) but has since altered her opinion, although she continues to see the skeleton on fol. 95v and its landscape in terms of that painter (oral communication).

9 For this nearly contemporary drawing, see *Mantegna* 2008, 269–270, cat. 97–101.

10 For at least three versions, see *Treasures of the Fitzwilliam* 2005, 18–19, *Mantegna e le Arti* 2006, fig. 15, and Del Bravo 1976, CXXVIII–CXXXI and plates CLXXXV and CXCV.

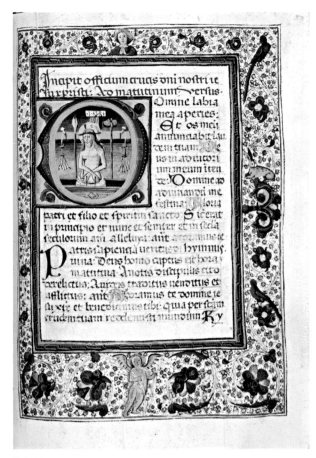

Cat. 14

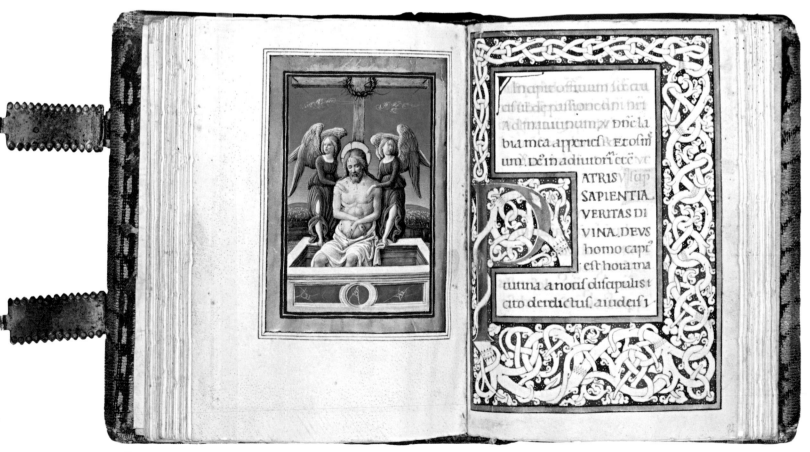

Cat. 15

16

Andrea Mantegna (*c.*1431–1506)
*Man of Sorrows with Mary, Mary Magdalene
and Saint John, c.*1455–1460

Pen and brown ink on white paper, 127 × 98 mm. (5 × 3.85 in.)
Venice, Gabinetto dei Disegni e Stampe delle Gallerie dell'Accademia, n. 115

Mantegna's tiny but masterful drawing lies at the historical crossroads of the interpretation of the *Imago pietatis* in Venetian Renaissance art. Formerly attributed to Giovanni Bellini, his brother-in-law, it is now accepted as by Mantegna, who may have executed it soon after completing the Saint Luke Altarpiece in 1454 for Santa Giustina, Padua.[1] There, on the crowning pinnacle of a polyptych, he had portrayed a traditionally frontal and motionless Man of Sorrows flanked by Mary and John, each on a separate panel.[2] Altering his concept significantly in this drawing, Mantegna composed a taut arrangement of two grief-stricken Marys jointly sustaining the weighty torso of the dead Christ atop his sarcophagus, while the anguished Saint John looks out from behind.[3] Christ's head, falling unconventionally to our right, bears signs of physical suffering.

Mantegna and his in-laws, Jacopo and Giovanni Bellini, created a remarkable series of varying interpretations of the Man of Sorrows throughout the second half of the fifteenth century, establishing a broad range of dramatic, spiritual and affective connotations. Mantegna's drawing portrays viscerally felt grief in a moment of time. Different from Jacopo and Giovanni, who also depicted the Dead Christ with family and friends, Mantegna escalates the human heartbreak unleashed by Christ's death.[4] Emotionally volatile but expertly controlled, his figures are arranged to form an arched composition squeezed into a narrow vertical format, yet each head moves independently to create individually sorrowful figures.

The drawing was probably preparatory to a devotional work, but Mantegna's only extant independent panel dates to decades later when he conceived an original interpretation of the Man of Sorrows (fig. **18**). Accompanied by two distraught angels, seated on an antique sarcophagus placed before a minutely described landscape with Golgotha seen in the distance, the innovative full-length figure of Christ appears to awaken as daybreak fast approaches. Showing the wounds on his hands, he takes one step forward.

1 Annalisa Perissa Torrini in *Mantegna e Padova* 2006, 202–203, cat. 30, and Antonio Mazzotta in *Mantegna* 2008, 144–145, cat. 44; see the second publication, 110–112, cat. 25, for the Saint Luke Altarpiece.
2 For another traditional Man of Sorrows by Mantegna in a drawing probably prepared for a medallion to adorn a crucifix, see Stefano L'Occaso in *Mantegna* 2008, 269–270, cat. 99.
3 Most scholars identify the curly-haired figure in the center as John.
4 For folio 7v in Jacopo's album in the Louvre, see *Giovanni Bellini* 2008, 109, fig. 6. For two drawings by Giovanni, see ibid., 190–203, cat. 17, and 228–231, cat. 27. Giovanni's only dramatic representation of the subject is the *Man of Sorrows with Mary and John* in the Ducal Palace, Venice, for which see ibid., 172–175, cat. 12. See also fig. **7** in this catalog, a Bellini-like relief in the island cemetery of San Michele; and for the many painted versions after Bellini, see Heinemann 1962.

17

Bartolomeo Sanvito (1435–1511), attributed to
Mill of the Host, 1466 (after a design by Nicolò Pizolo)

Pen and ink, 300 × 213 mm. (11.8 × 8.38 in.)
J. Paul Getty Research Center, Los Angeles, CA n. 900255

The Man of Sorrows in the Getty drawing stands out in the context of our exhibition for its inscription of *Christo passo* (see pp. **13–14**), its placement (atypical in the Veneto) vis-à-vis the altar and the questions raised by the figure's stylistic formulation.[1] The sheet is also a well-known fifteenth-century Italian drawing for its information regarding business practices and its association with Bartolomeo Sanvito, the scribe who wrote the accompanying contract, who was the inventor of italic print and collaborated with many humanists of the period.[2] It depicts the Mill of the Host, a Eucharistic subject, here preparatory for the altarpiece of Bernardo de Lazara's *Cappella del Corpus Domini* in Sant'Antonio, Padua's Franciscan church whose high altar complex by Donatello includes the Man of Sorrows (fig. **16**).[3] The de Lazara contract discloses that Pietro Calzetta (active *c*.1450–*c*.1486) was commissioned for the altarpiece, but was to follow a drawing by Nicolò Pizolo (d. 1453) that belonged to Francesco Squarcione, master of the most important artistic studio in Padua, where Andrea Mantegna and others trained *c*.1440–1465. Given the several prominent men whose names converge on this sheet, its historical significance is enormous.

Like all depictions of the Mill of the Host, this one shows a mill producing the Holy Wafer, but the de Lazara project is unique for its political and theological complexities.[4] At the top center, God sends the Christ Child towards Mary and Gabriel. On the left, rainwater running down a channel tended by prophets passes through a sluice, Saint Peter dispensing the water into a waterwheel. In the center Christ's spirit emanates past the Annunciation and penetrates a large funnel, its sides adorned with the evangelistic symbols, the lion of Mark on the front. Below, a millstone powered by Peter's waterwheel produces little loaves or hosts in a large vat, at whose corners stand the Four Doctors of the Church, Gregory the Great the most prominent at the lower left corner.[5] The faithful kneel in adoration of the mill's miraculous yield, the wafers finding sacramental realization in the Man of Sorrows emerging from the sarcophagus, where angels support him.

This representation of the Mill of the Host is unique in privileging the Annunciation, the Lion of Saint Mark, Saint Peter, and Gregory the Great. The first two can only refer to Venice—its legendary founding on the feast day of the Annunciation and its saintly founder, Mark. The de Lazara family, with Bernardo's father at its head, had been instrumental in ousting the tyrannical Carraresi family from Padua in 1405 so as to incorporate the city into the Venetian Republic, and here the Annunciation and Lion of Saint Mark articulate dynastic pride and civic devotion.[6] The inclusion of Peter dispensing water and Pope Gregory implementing communion (note his arm in the vat) leaves little doubt that the altarpiece also emphasized Rome's authority to tender the

1 Lucco 1984, pp. 130–132, proposed that the figure of Christ is related to the art of Marco Zoppo, a pupil of Francesco Squarcione in the late 1450s who lived with his master between 1455 and 1461. The figure is stylistically quite close to Zoppo's two versions of the subject, one in the Museo Civico, Pesaro, and the other now on loan from a private collection to the Metropolitan Museum of Art. The *Imago pietatis* appeared nearly a dozen times in the church of Sant'Antonio between *c*.1430 and 1500; our study on the Man of Sorrows in Franciscan Padua is forthcoming.
2 The sheet has been much studied; see Callegari 1996, 14, Welch 1997, 104–105, O'Malley 2005, 201–205, and Pesenti 2006, 145–147 (all with older bibliography). For the drawing's copy in Padua, see *Mantegna e Padova* 2006, 266–267, cat. 58. For Sanvito and italics, see Wardropt 1963. Sanvito is also credited with many manuscript illuminations; see De la Mare and Nuvoloni 2009, passim, and 27–28, 47, 65 for this drawing.
3 Scriptural exegeses are based on such texts as John 6:31ff.: "Verily, verily, I say unto you, Moses gave you not bread from heaven; but my father giveth you the true bread from heaven. For the bread of God is he which cometh down from heaven, and giveth life unto the world." For the subject of the Mill of the Host, see Rubin 1991, 312–316.
4 Rare in Italy, the subject appeared mostly in German-speaking lands; see Rye-Clausen 1981 and Heimann 1982.
5 All other representations of the Mill of the Host show the twelve apostles cranking a bar that rotates and powers the millstone.

Corpo di Cristo to the faithful and its prerogative to mediate between them and God. The ideologies of Venetian loyalty and papal supremacy would appear to be at odds with the antagonism traditionally characterizing Venetian–Roman relations. Only the recognition that de Lazara's project dates to 1466 brings these opposing principles into harmony, for while the enterprise was going forward, the Venetian patrician Pietro Barbo reigned on the Throne of St. Peter as Paul II (1464–1471).

The clear articulation of the above-mentioned ideologies, the destruction of both altarpiece and chapel *c.*1550, the lack of Pizolo's original design, and the impossibility that he could have foreseen Paul's election before his death prompt a plethora of questions that cannot be addressed here. But surely there is no need to assume that the Getty drawing faithfully copies Pizolo's original, or that Sanvito was the artist because the captions on the drawing correspond with his handwriting on the contract. Given the artistic activity animating Squarcione's shop and the messages eloquently communicated by the de Lazara altarpiece, the Getty drawing and its artistic milieu merit further exploration.[7]

6 Unlike other interpretations where the four symbols appear jointly, the lion here takes pride of place. It is not a generically depicted beast but one familiar from several Venetian formulations, for example on the façade of the fourteenth-century Palazzo Agnusdio in Venice.
7 For Sanvito as a miniaturist, see De la Mare 1999, 500, Beatrice Bentivoglio-Ravasio in *Dizionario Biografico* 2004, 928–936, and De la Mare and Nuvoloni 2009.

18

Antonio Maria da Villafora (fl. 1467–d. 1511), attributed to
Man of Sorrows with Mary and Saint John,
101 × 41 mm. (3.97 × 1.6 in.)

Statute Book of the Monte di Pietà of Padua, 1490s
Fol. 1r, 250 × 170 mm. (9.84 × 6.69 in.)
Biblioteca Civica, Padua, inv. no. B.P. 103

In 1491 the Observant Franciscan friar Bernardino da Feltre responded to the urgent call of Pietro Barozzi, bishop of Padua, to found a local chapter of the Monte di Pietà, a lending institution established by the Franciscans in the 1460s and promulgated by Bernardino throughout Tuscany, Umbria, Lombardy and the Veneto between 1484 and his death ten years later.[1] The Venetian Senate and Paduan city council had already approved the local Monte, but the new bank needed capital, and on August 1, 1491, Bernardino led a fundraiser in the city streets that realized more than 5,000 ducats, his success aided by a banner emblazoned with the Man of Sorrows high in the air.[2] The friar soon became intimately associated with the image, and all Monte offices eventually employed the figure as their official emblem (fig. **13**).

The Paduan banner of 1491 no longer exists, but fortunately the statute book founding the Monte that year does; its initial date is *10 maggio 1491*, and its opening text names Agostino Barbarigo, Melchior Trevisan, and Antonio Marcello as, respectively, Venetian doge, and *podestà* and *capitano* of Padua.[3] Like many *mariegole* of the era (cats. **40** and **41**), this book also has few miniatures, here only the Man of Sorrows with Mary and Saint John seen against a verdant landscape, an image promising spiritual salvation to those supporting the bank and regeneration to those rescued by its loans. Heretofore unattributed, this miniature, the opening initial (*A* for *Augustinus*) and the border decoration all correspond with the work of Antonio Maria da Villafora, a leading illuminator in Padua who worked continuously for Barozzi during his episcopate, from 1487 to 1507.[4] The figures in the miniature, though weaker in draftsmanship than usual, closely match their counterparts in Villafora's illumination of the Crucifixion in the missal he prepared for the bishop the same year the Paduan Monte was founded; the two sets of Mary and John are almost identically garbed, and their draperies hang with comparable folds.[5]

1 Puglisi and Barcham 2008.
2 Fol. 11r–v of this codex describes the procession of the day and states that Bishop Barozzi blessed the "vexillum novum hac de causa imagine pietatis." See also De Sandre Gasparini 1974, XCII, n. 57.
3 Later statutes are dated *30 dicembre 1503* and *16 marzo 1524*. The Paduan Monte's first banking ledger also survives, and its opening page similarly depicts the Man of Sorrows; we thank Francesca Fantini D'Onofrio, Director of the Archivio di Stato di Padova, for facilitating our study of the codex (Santo Monte di Pietà, reg. 19).
4 The authors are grateful to Gilda Mantovani, Director of the Biblioteca Civica di Padova, for permission to study this codex, and to Federica Toniolo, Università di Padova, for the attribution of its miniature. For Villafora, see *Miniatura a Padova* 1999, 576–577, Bagatin 2001, Mariani Canova 2002, and Laura Paola Gnaccolini in *Dizionario Biografico* 2004, 36–40.
5 See Mariani Canova 2002, fig. 100.

I N nomine dei omnipotentis amen etc

A VGVSTINVS BARBADI, CO: Dei gratia DVX Venetiarᴢ &ᶜ· Nobilibus et sapientibus Vi ris Melchiori Triuisano de suo man dato potestati, & Antonio Marcello Capitaneo Paduae' & successoribus suis fidelibus di lectis, salutem & dilectionis affectum. Fidelissima et carissima ista communitas nostra per eius oratores missos ad presentiam nostram declarari nobis fecit, se maximopere desyderare pro commoditate et benefi cio pauperum personarum construere' unum montem pietatis, pro subueniendo pauperibus in eorum necessi tatibus & indigentijs absq: aliquo eorum damno que admodum obseruatur in ciuitate nostra Vincentiae ostendiq nobis fecit modulam capitulorum, cu qui bus erigere' intelligit montem ipsum pietatis, petens suppliciter, ac reuerenter dignemur confirmare di cta capitula VNDE satisfacere' intendentes huiu scemodi pio, et Christiano desyderio ipius fidelissi mae' communitatis, capitula ipsa, cum nostro consi lio rogatorum laudauimus: approbauimus, et confir mauimus, ac presentium tenore' laudamus, approba mus, & confirmamus: uolentes & imperantes, ut per

19

Michele Giambono (fl. *c*.1420–1462)
Man of Sorrows, c.1450–1460

Tempera on wood, 51 × 36 cm. (20 × 14.1 in.)
Inscribed: OPUS•ANDREAE•MANTEGNAE•PAT•
Padua, Museo d'Arte Medioevale e Moderna, inv. no. 6

A leading artist in the Veneto prior to the emergence of Giovanni Bellini, Giambono portrayed the Man of Sorrows six times and ranks as one of its foremost interpreters in the region.[1] This panel, his only solitary figure of the subject, is very different from his earlier, anguished image in New York (fig. **20**).[2] Here, Giambono appropriated the movement and naturalism that Donatello had introduced into his Santo relief (fig. **16**) and opened Christ's arms wide as in his New York work, creating a configuration that had appeared in Tuscan art decades earlier in which angels or Mary and John usually supported Christ's arms and hands.[3] Such an image of the Man of Sorrows was known in the Veneto but principally as a full-length, standing and tormented Christ without angels: Zanino di Pietro and Jacopo Bellini each painted this type of Dead Christ, and Antonio Bonvicino carved a comparable statue in wood in the early 1400s.[4] Modernizing the time-honored half-length Man of Sorrows by means of Donatello's spatial and figural innovations, Giambono nonetheless endowed it with late Gothic sensibility, with blood spurting from Christ's wounds and his eyes opened as if witnessing his own gory death.

Was this panel a pinnacle for a polyptych, or an independent devotional work like Giambono's New York painting?[5] No definitive conclusion can be reached until the panel is subjected to technical analyses. For the moment it should be kept in mind that it tallies in size with other late Gothic or early Renaissance pinnacles, for example, the London work (cat. **3**), Antonio Vivarini's panel for his Praglia Polyptych (*c*.1448), and Andrea Mantegna's for his Saint Luke Altarpiece (1454).[6] But Giambono's painting bears a series of pictorial contradictions vis-à-vis these three. First, though it portrays Christ's arms apart as in Vivarini's and Mantegna's contemporary works, the panel lacks Mary and John. Was it accompanied by flanking panels on a now lost polyptych, as Mantegna's still is? Giambono also projected a view into the tomb while showing the crossbar from below, an old approach typical of the London pinnacle in this exhibition and others of the same early era. Respecting the new code of Renaissance visual believability, however, Vivarini and Mantegna devised their respective sarcophagi to correspond with their elevated placement. Exploring new ground yet restrained by tradition, Giambono's *Man of Sorrows* reveals the painter's historically complex artistic personality.

1 The authors are very grateful to Franca Pellegrini, curator at the Museo d'Arte, Padua, and to Antonella Daolio, restorer, who examined the panel with them in June 2009. The inscription OPUS. ANDREAE. MANTEGNAE. PAT is later. For Giambono generally and for his position in Veneto art at the time, see Franco 1996 and Franco 1998, and Andrea De Marchi and Franco, "Il Gotico internazionale: Da Nicolò di Pietro a Michele Giambono," in Curzi 2000, 73–80.
2 Franca Pellegrini dates the panel *c*.1440 (written communication), closer in time to the New York painting.
3 For paintings by Gherardo Starnina (d. 1413), Angelo Pucinelli (d. *c*.1407), and Giuliano di Simone (d. *c*.1397), see Filieri 1998, 19, 21, 165, 188; for works by Lorenzo Monaco (d. 1425/30) and Masolino (d. *c*.1435), see Eisenberg 1989, figs. 18–19 and 333; and for a panel of the 1440s by Benozzo Gozzoli, and for a fresco of 1423–1424 by Giovanni Toscani, see Strehlke 2004, plate 35.
4 See Mauro Minardi in *Fioritura* 1998, 208–209, cat. 72, for Zanino, Gamulin 1963 for the attribution of a panel in Zagreb to Jacopo Bellini, and Schulz 2004b for Bonvicino.
5 See Franca Pellegrini in *Pisanello* 1996, 200–201, and Banzato's summary of this issue in Banzato and Pellegrini 1989, 99–100, cat. 77. For further discussion, see Land 1980, Sandberg Vavalà 1947, and Franco 1998, 107–108.
6 The London panel measures 52.3 × 30 cm.; Vivarini's, 47 × 33 cm.; and Mantegna's, 51 × 30 cm. For these last two, see *Mantegna e Padova* 2006, 102, fig. 16, and 166–167, cat. 12.

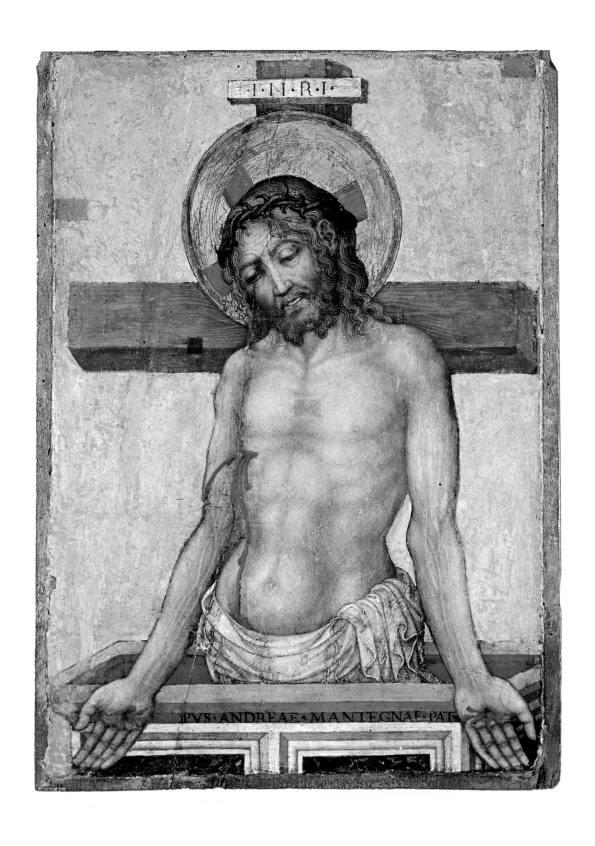

20

Anonymous Venetian artist
*The Dead Christ Supported by Angels, c.*1500

Bronze, 9 × 11 cm. (3.54 × 4.3 in.)
National Gallery of Art, Washington, DC, Widener Collection, inv. 1942.9.189

Illustrating the fine quality and expressive power of the best small bronzes of the Renaissance, this plaquette portrays the Dead Christ displayed in his sarcophagus by two cherubs holding the long, winding shroud while two others lament behind. Christ's body is set at an angle but flush with the surface. Crowned with thorns, his head slumps towards his right shoulder as his arms splay outwards. Formerly attributed to Donatello on the basis of a stylistic comparison with his Santo relief (fig. **16**), this work and its many variants thought to date from the last quarter of the fifteenth century find parallels for their horizontal format and composition in Donatello's marble relief in the Victoria and Albert Museum and Giovanni Bellini's *Man of Sorrows with Four Angels* (fig. **17**).[1] The artist of the Widener plaquette and its related versions also found in Bellini a model for the design of Christ's body and head along a diagonal and for the four cherubic attendants with loose tunics.[2] Details in the work may be compared too with corresponding elements in an anonymous wood relief in the Musée du Louvre.[3]

The Widener plaquette is a rare example of this design with a full upper border, differing from replicas in Berlin and Washington where the figures are silhouetted; an example in the Louvre has a vertical format, allowing for the inclusion at the top of a large schematic cross.[4] The above-mentioned Berlin variant and second Washington version both show Christ's side wound incised in the bronze; this is not evident in the Widener relief. The number of surviving variants attests to the success of the composition and suggests its popularity in the growing market for collectors.[5] Marks on the back of the Widener plaquette indicate that it was mounted on a larger display, possibly as a pax tablet (see cats. **30–32**); this may link the panel to the Franciscans, who have been credited with introducing the pax into the liturgy.[6] MD

1 Bode 1906, cat. 171, attributed the Widener plaquette to a Paduan follower of Donatello; and see Bange 1922, cat. 353. For the V & A relief, see Pope-Hennessy 1964, vol. 3, cat. 62. Lewis 2010–2011, cat. 312, also recognized the compositional source in Bellini and noted parallels with a later relief, ascribed to a Paduan sculptor, in the Kunsthistorisches Museum, Vienna, for which see Leithe-Jasper 1986, no. 24, 122–23.
2 Bange 1922.
3 For the wood relief described as northern Italian in the Musée du Louvre (R.F. 706), see Molinier 1886, cat. 74.
4 For the version in Berlin, see Molinier 1886, cat. 73, and Bange 1922, cat. 353; for the one in the Kress Collection, National Gallery of Art, Washington, DC, see Pope-Hennessy 1965, cat. 344. For the vertical version in the Musée du Louvre (OA 2552), see Molinier 1886, cat. 74. Eight casts are known in the silhouetted form and two in the full-plate form; see Lewis 2010–2011, cat. 312.
5 Leino 2007, 252–253.
6 Leino 2007, 251–252. For the Franciscans and the pax, see Bona 1671, II, xvi, §7, and Herbermann et al., 594; see also Miotto 1999, 138–144.

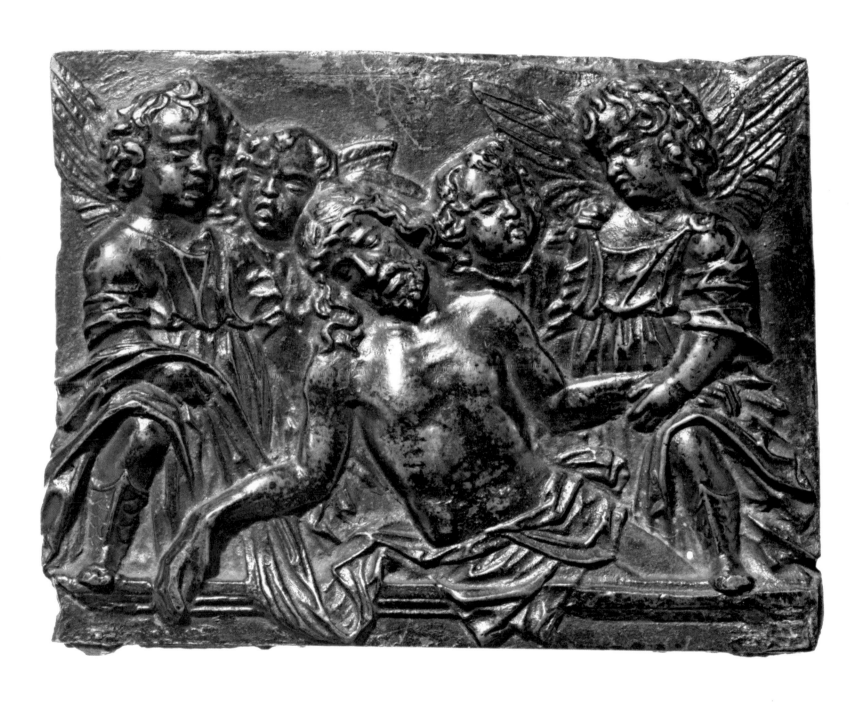

21

After Donatello, Italian

Dead Christ Supported by Two Angels, late fifteenth century

Polychromed papier-mâché, 45 × 52 cm. (17.7 × 20.47 in.)
Princeton University Art Museum, Princeton, NJ, Y1962-75
Bequest of Dan Fellows Platt, Class of 1895

Supported by two grieving cherubs, Christ sits on the edge of a sarcophagus. His head, crowned with thorns, projects in highest relief and carries his suffering into the viewer's space. Thick drops of blood, built up three-dimensionally in gesso, ooze down his face and chest and run from the wounds in his hands and side, which are graphically conveyed by actual holes in the relief.[1] Though the blood on Christ's arms appears to have flowed upward, against gravity, it dried while he was nailed to the cross, creating here a visceral and palpable effect recalling Christ's anguish during the Crucifixion. This gory and highly emotional work of art finds its sources in the works of Donatello, whose bronze Dead Christ for the high altar at the Santo in Padua (fig. **16**) served as a formative model for many Venetian late fifteenth-century images of the Man of Sorrows, including those by Giovanni Bellini (fig. **17**).[2] But a still closer visual relationship between the Princeton relief and Donatello's work exists with the *Dead Christ Tended by Angels*, a marble in the Victoria and Albert Museum made after the master's design. The Princeton and London works portray the same physical intimacy linking Christ to the cherubs holding him, a feature lacking in the restrained interpretation in the Santo Dead Christ.[3] The bright colors of the Princeton relief, however, produce a more vibrantly lifelike and expressive Dead Christ than either the monochromatic Victoria and Albert marble or the polished Santo bronze.

The work was likely used for private devotions in a domestic setting.[4] Cast in papier-mâché from a now lost master mold designed and possibly created by Donatello, it was perhaps produced speculatively, like many other reliefs subsequently made in inexpensive materials such as terracotta, stucco, or papier-mâché that were then polychromed. The success of this design is attested to by its reproduction in four other known examples, two in terracotta and two in papier-mâché, and its influence on other works across the Veneto.[5] The Princeton relief and its kin would have aided the private devotions of an emerging middle class, encouraging penitence and inspiring reverence for the *Cristo passo*.[6] CK

1 De Marchi 1996, 71–76.

2 De Marchi 1996, 74, argued for a Donatellan prototype, invented prior to 1444 and diffused from Padua across the Veneto in the second half of the century.

3 For the *Dead Christ Tended by Angels* after Donatello in the Victoria and Albert Museum, London (no. 7577-1861), see Pope-Hennessy and Lightbown 1964, 73–75, and Rosenauer 1993, 146.

4 De Marchi 1996, 73, identifies the medium of the Princeton relief as stucco, but its recent restoration by Norman Muller at the Princeton Art Museum reveals its medium as papier-mâché. For works in papier-mâché, or *cartapesta*, see *La scultura in cartapesta* 2008. For devotional paintings and sculptures in Renaissance interiors, see Thornton 1991, 261–265, and 268.

5 In addition to the four replicas cited in De Marchi 1996, 72–75 (ex-Berlin [now destroyed], Faenza, Parma and Princeton), a fifth example, also in terracotta, is in a private collection. De Marchi suggests that the extra hand in the Princeton relief indicating the wound in Christ's side results from an error in copying the prototype depicting a third cherub behind Christ.

6 For multiple production, see Radcliffe 1992 and Comanducci 2003. For Donatello and multiple production, see Pope-Hennessy 1980.

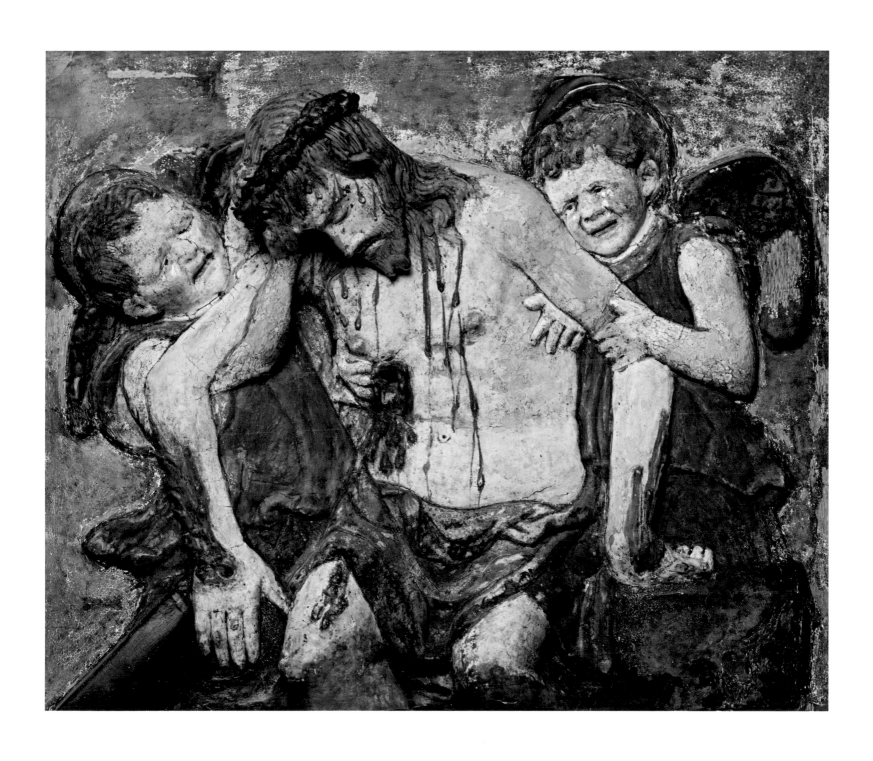

22

Carlo Crivelli (*c*.1430/35–*c*.1495)
*Dead Christ Supported by Two Angels, c.*1470–1475

Tempera and tooled gold on panel, 71 × 47.2 cm. (27.95 × 18.58 in.)
Philadelphia Museum of Art, John G. Johnson Collection, 1917,
PMA acc. cat. 158

Powerfully depicting grief and suffering, this panel is one of Crivelli's numerous moving variations on the Man of Sorrows that span his career, portraying the figure alone, with angels or in other sacred company. Though Venetian born and Padua trained, the artist worked mainly in the Marches on the Adriatic coast south of Venice, supplying polyptychs to the many new or refurbished Mendicant churches that accommodated the vital Observant reforms in the region.[1] Like his contemporary *Dead Christ with Angels* from the Montefiore Polyptych, Crivelli's Philadelphia panel once formed the central pinnacle of a Gothic polyptych; it probably also once had a similar plain gold background framed by a rounded top before being rendered "Gothic" at a much later date by means of a pointed arch and a richly patterned golden cloth of honor.[2] Lightly incised lobes on either side of the panel above the cherubs' heads, still visible today, suggest that tracery was originally applied around its upper contour as in the San Martino Polyptych, executed by Crivelli's brother Vittore around a decade later, which remains in its original frame. The closely related San Martino pinnacle repositions Christ's head while directly quoting the placement of hands and the two cherubs from the Philadelphia composition.[3]

Pale with death, his mouth open, Christ falls backward with his pointed chin thrust dramatically upward, while two cherubs brace themselves on the parapet and struggle to hold him upright. Crivelli graphically portrays Christ's suffering both before and on the cross with the thorns digging into his forehead, the gaping side wound, the open gash on his left hand silhouetted against the gold ground, and the gory hole in his right hand hanging over the marble sarcophagus and set against a deep vermillion velvet fabric.[4] Decorated with pomegranates heralding the Resurrection, this brocade evokes a liturgical textile on the altar. This imaginative interpretation of the Dead Christ with Angels stands out from the near-contemporary works in this catalog (cats. **21** and **23**) because of its vivid depiction of Christ's bodily agony linked with the cherubs' intense grief, and, moreover, for Crivelli's consummate mastery of the latest innovations in rendering surface realism while respecting the timelessness of late medieval art.[5] KS

1 Lightbown 2004, 47–56.
2 For the pinnacle of the Montefiore Polyptych now in London, National Gallery, 72.4 × 55.2 cm., see Lightbown 2004, 200. Lightbown 2004, 136, rejected the association of the Philadelphia panel with the Erickson Polyptych because of the discrepancy in the source of lighting with the other proposed Erickson panels. As first suggested by Keith Christiansen in *Linsky Collection* 1984, cat. 5, and recently confirmed by close examination of the panel prior to technical analysis, the tooled cloth behind Christ is not original and was perhaps added to enhance the panel. We thank Mark Tucker and Teresa Lignelli, Conservators at the Philadelphia Museum of Art, and Carl Brandon Strehlke, Curator of the Johnson Collection, for examining the painting with us.
3 For Vittore's polyptych, see De Vecchi 1997, 84–87. The dimensions of its pinnacle (71 × 47 cm.) closely correspond to the Philadelphia panel.
4 Painted with lake, some of the original blood dripping from the wounds has faded.
5 For a discussion of Crivelli's style, see Lightbown 2004, 4–12.

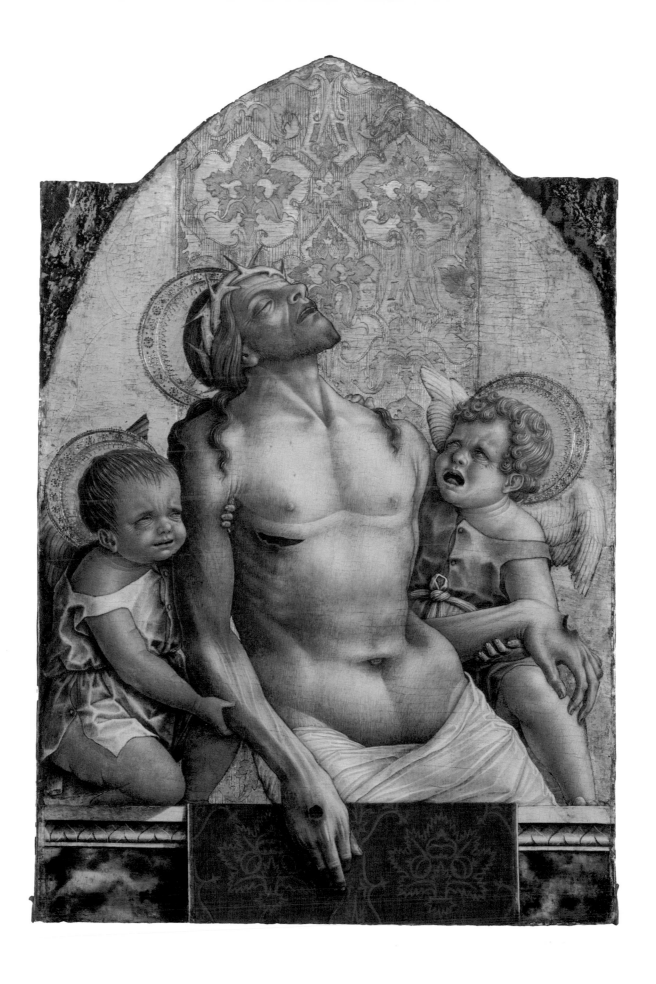

23

Bartolomeo Vivarini (fl. *c*.1445–*c*.1500)
Dead Christ with Two Angels, *c*.1470–1480

Tempera on panel, 46.4 × 76.5 cm. (18.2 × 30.1 in.)
Bob Jones University Collection, Greenville, SC
Gift of Mr. and Mrs. Robert Lehman, 23.1

Bartolomeo and his brother Antonio and nephew Alvise dominated Venetian religious art in the middle and second half of the fifteenth century together with Jacopo, Gentile and Giovanni Bellini. Between them, the two family workshops produced more than twenty versions of the Man of Sorrows, the Vivarini being responsible for the majority, most of these for altar polyptychs but several as private panels.[1] Though pictorially less adventurous than the Bellini, the Vivarini were extraordinarily successful, executing immense, gilded altarpieces for churches in Venice and the Veneto, Bologna and elsewhere (fig. **6**), and also, like Crivelli, for provincial towns in the south. Approximately twelve Vivarini polyptychs privilege the *Cristo passo* and do so, unsurprisingly, in the top central pinnacle.[2] Their interpretations of the figure demonstrate their creativity in mediating between late Gothic expressiveness and burgeoning Renaissance naturalism, and they highlight too the figure's intrinsic ability to adapt subtly to different contexts.[3]

Bartolomeo produced the *Imago pietatis* for seven altarpieces that still survive intact, their dates ranging from 1450 to 1482 (some of them executed in collaboration with Antonio). Five of the seven show Christ with his hands traditionally together and two with his arms open, a configuration that Antonio was responsible for as early as 1440 on the Parenzo Altarpiece.[4] Bartolomeo, for his part, did not adopt this design until 1476 for the Bari Altarpiece, and again in 1482 for the Ca' Bernardo Altarpiece in the Frari, Venice; he also used it on the Bob Jones panel, which probably once belonged to a large polyptych.[5] The figure of Christ here is very close to that at the Frari, and Bartolomeo repeated the crossbar in both works.[6] His idiosyncratic angels reappear at the top of his Scanzo Polyptych inscribed 1488, so the Greenville panel is likely to have belonged to an altarpiece of the 1480s.[7] Two elements distinguish its Christ in particular: his open eyes and his difficulty in holding up his forearms, their weight requiring him to rest them on the tomb rim. The implication is that Christ is alive despite death, a conception less frequently explicit in Italian representations than in those of northern Europe. Finally, Bartolomeo's frontal and immobile image unambiguously recalls the venerable and time-honored Man of Sorrows of the past. Such a traditional evocation, though viewed critically today through the lens of Renaissance innovations like those of Bellini (fig. **17**), was of undoubted devotional importance to the artist's patron.

1 Given their less varied subject matter and stylistic uniformity, the Vivarini have fared critically less well than the Bellini. The result is that they are less studied, but see Pallucchini 1962, Steer 1982, Lucco 1989–1990, and Humfrey 1993.
2 See cats. **3**, **19**, and **22** as earlier and contemporary examples.
3 An outstanding example of this is the Certosa Altarpiece, 1450, whose *Man of Sorrows* (fig. **6**) appears the most traditional of all but whose configuration responded to the particular needs of its monastic environment. The authors will deal with this in a later publication.
4 Most Venetian painters did not present the figure in this fashion until later in the century, but see fig. **20**. Some of the polyptychs, though all their panels are still united, lack their original gilded frames.
5 The last digit of the date inscribed on the Parenzo Polyptych, illegible today, is either 0 or 4 (1440 or 1444); see Pallucchini 1962, 95, cat. 4; Lucco 1989–1990, vol. 1, 66, fig. 82; Pavanello and Walcher 1999, 149–150, cat. 273; and Walcher 2006, 141–144. For the Bari Altarpiece, see Humfrey 1993, pl. 113, and 346, cat. 23, and Clara Gelao in *Mantegna e le Arti* 2006, 245, cat. 30; for the Frari painting produced for a prestigious transept chapel, see Humfrey 1993, pl. 206, and 348, cat. 35. For the viewpoint, see Pallucchini 1962, 128, cat. 207, and Pepper 1984, 27, cat. 23. We are grateful to John Nolan, Curator at the Bob Jones University Museum and Gallery, for examining and discussing the panel with us. In 1957,

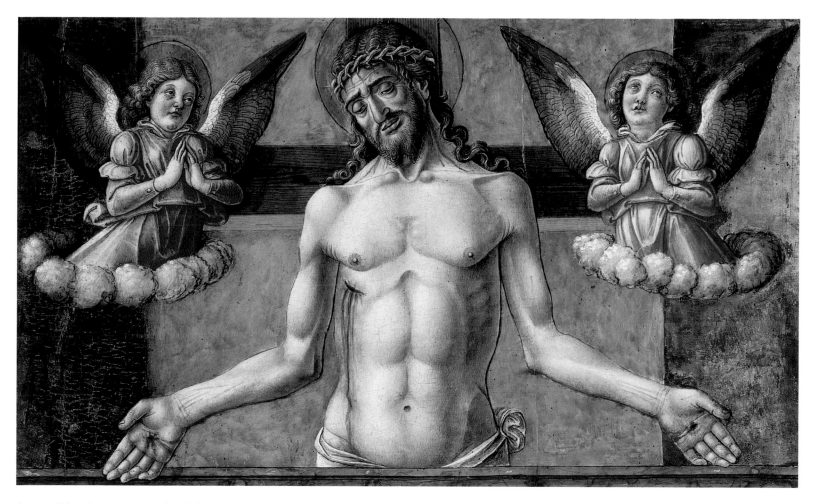

the panel's bowing was corrected with the radical treatment of inserting three hollow stainless steel rods into channels in the back of the panel. The crossbar is always represented as seen from below; the sarcophagus in the painting is also shown that way, as is Christ's little finger on his right hand. The bumps on the reverse of the panel are evidence of nail holes for attachments to an altarpiece. See Ruggeri 1993, figs. 1 and 2, for two other panels that were pinnacles on polyptychs.

6 Other similarities should be noted: the Frari version is 75 cm. wide and the Bob Jones panel 76.5 cm. wide; their differences in height may be accounted for by the cutting of the Bob Jones work, whose superscription is missing. Given the angels, there was likely a blue sky, the azurite altering over time to green. Two important differences between the Greenville and Venice versions are that the stone tomb in the latter agrees with the stone ground where the saints stand, and Christ's shoulders in the two panels are not at the same level against their respective crossbars.

7 Pallucchini 1962, 128, cat. 207, dated the Bob Jones panel to the mid-1490s; see Pallucchini 1962, 129–130, cats. 213–214; and Rossi 1988, 320, cat. 332, for the Scanzo or Carrara Polyptych.

24

Domenico Morone (*c*.1442–*c*.1518/20),
or the Maestro della Libreria Sagramoso
Madonna and Child and the Man of Sorrows, c. 1500

Tempera on cloth, 33.8 × 22.1 cm. (13.3 × 8.7 in.)
Inscribed: IHSUS XPS [atop] and REGINA CELI [above the *Madonna and Child*]
Museum of Art and Archaeology, University of Missouri, Columbia, MO, inv. 61.75
Samuel H. Kress Collection, K461

Attributed variously to Domenico Morone, Girolamo dai Libri or "School of Verona," this linen cloth—once called the *Madonna Noseda* after its former Italian collector—has also been given to the Maestro della Libreria Sagramoso associated with the frescoes of 1503 in the library of that name at San Bernardino, Verona.[1] Although sometimes identified as a processional standard, the cloth is too small for easy visibility from afar, and its inscriptions, its delicate foliage, the shimmering design on the opulent tapestry, and the fine gold highlights on the three figures' hair all demand proximity for appreciation.[2] Furthermore, the cloth lacks any indication that it was attached to a staff. Given the increasing use of linen and canvas in northern Italian workshops at the time, the painter here may, like others, have been experimenting with a new material.[3] On the other hand, it should be remembered that the veil through which one passed into the Holy of Holies in Jerusalem was woven of fine linen, a detail insisted upon in the Bible.[4] Since the Missouri cloth shows the baby Christ holding what must be bread symbolizing the Eucharist (a form of pictorial prolepsis referring to the redemptive body above), it may well have carried a liturgical significance, particularly as Mary appears to witness the holy species.

The halos of both Christs contain cruciform designs whose red matches the blood on the Man of Sorrows, the drapery ennobling Mary and Child, the coral necklace protecting the infant from evil and the strings attaching the whips to the cross. The painter exalted Christ twice, a rich brocade falling behind Mary below and one embroidered in gold above, where his first name appears in Latin, his second in Greek. The artist also called attention to his figures' submissiveness. The despondent Christ, whose frowning face tilts unfamiliarly to our right, is beset by the crown of thorns, lance, sponge and whips that tormented him, and the Madonna sits atop a cushion on the ground in deliberate juxtaposition with her title as REGINA CELI (Queen of Heaven).[5] The Man of Sorrows and the Madonna of Humility were already juxtaposed in the late fourteenth century, notably on a triptych in the Gallerie dell'Accademia, Venice, where the same vertical alignment compares their humility.[6] Mary's meekness voices her role as humble intercessor, whereas Christ's evokes the rejection and derision he wretchedly endured, the very ordeals defining him as the Man of Sorrows.

1 Longhi 1978 first separated Morone's hand from that of the frescoist of the Libreria Sagramoso and was followed by Bellosi 1994, and by Mauro Lucco in *Pinacoteca civica* 2003, 148–152, cat. 25a–c (*Stories of S. Biagio*), and cat. 26 (*Due santi e beati francescani*), works datable *c*.1500–1510. Debora Tosato in *Mantegna e le Arti* 2006, 306–308, cats. 71a–c and 72, returns these last works in Vicenza to Morone. Whether by Morone or the frescoist working in the Libreria Sagramoso, Mary's physiognomy in Missouri is absolutely like that of the female onlookers in Vicenza's *Torturing of San Biagio* and her draperies are compatible with theirs, and the setting of the Missouri *Madonna and Child* is akin to the landscape in *Due santi e beati francescani*. Especially relevant are the similarly pointed fingers of the two Christs in Columbia and those of the two Franciscans in Vicenza. See Palumbo 1973, 30, for a Man of Sorrows labeled "Circle of Domenico Morone" showing the identical arrangement of lance and sponge as in Missouri and stylistic characteristics similar to those in the Vicenza panels; Bellosi 1994, 299, n. 7, included this last work among those given to the anonymous Master. See Land 1999, 34–36, for the Missouri painting as "School of Verona."
2 Land 1999, 34, posited a banner.
3 Dubois and Klaassen 2000. A famous painting on linen is Andrea Mantegna's *Adoration of the Magi* (J. Paul Getty Museum, Malibu, CA), *c*.1500, for which see *Mantegna 1431–1506* 2008, 415–416, cat. 181; Mantegna also executed a series of large works on canvas, the *Triumphs of Caesar*.
4 Ex. 26:31–33 and 36:35, and 2 Chron. 3:14. See also cat. **4** for another work on linen.
5 According to *Mysterium* 2004–2005, 31–32,

the *Arma Christi* compose the *vexilla regis*, or the standards of Christ's nobility, and fall into four categories: (1) those the Empress Helen sought when she went to the Holy Land in the fourth century (the nails, crown of thorns, lance, sponge, and whips); (2) a group drawn from the Gospels during the thirteenth century that includes the cock ("Jesus answered him [Peter], Wilt thou lay down thy life for my sake? Verily, verily, I say unto thee, The cock shall not crow, till thou hast denied me thrice"); (3) objects needed to fill out the Crucifixion story, such as the pliers for removing the nails; and (4) a group comprising the hands that slapped Christ and Peter's knife cutting the ear of the centurion's servant. To our knowledge, the Instruments of the Passion never appear in connection with the *Imago pietatis* in painting in Venice, yet they often accompany the figure in painting in Verona. For three such works of the late fifteenth/early sixteenth century, see (a) *Mantegna e le Arti* 2006, 409–410, cat. 143, for a polychromed sculpture of the Man of Sorrows backed by a painting in San Lorenzo; (b) Dal Forno 1982, 146–147, for a triptych showing at its center the Man of Sorrows with Two Angels in Santi Nazaro e Celso; and (c) Berliner 1955, 87, for a small panel of the Man of Sorrows with Mary and John in the Museo del Castelvecchio.

6 Moschini Marconi 1955, cat. 14, and Guarnieri 2006, 42–44, and 112, fig. 117. Given that the Franciscans employed these two themes time and again, this work might have originated in their milieu. See Williamson 2008, 156–159, for the Madonna of Humility appearing on small-scale devotional images.

25

Nikolaus Tzafouris (*c.*1450–*c.*1500/01)
Man of Sorrows, late fifteenth century

Tempera on panel, 40 × 30 cm. (15.74 × 11.8 in.)
National Gallery of Ireland, Dublin

In 1453 the Ottoman Turks conquered Constantinople, destroying the millennial-old Byzantine Empire and engendering a mass exodus of Greeks and resident Venetians to the Mediterranean island of Crete, which Venice had controlled since 1211. Between the disaster of 1453 and 1669, when Venice lost the island after a devastating Turkish siege, Candia (as Venetians called Crete) enjoyed a rich and unique pictorial culture. Its post-Byzantine art, labeled Veneto-Cretan, produced fascinating icons amalgamating a Palaeologan, or late Byzantine, manner with Venetian Renaissance innovations.[1] Artists whose names have emerged only in recent decades painted panels employing gold backgrounds and Orthodox iconography in tandem with Western European modeling and notions of scientific perspective. Decorating churches and private dwellings, these painters worked for Greeks and Venetians alike, for Orthodox and Latin ecclesiastics, and for nobles and professionals on the island or for export to Venice.[2] Since most of these artists earned their living depicting the Madonna and Child, Venetians called them *madonneri*.

Nikolaus Tzafouris, one of the earliest identifiable painters of the Veneto-Cretan school, worked in the late fifteenth century.[3] His style is uncomplicated, far less intricate than the art of, for example, Michael Damaskinos and Georgios Klontzas of a century later or their younger contemporary Domenikos Theotokopoulos, famously called El Greco. Despite their simplicity, Tzafouris' icons communicate an affective pathos recalling works of his pre-1453 Byzantine forerunners. The Dublin painting, one of Tzafouris' best surviving panels, exemplifies how he merged different pictorial traditions. He modeled a Byzantizing Christ within a foreshortened sarcophagus mirroring recently imported ideas (and panels) from the Italian Renaissance.[4] He appropriated the grieving angels from Crusader art of the Holy Land and incorporated the Instruments of the Passion and a Latin superscription from Western painting. Beautifully calibrating these elements in terms of color, Tzafouris set them against a timeless gold background. Other, more intricate interpretations of the Man of Sorrows by Tzafouris include a panel with Mary and John in Vienna and an elaborate triptych in St. Petersburg, but his simple formula for the Dublin icon must have brought him a good measure of success, for similar surviving versions hint at his wide audience.[5] Apart from its touching portrayal of woe, Tzafouris' panel highlights how Orthodox art, which had exported the Man of Sorrows image to Italy centuries earlier, was subsequently enriched by its Italian progeny after the Greek world lost its political and cultural independence.

1 Bettini 1933; Cattapan 1968 and 1972; Chatzidakis 1974 and 1976; Constantoudaki-Kitromilides in *Venezia e Creta* 1998, 459–479 (also in English in *El Greco* 1999, 83–93); and Vassilaki 2009.
2 For an up-to-date summary of this school, see Drandaki 2009, 11–18.
3 Chatzidakis 1974, 86–90, and Bianco Fiorin 1983.
4 For Bellini-like paintings of the Veneto-Cretan school, see Heinemann 1962, 51–52, *Pinacoteca civica* 2003, 222, cat. 76, and Lazovic 1985, cat. 11.
5 Four almost identical versions exist: in the Musée d'art et d'histoire, Geneva (inv. F325); the Museo Nazionale, Ravenna (inv. 4476); the Museo Civico, Pesaro; and the Monastery of Zoodochos Pighi, Chora, Patmos. See Kreidl-Papadopoulos 1970 for the painting in Vienna, and *Serenissima* 2000 for the triptych in St. Petersburg.

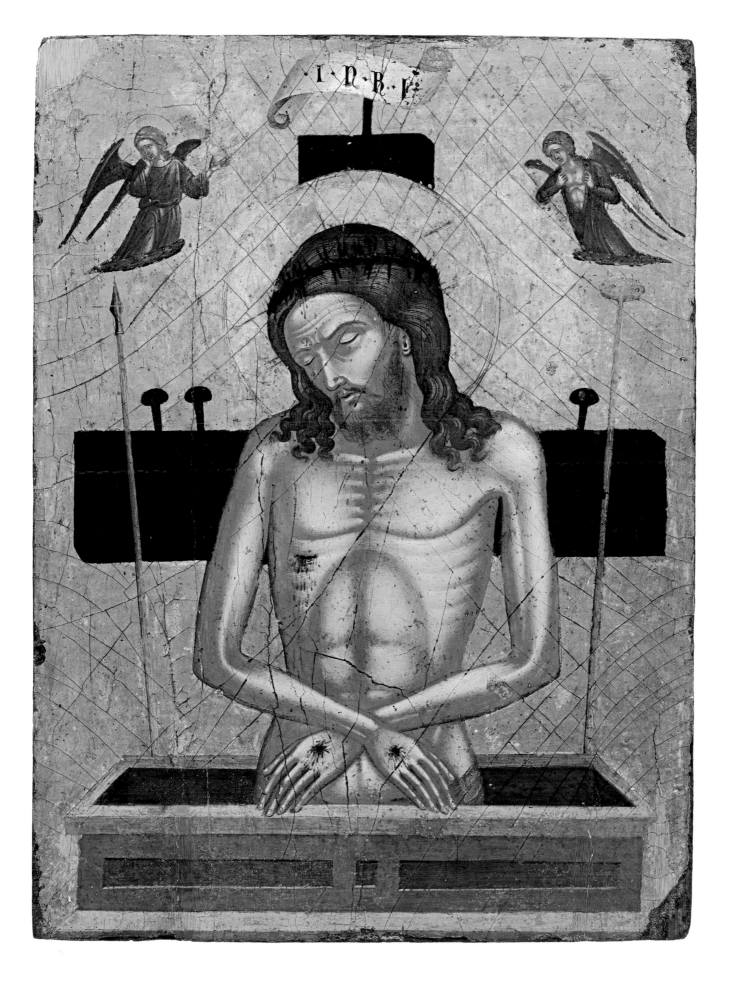

26

Anonymous Veneto goldsmith

Hexagonal Pyx, with the Man of Sorrows as the lid handle, 1474

Gilt silver, 33 × 12.5 cm. (12.99 × 4.92 in.)
Inscribed: DIVO / JESU CHR / UNIGEN / DEI F / OPTIMO MAXIMO / DEODATUS /
AN SAL / MCCCCLXXIIII / KLIVL
Museo Diocesano, Treviso

Dating to the years when Veneto artists produced the greatest number of representations of the *Imago pietatis*, this exquisite pyx is one of many liturgical objects in silver produced for churches in the region that also depict the subject. Others are the paten for San Giovanni in Bragora (fig. **8**), the chalice for Sant'Eufemia, the candlesticks for San Marco, Nicolò Lionello's impressive pax for San Francesco, Udine (Naples, Museo Nazionale di Capodimonte) and Bartolomeo da Bologna's great Reliquary Cross for the Cathedral of Padua (Padua, Museo Diocesano).[1] The Treviso pyx is singular among these in that it alone held the consecrated host, and indeed the Man of Sorrows played an intimate role at Mass when the celebrant—most likely the bishop, given the object's provenance in the city's cathedral—took the Eucharistic wafer from its container by grasping the tiny figure in order to open the lid.[2] Today the urn holds ashes on Ash Wednesday, continuing the traditional association of the *Imago pietatis* with Holy Week rites.[3]

The pyx has a quasi-architectural structure: an intricate play of alternating polylobed shapes decorates the base, while arches filled with luxuriant rosettes and topped by little pinnacles—not all original—support and surround the domed lid. The three-quarter-length Man of Sorrows rises above, his apparent emergence consonant with the withdrawal of the host for its elevation at Mass. Though the goldsmith is unidentified, the pyx has been linked to ducal craftsmen responsible for the remarkable candlesticks, mentioned above, donated to St. Mark's in Venice by Doge Cristoforo Moro (r. 1462–1471), one of which also bears the Man of Sorrows.[4] These works are contemporary with Giovanni Bellini's absorption with the figure and Bartolomeo Vivarini's similar attachment to the subject (fig. **17**; cat. **23**). An inscription on the pyx base (see above) states that *ser Deodatus* donated the object to the Cathedral in 1474. His generous bequest was so highly valued by the local ecclesiastical community that in 1520 Pordenone depicted the work as the major gift offered by one of the kings to the Holy Family in the *Adoration of the Magi* fresco he painted in the Malchiostro Chapel of Treviso Cathedral (fig. **26.1**). Pordenone's centrally placed figure dressed in red opens the pyx before the prescient Christ Child, who recoils at its contents, a visual and dramatic affiliation grasped by worshipers as the mystical union between the Body of Christ and the Holy Sacrament.[5]

Fig.26.1

Fig. 26.1 Pordenone
Adoration of the Magi, 1520, detail
Fresco
Malchiostro Chapel, Treviso Cathedral

1 For the pyx and the Paduan reliquary cross, see Spiazzi 2004, 97–98, cat. 14, and 120–121, cat. 43. For Lionello's pax, see Miotto 1999, and Castelnuovo and de Gramatica 2002, 804–805, cat. 162; for the candlesticks, see *Immagine* 1981, 39–40, cat. 45.
2 On pyxes in general, see *Suppellettile* 1988, 101ff.; and McLachlan in *Liturgy* 2001, 396–398.
3 See Green, 1966, for Ms. Garrett 39, Princeton University Library; the code number in the Index of Christian Art for the illumination on fol. 123r initiating the Collect for Holy Wednesday is *32 P935 LUn 018*; the system number is *000121553*.
4 Delfini Filippi 1995, 46–48, cat. 8.
5 Smyth 2007, 67.

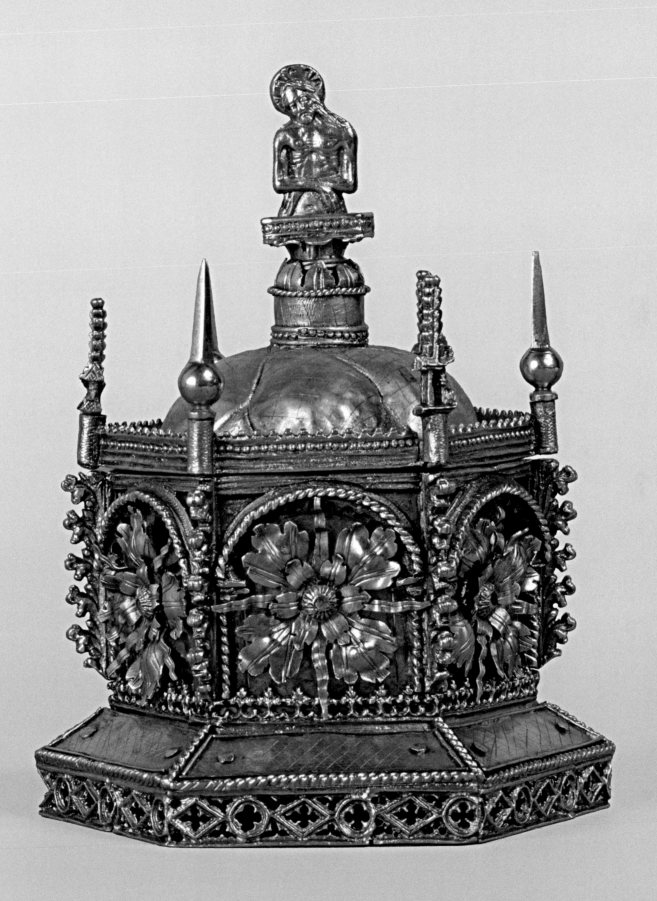

27

Bartolomeo Bellano (1437/38–1496/97)
*The Dead Christ with Two Angels, c.*1470

Gilt bronze, 23.75 × 18.2 cm. (9.35 × 7.1 in.)
Inscribed on the rear: VELLANO
National Gallery of Art, Washington, DC, Samuel H. Kress Collection,
1957.14.139

Given to Bellano, one of Donatello's young associates in Padua, the Washington *Dead Christ with Two Angels* is a large gilt bronze plaque produced in the Veneto soon after the master's relief of the same subject and in the same medium for the Santo (fig. **16**), and as such it merits serious consideration.[1] Occupying an important position in the history of Paduan sculpture, Bellano was not only a purveyor of Donatello's innovations but also a creator in his own right: he sculpted the funerary monuments of the eminent Paduans Raimondo Solimani and Pietro Roccabella and produced a bronze statue of the Venetian pope Paul II; he probably visited Sultan Mehmet II in Constantinople as a state artist and was responsible for small works in bronze, stone and terracotta.[2] He was highly regarded by statesmen, ecclesiastics and humanists alike.

Reservations about attribution notwithstanding, this plaque can be related to Bellano, for it corresponds with his London *Pietà* (Victoria and Albert Museum) in which the facial expressions, gestures and drapery resemble those here, and with his Paris *Saint Jerome* (Musée du Louvre), whose physiognomy is close to Christ's.[3] As a work in gilt bronze, the Washington relief must be considered a prestigious commission even though its function is unclear. It must also be viewed in the larger context of Veneto art since its composition and style appear in two anonymous works, *c.*1470–1480, in provincial parish churches outside Vicenza: a tightly compressed group on a sacrament tabernacle in Molina di Malo and an amplified version in the lunette of a sculpted altarpiece in Nanto.[4] Why was the composition then so appreciated if today neither it nor Bellano's art in general are highly esteemed? The answer lies in the hybridization on the relief of late Gothic expressionism combined with Renaissance classicism. Christ's expression of anxiety harks back to Giambono's early *Imago pietatis* (fig. **20**), but the paired angels recall Donatello's *spiritelli*, though their diminutive size does not. Like many Renaissance works portraying the Man of Sorrows with Angels, this relief evokes the life-giving force of the crucified Christ by stimulating affective empathy, and it does so here on a glowing, semi-precious work of art.

1 For the work as Bellano's, see Pope-Hennessy 1965, 8, cat. 3; and James Draper in Darr 1985, 229–230, cat. 85, and in Darr and Bonsanti 1986, 257–258, cat. 107. Bellano is also credited with other versions of the theme in the Musei Civici, Padua, and the Musée Jacquemart-André, Paris. Krahn 1988, 108–111, does not accept the Washington relief as Bellano's.
2 See Krahn 1988; also Krahn in De Vincenti 2001, 63–79. Bellano is considered the historical link between Donatello and Riccio.
3 As noted in n.1, Krahn does not accept the work as autograph, though not all his reasons are convincing, especially that no other gilded work by Bellano is known. Avery 1986, 18, writes that the relief is "too sensitively modeled and chased to be by . . . [Bellano], unless it was executed from a wax model by Donatello himself." According to Lewis 2010–2011, the inscription *Vellano* on the rear is possibly from the original wax.
4 See Barbieri 1984, figs. 11 and 18; James Draper in Darr 1985, 229; Krahn 1988, 108–111. For a discussion of Vicentine sculpture of the period, see Giuliana Ericani in Rigoni 1999, 45–79. An important difference between the Molina and Nanto works, apart from size and context, lies in the perspective views of the two sarcophagi: that in Molina is tilted forward as in the Washington design whereas the Nanto tomb is seen from below, conforming to its actual position on the altarpiece. Such diverging perspectival accounts are known even in the works of Antonio Vivarini and Giovanni Bellini, both of whom depicted the tomb of the *Imago pietatis* as seen from above and as seen from below. Two other anonymous, late fifteenth-century

representations of the Man of Sorrows, but
without angels, are stylistically consonant
with the Washington work in very general
terms: the figure in the exterior lunette
over the doorway into Sant'Andrea della
Zirada, Venice (fig. 14; Rizzi 1987, 414, cat. 53,
fig. SC53), and another on a large bronze
relief in a private collection (see Vittorio
Sgarbi in De Vincenti 2001, 218–219, cat.
60). This last work (at 88 × 53.5 cm., taller
than Donatello's relief measuring 58 × 56
cm.!) is very interesting. Its inscription IE
RO SOLIM (Jerusalem) hints that it was
perhaps made for a patron who had
journeyed to the Holy Land, and though
Christ is backed by the winding sheet,
his hands are tied and he holds the reeds,
implying that he is both alive and dead,
an interpretation more akin to those in
northern Europe at the time than to those
in the Veneto, where such narrative
syntheses are more commonly found in
the later sixteenth century than in the
Quattrocento.

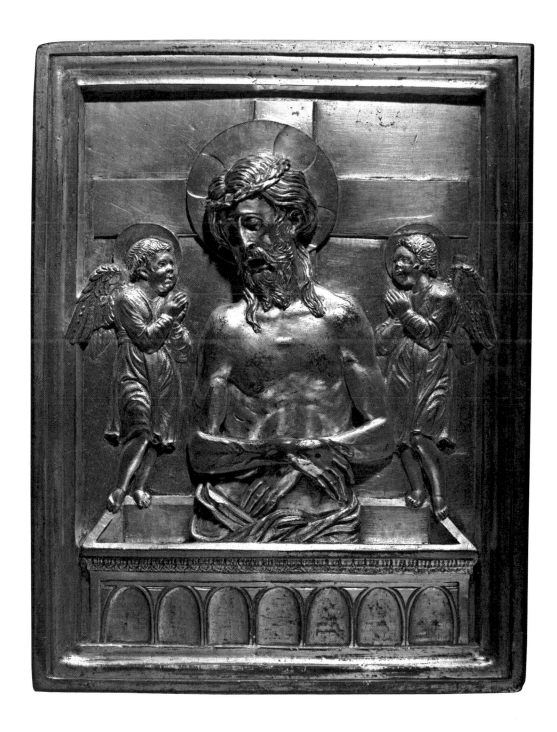

28

Antonio Rizzo (bef. 1440–*c*.1499), attributed to
Man of Sorrows with Mourning Angels, 1480s

Istrian stone, 62.2 × 47 cm. (24.48 × 18.5 in.)
Private collection, New York

This newly identified work is attributed to Rizzo who, together with Pietro Lombardo (*c*.1435–1515), is credited with introducing the new Renaissance style into Venetian sculpture and architecture beginning *c*.1470.[1] The two men ran the major sculpture workshops in Venice at the same time as the Bellini and Vivarini families were running the major painting workshops there (fig. **17**; cat. **23**). This relief is by a master whose style shares characteristics with Rizzo's sculpture and whose motifs recall several of Giovanni Bellini's versions of the Man of Sorrows. Christ's softly flowing hair suggests Rizzo's style, as do the chubby-faced angels, their gathered draperies and the solid sense of gravity they convey. Bellini's influence can most plainly be felt by looking at his early panel in the Museo Correr, Venice, in which Christ's arms are similarly extended and his veins defined with a surprisingly analogous linearity. The angels in this relief and those on Bellini's panel are correspondingly portrayed: their very round faces are set in troubled expressions, their wispy hair is cut short, and they support Christ in a similar manner in both works. Links exist too with Bellini's panel in Rimini, especially the angels' antique style of dress consisting of a short tunic belted around the hips.

This same garb appears of course on Donatello's pivotal Santo relief (fig. **16**), which was undoubtedly known to most artists in the region and from which the general compositional idea here is derived, together with the specific movement and patterns of the angels' feet.[2] But Christ on this relief is frontal and not isolated, whereas on the Paduan altar he is slightly turned and separated from the angels. The marble work nonetheless matches the Santo bronze in one unexpected and striking aspect: the dimensions of the two are approximately the same.[3] One suspects that this large sculpture, sadly showing some damage towards the bottom, was conceived, like Donatello's in Sant'Antonio, to adorn an altar. The band-like delineation of Christ's bier is alike in both cases, and—given the size of both—the physical relationship between each altar image and the celebrant standing before it would have been identical too. Since flanking angels usually (though not always) endow the Man of Sorrows with a Eucharistic significance, this large relief might certainly have ornamented an important altar, even one dedicated to the Holy Sacrament (see cat. **29**).[4]

1 Paoletti 1893, vol. 2; see also Wolters, 134–142, in Huse and Wolters 1990. For Rizzo, see Schulz 1983.
2 There are correspondences too between the typology of the angels and several on the individual reliefs of the Santo altar.
3 Donatello's relief measures 58 × 56 cm.
4 One of the best known of such large Veneto reliefs of the *Imago pietatis with Angels* now adorning an altar is the polychromed limestone work of 1456 on the Poiana Altar in San Lorenzo, Vicenza, for which see Arslan 1956, fig. 839, and Lucco 1989–1990, vol. 2, fig. 721. For later examples, see cat. **29**. Two other good-sized contemporary Veneto reliefs of the same subject but belonging to tombs are those by Pietro Lombardo for the Malipiero Monument, *c*.1465–1470, in Santi Giovanni e Paolo, Venice (Zava Boccazzi 1965, 113–117), and Giovanni Antonio Amadeo for the Tomb of Medea Colleoni, *c*.1470, since 1842 in the Colleoni Chapel, Bergamo Alta, but originally in Santa Maria di Basella, Urgnano (a town just south of Bergamo).

29

Cristoforo Solari (fl. 1489–1524), attributed to
*Man of Sorrows, c.*1500

Marble, 67.5 × 32 cm. (26.57 × 12.59 in.)
Art Institute, Dayton, OH
Museum purchase with funds provided by the 1971 Associate Board Art Ball
and the Virginia V. Blakeney Endowment, 1970.29

Despite its imposing presence, the Dayton *Man of Sorrows* presents several enigmas regarding attribution, context and function. Ascribed to the Milanese sculptor Cristoforo Solari, active both in his native city and in Venice and Rome, the work lacks many of the elements associated with his recognized output, especially its rich textures.[1] The sculpture is even more stylistically dissimilar to representations of the Man of Sorrows by the Bregno and Lombardo families working in Venice in the late fifteenth and early sixteenth centuries.[2] The elusive attribution of the work is due in part to its incompleteness, but its highly classical appearance and heavily worked musculature, Hellenistic in impact, suggest a Venetian artist very familiar with ancient marbles.[3]

Though shamefully cut from its original ensemble, Dayton's *Man of Sorrows* still hints at its ecclesiastical site and liturgical function. Neither of wood nor terracotta, the figure cannot have been a provincial creation; its size, expert realization in high relief and undeniable classical beauty all argue for a metropolitan commission.[4] Two large-scale stone Angel Pietàs do exist in Venice today: an anonymous work in San Pietro Martire, Murano, and a work by Giammaria Mosca now in the chapel of a Venetian retirement home.[5] But unlike the central figures in these groups, Dayton's Christ is bereft of his attendants, whose draperies even now cover his elbows.[6] Given the severity of the cuts, the lateral figures must have tightly flanked Jesus, and his lower arms would have extended symmetrically and slightly outward in a position analogous to that of the arms in Bartolomeo Vivarini's panel (cat. **23**) and in paintings by Cima da Conegliano and Lorenzo Lotto.[7] Did angels accompany the Dayton Christ or did Mary and John, and did the group adorn an altar or a tomb? We propose, first, that the conspicuous blood on the chest was matched by comparable bleeding on the hands perhaps held by angels. Second, the stigmata and the impressive workmanship on Christ's torso and head require close viewing and therefore lessen the probability that the ensemble adorned the crowning lunette of either a tomb or an altar. Conceived in all likelihood as the centerpiece of an Angel Pietà, the Dayton marble likely decorated a Holy Sacrament altar, Christ's timeless beauty and flowing blood inspiring worshipers at Communion.

1 Cahill 1971, and Maria Teresa Fiorio in *Leonardo* 1992, 396–397, cat. 89. Brown 1987, 106, gives the work to Solari, but Schulz 1988–1989 does not mention the work.
2 For Bregno, see Schulz 1991, 49–50; 185–188, cat. 26, pl. 98–99; 63–64; and 196–200, cat. 26, pl. 161–171. For the Lombardo, see Zava Boccazzi 1965, 113–17, and Sarchi 2008, 80–85, fig. 48. See Schulz 1983, 55–56, for Giovanni Buora's *Man of Sorrows with Two Angels* in Santi Vito e Modesto, Spinea.
3 Christ's torso recalls those of several figures by Danese Cataneo, the Tuscan sculptor who worked in Venice and the Veneto from the late 1520s until his death in 1572; see Rossi 1995, figs. 77 and 80, for Cataneo's *Christ* of 1565 on the Fregoso Monument of S. Anastasia, Verona, and his *Saint Jerome* of 1530 (Venice, S. Salvador).
4 *Imago lignea* 1989, 192, cat. 35, and 257–261, cat. 53, both examples from little towns and dating to 1520–1530; see also *Histria* 2005, cat. 16, for a limewood figure of *c.*1600. Goi 1988, figs. 35 and 37, illustrates two early sixteenth-century groups in Friuli.
5 Florio in *Leonardo* 1992, 396–397, cat. 89, mentions the first group (its altar inscribed *1495*) formerly in S. Stefano on Murano; and see Schulz 2004 for the work in Casa Cardinal Piazza which she dates *c.*1525. Many examples of the Man of Sorrows have been torn from their original contexts; two by Giovanni Buora are a relief now on the flank of Santa Maria del Rosario, in the Rio Terrà Antonio Foscarini, Venice (see Rizzi 1987, 463, cat. 96), and an unpublished work in the Rosenbach Library, Philadelphia, for whose identification we are grateful to Debra Pincus.

6 The shroud usually appears hoisted up behind Christ as in Donatello's Paduan relief (fig. 16). In the later sixteenth century, the shroud often lies under Christ; see cats. **52, 54, 58**.

7 See Pedrocco 2001, 10–11, for Cima's painting in Ca' Rezzonico, and Humfrey 1997, fig. 24, for the lunette of Lotto's altarpiece in S. Cristina al Tivarone, outside Treviso.

Galeazzo Mondella, called Il Moderno (1467–1528)
The Dead Christ Supported by the Virgin and Saint John

30
Gilt bronze, 7.8 × 6.5 cm. (3 × 2.36 in.)
Private collection

31
Bronze, 8.33 × 6.58 cm. (3.27 × 2.59 in.)
National Gallery of Art, Washington, DC, Samuel H. Kress Collection, inv.
1957.14.298

32
Bronze, 14 × 10.5 cm. (5.5 × 4.1 in.)
The Metropolitan Museum of Art, New York, inv. 31.33.08

Mondella hailed from Verona like other artists in this exhibition.[1] His numerous bronze plaquettes of the Man of Sorrows belong to the Renaissance tradition generated by humanist connoisseurs avid for antique reliefs and their modern counterparts.[2] Assuming the sobriquet Moderno while still young, Mondella quickly became acquainted with a wide range of paintings and sculptures in the Veneto and Emilia, but though quite successful owing to the patronage of many cultivated patricians, he stopped producing new designs before the age of 50.[3] His surviving reliefs vary in quality, as is visible in this sampling, in part because of the vicissitudes of time and the vagaries of casting (some reliefs were made after his death), but also because the patina and sensual appeal of his best works invited frequent handling. Those of the Dead Christ were especially prone to damage: holes might be drilled in them for use as pendants, and repeated touching and kissing abraded those serving as paxes.

Like many other comparable bronzes by Moderno, the three here correspond compositionally with his greatest representation of the Man of Sorrows, on the sumptuously enframed silver pax of 1513 in Mantua, which was not necessarily the first of his numerous similar designs.[4] In fashioning his subject, Moderno seems to have considered many fifteenth-century works of art, and he could have devised his compositional idea well before producing the Mantuan pax. His Christ, Herculean in strength but paradoxically sapped of power, closely follows Giovanni Bellini's counterparts on his panels in Berlin and Rimini (fig. **17**) but fills the composition, the sculptor reducing the volume of the two companions.[5] He dropped Christ's knees in space, and without a lap, the figure seems to thrust forward into the hands of the patron holding him. Benefiting from visual and tactile intimacy with the plaquette, the owner experienced Christ's physical grandeur, notwithstanding actual size. But despite their apparent High Renaissance style, Moderno's reliefs stand rooted in an earlier sensibility. The anguish of his Mary and John, for instance, recalls the art of both Bellini and Andrea Mantegna, but the work that most forcefully jumps to mind in this regard is Niccolò dell'Arca's remarkable terracotta ensemble of the *Lamentation* in Bologna, all of whose standing *dramatis personae* similarly grimace and shriek with pain.[6] Moderno's brilliance was to introduce the innovative expressiveness of an older generation of

1 See cats. **10, 15, 24, 28, 50–53, 59.**
2 Leino 2007.
3 Lewis 1989.
4 The Metropolitan Museum of Art example lacks the little grieving angel straining under Christ's right arm. For the work in Mantua, see Gianfranco Ferlisi in Sgarbi 2006, 172–173; and for a pax by Moderno in the Vatican Museums that is also splendidly enframed, see Cornini 2006, 46, fig. 4. See Lewis 2010–2011 for the version in Washington dated to *c.*1508–1513.
5 Indeed, rotating Bellini's Berlin figure by 180 degrees virtually produces Moderno's.
6 The saints' anguish intensifies Bellini's corresponding figures in his work in the Ducal Palace, Venice, and it recalls too the grieving figures in the upper left-hand corner of Mantegna's *Dead Christ* in Milan; the frontality of Moderno's two saints also harks back to their counterparts in Bellini's Bergamo *Man of Sorrows*. For works in terracotta by Niccolò dell'Arca and others, see Giancarlo Gentilini in Sgarbi 2006, 46–51.

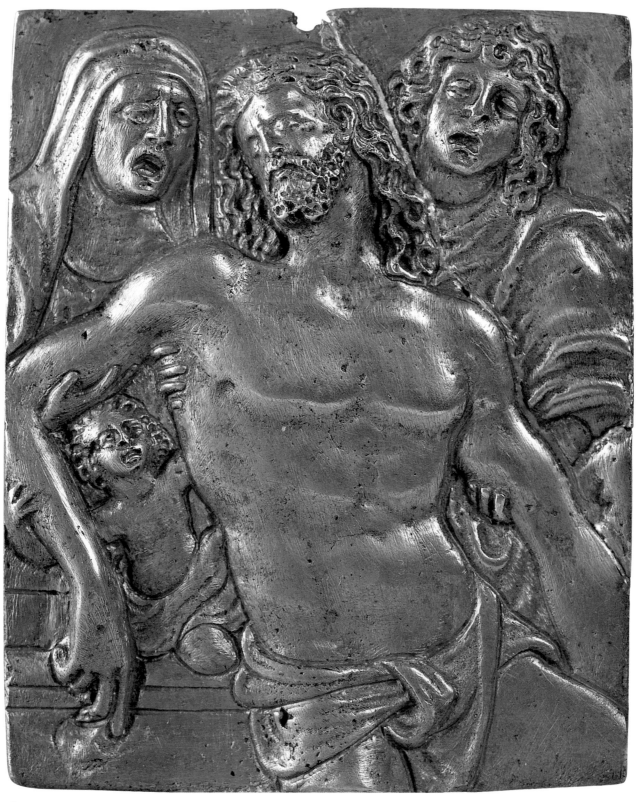

Cat. 30

artists into an art form that had yet to articulate the drama of large-scale painting and sculpture (cf. cat. **27**).[7]

This is evident by comparing his reliefs with others that were also used as liturgical paxes. The custom of employing a small, decorated wooden or metal tablet for what is termed the "kiss of peace," which was exchanged between the celebrant and his acolyte or with important members of the congregation immediately prior to the consecration of the Eucharist, developed in or by the thirteenth century.[8] By Moderno's time, framing a little relief or figure and mounting a handle on the rear so that the priest might hold it for a kiss was an established tradition (cat. **32**). In northern Italy as elsewhere, these paxes varied a great deal. Some showed scenes like the Crucifixion or Deposition; others depicted the Man of Sorrows, usually alone, and these ranged in complexity from anonymous and unpretentious tablets to the singularly ostentatious pax of *c.*1440 by Nicolò Lionello for S. Francesco in Udine (now Naples, Museo Nazionale del Capodimonte), a gilded and filigreed work ornamented with colored enamels and which originally held relics.[9] Seen against its northern Italian precedents, Moderno's pax-plaquette was genuinely innovative: no longer frontal, Christ swings dramatically in space. The sculptor also altered the very nature of the liturgical kiss of peace. Rather than simply presenting his dead body for oscular adoration, this Man of Sorrows bestows himself onto the worshiper while Mary and John fervently bewail his tragic sacrifice.

7 For a few examples of contemporary small reliefs of identical subject matter but lacking Moderno's dramatic urgency, see Rossi 1974, 11, cat. 15b; Banzato and Pellegrini 1989, 76–77, cat. 52; Toderi 1996, 137–138, cat. 249; and Pinacoteca Civica di Vicenza 2005, 199, cat. 224. For plaquettes in general, see Douglas Lewis in Rossi 2006, 3–15.

8 The phrase *pax tecum* derives from Judges 6:23, which in the Latin Vulgate reads as *dixitque ei Dominus pax tecum ne timeas non morieris* (KJV, "And the Lord said to him: Peace be with thee: fear not, thou shalt not die"). The New Testament also employs what are termed liturgical salutations; see http://www.newadvent.org/cathen/11595a.htm. For paxes, see Righetti 194, 399–403; *Dizionario Enciclopedia del Medioevo* 1999, 1365; and *Suppellettile* 1988, IV, 315.

9 For Lionello's work, see Miotto 1999, and Castelnuovo and de Gramatica 2002, 804–805, cat. 162. Another late fifteenth-century relief mounted as a pax that also provides a dramatic comparison with Moderno's is a work in storage at the Metropolitan Museum of Art, inv. 1980.113.

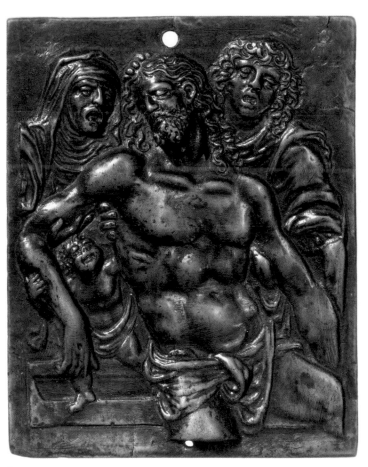

Cat.31

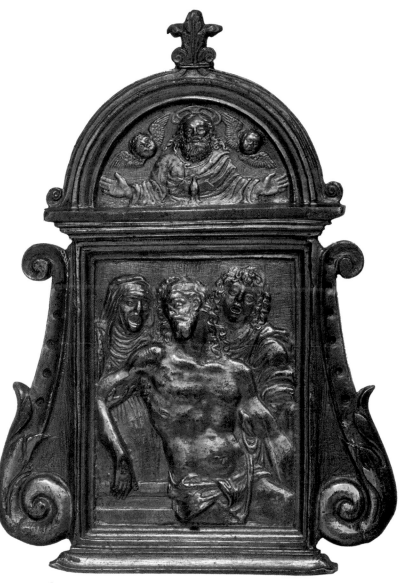

Cat.32

33

Anonymous Genoese sculptor
Sacrament Tabernacle, c.1475–1500

Gilded and polychromed marble, 104.8 × 68.6 × 8.5 cm.
(41.2 × 27 × 3.3 in.)
Inscribed (along bottom): AVE • MARIA • GRASIA • PLENA
David and Alfred Smart Museum, University of Chicago
Gift of the Samuel H. Kress Foundation, 1973.55

This imposing tabernacle, one of two in American collections that include the Man of Sorrows, once functioned as a wall repository for the sacrament.[1] Prior to the Council of Trent (1545–1563), reservation of the Host was not on the high altar but in tabernacles situated on the wall behind or to the side of it.[2] Large wall tabernacles of marble or wood proliferated throughout Italy in the fifteenth century in response to a threefold need: to safeguard, display and honor the Eucharist. As the Host was normally out of sight behind the locked door of the tabernacle and its display restricted, the sculpted imagery of the complex offered the laity a permanent focus for their keen desire to venerate the host at all times.[3]

By the mid-fifteenth century, well-known Tuscan sculptors had established an influential model for the wall tabernacle, designing it as a classical aedicule.[4] An independent and equally rich artistic tradition developed in the Veneto, especially in and around Vicenza (fig. **15**). The Smart tabernacle, like those in the Veneto, reveals a delight in polychromed surface decoration and in the profusion of sculpted figures and ornament, notably the foliate decoration here carved around the opening of the repository.[5] But the central design draws upon Tuscan precedents for its evocation of a church portal with a vault shown in perspective.[6] The inclusion of angels follows custom, but unlike those in Tuscan tabernacles, which stand in the same space as the portal, the Chicago figures are stacked vertically in niches flanking the doorframe.[7] Perhaps Genoese in origin, the Smart tabernacle presents a hybrid style drawn from northern Italian tabernacles of the last quarter of the fifteenth century, which, while respecting local tradition, absorbed Tuscan innovations.[8] The placement of the Man of Sorrows with arms extended over the door was essential to Veneto tabernacles and was also adopted in some Tuscan works. Distinctive in the Smart tabernacle is the prominence given to the angels and Mary. As many as eight seraphim, the order of six-winged and red-robed angels closest to God in the celestial hierarchy, decorate the work: one pair is on the same vertical axis as the Man of Sorrows at the apex of the arch, and below the opening another two kneel on either side of Christ, while four more flank the door.[9] The inscription at the bottom is unusual on a sacrament tabernacle but nonetheless invokes the Annunciation, sometimes shown on Veneto examples with sculpted figures of Gabriel and the Virgin. In conjunction with the pairing of Mary's and Jesus' monograms in the spandrels, the Marian references make explicit the traditional metaphor of the Madonna as the sanctified tabernacle for her divine son.[10]

1 We thank Michele Marincola, Deputy Director and Professor of Conservation at the Institute of Fine Arts, and Julia Sybalsky and Sara Bellis, for discussing the results of their restoration and analysis of the Smart tabernacle with us. Remains of mortar on all sides indicated that it was formerly embedded in a wall. The other example, attributed to the Veronese master Bartolomeo Giolfino (c.1410–1486), is now immured on the ground floor in the courtyard of the Isabella Stewart Gardner Museum, Boston; see *Gardner Museum* 1977, 128–129, cat. 159.

2 At times, it was reserved in the sacristy. See Righetti 1949, 565, and the fundamental study by Caspary 1965.

3 See Van Os 1989, especially 205–208, for a discussion of wall tabernacles and Eucharistic devotion in Siena but whose general points pertain to northern Italy as well. See also Francesco Caglioti, "Altari Eucaristici Scolpiti del Primo Rinascimento: Qualche Caso Maggiore," in Stabenow 2006, 53–89, for a discussion of sacrament tabernacles, altars and chapels, mostly Tuscan.

4 For Tuscan tabernacles, see Caspary 1965 and Francesco Caglioti in Stabenow 2006 (as cited above).

5 Various holes on the top of the reverse side may have served for attachments for now lost crowning elements, either sculpted figures or ornaments. For a typical Veneto example, see the tabernacle attributed to the circle of Antonino da Venezia in the Museo Civico, Vicenza (*Pinacoteca Civica di Vicenza* 2005, 58–59, cat. 18). On Veneto and Vicentine tabernacles, see Wolters 1976; Barbieri 1975; and Menato 1974–1976.

6 For a good summary of the design of Tuscan tabernacles, see Van Ausdall 1994, 73–74.

7 Angels are invoked in the prayer of the Eucharistic liturgy: "Almighty God, we pray that your angel may take this sacrifice to your altar in heaven."

8 Middeldorf 1976, 61–62, associated the work with the Gagini workshop. The composition of the Ligurian tabernacle he cites in Finalpia (Salvi 1910, fig. 2) does not, however, reveal Tuscan innovations. For a comparable example of hybrid style from 1488 in the parish church of Torri di Quartesolo, outside Verona, which combines a classicizing architectural framework with northern decorative exuberance, polychromy, and traditional imagery, see Barbieri 1984, fig. 20.

9 Giorgi 2003, 294–304.

10 Van Ausdall 1994, 67. Note too the foliate design along the bottom edge of the door that culminates at the center as if to suggest that its blossom resides within, the symbolic fruit of Mary's womb within the tabernacle. The Marian and angelic imagery suggests that the original setting of the tabernacle was likely in a church dedicated to Santa Maria degli Angeli. We thank David Boffa for his observation that the lettering and formulation of the inscription are consistent with a dating of the tabernacle to the end of the fifteenth century.

34

Anonymous Spanish painter,
*The Mass of Saint Gregory, c.*1500–1520

Oil and gold on wood, 72.1 × 55.6 cm. (28.38 × 21.88 in.)
The Metropolitan Museum of Art, New York, inv. 1976.100.24

Picturing the performance of the sacrament at the altar, this Spanish panel re-creates a legendary seventh-century miracle that occurred when Pope Gregory the Great (r. 590–604), praying for a sign during Mass to allay a woman's doubts about the nature of the Eucharist, witnessed the host transform into Christ's bleeding figure (see p. **13**).[1] Centuries later, the Carthusian monks at Santa Croce in Gerusalemme, Rome, obtained a Byzantine mosaic icon of the Orthodox *Akra Tapeinosis* (fig. **1**) and construed it as a visualization of Gregory's miracle. By *c.*1400 the Carthusian image was essentially identified with the vision, and the cult of the Mass of Saint Gregory intensified, unquestionably stimulated by the late fifteenth-century print by the German engraver Israhel van Meckenem that explicitly linked the papal revelation with the Santa Croce icon (fig. **4**).[2]

This panel amalgamates the historical and visionary experiences with the Man of Sorrows, as do many paintings depicting the subject.[3] Gregory kneels before the altar at the consecration of the bread and wine, as evidenced by the elevation of the chalice, the lit candles and the lifting of his vestments; a full-length, standing Man of Sorrows materializing next to the Host and chalice attests to Christ's real presence in the sacrament.[4] Instruments of the Passion hang behind and to the left of Christ; juxtaposed too are the Veil of Veronica, a miraculous image directly linked to Rome (cat. **39**), the papal tiara, and a fictive relief above the stone arch showing what must be the papal keys, all these elements strengthening the scene's papal connections.[5] By sharing in Gregory's vision, the devout were encouraged to see the Man of Sorrows as signifying the Eucharist and thereby bridging past, present and future.

The Man of Sorrows whose blood pours from his side wound into a sacred chalice is represented in many images of the Mass of Saint Gregory but appears infrequently in Venetian art. Yet three significant examples of the type come to mind: Antonio Vivarini's of 1443 on the Rosary Altarpiece (Venice, San Zaccaria), Giovanni Bellini's *Blood of the Redeemer, c.*1460–1465 (London, National Gallery; fig. **34.1**), and Vittore Carpaccio's *Redeemer* of 1496 (Udine, Museo Civico). Not one participates in a Gregory Mass, however. Indeed, though widely disseminated throughout Italy and the rest of Europe, the Mass of Saint Gregory is absent from Venetian art. Can one speculate that the mistrust Venice felt for Rome during the Renaissance and thereafter hindered the depiction of this scene, its reference to papal authority being so explicit?[6] IV

1 On the history of the legend and its significance, see Heinlen 1998, Rubin 1991, Bynum 2006, and Meier 2006.
2 For the significance of the icon in the diffusion of the Man of Sorrows image, see the discussion in the introductory essay to this catalog; see also Westfehling 1982 and Borchgrave d'Altena 1959. Commissioned by the Carthusians to reproduce the icon, van Meckenem made two prints after the Santa Croce icon, see *Hollstein* 1986, I, 74–75, nos. 166–167, and II, 65. These and others by van Meckenem of the Mass of Saint Gregory had indulgences attached and were widely disseminated; see Ringbom 1984, 66, Parshall 1993, 556–560, Van Os 1994, 110–113, and Netzer and Reinburg 1995, 37.
3 Jonathan Brown has kindly informed us that the painting appears to be Castilian in origin and may date as late as *c.*1520.
4 Westfehling 1982, Borchgrave d'Altena 1959. For the practice of lifting the pope's vestments so that he can raise the Host and chalice, see Gesink 1997.
5 On the iconography of the Mass of Saint Gregory, see Westfehling 1982 and Borchgrave d'Altena 1959. The Madonna and Christ Child in the stained glass window located on the back wall, Veronica's Veil in the middle plane, and the Man of Sorrows on the altar refer to Christ's Incarnation, Passion, and Death and Resurrection, and the gaze of the infant Christ toward the altar foreshadows the salvific events present in the Eucharist.
6 The antagonism between Venice and the papacy did not heat up until the early 1500s, but tensions arose even during the late fifteenth century as a result of the

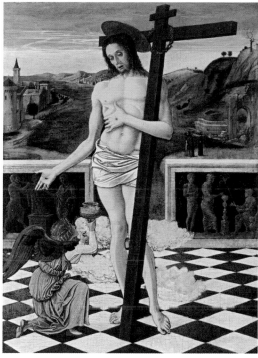

Fig. 34.1

Fig. 34.1. Giovanni Bellini
The Blood of the Redeemer, c.1460–1465
Tempera on panel
National Gallery, London

Ottoman conquest of Constantinople in
1453; see for example Cardini 1987.
Regarding this panel, it should be recalled
that if it was produced *c.*1500, the reigning
pope was the Spanish Alexander VI Borgia
(r. 1492–1503).

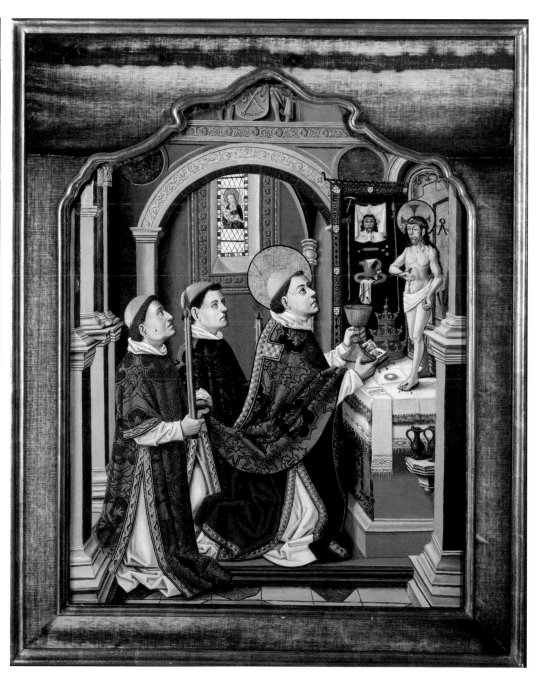

Albrecht Dürer (1471–1528)

35

The Man of Sorrows with Arms Outstretched, c.1500

Engraving, sheet (trimmed to plate mark) 118 × 71 mm. (4.64 × 2.79 in.)
National Gallery of Art, Washington, DC, Rosenwald Collection, 1943.3.3478

36

The Man of Sorrows Mocked by a Soldier, c.1511

Frontispiece of the *Large Passion*
Woodcut, 198 × 195 mm. (7.79 × 7.67 in.)
National Gallery of Art, Washington, DC, Gift of W. G. Russell Allen, 1941,
1941.1.22

In his introduction to a projected treatise on painting, Dürer expressed the devout view that "the art of painting is used to make known the suffering of Christ and to serve the Church."[1] The special emphasis the German printmaker placed on the Dead Christ is attested by its prominent position as frontispiece in two widely distributed books he illustrated that are known as the *Large Passion* and the *Small Passion* and, moreover, by his painted *Self-portrait as the Man of Sorrows*, 1522, a work suggestive of the theme's personal meaning for him.[2] Dürer's depictions of Christ's torments also reflect contemporary piety in his native Nuremberg and across northern Europe, stimulated in part by the religious movement of the *devotio moderna* that encouraged the laity to experience their faith on a very personal level.[3]

In addition to showing Dürer's deep engagement with portraying Christ's Passion, his two prints in this exhibition on the theme of the Man of Sorrows reveal his mastery of the engraving and woodcut techniques and his study of Italian art. They also offer interpretations distinct from those he witnessed first hand by contemporary artists in Venice.[4] The engraving (cat. **35**) shows a full-length Christ, of a type adopted early on in the North and bearing the marks of the Crucifixion; he stands miraculously against an open landscape at the foot of the cross, of which Dürer has depicted only the trunk. The artist has dramatically positioned the hole that affixed Christ's feet to the cross next to his head, and on the ground he has set a few of the Instruments of the Passion—the sponge, flail, dice, and robe, and also a skull, which is traditionally identified with that of Adam (see also cat. **13**). Christ's uplifted hands recall the *orans* or Early Christian gesture of prayer, and his muscular build and classical *contrapposto* pose derive from the artist's study of Italian Renaissance models for a modern handling of the male nude.[5]

Dating from a decade later and following his visit to Venice, the frontispiece to the *Large Passion* recasts a traditional Northern type in an innovative image. The powerfully built Christ sits on a stone slab, evoking early fifteenth-century depictions of Christ on the Cold Stone where an isolated, forlorn Jesus is shown alive and seated momentarily on his way to Golgotha (cat. **61**).[6] But Christ's hands, already pierced with the wounds of the Crucifixion, are clasped in prayer and not bound as is customary. He looks beseechingly out at the viewer, and the Latin text beneath the image communicates his thoughts, which directly confront the viewer with an account of his suffering for

1 Hass 2000, 170. Parts of the manual were published posthumously in the 1530s; see Kantor 2000, 46, n. 6.

2 In previously published Northern devotional books of the Passion, the Man of Sorrows was not the frontispiece but was often paired with the Crucifixion or inserted as the concluding image to the cycle (Hass 2009, 221). Since Dürer's *Engraved Passion* was not bound as a book, his *Man of Sorrows by the Column* was not a proper frontispiece but was meant to be the first image in the cycle of fifteen prints. On the artist's personal engagement with the theme, see Kantor 2000, I, 17. For Dürer's painting of *c.*1493 in the Staatliche Kunsthalle, Karlsruhe, see Anzelewsky 1981, 34.

3 For the movement centered on Thomas à Kempis's spiritual text *The Imitation of Christ*, see Marrow 1979. For Passion piety in Nuremberg, see Hass 2000, 170.

4 Luber 2005, chapter 2, challenges the traditional view of Dürer's two trips to Venice, rejecting the evidence for a first trip in 1494–1495 and arguing for a sojourn only in 1505–1507. For Dürer's six Passion cycles, see Kantor 2000.

5 Dürer perhaps knew Giovanni Bellini's painting, *The Blood of the Redeemer*, *c.*1460–1465, portraying a full-length Christ in *contrapposto* and holding a cross (London, National Gallery; fig. **34.1**).

6 On "Christ on the Cold Stone," see Mâle 1958, 113–116, and Quarré 1971, 5–10 and 15.

7 The Benedictine monk Benedictus

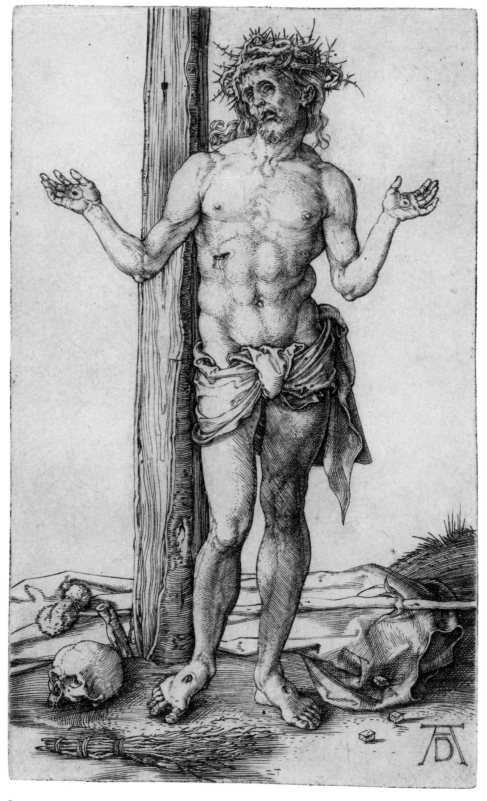

Cat. 35

humanity, seemingly endured in perpetuity.[7] Although the flail underneath the stone slab and the kneeling soldier in contemporary dress who mocks him with a reed scepter herald the full Passion narrative presented in the ensuing folios of the set, the two figures are lifted up on clouds, removed from time and space. Both woodcut and engraving addressed a wide range of devotees. The *Large Passion* frontispiece was published when the woodcuts were collected to form the *Passio domini nostri Jesu*, and Dürer also released it as a separate print without Latin text for a public unable to purchase the entire book.[8] The small engraving was likewise a single-leaf print and so was affordable and easily portable for devotional use. cw

Chelidonius, Dürer's friend, wrote the Latin verses for the 1511 book edition of the "Perpetual Passion." Merback 2005, 626–629, has recently studied Chelidonius's role in fomenting anti-Semitism, focusing specifically on his commission of the Pulkau Altarpiece. The full frontispiece text reads (as in Panofsky 1955, 139):

These cruel wounds I bear for thee, O man,
And cure thy mortal sickness with my blood.
I take away thy sores with mine, thy death
With mine – a God Who changed to man
for thee.
But thou, ingrate, still stabb'st my wounds
with sins;
I still take floggings for thy guilty acts.
It should have been enough to suffer once
From hostile Jews; now friend, let there
be peace.

8 Stephanie E. Loeb in Boston 1988, 179, cats. 159–160.

Passio domini nostri Jesu. ex hiero nymo Paduano. Dominico Mancino. Sedulio. et Baptista Mantuano. per fratrem Chelidonium collecta. cum figuris Alberti Dureri Norici Pictoris.

¶ Has ego crudeles homo pro te perfero plagas

Atqʒ meo morbos sanguine curo tuos.

Vulneribusqʒ meis tua vulnera, morteqʒ mortem

Tollo deus:pro te plasmate factus homo.

Tuqʒ ingrate mihi:pungis mea stigmata culpis

Saepe tuis.noxa vapulo saepe tua.

Sat fuerit.me tanta olim tormenta sub hoste

Iudaeo passum:nunc sit amice quies.

37

Anonymous German or Northern sculptor
Memento Mori, mid-sixteenth century

Boxwood, height 11.4 cm. (4.3 in.); with figure released and standing,
approx. 20 cm. (7.87 in.)
Fine Arts Museums of San Francisco, Legion of Honor
Gift of Albert C. Hooper, inv. no. 41751

This memorable and apparently matchless object is carved of boxwood, a hard wood prized for its smooth grain that was used for sculpture in northern Europe during the late Middle Ages and Renaissance.[1] Many large altarpieces and full-scale statues were sculpted out of this and other wood species, above all in Germany and Flanders, in the fifteenth and sixteenth centuries. Numerous rosaries, figurines, and small devotional objects of boxwood also survive from this era and focus in particular on Christ's Passion (cat. **60**). One such instance is this unique Janus-like head featuring a remarkable dead trio: the face of death itself on one side, Christ's beautiful countenance crowned with thorns on the other, and also, when a spring is released by applying pressure to Christ's scalp, a full-length Man of Sorrows who emerges in *contrapposto* to promise resurrection and the raising of souls at the end of time. This extraordinary "pop-up" figure issuing from Christ, not from the skull, expresses the theme of Christian triumph over death.

The large size of the head would seem to preclude its role having been that of a paternoster, a bead that hung from a belt and helped its owner count the number of times he recited the Lord's Prayer, or *Pater Noster*.[2] Also, with the head dangling from a belt there would probably have been a risk of its internal mechanism springing into action. The work more likely sat on a wealthy devotee's desk or table, appealing to the owner for its remarkable craftsmanship, Christ's contemplative visage, and of course the pop-up mechanism. Simultaneously this skull recalled the inexorability of death and the vanity of worldly possessions; images conveying these themes are termed either a *memento mori* (a Latin expression meaning "remember that you must die") or a *vanitas*.[3] Furthermore, a skull often sits at the base of the cross in representations of the Crucifixion (cats. **13** and **35**) because the four gospels locate Christ's death at Golgotha, "the place of the skull."[4] Theologians, moreover, interpreted the biblical passage from 1 Cor. 15:45–47 to mean that Christ's triumph on the cross rested upon Adam's sin and death, the skull and bones of the first father being buried beneath the cross of Golgotha.[5] But a particularly germane scriptural text derives from Eph. 1:20–23 wherein, after the Resurrection, Christ is termed the head (or *caput*) of the Church.[6]

1 See Penny 1993, 144–148; and *Bronze and Boxwood* 2008. We are grateful to Elisabeth Cornu, Conservator at the Fine Arts Museums of San Francisco, for information regarding this anonymous work, particularly that the ring atop is modern. Frits Scholten, Senior Curator of Sculpture at the Rijksmuseum, Amsterdam, has suggested that this work might be Flemish or Franco-Flemish in origin.

2 For paternosters, rosary beads and prayer beads as skulls, see Cleveland 1972, 110–111; Marks 1977; Clifton 1977, 144–145, cat. no. 66; and Netzer and Reinburg 2007, 132, cat. 32. For paternosters in general, see the very rich discussion in Lightbown 1992, 342–354.

3 The phrase has sometimes been related to Isaiah 22:13: *comedamus et bibamus cras enim moriemur*, or "Let us eat and drink, for tomorrow we shall die."

4 Mark 15:22, Matt. 27:33, Luke 23:33, and John 19:17. The name Golgotha is no longer traced to the Aramaic word *gulgulta*. One of the most famous examples of a skull beneath the cross appears in Rogier van der Weyden's *Deposition* of c.1440, in the Museo del Prado, Madrid.

5 1 Cor. 15:45–47: "The first man Adam was made into a living soul; the last Adam into a quickening spirit. Yet that was not first which is spiritual, but that which is natural: afterwards that which is spiritual. The first man was of the earth, earthly: the second man, from heaven, heavenly."

6 Eph. 1:20–23: "Which he wrought in Christ, raising him up from the dead and setting him on his right hand in the heavenly places.... And he hath subjected all things under his feet and hath made

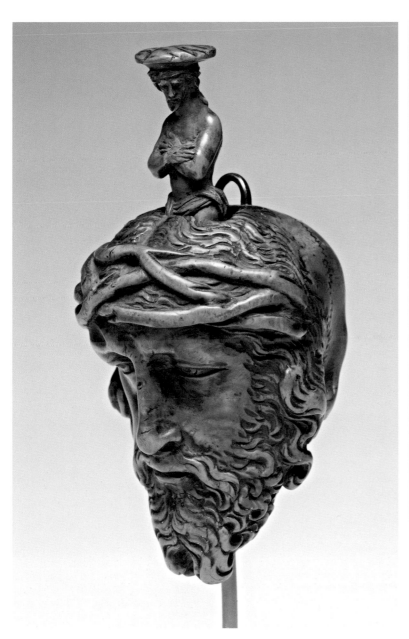
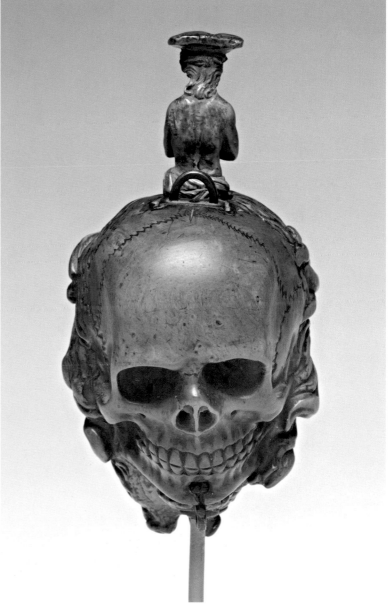

him head over all the church, Which is his
body and the fullness of him who is filled
all in all." See Kirkman 2010; we are very
grateful to Prof. Kirkman for bringing
our attention to this important *caput*
connection.

38

Anonymous Flemish painter
*Holy Face, c.*1510–1515

Oil on panel, overall 27.8 × 21 cm. (10.6 × 8.2 in.);
painted portion 24.2 × 17.8 cm. (9.5 × 7 in.)
Allen Memorial Art Museum, Oberlin College, Oberlin, OH
Charles F. Olney Fund, 1959.11

Like the early Man of Sorrows, the Holy Face presents a frontal, close-up image of Christ but shows him alive. Moreover, its origin was purportedly miraculous, as an image "not made by human hands" (an *acheiropoieton*). As recounted by both Eastern and Western legends, the holy icon of the Mandylion preserved the imprint of the likeness that Christ himself had sent to King Abgar of Edessa on a holy cloth (*mandylion*).[1] After its transmission to the West in the thirteenth century, its status was eclipsed by a second icon of the Holy Face known as the Veronica, or *vera icon* meaning "true image." Promoted by Pope Innocent III (1198–1216), this second cult spread widely after the pope offered an indulgence to anyone reciting a special prayer before the Veronica.[2] Despite their visual links with the Man of Sorrows, representations of the Mandylion and Veronica were hardly seen in Venice, perhaps because of the icons' close ties with other cities (that is, Genoa and Rome). Yet during the fifteenth and sixteenth centuries, Flemish devotional works such as this one proliferated, and many were exported for sale to private collectors in Italy.[3]

Neither precisely a Mandylion nor a Veronica, the Oberlin panel combines features of both. The face of Christ materializes as if in a vision, rays emanating from his disembodied head and his hypnotic gaze directed towards the devotee; long, dark brown curls frame his oval-shaped face, and a short, forked beard defines his chin. The background echoes the golden revetment of the Mandylion icon, the face not silhouetted by the frame.[4] Christ's head seems to project towards the viewer and presents the realistic features of the type often seen in images of Veronica's Veil (see cat. **39**). Like the Mandylion and the Veronica, the Oberlin *Holy Face* depicts the direct gaze of Christ, whose close placement to the picture plane serves to engage worshipers and inspire meditation. For the relationship of a work such as this to the theme of our exhibition, see the entry for cat. **39**. IV

1 See Belting 1994, 208–224; Kessler and Wolf 1998; Morello and Wolf 2000; and *Mandylion* 2004, which examines the Mandylion icon in San Bartolomeo degli Armeni, Genoa.
2 Maryan W. Ainsworth in Evans 2004, 562, cat. 334, and Belting 1994, 220.
3 The Oberlin panel was reportedly bought from the Piccolomini Collection, Siena. Stechow 1967, 56, placed the genesis of the Oberlin panel in Antwerp and associated it with Jan Mostaert's art, but Ainsworth in Evans 2004, 562, cat. 334, situated its production in Bruges in the circle of Gerard David.
4 In addition to the Mandylion in Genoa (see n. 1 above), the Veronica in the Vatican is also in a frame that contours the perimeter of Christ's face and beard but partially obscures the remainder of the icon.

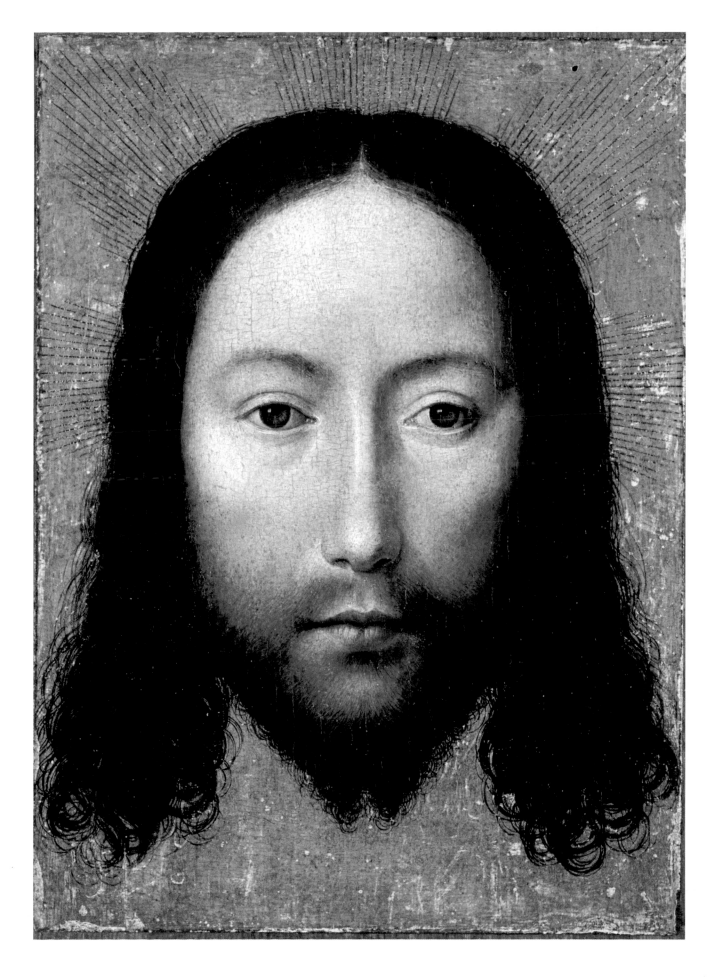

39

Anonymous Italian or Spanish artist
Veil of Veronica, seventeenth century

Oil on olive wood, 21 × 12.5 × 2.5 cm. (8.26 × 4.7 × 0.9 in.)
Private collection

Believers deem the Veil of Veronica, or *vera icon*, a "true image" of Christ's face. According to tradition, a woman named Veronica wiped Jesus' brow as he bore the cross on his climb to Golgotha.[1] The ancient cloth relic entered St. Peter's, Rome, in the early thirteenth century and a cult quickly developed. The relic's surge as an illusionistic image was a seventeenth-century phenomenon, and the painter of this little Baroque *Veronica*, exploiting *trompe l'oeil*, used his convex support to invoke Christ as if seen in a mirror. Paintings of the Veronica grew in number as the Man of Sorrows all but disappeared as an artistic subject.

The Veronica is one of four Eastern icons considered true likenesses of Christ and thought to have arrived in Western Europe in the thirteenth century; three are on cloth.[2] The Mandylion, or Holy Face (cat. **38**), shows Christ's visage before the ordeal in Gethsemane; the Mandylion now in San Bartolomeo degli Armeni, Genoa, is claimed to be the original cloth sent by Christ himself to King Abgar in Edessa.[3] The third and most famous cloth icon is the Holy Shroud in Turin, said to have wrapped Christ's body after death.[4] The fourth Eastern icon is the *Volto Santo*, a full-length wood sculpture of the crucified Christ believed to have been carved in Jerusalem but today in the Cathedral of Lucca. The relationship of these four so-called *acheiropoieta* may seem of doubtful historical relevance to the theme of our exhibition, but the Man of Sorrows also came west in the thirteenth century, and similarly evoked empathy with Christ's suffering, its traditionally close-up view heightening that experience. Unlike the four Eastern icons, no image of the Man of Sorrows is considered unique or miraculous; nonetheless it paradoxically trumps the others in that it alone depicts Christ as simultaneously dead and alive. Reading the four *acheiropoieta* in the order of the Passion narrative, the Mandylion portrays Christ before his suffering; the Veronica, on the path towards Crucifixion; the *Volto Santo*, on the cross; and the Shroud, dressing his buried body. But only the *Imago pietatis* implies that Christ is at the same time human and divine. In fact the extraordinary and singular power of the figure lies in its proposition that it authenticates what Christ alone could accomplish, earthly resurrection. It asserts too a fundamental Christian belief: that the beginning follows the end.

1 Kuryluk 1991, Belting 1994, and Kessler 2006.
2 Von Dobschütz 1899, and Morello and Wolf 2000.
3 Kessler and Wolf 1998 and *Mandylion* 2004
4 Coppini and Cavazzuti 2000.

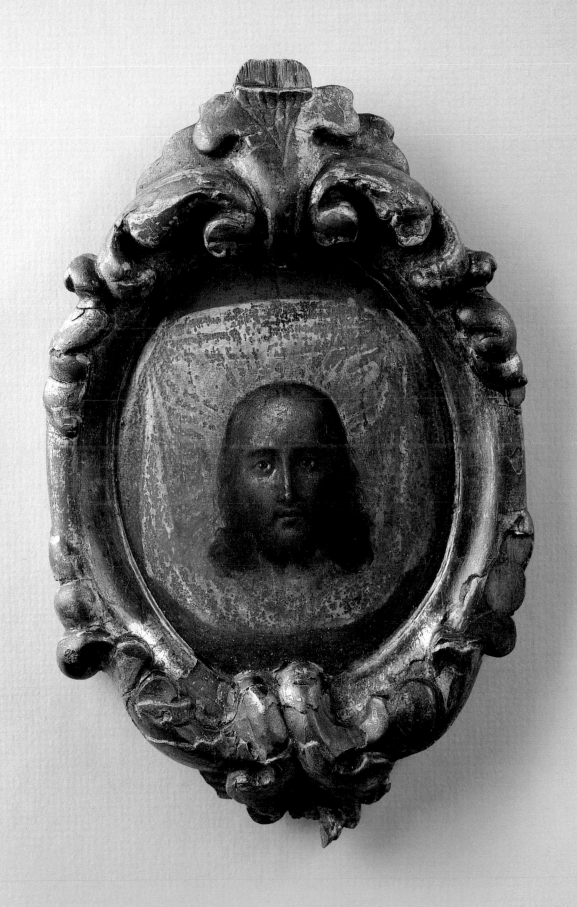

40

Benedetto Bordon (fl. 1488–d. 1530), attributed to
Mariegola, Confraternity of the Holy Sacrament, *c*.1505,
from San Geminiano, Venice

Vellum, pp. 9–10, 296 × 202 mm. (11.65 × 7.95 in.)
Isabella Stewart Gardner Museum, Boston, 14.2.b.2

41

Anonymous Italian miniaturist
Mariegola, Confraternity of the Holy Sacrament, 1512,
from Santa Maria Mater Domini, Venice

Vellum, folios 13v–14r, each folio 318 × 220 mm. (12.5 × 8.66 in.)
The Art Museum, Princeton University, 40–401

The books on display exemplify a category of manuscripts known in Venice as *mariegole*.
A *mariegola*—thought to be a Venetian contraction of *madre regola* ("mother rule") but
possibly from the Latin word *matricula*, meaning a public register—was the statute book
of a lay confraternity setting out its charter, membership list, and confraternal
responsibilities. Encouraged and regulated by the State, these confraternities were called
scuole and played an important role as corporate entities fulfilling civic piety.[1] The oldest
confraternity dedicated to the Holy Sacrament (*Santissimo Sacramento*) or Body of Christ
(*Corpo di Cristo*) dated to 1395, but their number proliferated in the first quarter of the
sixteenth century when each of the seventy parishes in the city established its own
Scuola del Santissimo Sacramento.[2] The primary responsibility of every *scuola* was to
maintain and embellish the sacrament altar or its chapel in the parish church; each also
participated in the annual city-wide Corpus Christi procession and in local processions
on Good Friday, carried the Viaticum to its terminally ill brethren, and attended to its
members' burial rites. The *mariegola*, a precious part of the *scuola*'s communal property,
was kept safe by the elected official (*gastaldo*), who was also responsible for updating the
book with lists of new members, inventories, resolutions, and printed decrees.[3] Study of
surviving early *mariegole* reveals that the first pages followed a general formula in
establishing the *scuola*'s foundation, confirming its official authorization, and
enumerating its governing statutes. As is apparent in the examples in this exhibition,
the opening handwritten text was typically enframed in a decorated border and
accompanied by miniatures. The *scuola*'s dedication to the Eucharist encouraged its
embrace of the Man of Sorrows as the ideal image for the frontispiece of the *mariegola*.
Displayed on feast days and subject to frequent handling by generations, *mariegole* of
Holy Sacrament confraternities kept the image immediate in the Eucharistic devotions
of Venetians throughout the sixteenth and into the seventeenth century. These two
examples illustrate shared characteristic elements and significant stylistic variations in
the imagery of *mariegole*.

 The Boston version originally belonged to the Venetian sacrament confraternity of
San Geminiano, a parish church for the local neighborhood that stood at the side of

1 For the history of the *scuole*, see Brown
1996, and for a compendium of *scuole* in
Venetian parish churches, see Vio 2004.
2 For the most recent comprehensive
study of Venetian sacrament
confraternities and their *mariegole*, see
Marcon 2007 with earlier bibliography.
3 Later additions, interpolations, and
rebindings often make dating the
miniatures in *mariegole* very difficult.

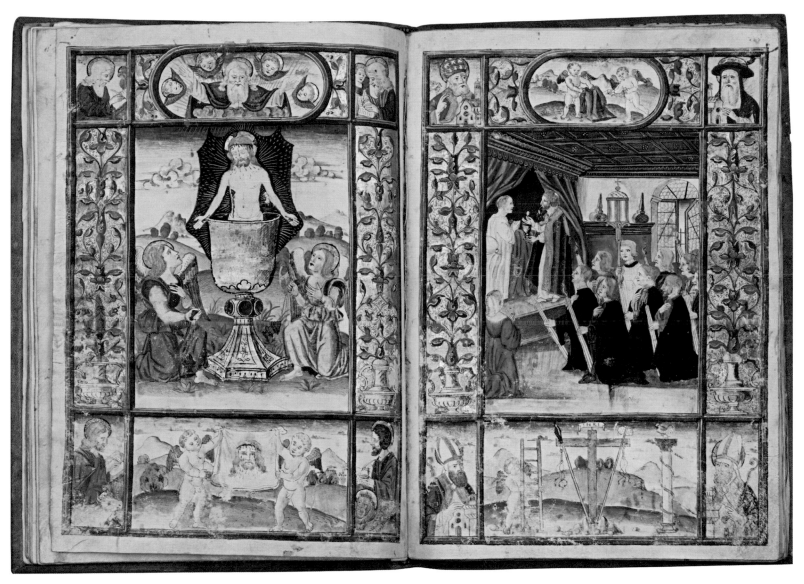

Cat. 41

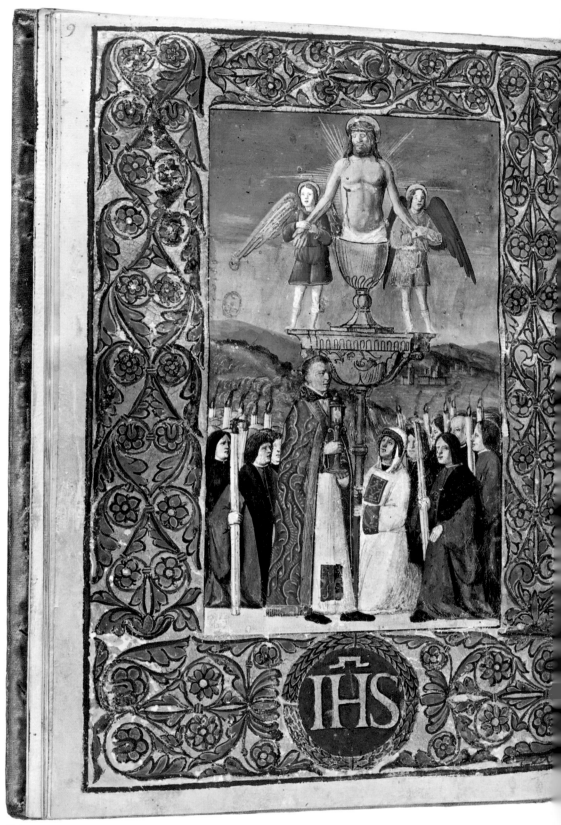

Cat. 40

AD honorem Laudem et gloriam beatissime trinitatis: Patris: et Filij et Spiritussancti: et ad honorem gloriose uirginis matris marie: et ad reuerentiam sancti confessoris et Patroni nostri Geminiani: et gloriosi euangeliste sancti Marci protectoris et defensoris almae Ciuitatis Venetiarz: et ad Laudem et Reuerentiam totius celestis curie: et ad honorem etiam patris nostri summi Pastoris Domini Pontificis z suorz fratrum Cardinalium: et totius Romane Curie ecclesie: et ad honorem Reuerendissimi d. Patriarche Thome donati: et ad honorem Serenissimi Principis D. Leonardi Lauredani z sui sapientissimi Consilij: et ad honorem dni Plebani presbiteri hieronymi boneti: et honestissiorz eius sacerdotum: et ad summum augmentum & xm Dominij Venetiarz: Cum Caritas sit mater et fons ceterarz uirtutum sine qua nullum perfectum opus potest inchoari nec perfici asserit beatus apostolus Paulus. Caritas etc. Que caritas eo tunc placet omnipotenti deo cum in plures personas unah distributa est: testante

Piazza San Marco opposite the basilica until 1809. Attributed to the distinguished Paduan miniaturist Benedetto Bordon, the decoration of the lavish double-page spread shown here, with its richly illuminated foliate borders, attests to the piety and affluence of the confraternity.[4] On the right-hand page, a historiated initial opens the text and an image of San Geminiano fills the roundel in the lower border. On the facing page, a full miniature depicts Christ's half-length figure emerging from a large golden chalice, his hands extending outward toward two angels, all three atop a gilt processional standard that has miraculously grown in size. Confraternal members, attending to the Host monstrance held by a priest but apparently unaware of the apparition above, kneel while holding long, lit candles. The vision of Christ in the Chalice gives visual expression to the doctrine of the Real Presence in the Eucharist. As a variant of the Man of Sorrows with Angels, substituting the chalice for the tomb, *Cristo in caín*—as it is familiarly called in Venice—enjoyed particular favor with sacrament confraternities.[5] Sculpted reliefs with this subject can still be found on Venetian buildings, for example, above the door of the former meeting hall of the Confraternity of the Holy Sacrament of San Gregorio (fig. **10**). The miniaturist of the *mariegola* of San Geminiano likely found inspiration for the central motif of his scene from actual processional standards bearing the carved and gilded figure of *Cristo in caín* like those still in San Martino and the Museum of San Marco.[6]

Christ in the Chalice also dominates the left-hand page in the unusually richly decorated *mariegola* from Santa Maria Mater Domini.[7] Its stem studded with gems, the chalice stands before an uninhabited landscape and between two angels genuflecting in adoration and swinging censers while gazing at Christ. The Eucharistic meaning of the image is expanded by the surrounding imagery, which includes portraits of the Evangelists in the four corners of the illuminated border and of the four Fathers of the Church in the corresponding spaces on the facing page, and a half-length figure of God the Father in the elliptical field in the upper border at left; cherubs displaying the Veil of Veronica and Instruments of the Passion fill the remaining borders on both pages. Apart from the rare presence of the symbols of the Passion, the rest of the border imagery is repeated in other *mariegole* but depicting saints particular to each *scuola*'s ecclesiastical home.

The right folio of the double-spread page in the Princeton *mariegola* includes a large miniature depicting a Venetian interior where a priest administers the host to a bedridden man watched by confraternal members who have accompanied the

4 For the attribution, see Szépe 2004; see also Morris Carter in *Choice of Manuscripts* 1922, 30–32. For Bordon's activity, see Susy Marcon in *Dizionario Biografico* 2004, 121–125.

5 For the Venetian dialect for *Cristo nel catino*, see Antonio Niero in Favaretto and Urbani 2003, 95, who explains its derivation from the similarity of shape between chalices and domestic water cisterns.

6 For the San Marco standard, see Favaretto and Urbani 2003, 107–109, cat. 10.

7 The *mariegola* of Santa Maria Mater Domini, a church located in the *sestiere* of Santa Croce, also has a third miniature by a different hand below the opening text on folio 3r, depicting Christ in the Chalice adored by members of the *scuola* (fig. **11**); the double spread was reinserted at a later date in the *mariegola*. Contrary to Rubin 1991, p. 294, n. 42, the attribution of this *mariegola* to the Sienese miniaturist Pellegrino di Mariano (active 1449–1492) cannot be sustained.

8 Similar deathbed scenes are found in the *mariegole* of San Nicolò dei Mendicoli (Venice, Giorgio Cini Foundation; ms. 5, inv. 2506; Mariani Canova 1978, 72); San Giacomo dall'Orio (Venice, Museo di San Marco; Favaretto and Urbani 2003, 110-111, no. 19); San Tomà (Biblioteca del Museo Civico Correr, ms. Cl. IV, 44; Marcon 2007, 293) and San Pantalon (whereabouts unknown; Marcon 2007, 293).

sacrament to the house and hold lit candles.[8] The frequent depiction in *mariegole* of carrying Communion to the ill underlines the importance of this sacred duty for each confraternity, whose constituents were deeply concerned with preparation for a good death in a state of grace.[9] At left in the scene, the kneeling woman may be the sick man's wife, as suggested by her attire and isolated placement. Offering a glimpse into a contemporary home, the domestic setting directly reflects the urban life of the *scuola's* members and contrasts with the idealized landscapes behind the *Dead Christ* in the corresponding miniatures of the two *mariegole* here. Whether in the chalice or emerging from the tomb, The Man of Sorrows promised the pious members of each *scuola* both salvation and eternal life.

9 In another Venetian *mariegola* (Venice, Biblioteca Civica del Museo Correr, Cl. IV, 196, San Michele, for which see Vanin and Eleuteri 2007, 140), members of the *scuola* earned an indulgence in fulfilling this duty. Sanvito 2009, 152, notes the link between the *Ars moriendi* and the administering of Last Rites as depicted in the *mariegola* from San Nicolò in the Cini Foundation.

Processional Standards
San Trovaso, Venice

42
Man of Sorrows, late sixteenth century

Polychromed and gilded wood, total height 227 cm. (7.44 ft.);
crowning sculpture, 73 × 44.5 × 17 cm. (28.74 × 17.51 × 6.69 in.)

43
Dead Christ with Angels,
seventeenth or eighteenth century

Gilded wood, total height 217 cm. (7.12 ft.);
crowning sculpture, 78 × 96 × 36 cm. (30.7 × 37.79 × 14.17 in.)

Processional standards once served a fundamental devotional function in the sacred processions of Venetian Holy Sacrament confraternities, as was stipulated in their *mariegole* (cats. **40** and **41**). The most important of these processions annually marked the feast of Corpus Christi dedicated to the body of Christ. The pageant of Corpus Christi, initiated in 1295, surpassed in size, length, and spectacle all others staged throughout the year in Venice.[1] The daylong procession took place in the Basilica and Piazza of San Marco and offered an extraordinary display of communal piety to the thousands who attended. Governmental representatives, the religious orders, the *Scuole Grandi*, and of course the parish sacrament confraternities all took part.[2] Subject to a fine if they did not comply, confraternal brethren pledged to attend the Corpus Christi procession, and each *scuola* subsequently held a local procession in its parish on the Sunday following the feast.[3] Together with floats adorned with allegorical *tableaux vivants*, banners, and candles, the standards contributed to the visual splendor of the event hinted at in Gentile Bellini's *Procession in the Piazza San Marco*, 1496, and in Giacomo Franco's print showing the Corpus Christi procession in the early seventeenth century.[4] One foreign pilgrim participating in the procession of 1506, on the eve of his embarkation for the Holy Land, remarked on the marvelous display of "figures of the blessyd sacrament" and the "deuyses" of the *scuole*.[5] Perhaps it was standards with carvings of the Man of Sorrows, like these in San Trovaso, that caught this pilgrim's attention.

Now flanking the altar of the *Cappella Milledonne* in San Trovaso, these two standards were likely commissioned by the Confraternity of the Holy Sacrament.[6] The earlier of the pair probably dates to the late sixteenth century when the *scuola* voted to construct a new chapel in the left transept of the church.[7] Currently backed by a cross displaying the superscription, the three-quarter-length *Cristo passo* seems to emerge from a console-tomb embellished with gilded acanthus leaves and a Eucharistic grape cluster. He raises his left hand to indicate the wound in his side, and this gesture, together with his downward gaze, would have infused vitality into the carved wood, engaging spectators while the standard bobbed over their heads. The wide platform of the later processional standard exemplifies the so-called boat type and supports a multi-figured group of the Dead Christ with Angels. On the front of the boat are three

1 Muir 1981, especially chapter 6.
2 For the Corpus Christi procession in Venice, see Muir 1981, 223–230.
3 See, for example, Capitolo XXIIII of the *mariegola* of Santa Maria Mater Domini in Princeton.
4 For Bellini's painting, see Brown 1988, 144–152, color plate XVIII; and for Franco's print, see Muir 1981, fig. 10.
5 "The Pylgrymage of Sir Richard Guylforde," quoted in Muir 1981, 226.
6 We thank Don Silvio Brusamento for generously facilitating our study.
7 Bianchi 1979–1980, 33. For the Chapel of the Sacrament, see Caputo and Perissa 1994, 13–21, 34–37, and 39–42.

Cat. 42

symbols of the Passion carved in relief: the crown of thorns, hammer, and pliers. Semi-recumbent, Christ leans against a supporting angel, while a grieving cherub kneeling at his feet dabs his face with the edge of the shroud falling over the front of the standard. The fragment of the shroud behind Christ's body was once probably held by another cherub or angel and draped in front of a now lost cross inserted in the existing hole on top of the platform behind Christ. Similar groupings exist on standards in the Museo di San Marco and in the *Cappella del Santissimo Sacramento* in the church of San Salvador.[8] In contrast to the single figure of the earlier standard and others elsewhere in Venice, all of these multi-figured examples present a pictorial composition akin to seventeenth-century paintings depicting the Dead Christ mourned by angels or cherubs, such as Pietro della Vecchia's canvases in Greenville, South Carolina, and Rovigo.[9] Once significant symbols of lay piety, processional standards were rallying markers for members of a *scuola* within an urban gathering, and emblems, too, of their dedication to the sacrament embodied in the crowning Man of Sorrows.[10]

8 For the standard in the Museo di San Marco dated to the eighteenth/nineteenth century, see Favaretto and Urbani 2003, 108–109, no. 11; and for the one in San Salvador, see Bertoli and Romanelli 1997, 27, and Pichi 2007, 46, and fig. 1.

9 See the processional standards with the single figure of Christ in the Chalice in San Martino (*San Martino de Geminis* 2004, 35) and in the Museo di San Marco (Favaretto and Urbani 2003, 106–109, no. 10). Marcon 2007, 280, notes that most early standards have not survived because of their continual renewal over centuries. For Pietro della Vecchia, see Aikema 1990, 131–132, cats. 103–104, fig. 22. Other related paintings of the Dead Christ Mourned by Angels include an anonymous Venetian panel on slate in the Gallerie dell'Accademia, Venice (Moschini Marconi 1962, II, 97, cat. 207), and a canvas attributed to Andrea Schiavone in the J.Q. van Regteren Altena Collection, Amsterdam (Richardson 1980, 152, cat. 245, fig. 172).

10 Maria da Villa Urbani in Favaretto and Urbani 2003, 106, nos. 10–16.

Cat. 43

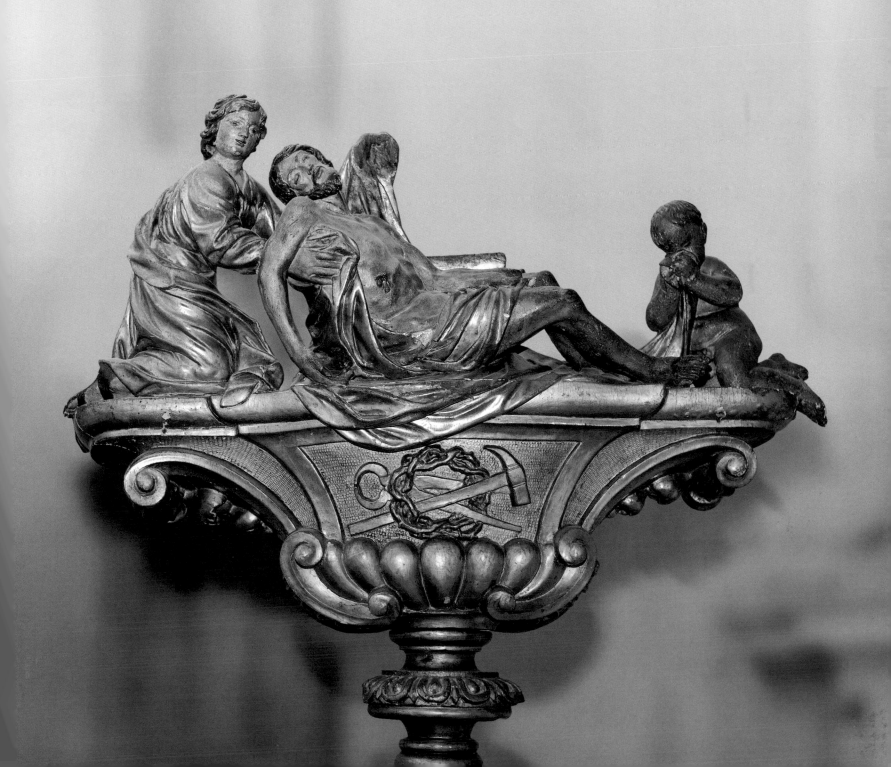

44

Vittore Belliniano, or Vittore di Matteo (*c*.1456–1529)

Man of Sorrows, *c*.1515–1520

Oil on canvas, 56 × 81 cm. (22 × 31.8 in.)
Inscribed: *yħς – χϱς*
Scuola Grande di San Rocco (Sala Capitolare), Venice

This very traditional yet modernized Man of Sorrows led an erratic life until recently when it was discovered to be by Belliniano, who worked in the Ducal Palace and elsewhere in Venice and who assumed a new surname in 1516 in honor of his master, Giovanni Bellini, who died that year. Belliniano's painting probably once graced the interior of San Rocco, a church built by the Scuola Grande that was a lay confraternity dedicated to the eponymous saint. The Scuola brought the work from the church into its own building in the early 1700s, but by that time Belliniano's authorship had been forgotten. An inventory of 1763—noting the Greek letters on either side of Christ—identified the painting as from the "scuola di Paolo," that is, Paolo Veneziano's late fourteenth-century workshop.[1] By the mid-nineteenth century, the work was categorized as Titianesque; it was upgraded to the young Titian himself in 1935.[2] Two decades later, Titian ceded to Giorgione, and in the 1980s the painting was re-attributed to Bellini.[3] Bellini lost the painting in the restoration of 2000 when his pupil's signature was discovered beneath the Greek letters: VICTOR - BELLINAS.[4] It is likely that Belliniano painted the canvas between 1515 and 1520, possibly around 1518 after assuming his new name and when the Scuola Grande di San Rocco received in donation "a thorn from the crown of our Lord Jesus Christ," a relic subsequently much venerated and one that Belliniano perhaps refers to with the terrible spikes piercing Christ's brow.[5]

In composing his very beautiful Man of Sorrows Belliniano reconciled old with new, unlike the Vivarini brothers, who had faithfully maintained the traditional *Imago pietatis*, and unlike Bellini, who had altered it (cat. **23** and fig. **17**). The work is exceptional, too, when compared with Lorenzo Lotto's contemporary interpretation of the subject (cat. **45**). Belliniano recalled Byzantine convention in the abbreviated configuration of Christ's chest, partly by way of Paolo Veneziano's Man of Sorrows on the *Pala feriale* (fig. **5**) but also by referring to the famous Greek mosaic icon in Rome (fig. **1**) via Israhel van Meckenem's late fifteenth-century engraving, which was in wide circulation by the time Belliniano painted his canvas (fig. **4**). Further abridging Christ's chest, Belliniano fashioned it anew pictorially, employing Giorgione's and Bellini's poetic *sfumato* of tempered lights and darks to soften Christ's crucified body and to portray his face eternally and peacefully asleep.[6] If it was Belliniano's goal to evoke Paolo Veneziano's great image on the *Pala feriale* through the lens of his teacher Bellini, he succeeded splendidly. MMW

1 Examination has shown that the inscription postdates the painting; see Nepi Scirè 2000.

2 For the first attribution, see Paoletti 1840, 108, and Moschini 1847, 123. For Titian, see *Mostra di Tiziano* 1935, 21, cat. 1.

3 See Lucco 1983, 453, and, for a summary of the history of the many attributions, Chiara Ceschi, "Vittore Belliniano. Cristo in pietà," in Posocco and Settis 2008, 333–334, cat. 374.

4 Nepi Scirè 2000.

5 See Maria Agnese Chiari Moretto Wiel, "Nicolò dalla Croce. Reliquiario della Spina," in Posocco and Settis 2008, 340–341, cat. 385.

6 Belting 1996, 69 (but still called a work by Titian).

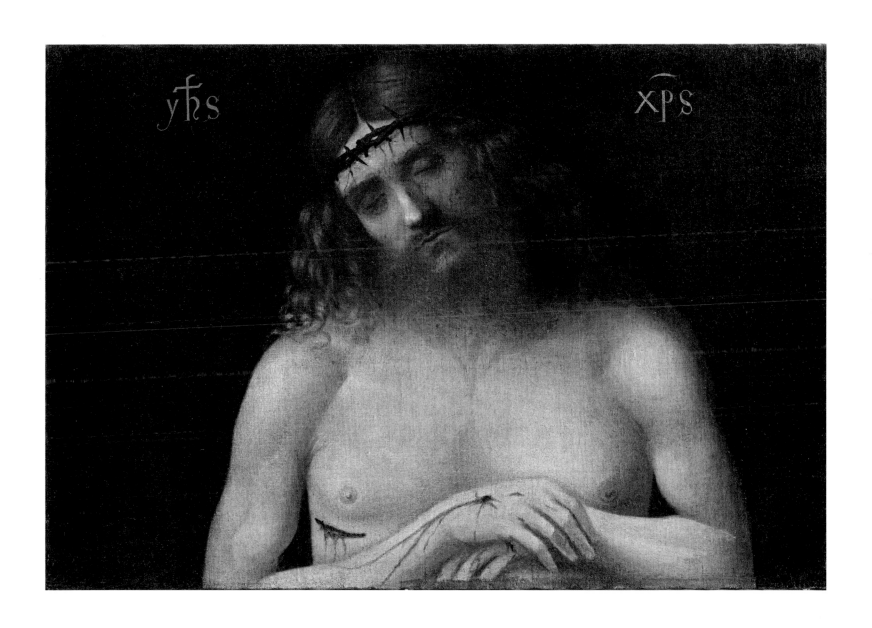

45

Lorenzo Lotto (*c*.1480–1556)

The Body of Christ Supported by Angels, *c*.1516–1525

Oil on panel, diameter 16.8 cm. (6.6 in.)
North Carolina Museum of Art, Raleigh, NC, Samuel H. Kress Collection,
60.17.42

Probably originating in Bergamo, this tiny and seated Man of Sorrows with Two Angels is one of several expressive variations on the theme by the Venetian-born Lorenzo Lotto, who produced altarpieces, private devotional pictures, and portraits, primarily for patrons in Treviso and Bergamo in the Veneto, and in the Marches.[1] Lotto's emotional intensity and dynamic composition distinguish this work, the lunette of his large altarpiece of 1506 in Santa Cristina al Tiverone (outside Treviso), and the crowning field of the St. Dominic Polyptych, 1506–1508, in Recanati close to the Adriatic Sea.[2] The three figures of the tondo here loom large despite their small size, and Lotto conformed the composition to the circular frame, filling it with bent limbs and wings. His source for Christ's position and for the motif of the angel lifting the limp right hand derive, in reverse, from Bellini's *Man of Sorrows with Four Angels* (fig. **17**), but in drawing up Christ's legs, stretching the arms of the right angel to embrace and support both head and torso, and tilting all of the figures' heads sharply to the right, Lotto injected disquiet and despondency into his image.[3]

Along with its companion tondo of the *Martyrdom of Saint Alexander*, this work was formerly believed to have decorated the pilasters flanking Lotto's colossal Martinengo Altarpiece of 1516 for Santo Stefano, Bergamo.[4] Discrepancies in lighting and style between the tondos and the larger scene militate against such an association, and any proposed reconstruction must also consider the iconographic tradition of the Man of Sorrows in the Veneto that invariably situated the figure, when part of a pictorial ensemble, on the central axis.[5] Furthermore, the diminutive dimensions of the tondos preclude the possibility that they could have been seen from afar on the monumental Martinengo Altarpiece. Given that Alexander is the patron saint of Bergamo, the two works were likely painted for a local patron before Lotto departed for Venice in 1525. Both may have decorated a private devotional work or even a liturgical piece of furniture, with the *Body of Christ* in the center flanked by the *Martyrdom of Saint Alexander* on one side and by another scene, still unknown, on the other.[6] AV

1 For Lotto's training and formative influences, see Humfrey 1997. On his period in Bergamo, which returned to the Venetian Republic in 1515 after six years of French domination, see ibid., chapter 3.

2 For the works in Santa Cristina al Tiverone and the Pinacoteca Comunale of Recanati, see Humfrey 1997, 17–20, pl. 24, and 27–31, pl. 31. Unremarked upon previously is Lotto's depiction of a traditional half-length Man of Sorrows within a small framed painting that appears on the altar in his frescoed *Scenes from the Life of Saint Bridget* (1523–1524) in the Oratorio Suardi, Trescore; see the illustration in *Lorenzo Lotto* 1997, 52.

3 During his stay in Iesi in 1511–1512, Lotto likely saw Bellini's work in nearby Rimini. Underdrawing revealed in the infrared reflectogram shows that the facial expressions of all three heads were changed from peaceful to anguished. We thank William P. Brown, Chief Conservator at the North Carolina Museum of Art, for sharing the 1996 conservation report with us.

4 Bianconi 1955, 44–46; Berenson 1956, 38–43; and *North Carolina Museum* 1965, 86. For the *Martyrdom of Saint Alexander*, also in Raleigh, see ibid., 86. Both tondos appear to have been transferred from panel to canvas and then remounted on panel in the nineteenth century.

5 Mascherpa 1978, 40–53, followed by Humfrey 1997, 170 n. 15, and Mauro Lucco in *Lorenzo Lotto* 1997, 109, all rejected the association for stylistic reasons.

6 Although labeled workshop by the museum, the artistic quality of the *Body of Christ Supported by Angels* recommends its autograph status.

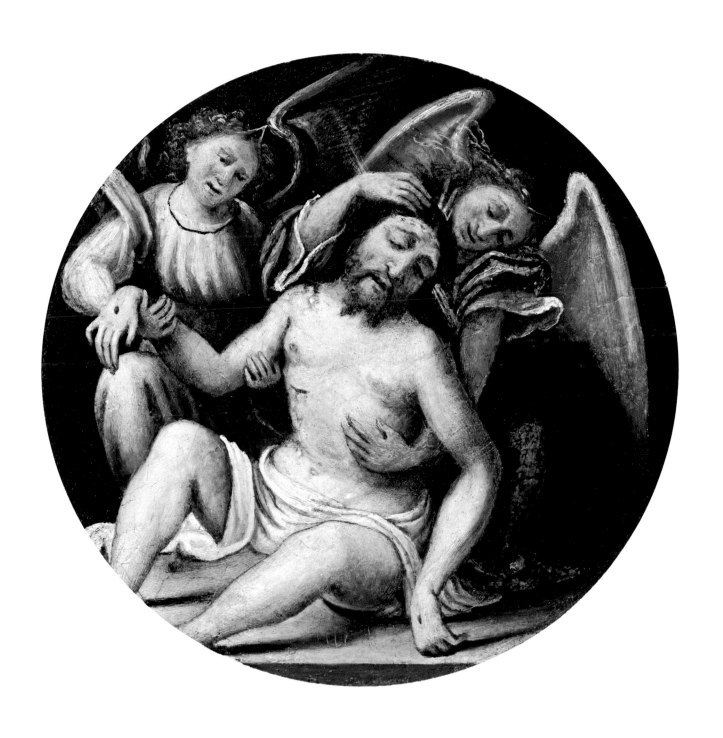

Battista Franco (c.1510–1561)

46

*Dead Christ Supported by an Angel, c.*1550–1555

Pen and brown ink, 166 × 119 mm. (6.53 × 4.68 in.)
The Art Museum, Princeton University, Princeton, NJ
Laura P. Hall Memorial Fund, 75-241

47

*Dead Christ with Two Angels, c.*1550–1555

Panel, 30.5 × 22.9 cm. (12 × 9 in.)
David and Alfred Smart Museum, University of Chicago, Chicago, IL
Gift of Ira Spanierman, 1981.58

48

*Dead Christ with Two Angels, c.*1550–1555

Etching, 263 × 204 mm. (10.35 × 8 in.)
The Metropolitan Museum of Art, New York, inv. 52.601.186

After two formative decades spent in Rome, Florence, and the Marches, Battista Franco returned in 1551 to spend the last decade of his life in his native Venice, where he secured major commissions for state projects in the Ducal Palace and Marciana Library, working in the main hall of the library alongside six other painters, including the younger Paolo Veronese. He also painted sacred subjects for altarpieces and frescoes decorating chapels in local churches for eminent Venetians.[1] However, the high regard accorded him in his lifetime rested on his draftsmanship, especially on his independent designs for prints, which Giorgio Vasari praised in his biography of the artist. Indeed, Franco was one of the most prolific painter-engravers of the sixteenth century, and his activity coincided with and helped promote the supremacy of copperplate printmaking over woodcuts in Venice.[2] Central to all of his pictorial work was his engagement with Michelangelo's works, which he had assiduously copied during his early Roman career. Back in Venice, Franco played a key role in transmitting Michelangelo's ideals to contemporary artists and patrons who accepted Mannerism to varying degrees.[3]

The Princeton drawing, Metropolitan Museum of Art print, and Chicago painting on view offer a fascinating glimpse into Franco's creative process and pose complex questions of sequence. He probably first conceived the subject in two pen and ink drawings, one now in Braunschweig and the other our Princeton sheet.[4] They present an intimately knit two-figure group in which the upper torso of the full-length, seated Christ is supported from behind by an adolescent angel. Both the angel's position and Christ's torsion draw inspiration from the sculpted Nicodemus supporting Jesus in Michelangelo's *Pietà* for Florence Cathedral, and this direct reference suggests that the two drawings date to after 1550.[5] The Princeton drawing, slightly larger than the rapid pen and ink sketch in Braunschweig, reveals more refined modeling in Christ's anatomy, implying that it was the later of the two studies, and it retains Franco's manual

1 For Franco's Venetian commissions, see especially Rearick 1958, and most recently Varick Lauder 2009, 36–50.
2 See Vasari 1985, 458–468, especially 468, for the life of Franco; on Franco's significance, see Van de Sman 1995, 101, and 2003, 136–143. See also Michael Bury, "Printmaking in the Age of Titian," in *Age of Titian* 2004, 277–281.
3 Gianvittorio Dillon, "Le incisioni," in *Da Tiziano a El Greco* 1981, 300–301.
4 Braunschweig, Herzog Anton Ulrich-Museum, inv. Z 2796, pen and ink, 162 × 91 mm. Anne Varick Lauder kindly brought to our attention this drawing, to be published by her in a forthcoming article in the *Burlington Magazine*; she believes it preparatory to the panel and print and earlier than the Princeton drawing. For the Princeton drawing, see David Acton in Reed and Wallace 1989, 54, cat. 25; Varick Lauder 2004, vol. 2, 608–609, cat. 427 DA; Biferali and Firpo 2007, 206 n. 54. For a discussion of Franco's practice, see Van de Sman 2000.
5 Van de Sman 1995, 111, n. 10.

Cat. 46

spontaneity in the fluid description of curling locks and feathered wings. It introduces, too, some modifications in the way the heads turn and in the positioning of Christ's torso. Presumably other compositional pen drawings and chalk figure studies intervened before Franco further elaborated the composition of the Chicago painting and Metropolitan Museum of Art print.[6]

The Chicago panel, newly identified here as Franco's work, is one of several paintings by the artist that can be related to a print of nearly identical dimensions.[7] Revising his preliminary designs, Franco reoriented Christ's body toward the right and inserted a second angel. He also amplified the figural proportions and defined Christ's musculature meticulously. As a result, both painting and print convey a ponderous monumentality that typifies Franco's deep commitment to Michelangelo's art. The atmospheric play of light and shadow softening the idealized forms underscores Franco's ability to infuse surface naturalism into his Michelangelesque models during

6 For examples of such chalk studies, see Van der Sman 2000.

7 The panel was called anonymous late-sixteenth century Italian, Bolognese or Venetian, in Rosenstein 2001, 30, fig. 21, and 84, cat. 32. Our attribution to Franco has been accepted by Varick Lauder 2009, 77, n. 28, who cites three other examples of corresponding paintings and prints, for which see ibid., 178. Whether Franco designed the painting or print first remains a matter of speculation.

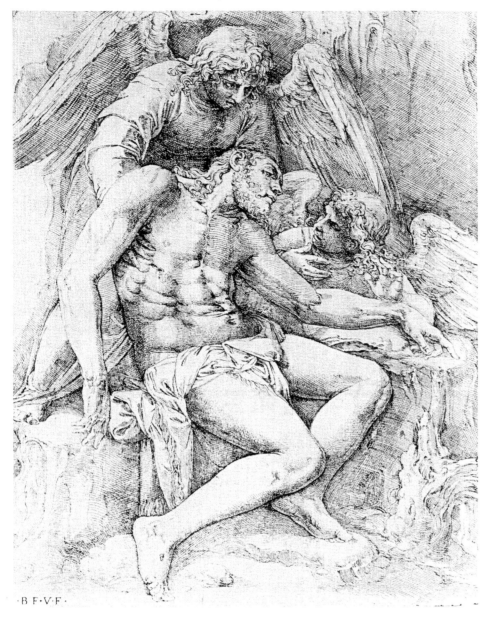

·B F·V·F·

Cat. 48

his Venetian years, but because the Chicago panel and Metropolitan Museum of Art print do not include the spacious landscape settings he adopted following his reacquaintance with Venetian art, they may have been conceived just after his repatriation.[8] A counterproof of the print is in fact dated 1555 and offers a point of reference for the completion of the composition.[9] Rethinking his preliminary ideas for the theme, Franco not only adjusted the composition and figural style but also significantly changed the meaning of the image. Christ, his eyes now opened, turns his gaze towards the newly introduced angel, whose startled reaction heralds the imminence of the Resurrection, a miracle further implied by Christ's left arm reaching out, animate and seemingly unsupported. Franco's novel interpretation of the traditional Venetian subject later inspired the variations on the Dead Christ with Angels by Paolo Veronese and Giuseppe Scolari (see cats. **50, 52, 53** and **54**).

8 For the related prints, see Biferali and Firpo 2007, 206–207. For Franco's incorporation of landscape into his Venetian works, see Van de Sman 1995, 108.
9 See Bartsch 1982, 74, no. 24, for the counterproof bearing the same measurements. Note that the Metropolitan Museum of Art example is trimmed at the bottom just above where Franco's initials appear in other examples, for which see Zerner 1979, 180, cat. 24. A related composition with a two-figure group of the *Dead Christ Supported by an Angel* was etched by

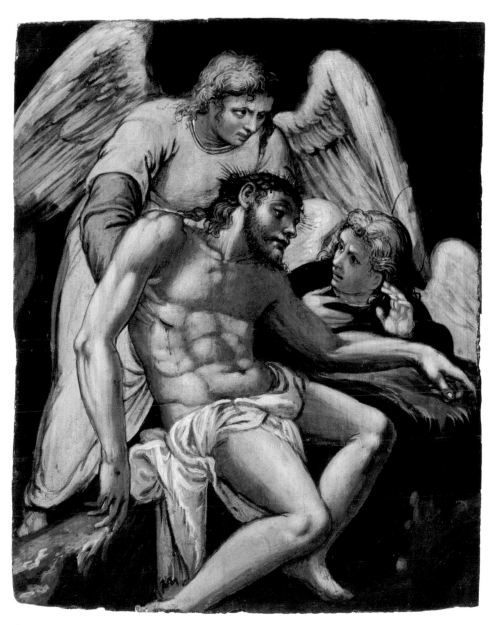

Cat. 47

Franco as one of nine small tondos on
the same sheet, now in the Vatican Library;
see Parma Baudrille 1995, 97, for an
illustration of the etching, which measures
105 mm. in diameter. Although its composi-
tion is oriented in the same direction as the
Princeton and Braunschweig drawings,
the description and position of Christ's
torso and arms more closely match the
panel and print. See also Varick Lauder
2004, vol. 3, cat. 61 PRA.

49

Jacopo Tintoretto (1519–1592)
Christ Mocked, c.1548–1549

Oil on canvas, 88.9 × 87.6 cm. (35 × 34.48 in)
Inscribed: I. TENTORETO. F
Private collection

This powerful but only recently identified work by Tintoretto (one of Venice's three great painters of the mid-sixteenth century together with Titian and Veronese) exemplifies how the young artist skillfully created an innovative portrayal of Christ during the Passion.[1] Deftly manipulating his brushwork to contrast the subtle chiaroscuro modeling of a tawny, muscular nude body with richly applied brushwork for the shadows and highlights of colorful drapery folds, Tintoretto realized a monumental and physically tangible Christ isolated in a world of almost total darkness and lacking identifiable markers. Even Christ's two supports are hidden from view. He sits directly before us; cut at the knees, his legs drop in space, a configuration similar to the solutions that both Bellini and Moderno employed for the Man of Sorrows (fig. **17** and cats. **30–32**).

Yet Tintoretto's Christ is not the Man of Sorrows.[2] His figure is alive and looks knowingly outward. Christ is untied, and his disrobed body has not been scourged. His crown of thorns pricks him so that blood streaks onto his forehead and shoulders. Tintoretto combined several moments from the Passion—the Crowning of Thorns, the Mocking and the *Ecce Homo*—but he disconnected Christ from the gospel accounts by expunging Pontius Pilate, the torturers, and the angry crowd. Eluding temporality, his painting nonetheless recalls the Passion narrative, as do related works by Antonello da Messina and Titian.[3] But different from their solitary figures of Christ, Tintoretto's neither weeps nor turns away. He and the faithful gaze upon each other, Christ asking them to accept responsibility for his suffering and impending death.[4] This indictment of universal culpability finds expression in Latin verses reportedly inscribed below a *Crucifixion* painted in the church of the Holy Sepulcher in Jerusalem: *Aspice qui transis/ quia tu mihi causa doloris* ("You who go this way were the cause of my woe"), a terrible accusation of man's guilt for Christ's suffering.[5] The very phrase inscribed in Jerusalem is incised too on an early relief of the Man of Sorrows in Cividale del Friuli, its sentiments resting at the core of our subject and reverberating with the message of Isaiah 53:3. Tintoretto's Christ, sentient rather than dead, seeks to cast the same tragic indictment.[6]

1 See Christiansen 2006, who published this painting, discussing both style and iconography.

2 Indeed, unlike Veronese he painted the figure but once and then for a public venue; see Sinding-Larsen 1974, 99–108, plates XXXII–XXXIII.

3 Christiansen 2006, 769, and Verdi, 46, fig. 36, cat. 4.

4 Mantegna's *Man of Sorrows with Angels* in Copenhagen (fig. **18**) and Dürer's *Man of Sorrows Mocked by a Soldier* (cat. **36**) do the same. See Sawyer 2010 for a discussion of the charge to mankind.

5 Theoderich 1986, 16, cites the inscription above the doorway leading into the church from the Great Cloister. The verses recall the Lamentations of Jeremiah 1:12, "o vos omnes qui transitis per viam adtendite et videte si est dolor sicut dolor meus" ("O all ye that pass by the way, attend, and see if there be any sorrow like to my sorrow") For the *Crucifixion* in the Holy Sepulcher and the diffusion of Jeremiah's verse and its variations, see Belting 1990, 6–8, and Appendix B, and Marrow 1979, 65–67. Sensi 2000, 85, also recognized the link between the Jerusalem *Crucifixion* and Jeremiah 1:12.

6 For the relief in Cividale, see Marioni and Mutinelli 1958, 189 and 531, and Puglisi and Barcham 2006, 412, n. 20.

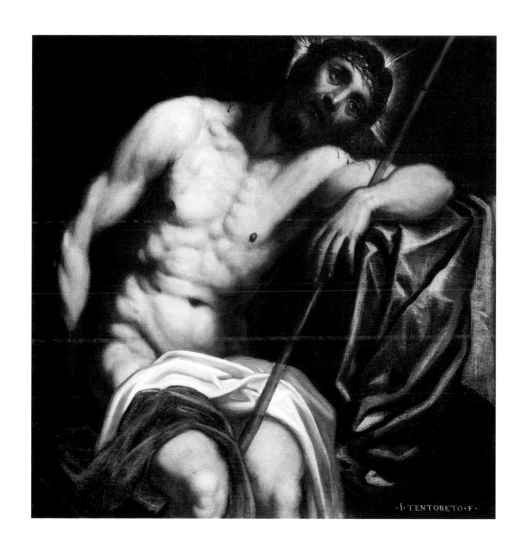

50

Paolo Veronese (1528–1588)

The Dead Christ Supported by Angels, 1563–1565

Oil on canvas, 221 × 250.5 cm. (87 × 98.6 in.)
National Gallery of Canada, Ottawa, inv. 3336

This lunette-shaped canvas originally formed the upper segment of a monumental altarpiece that Veronese painted for the Petrobelli family's funerary altar in the church of San Francesco, Lendinara.[1] The altarpiece was cut up and sold during the Napoleonic period and its surviving fragments are now scattered in four museums.[2] However, following long and painstaking restoration, the Ottawa lunette was recently reunited with its three companion fragments in a temporary reconstruction of the fifteen-foot-high altarpiece that conveyed its original grandeur and splendor (fig. **50.1**).[3]

The Dead Christ attended by three angels materializes as a vision on a cloudbank wafting down from the golden heavens into the earthly realm, demarcated by the stately fluted columns of a loggia opening onto blue sky and distant mountains. The lower half of the altarpiece presented donor portraits of Antonio and Gerolamo Petrobelli accompanied by their respective patron saints, Anthony Abbot and Jerome, and between them in the center, Saint Michael the Archangel vanquishing Satan. The altar itself was dedicated to Michael, but his iconographic associations with the Dead Christ were well established by the 1560s, as, for instance, on the central panel of the Metropolitan Museum of Art triptych (cat. **10**), also from the Veneto mainland, and even more explicitly in Giambono's *Archangel Michael* where the Man of Sorrows decorates the robe Michael wears as deacon-saint (fig. **9**).[4]

The Ottawa lunette is the earliest of Veronese's many variations on the theme of the Dead Christ with Angels and the first of two examples where the image filled the upper half of an altarpiece.[5] The gradual replacement of the Gothic polyptych by the Renaissance single-field altarpiece had disrupted the Venetian custom of positioning the Man of Sorrows in the crowning pinnacle (see cats. **19**, **22**, and **23**), and by the mid-sixteenth century the figure had all but disappeared from church altars. Creatively responding both to changing taste and to the devotional requirements of the Petrobelli, who belonged to Corpus Christi confraternities, Veronese adapted the Man of Sorrows for the new style of altarpiece, transforming the figure into a heavenly apparition.[6] While retaining the formal frontality and symmetry favored by his late fifteenth-century Venetian predecessors, he added a third angel behind Christ, perhaps to allude to the Trinity; below, he painted two airborne cherubs brandishing Instruments of the Passion.[7] Omitting the sarcophagus and adding an orange tree served to heighten the redemptive message of Christ's sacrifice for the Petrobelli.[8] Nearly two decades later, Veronese developed the pictorial innovations of his provincial work for an altarpiece in S. Zulian, Venice, and then revised the lunette's figural grouping for several independent easel pictures (see cats. **52** and **53**).

Fig. 50.1

Fig. 50.1. Stephen Gritt and Xavier F. Salomon
Reconstruction of the Petrobelli
Altarpiece, 2008

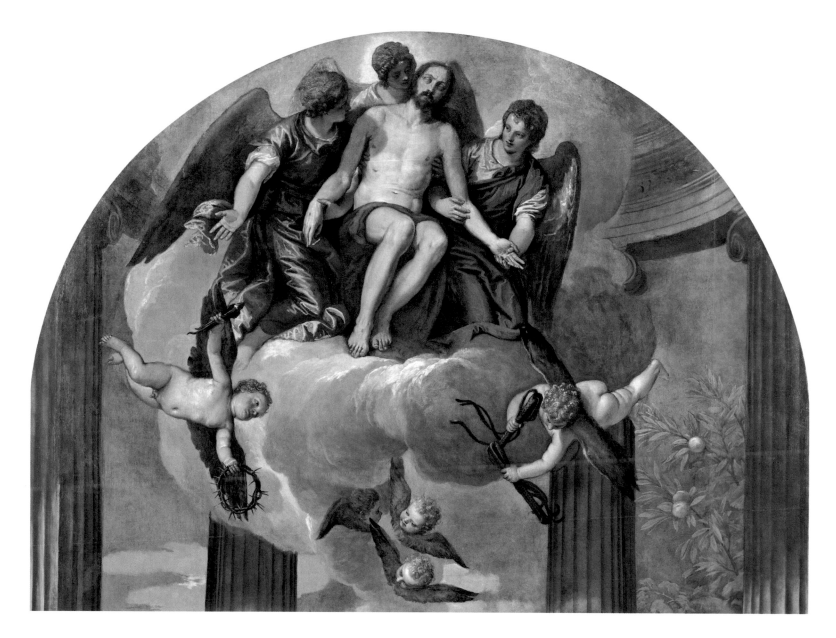

1 Lendinara is near Rovigo in the Veneto.
2 For the most recent discussion and earlier bibliography on the Petrobelli altarpiece and its fragments, see Salomon 2009.
3 We thank Stephen Gritt, conservator at the National Gallery of Canada, Ottawa, for keeping us apprised of the restoration; see his report "Pieces of the big Picture: the *Petrobelli Altarpiece* and Studio Practice," in Salomon 2009, 103–125.
4 Salomon in Salomon 2009, 85, notes too that Michael "fits within a known and well-established Franciscan cult of the archangel."
5 The luminosity of the restored lunette accords with the revised dating of the altarpiece to the early 1560s, as indicated by the founding of the altar in 1563 and the testimony of the early sources; see *Age of*

Titian 2004, 168–169, and Salomon 2009, 75. As noted by Humfrey, *Age of Titian* 2004, cat. 59, the early dating rules out workshop assistance, which has been further confirmed by the quality of execution revealed in the restored lunette; see Gritt in Salomon 2009, 111. For Veronese's second altarpiece, still *in situ* in S. Zulian (or S. Giuliano), Venice, see Pignatti and Pedrocco 1995, vol. 2, 403–404, cat. 292.
6 For background on the Petrobelli, see Humfrey in *Age of Titian* 2004, 168, and Salomon 2009, 71–73.
7 Salomon 2009, 86, suggests that the colors of the angels' garb might allude to the Three Theological Virtues.
8 For the symbolism of the orange tree, see Ferguson 1975, 35.

51

Agostino Carracci (1557–1602),
after Paolo Veronese (1528–1588)
Dead Christ with Mary and Angel, 1582

Engraving, 407 × 286 mm. (16 × 11.25 in.)
Inscribed (from bottom left): Agu. Car. fe. / Paolo Calliarj Veronese inve./
Oratio Bertelli for. 1582
The Metropolitan Museum of Art, New York, inv. 53.600.2099

The Venetian pictorial tradition was central to the reform of painting launched in Bologna at the end of the sixteenth century by the three Carracci: Annibale, Ludovico, and Agostino. But unlike his brother Annibale and cousin Ludovico, Agostino had trained as a printmaker and produced engravings after works by Titian, Tintoretto, and Paolo Veronese, which he studied at first hand during trips to Venice in the 1580s.[1] This print of the *Dead Christ with Mary and Angel* is one of six by Agostino after religious paintings by Veronese, with whom he was in close contact.[2] Veronese's biographer, Carlo Ridolfi, wrote that Agostino's engravings enhanced the Venetian artist's fame.[3] This engraving reproduces Veronese's canvas of 1581 (Hermitage, St. Petersburg) thought to have originally decorated the altar of the Pietà in the Dominican church of Santi Giovanni e Paolo, Venice.[4] In both the engraving and Veronese's painting, Mary and an angel accompany the full-length, seated Christ in a grouping that recalls the Petrobelli lunette of some twenty years earlier (cat. **50**), but here the design is more tightly knit. Mary, gently supporting Christ's torso from behind, and the angel, kneeling at his side, bend their heads together to gaze upon Christ's face, serene as if in sleep. The angel entwines his fingers with Christ's, lifting up his left hand to display the wound of the Passion. The angel's own left hand is outstretched, perhaps inviting the devotee to contemplate Christ, but his wondrous look and the seeming sign of incipient life in the raised fingers of Christ's right hand imply too that their gestures announce the impending miracle of the Resurrection.[5]

Agostino did not merely replicate Veronese's design but subtly altered the composition, opening space around the figures and setting them in a landscape with a massive tree at right. Soft, natural lighting, evoked by Agostino's range of grey tones, translates Veronese's divinely lit nocturnal scene from a chromatic to a graphic medium.[6] Unlike the Eucharistic function of the original painting for its altar, the engraving would have diffused the image for private prayer and also for the pleasure of connoisseurs who admired Agostino's masterful prints. MY

1 For Agostino's trips to Venice, see DeGrazia Bohlin 1969, 40.
2 For Agostino's commemorative portrait engraving of Veronese, see Bohn 1995, cat. .098, and for Agostino's five other engravings after Veronese, see DeGrazia Bohlin 1969, cats. 103–107, and Bohn 1995, .097, .099–.102. For a revised view of Agostino's business arrangements with artists and publishers, see Bury 2001, 75.
3 Ridolfi 1837, II, "Vita di Paolo Caliari Veronese," 75–76.
4 Cocke 2001, 80.
5 In the painting, the Resurrection is also presaged through color: Veronese used a warm pink tone for Christ's raised left arm to communicate the return of life while the angel leads him forth.
6 Bury 2001, 191–192, cat. 130, raises the possibility that Veronese advised Agostino on the changes.

Paolo Calliari Veronese inue.
Oratio Bertelli for. 1582.

Agu.Car.fe.

52

Paolo Veronese (1528–1588)

The Dead Christ Supported by Angels, c.1580–1588

Oil on canvas, 98.1 × 71.4 cm. (38.6 × 28.1 in.)
Museum of Fine Arts, Boston, Maria Antoinette Evans Fund, inv. 30.773

One of several depictions by Veronese of the Dead Christ with Angels from the last decade of his life, this canvas is distinctive in its intimate scale and meditative mood. The scene portrays Christ seated on the edge of a sarcophagus of red marble from Verona (the artist's native city), his upper body and head supported from behind by an angel clad in deep green. Vivid against the gleaming pallor of his skin, thin streams of blood trickle down Christ's side and streak across his hands and feet. A second angel dressed in shimmering rose kneels on the tomb and carefully holds Christ's arm while gazing at the wound on his left hand. The figures barely move against the enveloping darkness of the background, and silence suffuses the scene.

 The existence of a slightly smaller version of the same composition, in reverse, in the Staatliche Museen, Berlin, together with a copy in Bologna, suggests that Veronese's workshop assisted him in the 1580s in producing private devotional paintings of this theme.[1] Although his original study has not yet been identified, a sheet datable to 1573 includes two small pen and ink sketches for a full-length Dead Christ supported by two angels.[2] These studies reveal a fundamental shift in Veronese's development of the subject from the frontality and symmetry of the Petrobelli lunette (cat. **50**), still tied to the late fifteenth-century Venetian tradition, to a new, dynamically conceived figural grouping in which Christ's body turns in space and angels assume varied positions while undertaking specific tasks. Veronese further enriched his mature conception of the theme with saturated, glowing colors against a nocturnal setting, a juxtaposition first introduced perhaps in the *Dead Christ with Mary and Angel* in the Hermitage and repeated in the Boston painting shown here. These affective interpretations of the theme reflect the intense religious fervor of late sixteenth-century Venice that found fresh meaning in the image of the Man of Sorrows, newly transformed by Veronese and in contemporary works by Bassano and Scolari (cats. **54** and **58**), which influenced the many depictions that Palma il Giovane produced into the next century.

1 For the variant in Berlin, inv. 312 (95 × 64 cm.), see Pignatti 1984. In its firm modeling, smooth finish and saturated colors, the handling of the Boston canvas reveals the hand of a different member of the workshop from the Berlin version. Pignatti and Pedrocco 1995, 505, cat. A7, tentatively attributed the Boston canvas to Veronese's brother, Benedetto Caliari, and noted another replica, possibly by Veronese's youngest son, Carletto Caliari, in the Fondazione del Monte di Pietà di Bologna e Ravenna (Bologna).
2 Pen and ink with wash, heightened with white, 296 × 274 mm., Stuttgart, Staatsgalerie, Koenig-Fachsenfeld Collection, III, 76. W. Roger Rearick in Bettagno 1988, 59–60, cat. 16, rightly questioned the connection of the drawing to the Berlin *Dead Christ* with three-quarter-length figures (inv. 295), for which see Cocke 1984, 154–157, cats. 64, 64v. Christ's pose in the Stuttgart drawing reveals Veronese's study of Michelangelo's Florentine *Pietà*, also a source for Scolari's woodcut (cat. **54**).

53

Paolo Veronese (1528–1588)

The Dead Christ Supported by an Angel
and Adored by a Franciscan, c.1586–1587

Oil on canvas, 86 × 125 cm. (33.85 × 49.2 in.)
The Museum of Fine Arts, Houston, TX, Gift of Mr. and Mrs. Isaac Arnold, Jr.
in memory of Hugh Roy and Lillie Cullen, MFA, H #: 79.254

Veronese's mature representation of the Dead Christ varies greatly from the early Ottawa lunette (cat. **50**) and his other versions of the theme of the same decade (cats. **51** and **52**). Painted only a few years before his death, the Houston work might betray a preoccupation with mortality as has been suggested, but his engagement with the subject in the 1580s likely reflects the mood in Venice during years marked by war and natural disasters and impacted too by the reforms of the Council of Trent.[1] Like Bellini in his Rimini painting of a century earlier (fig. **17**), Veronese adopted a horizontal format here, unusual for the image and possibly indicative of an intended location over a door.[2] The Dead Christ and the supporting angel fill the right half of the scene and are balanced at left by the praying Franciscan friar and landscape view. A sumptuous red drapery, typically found in the artist's portraits of patricians, ennobles Christ and his angel, and draws out the splashes of blood on Christ's body. The drapery serves further to distinguish the sacred realm, where the divine vision appears, from the earthly sphere where the friar's meditation takes place.

Truncated at the base, Christ's muscular body leans forward, its corporeality accentuated as it seems to project into real space.[3] The shimmering white shroud heightens his pallor, which contrasts with the warm, rosy hue of the angel's limbs. Partially concealed behind Christ's broad torso, the angel gently lifts his right arm, offering its bloodied hand to the friar, whose intense gaze and fervent gesture of prayer imply that he is focusing on the wound, mirrored by his own stigmatic marks. The friar's clean-shaven face and robust stature belie his identification as Saint Francis of Assisi despite his stigmata. The figure's highly individualized features suggest a portrait of the patron, who may have borne the name Francesco, or professed special devotion to Saint Francis, or himself been a Franciscan, perhaps a tertiary (a lay member of the Order).[4] Though unique in Veronese's interpretations of the theme, the devotee's presence reaffirms the long association between the Franciscans and the Man of Sorrows. MY

1 See W.R. Rearick, "The 'Twilight' of Paolo Veronese," in *Crisi e rinnovamenti*, 237–253.
2 Rearick 1988, cat. 100, noted Veronese's source in Bellini's art, claiming unconvincingly that the composition is archaizing.
3 Clifton 1997, 154, cat. 71.
4 Wilson 1996, 365–366, cat. 36, proposed that another saintly stigmatic, not yet identified, is represented.

54
Giuseppe Scolari (fl. 1580–1607)
*Dead Christ Supported by an Angel, c.*1582

Woodcut, 453 × 311 mm. (17 13/16 × 12 1/4 in.)
Inscribed (lower right): 1582 / Koeck
The Metropolitan Museum of Art, New York, inv. 56.570.6

Inscribed in the Venetian painters' guild between 1592 and 1607 and active in his native Vicenza and nearby Verona, Scolari was one of the major printmakers working in the woodcut medium in the late sixteenth century.[1] His reputation rests on a small corpus of woodcuts displaying striking originality in both composition and technique. Titian's xylographic designs had conferred a high premium on the medium in Venice throughout the century, but Scolari—unlike Titian and most contemporaries—cut his own blocks and did so with exceptional technical prowess.[2] Four of his six prints depicting the suffering Christ narrate moments in the Passion story, while the remaining two present the close-up, half-length devotional figure of the *Ecce Homo* and the inspired invention of the Metropolitan Museum of Art's *Dead Christ Supported by an Angel*.[3]

Like Paolo Veronese, Scolari transformed the static half-length Man of Sorrows of the early Renaissance into a dynamic full-length figure, but the movement and drama he injected into this woodcut are more akin to the art of Titian and Tintoretto than to the contemplative serenity of Veronese's, as seen in cats. **50** and **52**. Scolari's heroic and idealized Redeemer looks towards Michelangelo's conception of the ideal male form and combines motifs from the sculptor's Vatican *Pietà* and Louvre *Dying Slave*.[4] Christ's body, propped against the tomb, is held upright by a muscular angel who crouches on the ledge of the open sarcophagus to support his Lord's weight. Forming a tightly knit group, the two figures seem to spiral upward, their ascent bracketed by the diagonal sweep of the angel's huge, partially spread wings. Scolari also draws upon the Venetian pictorial tradition for his atmospheric and chromatic effects: a turbulent wind blows across the figures to whip up the angel's hair and cause his drapery to billow. He has brilliantly manipulated black against white (and the reverse in the drapery folds) in order to create rich surface patterns that intensify the action.[5] Strong light falling from the upper right bathes the angel's anxious face and selectively illuminates parts of Christ's body. The artist's sharp diagonals accentuate the surging movement of the composition, the resulting image conveying the tragic impact of Christ's death and the promise of the Resurrection to come. The large scale and artistic virtuosity of Scolari's print distinguish it from the mass of anonymous devotional woodcuts produced in late sixteenth-century Venice (see cat. **56**).[6] CM

1 See Rosand and Muraro 1976, 296–297, for an overview of Scolari, whose painted oeuvre has been lost.
2 See Michael Bury, "Printmaking in the Age of Titian," in *Age of Titian* 2004, 277–281. Saff and Sacilotto 1978, 25–26, explain the influence of Albrecht Dürer's innovative woodcuts (cf. cats. **35** and **36**).
3 For his six prints, see Rosand and Muraro 1976, cats. 94, 95, 98, 100, 101, 102. Although labeled *Man of Sorrows,* their cat. 94 depicts the *Ecce Homo,* which Zerner 1965, 25, convincingly placed as the earliest in the sequence.
4 Rosand and Muraro 1976 have argued that "the left hand of Christ [in Scolari's woodcut] goes back indeed to [Michelangelo's] early *Pietà* in St. Peter's."
5 On Scolari's use of black and white, see Ivins 1919, 5, and for his predecessor Urs Graf and the white-line technique, see Saff and Sacilotto 1978, 19–20.
6 This is a later state of the print, with the added monogram of the publisher Koeck and a date, which perhaps provides a *terminus ante quem,* see Dreyer 1971, 61, cat. 46, who likens Scolari's image to the Paduan printmaker Gaspar Osello's print after Federico Zuccari, which was first cited by Nagler 1966, I, 945, no. 10; III, 82–83, no. 217.

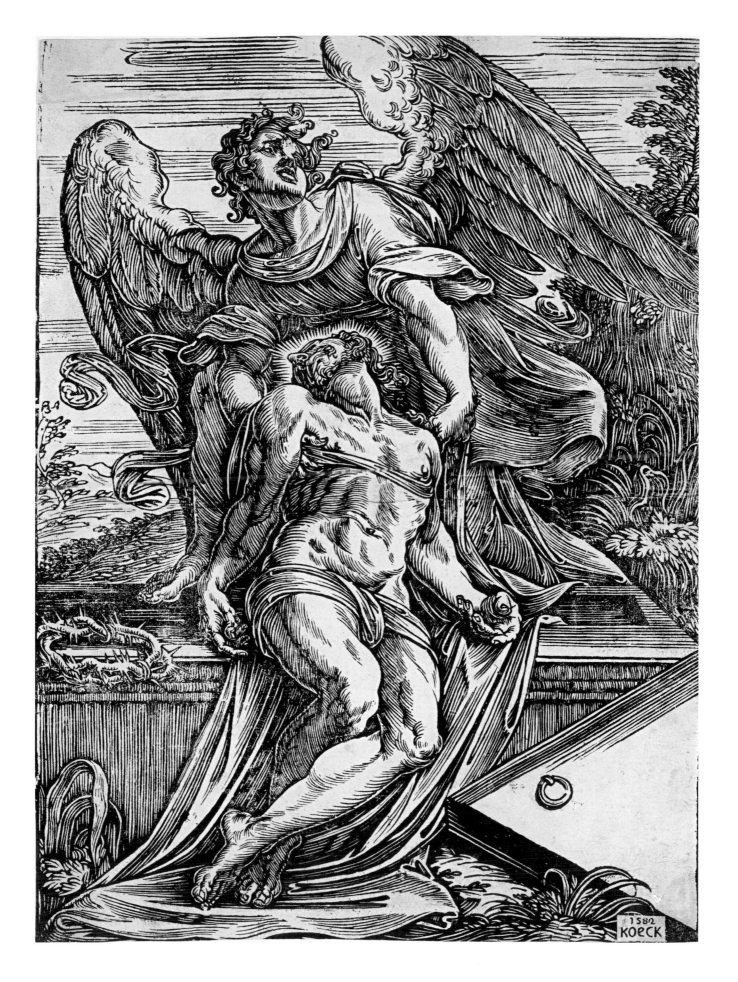

55

Anonymous Veneto goldsmith

Dead Christ Supported by Two Angels, 1589 (?)

Niello plate, height 43 mm. (1.68 in.)
National Gallery of Art, Washington, DC, inv. 1961.9.150

The niello technique consists of pressing a pasty, black alloy comprising varying substances into the lines or incisions of a bright metal plate, usually silver.[1] Used since antiquity, this form of inlay can approximate chiaroscuro effects for modeling, here visible on all three figures. Together with two other niello plates, the Washington *Dead Christ* reportedly decorated the base of a copper-gilt cross carrying the date 1589 that belonged to the abbey of San Cipriano on the island of Murano.[2] The year is crucial for reconstructing the possible genesis of the ensemble.

The medieval abbey of San Cipriano, which had belonged to the *giuspatronato* of the patrician Gradenigo family (that is, it had been under their legal and financial protection) since the late fourteenth century, received a new abbot in 1524 in the person of the patrician Giovanni Trevisan, a Benedictine monk. Appointed Patriarch of Venice in 1560, Trevisan nonetheless retained possession of the abbey thanks to Pope Pius IV, but, seeking to advance his own family, in 1587 he renounced title to it in favor of a nephew. Furious that they risked losing the *giuspatronato* of San Cipriano forever, the Gradenigo challenged Trevisan, but Pope Sixtus V settled the dispute in that same year by assigning the monastery and its properties in perpetuity to the episcopal revenues, or *mensa patriarcale*.[3]

Earlier that same decade, and just after renovating the high altar of Sant'Antonio in Padua, where Donatello had produced his bronze *Cristo passo* more than a century earlier (fig. **16**), Girolamo Campagna completed a monumental *Dead Christ with Angels* for the altar wall of the *Cappella del Santissimo Sacramento* in the Venetian church of San Giuliano, or San Zulian (fig. **12**).[4] Though following the tradition of Donatello and others that paired Christ with two angels (cats. **22, 23, 27** and **28**), Campagna created an innovative Man of Sorrows, one that may have influenced Paolo Veronese and Giuseppe Scolari (cats. **52, 53** and **54**) and unquestionably impacted upon the artist of the tiny niello plate.[5] Only slightly altering Campagna's Christ, and the position of the angel on the right, the anonymous master likely produced the plate and its copper cross to celebrate Sixtus V's decree of 1587 ceding control of San Cipriano and its income to the patriarchy. Trevisan himself is known to have consecrated the reconstructed church of San Zulian in 1580, which makes the link between the niello plate and Campagna's sculpture almost certain.

1 Hind 1936, 7; Lessing J. Rosenwald in *Early Italian Engravings* 1973, 528–531; and Penny 1993, 305.
2 The Crucifix belonged to the great Venetian collector and scholar, Leopoldo Cicognara (1767–1834); see Zanetti 1834, 79 (and museum curatorial files).
3 For Trevisan, see Niero 1961, 92–98. The abbey's history can be followed in Corner 1749, vol. 3, 156–317; Corner 1768, 630–637; Zanetti 1866, 95–97; and Zorzi 1977, vol. 2, 414–415. In 1632, Patriarch Federico Cornaro, Gianlorenzo Bernini's future patron at S. Maria della Vittoria, Rome, transferred the patriarchal seminary to San Cipriano from the land in Venice where Baldassare Longhena's new church of S. Maria alla Salute was to be built; the seminary returned to buildings adjacent to Santa Maria alla Salute, Venice, in 1817, and is still there (Barcham 2001, 227). San Cipriano was razed in 1832 when—one may hypothesize—the niello plate of the National Gallery of Art started its travels.
4 For the chapel, and its decoration, paid for by the church's *Scuola del SS Sacramento*, and for Campagna in Padua, see Mason Rinaldi 1976 (esp. 444); Gallo 1995, 22; and Martin 1998, 263.
5 For Campagna, see Timofiewitsch 1972, 35–45; and Martin 1998.

56

Anonymous Italian printmaker
Christ in the Chalice with Two Angels and Devotees,
late sixteenth century

Woodcut: sheet, 310 × 220 cm. (12.2 × 8.66 in.); print, 267 × 176 mm. (10.5 × 6.9 in.)
The Metropolitan Museum of Art, New York, inv. 22.73.3-120

The three-quarter-length figure of Christ emerging from a monumental chalice and supported by full-length angels appears as a vision high above an altar, over billowing clouds with two angelic heads.[1] Christ is both monumental and muscular; he wears the crown of thorns, and the flanking angels hold his arms out so that the male and female worshipers kneeling in reverence may see his gaping stigmata. The comparative simplicity of the devotees' clothing, in particular the lack of any official markings on the men's garb, and the generalized facial features of the foursome suggest that they are members of the *cittadini* or citizen class of Venetian society.[2] Possibly they belong to one of the Venetian *Scuole del Santissimo Sacramento*, or Confraternities of the Holy Sacrament, which were open to men and women alike but only from among the *cittadini*. The scene shown here resembles miniatures found in the *mariegole*, or rulebooks, of such confraternities (cats. **40** and **41**), and the woodcut was probably produced in this milieu.

For Confraternities of the Holy Sacrament, Christ in the Chalice held a special significance as the body of Christ present in the Eucharist.[3] Entrusted with the reservation of the host and obliged to carry the sacrament to its sick members, each confraternity encouraged a profound devotion to the Eucharist, and this woodcut possibly served as a devotional image for confraternal members, who perhaps tacked it onto a wall or pasted it to a panel as an affordable substitute for a painting.[4] In contrast to the ambitious contemporary prints by Agostino Carracci and Giuseppe Scolari (cats. **51** and **54**), the simplicity of the design and execution of the Metropolitan Museum of Art woodcut suggests that it was valued more for its religious function than for its artistry. Indeed, it would have been a daily reminder to its owner of his or her obligations to the sacrament, an issue that likely intensified following contemporary debates between Catholics and Protestants regarding the nature of the Eucharist. For the Catholic Reform, Christ in the Chalice offered a visual manifestation of the doctrine of transubstantiation and declared the triumph of the Eucharist to the faithful.[5] KM

1 Rightly rejecting both A. Hyatt Mayor's attribution to Paolo Veronese (Mayor 1938, 129) and Hans Tietze's to Palma il Giovane (Tietze 1948, 62–63), Rosand and Muraro 1976, 278, assigned the work to an anonymous Venetian sixteenth-century artist.

2 For examples of late sixteenth-century costumes, see Vecellio 2008.

3 For sacrament confraternities and decorative programs related to it, see Cope 1979, Hills 1983, and Worthen 1996.

4 Slightly damaged at the corners and creased as if once folded, the sheet suggests the customary heavy use and handling of such woodcuts, but of course the damage might also result from later collecting practices. For prints as devotional objects, see Ivins 1969, 27–28; Mayor 1971, illus. 87–93; and Rosand and Muraro 1976, 10.

5 For the use of the Man of Sorrows in a chalice in a later, northern print with clear Counter-Reformation significance, see Clifton 1997, 126.

57

Palma il Giovane (*c*.1548–1628)

*Man of Sorrows in Chalice with Four Angels, c.*1620

Pen and brown wash, 268 × 191 mm. (10.55 × 7.5 in.),
laid down on larger sheet, 350 × 225 mm. (13.77 × 8.85 in.)
Fondazione Musei Civici, Museo Correr, inv. 1734

Following upon Titian, Veronese, and Tintoretto, Palma was the last important Venetian artist trained in the sixteenth century.[1] He completed Titian's great *Pietà* on the master's death in 1576, then immediately began an illustrious public career with an enormous canvas for the ceiling of the Sala del Maggior Consiglio in the Ducal Palace after the fire of 1577.[2] Long-lived, prolific, and esteemed in his lifetime, Palma most likely left an altarpiece in every Venetian church. His career developed following the Council of Trent (1545–1563) and while Catholic reforms were under enactment. His many painted and drawn depictions of the Dead Christ with Angels reflect the spiritual innovations of the post-Tridentine Church and its renewed emphasis on Eucharistic celebration and the holy sacrament.[3]

In representing the Man of Sorrows as Christ in the Chalice, a theme found in sixteenth-century *mariegole* and in the New York woodcut (cats. **40, 41** and **56**), the beautiful Correr drawing and another, closely related one by Palma in Edinburgh convey the deeply held Catholic belief that the Holy Sacrament is the living body of Christ.[4] The two sheets are almost identical in size and medium, but their designs are reversed: whereas the Scottish composition shows Christ slightly turned to his proper right, his head falling likewise, its counterpart in Venice directs him to the worshiper's right, untraditional when viewed against the convention of the *Imago pietatis* but not unusual in the context of sixteenth-century interpretations. Both sheets have been pricked along the figures' outlines, and the oval design of the Correr composition is better defined.[5] It is difficult to determine the chronological relationship of the sheets —that is, which came first—until both are examined one on top of the other to see the alignment of the pricking. Perhaps Palma produced them for a print, but if so, it does not survive. He could also have prepared the finished drawings for liturgical use, either as an embroidery on a vestment or as a grouping on a tabernacle door, and we suggest too that a carpenter or sculptor might have used them for the top of a standard or a stone relief (cats. **42, 43**, and fig. **10**).[6]

1 Palma's sobriquet, *il Giovane* (the Younger), distinguishes him from his great-uncle, Palma il Vecchio (the Elder), who had died in 1528. Mason Rinaldi 1984 remains the best source for the younger artist.
2 Palma painted *Venice Crowned by Victory*; Veronese executed the *Triumph of Venice* and Tintoretto the *Triumph of Doge Nicolò da Ponte*.
3 Palma's versions are too many to list, but see Mason Rinaldi 1984, cats. 14, 16, 29, 45, 305, 489, 491, 514, 610, 611; and Mason 1990, 234–235, cat. 102. At least three of Palma's drawings are in the Musée du Louvre: inv. 5187–5189; and see too Mason in Furlan 2000, 190–191, cat. 54 (Louvre 5188). Material on the Catholic Reform movement, especially in Venice and the Veneto, is extensive: see Mason Rinaldi in Gullino 1990, 183–194, Prosperi 1999, and Christoph Jobst, "Liturgia e culto dell'Eucaristia nel programma spaziale della chiesa," in Stabenow 2006, 91–126.
4 For the Correr drawing, see Pignatti 1996, 115, cat. 1303, and Baviera and Bentini 1997, 164–165, cat. 46. Marcon 2007, 283, mentions the drawing in relation to the *mariegole*. For the Edinburgh drawing, see Finaldi 2000, 180–181, cat. 70, and *Age of Titian* 2004, 265, cat. 118. Stefania Mason has kindly brought to our attention yet a third, less finished drawing of the subject by Palma that appeared for sale at Sotheby's, London, on April 9, 1970, lot 20. The subject was of course known in northern Europe; see for example Hieronymus Wierix's engraving in Clifton 1997, 126, cat. 57.
5 We examined only the drawing in Venice.
6 For the suggestion of an ecclesiastical garment or tabernacle door, see *Age of Titian* 2004, 265, cat. 118.

58
Leandro Bassano (1557–1622)
The Dead Christ with Angels, c.1580

Oil on canvas, 123.3 × 96.5 cm. (48.54 × 37.99 in.)
Cleveland Museum of Art, Cleveland, OH, CMA 1916.806

Leandro is one of several painters in our exhibition representing the remarkable tradition of the Venetian family workshop; the others are Bartolomeo Vivarini, Paolo Veronese, and Jacopo Tintoretto. As the last important painter of these and other distinguished families, Leandro claims a noteworthy position in the history of Venetian art.[1] Born into the provincial but celebrated dal Ponte family of artists, remembered today by the name of their native town, Bassano, Leandro entered his father Jacopo's studio in the 1560s. He settled definitively in Venice in 1582 and spent the rest of his life there producing altarpieces, history paintings, and portraits.[2] He enjoyed great success in the city and on his death was honorably buried in the church of San Salvador near the Rialto Bridge.[3]

His Cleveland canvas replicates the angelic accompaniment typical of the Veneto tradition of the Man of Sorrows that reaches back centuries, but he adventurously turned Christ's body in profile. He also positioned the two angels asymmetrically, placing one behind Christ to support his upper body and the other kneeling at his feet. Leandro's invention expanded upon his father's own *Man of Sorrows with Two Angels* (Verona, private collection), but he was affected too by several of Jacopo's altarpieces where dead figures are carried to burial, the corpse parallel to the picture plane and seeming to initiate a narrative.[4] Indeed, Leandro opened a view to a landscape of Calvary on the right where three distant crosses refer to the Crucifixion. In the foreground, bright red blood gushes from Christ's head, hands, and side, and a white shroud with swirling folds underscores his imminent burial. The crown of thorns has fallen to the ground, and the halo replacing it on Christ's head glows to signify his divinity. Bassano's scene presents an early example of the "Angel Entombment," a theme that developed in art after the Council of Trent.[5] His moving image surely pleased many, because it was replicated several times. Four known versions exist, two of which, in Zadar and the Museo di Castelvecchio in Verona, are lesser in quality and are attributable to Gerolamo, Jacopo Bassano's youngest son.[6] CM

1 *Bassano Drawings* 1961, 1: "In the Veneto, where a tradition in family painting workshops often extended over three generations, the dal Ponte clan from Bassano extended its activity over an almost unparalleled century and a half, encompassing in style the tradition of the late Quattrocentro, exploring the Renaissance and Mannerist styles, and ending well after the height of the Baroque period." Leandro's brothers were Francesco, Giambattista, and Gerolamo.
2 Fröhlich-Brume 1932, 113; and Alberton and da Sessa 1992, 89.
3 *Jacopo Bassano* 1993, 565.
4 See *Jacopo Bassano* 1993, 21, fig. 6, for the painting in Verona, and 20, fig. 5, for an anonymous print after it; 108, fig. 40, for the *Good Samaritan* of 1562–1563 in the National Gallery, London; and 390–391, cat. 51, for the *Entombment of Christ* of 1574 in Santa Maria in Vanzo, Padua.
5 Mâle 1972, 288–291.
6 Oral communication from Stefania Mason, November 2009. See also Petricioli 1956, for illustrations of the replicas.

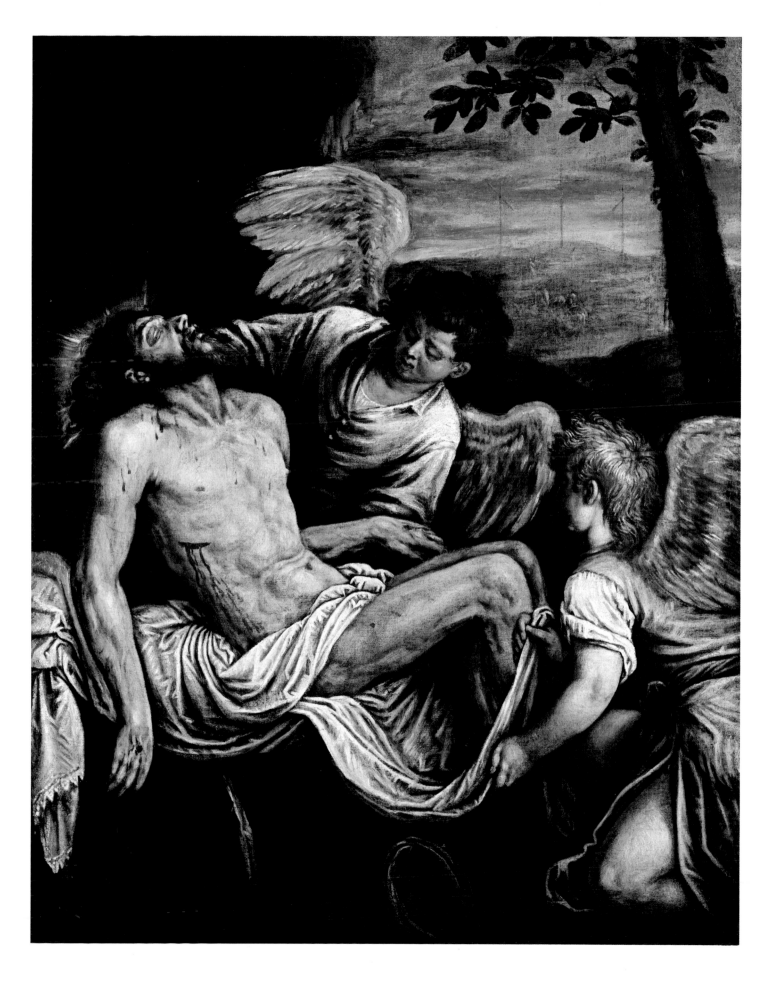

59

Alessandro Turchi, called l'Orbetto (1578–1649)

The Lamentation, c.1620–1625

Oil, heightened in gold, on copper, 26.1 × 20.96 cm. (10.27 × 8.25 in.)
The Minneapolis Institute of Arts, The Ethel Morrison Van Derlip Fund,
inv. 66.47

Born in Verona, Turchi was one of many northern Italian artists active in Rome between
c.1615 and mid-century; he enjoyed high regard in the papal capital, especially after 1637,
when he became Principe of the Accademia di San Luca, the official painters' academy.
Like other artists of the time, he sometimes interpreted religious narratives as
nocturnes, an innovation begun by Correggio of Parma with his *Adoration of the
Shepherds* of c.1530 (Dresden, Gemäldegalerie) in which an astonishing light emanates
from the baby Christ and onto the darkened world around him. Artists from Verona, only
55 miles from Parma, were especially struck by Correggio's renowned painting,
popularly called *La Notte*, and subsequently employed its invention, particularly for
scenes of Christ's death. Paolo Veronese is the best-known representative of this
development, but the ensuing generation of Veronese artists elaborated upon the idea
extensively. Turchi was the most famous of this group. Exploiting the fashionable new
supports of copper and slate—the first generating brilliance, the second offering its
intrinsic blackness as a haunting spatial milieu—the painters of Verona created
evocative images of the Dead Christ, his muscular but inert body resplendent as a result
of nearby gleaming torch- or firelight or simply glowing with its innate radiance.[1]

Turchi painted more than six different versions of this subject on several supports;
they are all nocturnes.[2] Here he expanded the traditional Man of Sorrows with Angels,
as had Battista Franco and Veronese before him (cats. **47** and **52**), by pairing the angels
asymmetrically. Like other works in this exhibition post-dating the Renaissance,
Turchi's Dead Christ also enriches the traditional Man of Sorrows with narrative
implications. The artist enhanced the scene by including Mary, who, instead of holding
her son as she does in Veronese's great canvas that Agostino Carracci re-created as an
engraving (cat. **51**), rushes onto the scene like a Mary Magdalene figure, gesticulating
passionately. Turchi's invention injects drama into a pictorial convention where a
hushed silence more typically reigns.[3] The angel with golden wings and dressed in green
restrains Mary, preventing her from touching her dead son, while his partner, with blue
wings and nearly nude, carries a burning torch so that she may at least witness him.
Christ has been laid upon his shroud and faces us, and his right index finger points
accusingly at the bloody crown of thorns and the three nails that pierced his hands and
feet. KS

1 For copper, see Bowron 1999, 11, 13. For
works on slate and other stone supports,
see the private Milanese collection
cataloged in Bona Castellotti 2000.
2 Scaglietti Kelescian 1999, 110, cat. 20.
3 For another version of the subject by
Turchi but on slate, bought by Cardinal
Scipione Borghese in 1617 and including
Mary Magdalene and several angels, see
Scaglietti Kelescian 1999, 100, cat. 15.

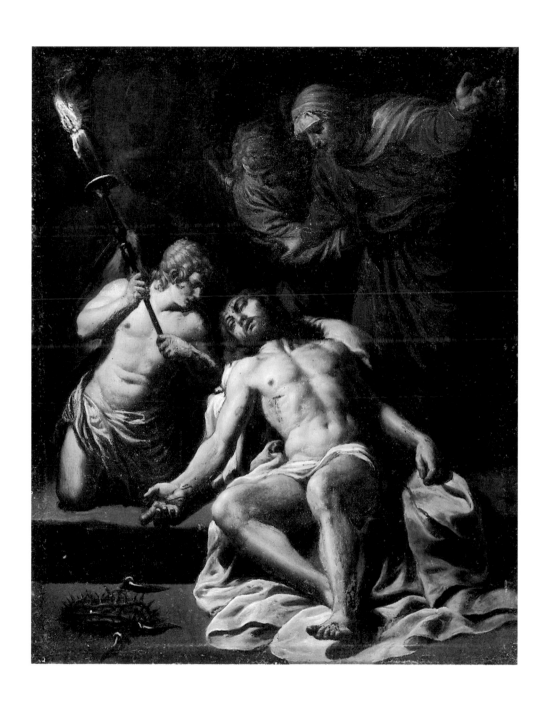

60

Anonymous Flemish sculptor
Ecce Homo, late sixteenth–early seventeenth century

Boxwood, height 22.2 cm. (8.74 in.)
Allen Memorial Art Museum, Oberlin College, Oberlin, OH
Mrs. F. F. Prentiss Fund, AMAM 1971.50

This delicate statuette of Christ underscores the visual resemblance and thematic interdependence of the Man of Sorrows and the *Ecce Homo,* especially in northern Europe (cats. **35** and **36**). German and Netherlandish depictions of these themes often portray Christ full length, standing and alive, seminude, and crowned with thorns, but many representations of the *Ecce Homo* show him wearing a long mantle fastened at the chest and holding a reed scepter.[1] According to the gospels of Mark, Matthew, and John, the Roman soldiers mocked Christ as King of the Jews by arraying him with a purple robe, a crown of thorns, and indeed a reed scepter (Mark 15:17–18, Matt. 27: 28–30, John: 1–3); the Oberlin figure probably once clasped such a rod between his right index finger and thumb. John 19:5 follows the Mocking, however, with the declaration by the Roman prefect Pontius Pilate as he presented Christ to the assembled crowd: "*Ecce Homo*" or "Behold the Man!" When extracted from a narrative representation of these events, the isolated figure of Christ evokes meditation upon the Passion, much as we see in this work and so often in the Man of Sorrows.[2] Yet because of his stance and his glance to the side, the Oberlin Christ insinuates the entire gospel episode of John 19:5, and in this important aspect the boxwood statuette differs from the seated figures of Tintoretto's canvas and the Doccia porcelain (cats. **49** and **61**), both of which sympathetically engage the devotee.

Single figures of the *Ecce Homo* were sculpted in northern Europe from the end of the fifteenth century.[3] The Oberlin figure, in contrast, was probably carved a century or more later, as suggested by its classicizing stance and by the idealizing portrayal of Christ's head and body untouched by any physical marks of the Passion.[4] Exploiting the high polish and rich color of the boxwood medium, the statuette resembles small bronzes and would have appealed to the devout collector as much for its superb quality as its pious subject (see also cat. **37**). LP

1 The lack of wounds on the hands and feet does not always distinguish one theme from the other. Panofsky 1956, 111, observes that northern late fifteenth-century paintings of the *Ecce Homo* often depict the figure as half-length.
2 Schiller 1971, 76; Ringbom 1984, 142–147; Panofsky 1956, 102, 108–122.
3 For the iconography of the theme, see Hourihane 2009, 220–225, who also notes the existence of two-figure sculpture groups presenting Christ with Pontius Pilate.
4 At its acquisition by the Allen Memorial Art Museum in 1971, the statue was already set on its later marble base. We are grateful to Frits Scholten, Senior Curator of Sculpture at the Rijksmuseum, Amsterdam, for informing us that the statuette may be Flemish in origin and date from the late sixteenth or early seventeenth century.

61

After Giovanni Battista Foggini (1652–1725)
Ecce Homo, mid-eighteenth century

White Doccia porcelain, 43.8 × 28 × 36.8 cm. (17.2 × 11 × 14.48 in.)
including base
Private collection

Foggini was the last great Baroque sculptor in Florence. First studying in Rome with Ercole Ferrata (1610–1686), one of Gianlorenzo Bernini's foremost collaborators, he then worked at the Medici court from 1676 until his death. He is famous for monumental works along with small bronzes, one of which provided the model for this figurine made in the Ginori porcelain factory at Doccia outside Florence, founded in 1737.[1] This exquisite statuette represents the widespread European taste at the time for pure white or multi-colored porcelain objects produced by royal factories like those at Sèvres, Capodimonte, and Meissen, in the vicinities of Paris, Naples, and Dresden respectively.[2] The Doccia translation of Foggini's original articulates a paradoxical tension between, on one hand, Christ's anguished face and the pull of his torso and arms to the side and, on the other, its gleaming white surface and gilt finish. Such contradictions may well have appealed to wealthy nobles who, while purchasing works expressing genuine piety, favored glitter and shimmer in their collections—here, the gilding of the cape and rope (augmenting the shine of the original Doccia facture but fired later in St. Petersburg, c.1800, when the statuette was embellished for the imperial collection of Paul I).[3]

Fascinating though its Florentine Baroque/Tsarist Russian history may be, this *Ecce Homo* also brings up issues pertinent to our exhibition theme. The porcelain apparently illustrates the same story as the Oberlin sculpture (cat. **60**), that is, the scene described in John 19:5 where Pontius Pilate proclaims "Behold the man!" before Christ is sent to his crucifixion.[4] But unlike the boxwood Christ, which is a traditionally standing *Ecce Homo*, the Doccia Christ is seated like those by Dürer and Tintoretto (cats. **36** and **49**), both of which insinuate moments from the Passion story different from John 19:5.[5] Representations of Christ's final hours on earth merged or blurred categories, and accounts in the Bible fused with others not described there to enlarge the canon of Passion imagery. This *Ecce Homo*, for example, carries overtones of the Mocking of Christ and also of Christ on the Cold Stone, where Jesus—seated on Calvary and meditating upon his death—seeks the attention of the world.[6] All these subjects inflected and enriched the conception of the Man of Sorrows, especially after the Catholic Reformation when iconographic types oftentimes approximated one another visually to enhance the emotional responses of devotees.[7]

1 *Twilight* 1974, 416–417, cat. 243.
2 Penny 1993, 178–188.
3 *Icons or Portraits?* 2002, 150–151, cat. 57.
4 Foggini's bronze figure may have worn the crown of thorns like the boxwood sculpture from Oberlin.
5 For discussions of the *Ecce Homo* conflating with the Mocking and the Flagellation, see Hourihane 2009, 220–226 (esp. 220), and Sawyer 2010.
6 For Christ on the Cold Stone, popular in Flanders during the late medieval period, see Mâle 1958, 113–116, and Quarré 1971; for this image one thinks in terms of the same words of the *Dies irae* of the Requiem Mass referred to in the introductory essay: *Quaerens me sedisti lassus*, "You sat down wearied while seeking me" (p. **14**). See Panofsky 1956 for the *Ecce Homo* merging with what he termed the *Ostentatio Christi*.
7 See Pope-Hennessy 1965, 121, cat. 451, fig. 464, for a full-length, silhouetted contour figure in gilt bronze termed a Man of Sorrows and described as "Christ . . . seated on a rock with bowed head . . . [h]is cloak falls over the rock, and his wrists are bound," in effect a representation of Christ on the Cold Stone.

62

George Frideric Handel (1685–1759) and Charles Jennens
(1700–1773)
The Messiah, composed 1741

Musical score printed by Randall & Abel, London 1767
The Morgan Library and Museum, New York, inv. PMC 66

Fig. 62.1

Fig. 62.1 Thomas Hudson
George Frideric Handel
Oil on canvas, 1756
94 in. × 57 1/2 in.
Purchased with help from the Handel
Appeal Fund and H.M. Government 1968
National Portait Gallery, London

Handel's great oratorio debuted in Dublin in April 1742, and thenceforth Aria #23 for alto, set to the words of Isaiah 53:3, has been praised for its declamatory effects, its "intense expression of grief" and for the composer's threading of alternating melodic phrases from singer to orchestra.[1] Handel wrote the aria specifically for the famous tragedienne Susannah Cibber who, though endowed with only a small voice, was famous for her dramatic powers of communication.[2] The contemporary composer Charles Burney wrote that "she often penetrated the heart, when others, with infinitely greater voice and skill, could only reach the ear." After hearing Cibber sing Aria #23, Dr. Patrick Delany of Saint Patrick's Cathedral, Dublin, famously said to her, "Woman, for this be all thy sins forgiven thee!"[3] The aria is still considered a test for the singer's charisma.[4]

Handel composed the *Messiah* in less than one month in late 1741 to a libretto by Charles Jennens (pronounced Jennings at the time), author, wealthy landowner and a devout Anglican conversant with the Bible. His text offered Handel the opportunity to write his only oratorio based on the New Testament, one centered on the belief in Christian redemption through Christ's suffering.[5] Following contemporary literary trends, Jennens evoked the sublime by drawing upon the poetic utterances of Old Testament prophets, and he especially acknowledged Isaiah's visionary powers by setting seven of his verses to music.[6] The Book of Isaiah has always exerted enormous influence upon Christian thought (p. **11**), and in particular the link between the prophet's Suffering Servant and Christ has been validated throughout the Christian world since the writings of early Church Fathers.[7] Additionally, Isaiah 53:3 was—and still is—read aloud in churches on Holy Wednesday, sometimes paired with readings from Paul's Philippians 2 (p. **12**), so that the dual recitation highlights Christ's humility and rejection, themes Jennens exalted in Part Two of his *Messiah*.[8] Yet when the oratorio premiered, not one of the works of art in this exhibition was called "Man of Sorrows;" all the same, Handel's musical sensitivity to the anguished imagery of Isaiah's verses complements the artistic figure whose biblical name we now take for granted.

1 The notes of the Morgan Library for the publication of 1767 cite it as the second edition of the full score; Larsen 1957, 215, writes that the "first *complete* edition of *Messiah* was published by Randall & Abel in 1767." And see Larsen 1957, 100.
2 Susannah Cibber (1714–1766) was the sister of the composer Thomas Arne and sister-in-law to the playwright Colley Cibber.
3 Larsen 1957, 141, 195.
4 Ibid., 141.
5 For Jennens, see Smith 1989 and Smith 1995, 190–192. See Lang 1966, 342, for the "plan" of the Christian message.
6 On the sublime in Jennens' libretto, see Smith 1995, 108–126.
7 Sawyer 1996, 44, 47.
8 Sawyer 1996, 93–94. Handel himself went so far as to inform Jennens that the great oratorio was "your Messiah;" see Smith 1989, 162.

63

Edouard Manet (1832–1883)

Dead Christ with Angels, 1866–1867

Etching and aquatint, 330 × 280 mm. (12.99 × 11.3 in.)
National Gallery of Art, Washington, DC, Rosenwald Collection, 1943.3.5755

Manet's etching reproduces his painting of 1864 in the Metropolitan Museum of Art that follows in the long pictorial tradition of the Man of Sorrows with Angels.[1] The artist conceived Christ's body monumentally and frontally so that the wounds are visible; two angels support his muscular figure in a rocky setting envisioned at night. As one angel lifts Christ's head, his eyes open as if Resurrection is underway. Snails and a snake in the foreground allude, respectively, to Christ in the tomb and his subsequent rebirth.[2] Andrea Mantegna's *Man of Sorrows with Angels* (fig. **18**), perhaps known to the French painter through Zoan Andrea's engraving of the panel, is the source that most immediately comes to mind for Manet's frontal, full-length figure, and Paolo Veronese's several interpretations of the theme perhaps suggested both the nocturnal setting and the relative positions and attitudes of the two angels (cat. **52**).[3]

Manet executed only two major religious paintings: the *Dead Christ with Angels* and the *Mocking of Christ* of 1865 (Chicago, Art Institute), and both focus on Christ's Passion, as was usual in French nineteenth-century religious imagery.[4] But Manet's canvas at the Metropolitan Museum of Art elicited strong criticism when it was shown in Paris at the 1864 Salon, in part for its presumed relationship with Ernest Renan's *La Vie de Jésus*, a controversial book published in 1863, and in part because of contemporary debates generally about the relationship between religion and science.[5] The painting was disparaged for Christ's naturalistic appearance and for what was termed the "misplacement" of the side wound on the proper left of his chest; the Bible does not specifically locate the wound, although it was traditionally set on the right.[6] In point of fact, Manet—a practicing Catholic—did not produce either of his two major works on Christ for religious sites but in order to exhibit in the Salons. Indeed he was more concerned with formal issues than with those relevant to sacred imagery. This etching, the largest of his prints, was never exhibited during his lifetime, perhaps to spare him further public disapproval.[7] The sheet demonstrates Manet's distinctive and accomplished technique as a graphic artist.[8] KF

1 Sheppard 1981, 199. Manet inscribed a reference to John 20:12 on a rock in the lower right corner of the painting, the gospel episode recounting Mary Magdalene's discovery of the empty tomb.
2 Werness 2004, 376, 381.
3 See Martineau 1992, 245, cat. 61, for Mantegna's painting and Zoan's print; Florisoone 1937 first suggested Veronese's impact on Manet.
4 Weisberg 1985.
5 Renan reinterpreted the life of Christ in a naturalistic manner, eliminating the "unnatural" or divine elements and claiming that the Magdalene's vision in John 20:12 was merely an hallucination.
6 Gurewich 1957, 358.
7 Cachin 1983, 207.
8 Harris 1990, 12, cat. 51.

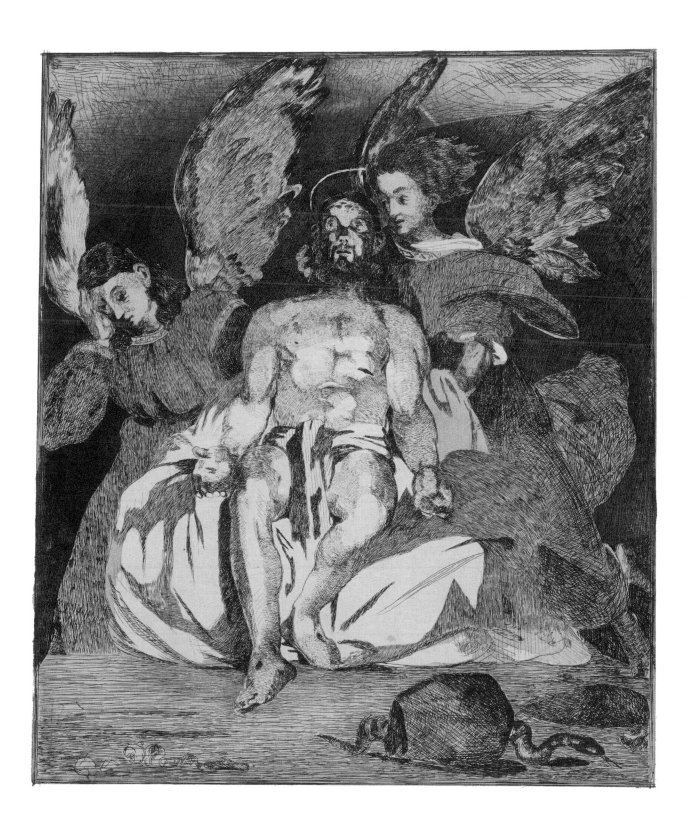

64

Paul Cézanne (1839–1906) after Alonso Cano (1601–1667)

Dead Christ, 1882–1890

Graphite pencil, watercolor, on wove paper; 124 × 116 mm. (4.88 × 4.56 in.)
Inscribed (along right side): Soccio, 7 rue/Maître albert
Philadelphia Museum of Art, Philadelphia, Gift of Mr. and Mrs. Walter H.
Annenberg, 1987, inv. 1987-53-34b

Formerly bound in one of the painter's sketchbooks, this drawing attests to Cézanne's life-long practice of closely studying the old masters for figural ideas.[1] His source in this instance was the art of the Spanish Baroque painter Alonso Cano, but the work Cézanne consulted was not Cano's canvas of the *Dead Christ Supported by an Angel* in the Museo del Prado, rather its reproductive print in the volume of the *Ecole espagnole* of Charles Blanc's *Histoire des peintres de toutes les écoles*, published in Paris in 1869. Cézanne subscribed to the book as part of Blanc's series.[2] Attempting "to do the old masters over again," he started with Cano's Christ but disregarded the landscape and eliminated the angel except for the two hands resting on Christ's shoulders, which appear on the sheet as disembodied vestiges. The Philadelphia drawing undoubtedly served as a starting point for Cézanne's later study of a male bather leaning over to gaze into the water, a work that eventually formed part of his corpus of about eighty painted studies of the human form for his cycle of bathers.[3] His focus here narrows onto the nude's upper body and chest, which he carefully modeled, paying close attention to the effects of torsion on the abdominal muscles. Cézanne's marginal annotation of an address along the edge of the sheet and the stray dabs of watercolor underscore the working nature of this small sketch.

Cézanne's selection of Cano as a source for his drawing did not reflect an interest in the sacred theme of the Dead Christ; like his contemporary compatriot Manet (cat. **63**), he was thinking in terms of the human figure, not in terms of religion. Yet because Cano knew Venetian paintings well and had exposure to many of them through his work with the Spanish royal collections, Cézanne's sheet after the 1869 print lies but a few steps from several works in our exhibition presenting the full-length, seated Dead Christ supported from behind by an angel in a landscape (cats. **46–48, 52, 54**).[4] The drawing is a telling example of how Cézanne created a complex but natural pose, and by way of Cano the sheet also extends the figure of the Venetian Man of Sorrows into the modern era. CO

1 The drawing belonged to Sketchbook I, p. 45v, disassembled sometime after 1950, for which see Reff and Shoemaker 1989, 9.
2 For Blanc's print, see Chappuis 1973, 155, cat. 524, fig. 74.
3 Neumeyer 1958, 15; Rewald 1983, no. 124, for Cézanne's closely related watercolor of a bather on a riverbank that develops Cano's figure of Christ.
4 Cano painted two representations of the *Dead Christ Supported by an Angel*. Both are in the Prado: acc. P00629 (Wethey 1955, 151, fig. 81, c.1646–1652), which Blanc reproduced, and acc. P02637 (Wethey 1955, 151, fig. 80), which shows Christ's head in profile. Cano's own source may have been Hendrick Goltzius's engraving of 1587, which in turn reflects Venetian models. On Cano and Venetian art, see Wethey 1955, 18–19, 47. For Cézanne's appreciation of Venetian art and his drawings based on figures from Veronese's *Marriage at Cana* (Paris, Musée du Louvre), see Ton 2007, 62–64, fig. 17.

65

Bill Viola (b. 1951)
Man of Sorrows, 2001

Color video on freestanding LCD flat panel, 48.26 × 38.1 × 15.24 cm.
(19 × 15 × 6 in.)
Duration: 16:00 minutes
Bill Viola Studio

Purposefully conceived in the traditional format of a small devotional painting, Viola's *Man of Sorrows* modernizes the time-honored sacred theme. His slow-motion video presents a bust-length image of a man dressed in a denim shirt, one button opened at the throat, and seen against a mottled brown backdrop. Throughout the video, the man moves his head from left to right and back, tilting it slightly as he opens and closes his eyes and mouth. Strong light directed from the right heightens the subtle tensing of facial muscles across his brow and cheeks and conveys his state of extreme anguish. Viola's narrow focus on a sorrowful male face closely recalls Antonello da Messina's bust-length images of Christ from the 1470s such as his paintings of the *Ecce Homo* and *Christ at the Column*.[1] Viola further enriched his interpretation through other historical precedents that he studied while a guest scholar in the Getty Research Institute's thematic program of 1997–1999, "Representing the Passions." Both late medieval and Renaissance devotional works, together with Charles Le Brun's well-known seventeenth-century physiognomic studies, provided a model for Viola's meticulous concern for facial expression.

Part of Viola's 2003 exhibition *The Passions,* this *Man of Sorrows* belongs to a series of videos dealing with strong human emotion, and it incorporates a variety of religious influences including Christian mysticism, ancient Hindu scripture, and Viola's personal spiritual involvement with Buddhism.[2] Indeed, Viola's actor does not portray Christ's Passion, presenting instead an archetypal expression of intense emotion. The artist sought to encourage reflection on sorrow and grief through his close-up view and slow tempo. According to Viola, the work serves "for cultivating knowledge of how to be in the world, for going through life. It is useful for developing a deeper understanding, in a very personal, subjective, private way, of your own experience."[3] *Emergence* (fig. **19**), also from *The Passions,* accomplishes the same goal but in contrast depends on a historicizing interpretation of our theme, referring to Masolino's *Pietà* of 1424.[4] Viola's contemporary *Man of Sorrows* evokes the expressiveness of traditional imagery, modifying it to accommodate our twenty-first-century awareness of the multitude of religious and spiritual beliefs. KF

1 For Antonello da Messina's works, see Lucco 2006, cats. 16, 43, 57.
2 Walsh 2003, 31.
3 Ibid., 25.
4 *Emergence* 2002 is a wall projection measuring 6 feet square and showing a slow-moving video that depicts a Christ figure emerging from a shallow tomb overflowing with water. Two women, identifiable as the Virgin and Mary Magdalene, provide assistance in raising the Dead Christ and then bringing him to the ground before wrapping him in a shroud; see Walsh 2003, 140–45. For Masolino's *Pietà* of 1424, see Eisenberg 1989, fig. 333.

Bibliography

Age of Correggio 1986
The Age of Correggio and the Carracci: Emilian Painting
 of the Sixteenth and Seventeenth Centuries,
 exh. cat., Washington, DC, National Gallery of Art
 (Washington, DC, 1986).

Age of Titian 2004
The Age of Titian: Venetian Renaissance Art From
 Scottish Collections, Peter Humfrey, Timothy
 Clifford, Aidan Weston-Lewis and Michael Bury,
 exh. cat., Edinburgh, National Gallery of Scotland
 (Edinburgh, 2004).

Aikema 1990
Aikema, Bernard, Pietro della Vecchia and the Heritage
 of the Renaissance in Venice (Florence, 1990).

Alberton and Da Sesso 1992
Alberton, Livia and Vinco Da Sesso,
 Jacopo Bassano. I dal Ponte: una dinastia di Pittori
 (Bassano del Grappa, 1992).

Anzelewsky 1981
Anzelewsky, Fedja, Dürer: His Art and Life
 (New York, NY, 1981).

Ariès 1977
Ariès, Philippe, L'homme devant la mort (Paris, 1977).

Armstrong, Hellmann and Short 1999
Armstrong, Regis, Wayne Hellmann and William
 Short, eds., Francis of Assisi: Early Documents I
 (New York, NY, 1999).

Armstrong, Hellmann and Short 2000
Armstrong, Regis, Wayne Hellmann and William
 Short, eds., Francis of Assisi: Early Documents II
 (New York, NY, 2000).

Armstrong, Hellmann and Short 2001
Armstrong, Regis, Wayne Hellmann and William
 Short, eds., Francis of Assisi: Early Documents III
 (New York, NY, 2001).

Arslan 1956
Arslan, Edoardo, Catalogo delle cose d'arte e di antichità
 d'Italia, Vicenza, vol. 1, Le Chiese (Rome, 1956).

Arte Lombarda 2008
Arte Lombarda, 153 (2008/2), Atti del Convegno, Tela Picta,
 Tele dipinte dei secoli XIV e XV in Italia Settentrionale.
 Tipologie, Iconografia, techniche esecutive.

Astell 2006
Astell, Ann, Eating Beauty: The Eucharist and the
 Spiritual Arts of the Middle Ages (Ithaca, NY, 2006).

Avery 1986
Avery, Charles, "Donatello Celebrations, A major
 exhibit at Detroit, Fort Worth and Florence,"
 Apollo, 123 (1986), 14–18.

Baetjer 1995
Baetjer, Katharine, European Paintings in The
 Metropolitan Museum of Art by artists born before
 1865, A Summary Catalogue (New York, NY, 1995).

Bagatin 2001
Bagatin, Pier Luigi, Tra Università, Curia e Monasteri,
 Un Miniatore ritrovato: Antonio Maria da Villafora
 (Treviso, 2001).

Baldelli 2007
Baldelli, Francesca, Tino di Camaino
 (Morbio Inferiore, 2007).

Bange 1922
Bange, E. F., Die Italienischen Bronzen der Renaissance
 und des Barock (Berlin and Leipzig, 1922).

Banzato 1988
Banzato, Davide, La quadreria Emo Capodilista. 543
 dipinti dal '400 al '700, exh. cat., Padua, Palazzo
 della Ragione (Rome, 1988).

Banzato and Pellegrini 1989
Banzato, Davide and Franca Pellegrini, Da Giotto al
 Tardogotico, Dipinti dei Musei Civici di Padova del
 Trecento e della prima metà del Quattrocento, exh.
 cat., Padua, Musei Civici (Rome, 1989).

Barbieri 1975
Barbieri, Franco, Sculture della Valle del Chiampo
 (Vicenza, 1975).

Barbieri 1984
Barbieri, Franco, Scultori a Vicenza 1480–1520
 (Vicenza, 1984).

Barcham 2001
Barcham, William, Grand in Design, The Life and
 Career of Federico Cornaro, Prince of the Church,
 Patriarch of Venice and Patron of the Arts
 (Venice, 2001).

Bartsch 1982
Bartsch, Adam von, Le peintre graveur, vol. 3,
 Maîtres Italiens (Nieuwkoop, 1982).

Bassano Drawings 1961
Bassano Drawings, exh. cat., New York,
 Seiferheld Gallery (New York, NY, 1961).

Battaglia 1984
Battaglia, Salvatore, Grande Dizionario della Lingua
 Italiana, vol. XII (Turin, 1984).

Baviera e Bentini 1997
Baviera, Salvatore and Jadranka Bentini, eds.,
 Mistero e Immagine: L'Eucaristia nell'arte dal
 XVI al XVIII secolo, exh. cat., Bologna,
 S. Salvatore (Milan, 1997).

Beckwith 1996

Beckwith, Sarah, Christ's Body: Identity, Culture and
 Society in Late Medieval Writings
 (New York, NY, 1993, 1996).

Bellinger and Farmer 1998
Bellinger, William and William Farmer, eds., Jesus and
 the Suffering Servant: Isaiah 53 and Christian Origins
 (Harrisburg, PA, 1998).

Bellosi 1994
Bellosi, Luciano, "Un'Indagine su Domenico Morone
 (e su Francesco Benaglio)," in Hommage à Michel
 Laclotte, Études sur la peinture du Moyen Âge et
 de la Renaissance, Pierre Rosenberg, Cécile
 Scailliérez and Dominique Thiébaut, eds.
 (Milan, 1994), 281–303.

Bellosi 2009
Bellosi, Luciano, ed., La Collezione Salini. Scultura
 e oreficeria (Florence, 2009).

Belting 1980–1981
Belting, Hans, "An Image and Its Function in the
 Liturgy: The Man of Sorrows in Byzantium,"
 Dumbarton Oaks Papers, 34–35 (1980–1981), 1–16.

Belting 1990
Belting, Hans, The Image and Its Public in the Middle
 Ages, trans. Mark Bartusis and Raymond Meyer
 (New Rochelle, NY, 1990).

Belting 1994
Belting, Hans, Likeness and Presence, A History of the
 Image before the Era of Art, trans. Edmund Jephcott
 (Chicago, IL, 1994).

Belting 1996
Belting, Hans, Giovanni Bellini. La Pietà, trans. Marco
 Pedrazzi (Modena, 1996).

Belting 2005
Belting, Hans, Das echte Bild: Bildfragen als
 Glaubensfragen (Munich, 2005).

Berenson 1956
Berenson, Bernard, Lorenzo Lotto (London, 1956).

Berliner 1955
Berliner, Rudolf, "Arma Christi," Münchner Jahrbuch
 der Bildenden Kunst, 6 (1955), 35–152.

Bertelli 1967
Bertelli, Carlo, "The Image of Pity in Santa Croce in
 Gerusalemme," in Essays in the History of Art
 Presented to Rudolf Wittkower, Howard Hibbard and
 Milton J. Lewine, eds. (London, 1967), 40–55.

Bertoli and Romanelli 1997
Bertoli, Bruno and Giandomenico Romanelli, eds.,
 Chiesa di San Salvador: arte e devozione
 (Venice, 1997).

Bettagno 1988

Bettagno, Alessandro, ed., *Paolo Veronese: Disegni e Dipinti*, exh. cat., Venice, Fondazione Giorgio Cini (Vicenza, 1988).

Bettini 1933

Bettini, Sergio, *La Pittura di Icone Cretese-Veneziane e i Madonneri* (Padua, 1933).

Bianchi 1979–1980

Bianchi, Gabriella, "La Chiesa di San Trovaso a Venezia," Tesi di Laurea, Università di Venezia, 1979–1980.

Bianco Fiorin 1983

Bianco Fiorin, Marisa, "Nicola Zafuri, Cretese del Quattrocento, e una sua inedita 'Madonna,'" *Arte Veneta*, 37 (1983), 164–169.

Bianconi 1955

Bianconi, Piero, *Tutta la pittura di Lorenzo Lotto* (Milano 1955).

Biferali and Firpo 2007

Biferali, Fabrizio and Massimo Firpo, *Battista Franco "pittore viniziano" nella cultura artistica e nella vita religiosa del Cinquecento* (Pisa, 2007).

Bode 1906

Bode, Wilhelm, *The Collection of Oscar Hainauer* (London, 1906).

Bodenstedt 1944

Bodenstedt, Sister Mary Immaculate, "The Vita Christi of Ludolphus the Carthusian," Ph.D. dissertation, Catholic University, Washington, DC, 1944.

Boehm 2009

Boehm, Barbara Drake, "Choirs of Angels: Painting in Italian Choir Books, 1300–1500," *The Metropolitan Museum of Art Bulletin*, 66, no. 3 (2009), 6–64.

Bohn 1995

Bohn, Babette, *The Illustrated Bartsch*, vol. 39, part 1, John T. Spike, ed. (New York, NY, 1995).

Bollati 2007

Bollati, Milvia, "Intorno a Lorenzo Monaco: qualche considerazione sull'attività di Bartolomeo di Fruosino," in *Intorno a Lorenzo Monaco. Nuovi studi sulla pittura tardogotica*, Daniela Parenti and Angelo Tartuferi, eds. (Livorno, 2007), 138–145.

Bona 1971

Bona, Cardinal Giovanni, *De Rebus Liturgicis* (Rome, 1971).

Bona Castellotti 2000

Bona Castellotti, Marco, *Pietra Dipinta, Tesori nascosti del '500 e del '600 da una collezione privata milanese* (Milan, 2000).

Borchgrave d'Altena 1959

Borchgrave d'Altena, Joseph de, "La Messe de Saint Gregoire: Étude Iconographique," *Bulletin des Musées Royaux des Beaux-Arts de Belgique*, 8 (1959), 3–33.

Boskovits 1972

Boskovits, Miklós, "Su Don Silvestro, Don Simone e la 'Scuola degli Angeli,'" *Paragone*, 23 (1972), 35–61.

Bosshard 1982

Bosshard, Emil, "Tüchleinmalerei, eine billige Ersatztechnik?," *Zeitschrift für Kunstgeschichte*, 45 (1982), 31–42.

Boston 1988

Boston, Museum of Fine Arts, Department of Prints & Drawings, *Albrecht Dürer: Master Printmaker* (New York, NY, 1988).

Bowron 1999

Bowron, Edgar Peters, "A Brief History of European Oil Paintings on Copper, 1560–1775," in *Copper as Canvas: Two Centuries of Masterpiece Paintings on Copper 1575–1775*, exh. cat., Phoenix, AZ, Phoenix Art Museum (New York, NY, 1999), 9–30.

Bronze and Boxwood 2008

Bronze and Boxwood, Renaissance Masterpieces from the Robert H. Smith Collection, exh. cat., Washington, DC, National Gallery of Art (Washington, DC, 2008).

Brooke 2006

Brooke, Rosalind, *The Image of St Francis: Responses to Sainthood in the Thirteenth Century* (Cambridge, 2006).

Brown 1987

Brown, David Alan, *Andrea Solario* (Milan, 1987).

Brown 1988

Brown, Patricia Fortini, *Venetian Narrative Painting in the Age of Carpaccio* (New Haven and London, 1988).

Brown 1996

Brown, Patricia Fortini, "Le 'Scuole,'" in *Storia di Venezia*, vol. V, *Il Rinascimento: Società ed economia*, Alberto Tenenti and Ugo Tucci, eds. (Rome, 1996), 307–354.

Büchsel 2003

Büchsel, Martin, *Die Entstehung des Christusporträts: Bildarcheologie statt Bildhypnose* (Mainz 2003).

Bury 2001

Bury, Michael, *The Print in Italy, 1550–1620*, exh. cat., London, British Museum (London, 2001).

Butterfield 1994

Butterfield, Andrew, "Social structure and the typology of funerary monuments in early Renaissance Florence," *RES*, 26 (1994), 46–67.

Bynum 2006

Bynum, Caroline W., "Seeing and Seeing Beyond: The Mass of St. Gregory in the Fifteenth Century," in *The Mind's Eye: Art and Theological Argument in the Middle Ages*, Anne-Marie Bouché and Jeffrey Hamburger, eds. (Princeton, NJ, 2006), 208–240.

Cachin and Moffett 1983

Cachin, Françoise and Charles S. Moffett, *Manet 1832–1883*, exh. cat., New York, The Metropolitan Museum of Art (New York, NY, 1983).

Cahill 1971

Cahill, Jane van Nuis. "A Lombard Sculpture of about 1500," *Dayton Art Institute Bulletin*, 30 (1971), 2–5.

Callegari 1996

Callegari, Raimondo, "Opere e committenza d'arte rinascimentale a Padova," *Arte Veneta*, 49 (1996/II), 6–29.

Cannon 1998

Cannon, Joanna, "Dominic *alter Christus*? Representations of the Founder in and after the *Arca di San Domenico*," in *Christ Among the Medieval Dominicans: Representations of Christ in the Texts and Images of the Order of Preachers*, Kent Emery Jr. and Joseph P. Wawrykow, eds. (Notre Dame, IN, 1998), 26–48.

Cannon 1999

Cannon, Joanna, "The Stoclet 'Man of Sorrows': a thirteenth-century Italian diptych reunited," *The Burlington Magazine*, 141 (1999), 107–112.

Caputo and Perissa 1994

Caputo, Giammatteo and Annalisa Perissa, eds., *Chiesa di San Trovaso: arte e devozione* (Venice, 1994).

Cardini 1987

Cardini, Franco, "Venezia, il papato e il dominio dell'Adriatico," in *Venezia e la Roma dei Papi* (Milan, 1987), 105–128.

Caspary 1965

Caspary, Hans, *Das Sakramentstabernakel in Italien bis zum Konzil von Trient* (Munich, 1965).

Castelnuovo and de Gramatica 2002

Castelnuovo, Enrico and Francesca de Gramatica, *Il Gotico nelle Alpi 1350–1450*, exh. cat., Trent, Castello del Buonconsiglio (Trent, 2002).

Cattapan 1968
Cattapan, Mario, "Nuovi documenti riguardanti pittori cretesi dal 1300 al 1500," in Πεπραγμένα τοῦ Β' Διεθνοῦς Κρητολογικοῦ Συνεδρίου, III (Athens, 1968), 29–46.

Cattapan 1972
Cattapan, Mario, "Nuovi elenchi e documenti dei pittori in Creta," Θήσαυρίσματα (Thesaurismata), 9 (1972), 202–235.

Cennini 1998
Cennini, Cennino, Il Libro dell'Arte, Franco Brunello, ed. (Vicenza, 1998).

Chappuis 1973
Chappuis, Adrien, The drawings of Paul Cézanne; a catalogue raisonné, 2 vols. (Greenwich, CT, 1973).

Chatzidakis 1974
Chatzidakis, Manolis, "Essai sur l'école dite 'italogrecque' précédé d'une note sur les rapports de l'art vénitien avec l'art crétoise jusqu'à 1500," in Venezia e il Levante fino al secolo XV, Agostino Pertusi, ed., vol. II (Florence, 1974), 69–124.

Chatzidakis 1976
Chatzidakis, Manolis, Études sur la peinture postbyzantine (London, 1976).

Childs 2001
Childs, Brevard, Isaiah (Louisville, KY, 2001).

Childs 2004
Childs, Brevard, The Struggle to Understand Isaiah as Christian Scripture (Grand Rapids, MI, 2004).

Choice of Manuscripts 1922
A Choice of Manuscripts and Bookbindings from the Library of Isabella Stewart Gardner, Fenway Court (Boston, MA, 1922).

Christiansen 2006
Christiansen, Keith, "Tintoretto's 'Christ mocked,'" The Burlington Magazine, 148 (2006), 767–771.

Cleveland 1972
"Twelve Additions to the Medieval Treasury," The Bulletin of the Cleveland Museum of Art, 59 (1972), 87–111.

Clifton 1997
Clifton, James, The Body of Christ in the Art of Europe and New Spain, 1150–1800, exh. cat., Houston, Museum of Fine Arts (Munich and New York, 1997).

Cocke 1984
Cocke, Richard, Veronese's Drawings: A Catalogue Raisonné (London, 1984).

Cocke 2001

Cocke, Richard, Paolo Veronese: Piety and Display in an Age of Religious Reform (Burlington, VT, 2001).

Colwell and Willoughby 1936
Colwell, Ernest Cadman and Harold Rideout Willoughby, The Four Gospels of Karahissar, 2 vols. (Chicago, IL, 1936).

Comanducci 2003
Comanducci, Rita, "Produzione seriale e mercato dell'arte a Firenze tra Quattro e Cinquecento," in Il mercato dell'Arte in Italia, Secc. XV–XVII, Marcello Fantoni, Louisa C. Matthew and Sara F. Matthews-Grieco, eds. (Modena, 2003), 105–113.

Cope 1979
Cope, Maurice E., The Venetian Chapel of the Sacrament in the Sixteenth Century (New York, NY, 1979).

Coppini and Cavazzuti 2000
Coppini, Lamberto and Francesco Cavazzuti, eds., Le Icone di Cristo e la Sindone: un modello per l'arte cristiana (Cinisello Balsamo, 2000).

Corner 1749
Corner, Flaminio, Ecclesiae Torcellanae antiquis monumentis . . . , 3 vols. (Venice, 1749).

Corner 1768
Corner, Flaminio, Notizie storiche delle chiese e monasteri di Venezia e di Torcello (Padua, 1768).

Cornini 2006
Cornini, Guido, "Tesori d'arte decorativa tra Medioevo e Rinascimento: restauri nei Musei Vaticani," Arte/Documento, 22 (2006), 44–51.

Cortelazzo 2007
Cortelazzo, Manlio, Dizionario veneziano della lingua e della cultura popolare nel XVI secolo (Limena, 2007).

Craig 1944
Craig, Clarence Tucker, "The Identification of Jesus with the Suffering Servant," Journal of Religion, 24 (1944), 240–245.

Crisi e rinnovamenti 1991
Crisi e rinnovamenti nell'autunno del Rinascimento a Venezia, Vittore Branca and Carlo Ossola, eds. (Florence, 1991).

Curzi 2000
Curzi, Valter, ed., Pittura Veneta nelle Marche (Cinisello Balsamo, 2000).

Da Tiziano a El Greco 1981
Da Tiziano a El Greco: Per la storia del Manierismo a Venezia, exh. cat., Venice, Palazzo Ducale (Milan, 1981).

Dal Forno 1982
Dal Forno, Federico, La Chiesa dei Santi Nazaro e Celso a Verona (Verona, 1982).

D'Arcais and Gentili 2002
D'Arcais, Francesca Flores and Giovanni Gentili, eds., Il Trecento adriatico, Paolo Veneziano e la pittura tra Oriente e Occidente, exh. cat., Rimini, Castel Sismondo (Cinisello Balsamo, 2002).

Darr 1985
Darr, Alan Phipps, ed., Italian Renaissance Sculpture in the Time of Donatello, exh. cat., Detroit Institute of Arts (Detroit, MI, 1985).

Darr and Bonsanti 1986
Darr, Alan Phipps and Giorgio Bonsanti, eds., Donatello e i suoi: Scultura Fiorentina del Primo Rinascimento, exh. cat., Florence, Forte di Belvedere (Milan, 1986).

Davies 1988
Davies, Martin, National Gallery Catalogues, The Early Italian Schools before 1400, Dillian Gordon, ed. (London, 1988).

De Benedictis 2002
De Benedictis, Cristina, ed., La miniatura senese 1270–1420, Ada Labriola, Cristina de Benedictis and Gaudenz Freuler (Milan, 2002).

DeGrazia Bohlin 1979
DeGrazia Bohlin, Diane, Prints and Related Drawings by the Carracci Family: A Catalogue Raisonné, exh. cat., Washington, DC, National Gallery of Art (Washington, DC, 1979).

De Hamel 2001
De Hamel, C., The Book: A History of the Bible (London 2001).

De la Mare 1999
De la Mare, Albinia Catherine, "Bartolomeo Sanvito da Padova, copista e miniatore," in La miniatura a Padova dal medioevo al settecento, exh. cat., Giordana Mariani Canova, ed. (Modena, 1999), 494–505.

De la Mare and Nuvoloni 2009
De la Mare, Albinia Catherine and Laura Nuvoloni, Bartolomeo Sanvito: The Life and Work of a Renaissance Scribe (Dorchester, 2009).

Del Bravo 1967
Del Bravo, Carlo, Liberale da Verona (Florence, 1967).

Delfini Filippi 1995
Delfini Filippi, Gabriella, in Restituzioni '95, Opere Restaurate, exh. cat., Vicenza, Palazzo Leoni Montanari (Vicenza, 1995).

Delumeau 1978
Delumeau, Jean, *La peur en Occident, XIVe–XVIIIe siècles* (Paris, 1978).

Delumeau 1983
Delumeau, Jean, *Le péché et la peur: la culpabilisation en Occident, XIIIe–XVIIIe siècles* (Paris, 1983).

De Marchi 1996
De Marchi, Andrea, "Centralità di Padova: Alcuni esempi di interferenza tra scultura e pittura nell'area adriatica alla metà del Quattrocento," in *Fifteenth-century Art of the Adriatic Rim: Papers from a Colloquium held at the Villa Spelman, Florence* (Bologna, 1996), 57–79.

Dempsey 1996
Dempsey, Charles, "Donatello's *Spiritelli*," in *Ars naturam adiuvans, Festschrift für Matthias Winner*, Victoria V. Flemming and Sebastian Schütze, eds. (Mainz, 1996), 50–61.

Dempsey 2001
Dempsey, Charles, *Inventing the Renaissance Putto* (Chapel Hill, NC, 2001).

De Sandre Gasparini 1974
De Sandre Gasparini, Giuseppina, *Statuti di Confraternite religiose di Padova nel Medio Evo* (Padua, 1974).

Despres 1989
Despres, Denise, *Ghostly Sights: Visual Meditation in Late-Medieval Literature* (Norman, KA, 1989).

D'Essling 1908
D'Essling, (Prince) Victor M., *Les Livres à Figures Vénitiens: Études sur l'art de la gravure sur bois à Venise de la fin du XVe siècle et du commencement du XVIe*, Part one, vol. 2, *Ouvrages imprimés de 1491–1500* (Florence and Paris, 1908).

De Vincenti 2001
De Vincenti, Monica, ed., *Donatello e il suo tempo: il bronzetto a Padova nel Quattrocento e nel Cinquecento*, exh. cat., Padua, Musei Civici (Milan, 2001).

Dizionario Biografico 2004
Dizionario Biografico dei miniatori italiani secoli IX–XVI, Milvia Bollati, ed. (Milan, 2004).

Dizionario Enciclopedia del Medioevo 1999
Dizionario Enciclopedia del Medioevo, vol. 3, Claudio Leonari, ed. (Rome, 1999).

Dobrzeniecki 1971
Dobrzeniecki, Tadeusz, "Imago Pietatis. Its Meaning and Function," *Bulletin du Musée National de Varsovie*, 12 (1971), 5–27.

Documenti per la storia 1886

Documenti per la storia dell'augusta basilica di San Marco (Venice, 1886).

Drandaki 2009
Drandaki, Anastasia, ed., *The Origins of El Greco: Icon Painting in Venetian Crete*, exh. cat., New York, Onassis Cultural Center (New York, NY, 2009).

Dreyer 1971
Dreyer, Peter, *Tizian und sein Kreis: 50 venezianische Holzschnitte aus dem Berliner Kupferstichkabinett, Staatliche Museen Preussischer Kulturbesitz* (Berlin, 1971).

Dubois and Klaassen 2000
Dubois, Hélène and Lizet Klaassen, "Fragile Devotion: Two Late Fifteenth-Century Italian *Tüchlein* Examined," in *The Fabric of Images, European Paintings on Textile Supports in the Fourteenth and Fifteenth Centuries*, Caroline Villers, ed. (London, 2000), 67–75.

Du Cange 1845
Du Cange, Charles, *Glossarium Mediae et Infimae Latinitatis*, vol. V (Paris, 1845).

Duomo di Napoli 2002
Il Duomo di Napoli dal paleocristiano all'età angioina, Atti della I Giornata di Studi su Napoli, Serena Romano and Nicolas Bock, eds. (Naples, 2002).

Early Italian Engravings 1973
Early Italian Engravings from the National Gallery of Art, Jay A. Levenson, Konrad Oberhuber and Jacquelyn L. Sheehan, exh. cat., Washington, DC, National Gallery of Art (Washington, DC, 1973).

Eisenberg 1989
Eisenberg, Marvin, *Lorenzo Monaco* (Princeton, NJ, 1989).

Eissfeldt 1965
Eissfeldt, Otto, *The Old Testament, An Introduction*, trans. Peter R. Ackroyd (New York, NY, 1965).

El Greco 1999
El Greco: Identity and Transformation: Crete, Italy, Spain, exh. cat., José Alvarez Lopera, ed., Madrid, Museo Thyssen-Bornemisza (Milan, 1999).

Elliott 2007
Elliott, Mark, ed., *Ancient Christian Commentary on Scripture: Old Testament XI – Isaiah 40–66* (Downers Grove, IL, 2007).

Epley 2008
Epley, Nicholas, "Rebate Psychology," *The New York Times*, January 31, 2008 (op-ed).

Eugeni 2008

Eugeni, Fausto, *Atlante Storico della Città di Teramo*, exh. cat., Teramo, Cathedral (Teramo, 2008).

Evans 2004
Evans, Helen C., ed., *Byzantium: Faith and Power (1261–1557)*, exh. cat., New York, The Metropolitan Museum of Art (New Haven and London, 2004).

Evans and Wixom 1997
Evans, Helen and William D. Wixom, ed., *The Glory of Byzantium, Art and Culture of the Middle Byzantine Era A.D. 843–1261*, exh. cat., New York, The Metropolitan Museum of Art (New York, NY, 1997).

Favaretto and Urbani 2003
Favaretto, Irene and Maria Da Villa Urbani, eds., *Il Museo di San Marco* (Venice, 2003).

Ferguson 1975
Ferguson, George, *Signs & Symbols in Christian Art* (London, Oxford and New York, 1975).

Filieri 1998
Filieri, Maria Teresa, ed., *Sumptuosa tabula picta: Pittori a Lucca tra gotico e rinascimento*, exh. cat., Lucca, Museo Nazionale di Villa Guinigi (Livorno, 1998).

Finaldi 2000
Finaldi, Gabriele, ed., *The Image of Christ*, exh. cat., London, National Gallery (London, 2000).

Fioritura 1998
Fioritura Tardogotica nelle Marche, exh. cat., Paolo Dal Poggetto, ed., Urbino, Palazzo Ducale (Milan, 1998).

Florisoone 1937
Florisoone, Michel, "Manet inspiré par Venise," *L'Amour de l'art*, 18 (1937), 26–27.

Franco 1996
Franco, Tiziana, "Intorno al 1430: Michele Giambono e Jacopo Bellini," *Arte Veneta*, 48 (1996), 7–17.

Franco 1998
Franco, Tiziana, *Michele Giambono e il Monumento a Cortesia da Serego in Santa Anastasia a Verona* (Padua, 1998).

Freuler 1997
Freuler, Gaudenz, *Tendencies of Gothic in Florence: Don Silvestro dei Gherarducci*, in *A Critical and Historical Corpus of Florentine Paintings*, Richard Offner, Klara Steinweg and Miklós Boskovits, eds., Section IV, vol. VII (Part II) (Florence, 1997).

Frinta 1964
Frinta, Mojmír S., "The Master of the Gerona Martyrology and Bohemian Illumination," *The Art Bulletin*, 46 (1964), 283–306.

Fröhlich-Brume 1932

Fröhlich-Brume, Lili, "Some Original Compositions by Francesco and Leandro Bassano," *The Burlington Magazine*, 61 (1932), 113–115.

Furlan 2000

Furlan, Caterina, ed., *Dal Pordenone a Palma il Giovane: Devozione e Pietà nel disegno veneziano del Cinquecento*, exh. cat., Pordenone, ex-church of S. Francesco (Milan, 2000).

Gallo 1995

Gallo, Andrea, *La chiesa di San Giuliano* (Venice, 1995).

Gamulin 1963

Gamulin, Grgo, "Ritornando sul Quattrocento," *Arte Veneta*, 17 (1963), 9–20.

Gardner Museum 1977

Vermeule, Cornelius C., Walter Cahn and Rollin Van N. Hadley, *Sculpture in the Isabella Stewart Gardner Museum* (Boston, MA, 1977).

Gesink Cornelisse 1997

Gesink Cornelisse, Melanie, "Israhel van Meckenem's Engravings of the Mass of Saint Gregory and the Santa Croce Imago Pietatis Icon," M.A. Thesis, University of Texas at Austin, 1997.

Gibbs 1989

Gibbs, Robert, *Tomaso da Modena, Painting in Emilia and the March of Treviso, 1340–80* (Cambridge, 1989).

Gilbert 1976

Gilbert, Felix, "The last will of a Venetian Grand Chancellor," in *Philosophy and Humanism: Renaissance Essays in Honor of Paul Oskar Kristeller*, Edward P. Mahoney, ed. (Leiden, 1976), 502–517.

Gilbert 1984

Gilbert, Creighton, "Tuscan Observants and Painters in Venice, ca. 1400," in *Interpretazioni Veneziane: Studi di Storia dell'Arte in Onore di Michelangelo Muraro*, David Rosand, ed. (Venice, 1984), 109–120.

Gilbert 2007

Gilbert, Creighton, "The Original Assembly of Donatello's Padua Altar," *Artibus et Historiae*, 28 (2007), 11–22.

Giorgi 2003

Giorgi, Rosa, *Angeli e Demoni* (Milan, 2003).

Giovanni Bellini 2008

Giovanni Bellini, exh. cat., Mauro Lucco and Giovanni Carlo Federico Villa, eds., Rome, Scuderie del Quirinale (Cinisello Balsamo, 2008).

Goi 1988

Goi, Paolo, ed., *La Scultura nel Friuli-Venezia Giulia*, vol. II, *Dal Quattrocento al Novecento* (Pordenone, 1988).

Gordon 2011

Gordon, Dillian, *National Gallery Catalogues: The Early Italian Schools before 1400* (London, 2011—forthcoming).

Green 1966

Green, Rosalie B. "The Iconography of a Missal: Garrett Manuscript 39," *The Princeton University Library Chronicle*, 27, no. 3 (1966), 159–165.

Grevembroch 1755

Grevembroch, Jan, *Varie Venete curiosità sacre e profane*, Venice, Biblioteca Museo Correr, Ms. Gradenigo-Dolfin 65, 1755.

Guarnieri 2006

Guarnieri, Cristina, "Per un corpus della pittura veneziana del Trecento al tempo di Lorenzo," *Saggi e Memorie di Storia dell'Arte*, 30 (2006), 1–131.

Guiffrey 1894–1896

Guiffrey, Jules, ed., *Inventaires de Jean Duc de Berry 1401–1416*, 2 vols. (Paris, 1894–1896).

Gullino 1990

Gullino, Giuseppe, ed., *La Chiesa di Venezia tra Riforma Protestante e Riforma Cattolica* (Venice, 1990).

Gurewich 1957

Gurewich, Vladimir, "Observations on the Iconography of the Wound in Christ's Side, with Special Reference to its Position," *Journal of the Warburg Institute and Courtauld Institutes*, 20 (1957), 358–362.

Gy 1996

Gy, Pierre-Marie, "La passion du Christ dans la piété et la théologie aux XIVe e XVe siècles," in *Le Mal et le Diable, Leurs Figures à la Fin du Moyen Âge*, Nathalie Nabert, ed. (Paris, 1996), 172–186.

Habig 1991

Habig, Marion A., ed., *St. Francis of Assisi, Writings and Early Biographies: English Omnibus of the Sources for the Life of St. Francis*, 4th rev. ed. (Quincy, IL, 1991).

Harris 1990

Harris, Jean C., *Édouard Manet: The Graphic Works, A Catalogue Raisonné*, rev. edn. (San Francisco, CA, 1990).

Hass 2000

Hass, Angela, "Two Devotional Manuals by Albrecht Dürer: The 'Small Passion' and the 'Engraved Passion.' Iconography, Context and Spirituality," *Zeitschrift für Kunstgeschichte*, 63 (2000), 169–230.

Heimann 1982

Heimann, Peter, "Mola mistica, Wandlungen eines Themes mittelalterlicher Kunst," *Zeitschrift für schweizerische Archäologie und Kunstgeschichte*, 39 (1982), 229–252.

Heinemann 1962

Heinemann, Fritz, *Giovanni Bellini e i Belliniani* (Venice, 1962).

Heinlen 1998

Heinlen, Michael, "An Early Image of a Mass of St. Gregory and Devotion to the Holy Blood at Weingarten Abbey," *Gesta*, 37 (1998), 55–62.

Heitzmann and Santos Noya 2002

Heitzmann, Christian and Manuel Santos Noya, *Lateinische Bibeldrucke 1454–2001* (Stuttgart-Bad Cannstatt, 2002)

Henderson 1978

Henderson, John, "The Flagellant Movement and Flagellant Confraternities in Central Italy, 1260–1400" in *Studies in Church History*, 15, Derek Baker, ed. (Oxford, 1978) 147–160.

Herbermann 1913

Herbermann, Charles, et al., *The Catholic Encyclopedia* (New York, NY, 1913).

Hills 1983

Hills, Paul, "Piety and Patronage in Cinquecento Venice: Tintoretto and the Scuole del Sacramento," *Art History*, 6 (1983), 30–43.

Hind 1936

Hind, A.M, *Nielli, chiefly Italian of the XV Century: plates, sulphur casts and prints preserved in the British Museum* (London, 1936).

Histria 2005

Histria, opere d'arte restaurate: da Paolo Veneziano a Tiepolo, exh. cat., Trieste, Museo Civico Revoltella (Trieste, 2005).

Hollstein 1986

Hollstein's German Engravings, Etchings and Woodcuts 1400–1700, vol. XXIV: Israhel van Meckenem, compiled by Fritz Koreny; Tilman Falk, ed. (Blaricum, 1986).

Honey 1933

Honey, W. B. "Gold engraving under Glass," *The Connoisseur*, 388 (1933), 372–381.

Hourihane 2009

Hourihane, Colum, *Pontius Pilate, Anti-Semitism, and the Passion in Medieval Art* (Princeton, NJ, 2009).

Humfrey 1993

Humfrey, Peter, *The Altarpiece in Renaissance Venice* (New Haven and London, 1993).

Humfrey 1997

Humfrey, Peter, *Lorenzo Lotto* (New Haven and London, 1997).

Huse and Wolters 1990

Huse, Norbert and Wolfgang Wolters, *The Art of Renaissance Venice, Architecture, Sculpture, and Painting, 1460–1590* (Chicago and London, 1990).

Icons or Portraits 2002

Icons or Portraits? Images of Jesus and Mary from the Collection of Michael Hall, exh. cat., Ena Giurescu Heller, ed., New York, The Gallery at the American Bible Society (New York, NY, 2002).

Imago lignea 1989

Imago lignea: Sculture lignee nel Trentino dal XIII al XVI secolo, Enrico Castelnuovo, ed. (Trent, 1989).

Immagine 1981

L'Immagine di San Lorenzo Giustiniani nell'Arte, Documenti di Cultura e Vita Religiosa nel Suo Tempo, exh. cat., Venice, S. Stae (Venice, 1981).

In Hoc Signo 2006

In Hoc Signo. Il Tesoro delle Croci, Paolo Goi, ed. (Milan, 2006).

Ivins 1919

Ivins, William M., "Prints and Illustrated Books on Exhibition," *The Metropolitan Museum of Art Bulletin*, 14, no. 1 (1919), 4–5.

Ivins 1969

Ivins, William M., *Prints and Visual Communication* (New York, NY, 1969).

Jacopo Bassano 1993

Jacopo Bassano c.1510–1592, exh. cat., Beverly Louise Brown and Paola Marini, eds., Fort Worth TX, Kimbell Art Museum (Fort Worth, TX, 1993).

Janowski and Stuhlmacher 2004

Janowski, Bernd and Peter Stuhlmacher, *The Suffering Servant: Isaiah 53 in Jewish and Christian Sources* (Grand Rapids, MI, 2004).

John of Caulibus 2000

John of Caulibus, Meditations on the Life of Christ, trans. and eds., Francis X. Taney, Anne Miller and C. Mary Stallings-Taney (Asheville, NC, 2000).

Johnson 1999

Johnson, Geraldine A., "Approaching the Altar: Donatello's Sculpture in the Santo," *Renaissance Quarterly*, 52 (1999), 627–666.

Kalavrezou-Maxeiner 1985

Kalavrezou-Maxeiner, Ioli, *Byzantine Icons in Steatite*, 2 vols. (Vienna, 1985).

Kantor 2000

Kantor, Jordan, *Dürer's Passions*, 2 vols., exh. cat., Cambridge, MA, Fogg Art Museum (Cambridge, MA, 2000).

Kessler 2006

Kessler, Herbert L., "Face and Firmament: Dürer's *An Angel with the Sudarium* and the Limit of Vision," in *L'Immagine di Cristo dall'Acheropita alla Mano d'Artista*, Christoph L. Frommel and Gerhard Wolf, eds. (Vatican, 2006), 143–165.

Kessler and Wolf 1998

Kessler, Herbert L. and Gerhard Wolf, eds., *The Holy Face and the Paradox of Representation, Papers from a Colloquium Held at the Biblioteca Hertziana, Rome, and the Villa Spelman, Florence* (Bologna, 1998).

Kirkman 2010

Kirkman, Andrew, *The Cultural Life of the Early Polyphonic Mass: Medieval Context to Modern Revival* (Cambridge, 2010).

Krahn 1988

Krahn, Volker, *Bartolomeo Bellano: Studien zur Paduaner Plastik des Quattrocento* (Munich, 1988).

Kreidl-Papadopoulos 1970

Kreidl-Papadopoulos, Karoline, "Die Ikonen im Kunsthistorischen Museum in Wien," *Jahrbuch der Kunsthistorischen Sammlungen in Wien*, 66 (1970), 49–134.

Kreytenberg 1998

Kreytenberg, Gert, "La tomba di Gualtieri dei Bardi, opera di Agnolo di Ventura, e Maso di Banco scultore," in *Maso di Banco: La cappella di San Silvestro*, Cristina Acidini Luchinat and Enrica Meri Lusanna, eds. (Milan, 1998), 51–55.

Kreytenberg 2001

Kreytenberg, Gert, "Ein doppelseitiges Triptychon in Marmor von Tino di Camaino aus der Zeit um 1334," in *Medien der Macht: Kunst zur Zeit der Anjous in Italien*, Tanja Michalsky, ed. (Berlin, 2001), 261–274.

Kuryluk 1991

Kuryluk, Ewa, *Veronica and Her Cloth: History, Symbolism, and Structure of a "True" Image* (Cambridge, 1991).

Land 1980

Land, Norman E., "Two Panels by Michele Giambono and Some Observations on St. Francis and the Man of Sorrows in Fifteenth-Century Painting," *Studies in Iconography*, 6 (1980), 29–41.

Land 1999

Land, Norman E., ed., *The Samuel H. Kress Study Collection at the University of Missouri* (Columbia, MO and London, 1999).

Lang 1966

Lang, Paul Henry, *George Frideric Handel* (New York, NY, 1966).

Larsen 1957

Larsen, Jens Peter, *Handel's Messiah: Origins, Composition, Sources* (New York, NY, 1957).

Lazovic 1985

Lazovic, Miroslav and Stella Frigerio-Zeniou, *Les Icônes du Musée d'Art et d'Histoire, Genève* (Geneva, 1985).

Leaves of Gold 2001

Leaves of Gold, Manuscript Illumination from Philadelphia Collections, exh. cat., James R. Tanis, ed., Philadelphia Museum of Art (Philadelphia, PA, 2001).

Leino 2007

Leino, Marika, "The Production, Collection and Display of Plaquette Reliefs in Renaissance Italy," in *Depth of Field: Relief Sculpture in Renaissance Italy*, Donal Cooper and Marika Leino, eds. (Oxford, 2007), 251–374.

Leithe-Jasper 1986

Leithe-Jasper, Manfred, *Renaissance Master Bronzes from the Collection of the Kunsthistorisches Museum, Vienna*, exh. cat., Washington, DC, National Gallery of Art (Washington, DC, 1986).

Leonardo 1992

Leonardo & Venice., exh. cat., Venice, Palazzo Grassi (Milan, 1992).

Lewis 1989

Lewis, Douglas, "The Plaquettes of 'Moderno' and His Followers," in *Italian Plaquettes*, Alison Luchs, ed., *Studies in the History of Art*, vol. 22 (Washington, DC, 1989), 105–141.

Lewis 2010–2011

Lewis, Douglas, *National Gallery of Art Systematic Catalogue, Renaissance Plaquettes* (Washington, DC and Oxford, 2010–2011—forthcoming).

Lightbown 1992

Lightbown, Ronald W., *Mediaeval European Jewellery: with a catalogue of the collection in the Victoria and Albert Museum* (London, 1992).

Lightbown 2004

Lightbown, Ronald, *Carlo Crivelli*
 (New Haven and London, 2004).

Linsky Collection 1984
The Jack and Belle Linsky Collection in the Metropolitan
 Museum of Art (New York, NY, 1984).

Liturgy 2001
The Liturgy of the Medieval Church, Thomas J. Heffernan
 and E. Ann Matter, eds. (Kalamazoo. MI, 2001).

Löffler 1922
Löffler, Heinz, "Ikonografie des Schmerzensmannes,
 Die Entstehung des Typus und seine Entwicklung
 in der deutschen Kunst," Ph.D. dissertation,
 Friedrich-Wilhelm-Universität, Berlin, 1922.

Longhi 1978
Longhi, Roberto, "Il Carpaccio e i due Tornei della
 National Gallery," in *Edizioni delle opere complete*
 di R. Longhi, vol. X (Florence, 1978), 72–81.

Lorenzo Lotto 1997
Lorenzo Lotto: Rediscovered Master of the Renaissance,
 exh. cat., David Alan Brown, Peter Humfrey and
 Mauro Lucco, eds., Washington, DC, National
 Gallery of Art (Washington, DC, 1997).

Los 2001
Los, Sergio, *Carlo Scarpa: guida all'architettura*
 (Verona, 2001).

Luber 2005
Luber, Katherine Crawford, *Albrecht Dürer and the*
 Venetian Renaissance (New York, NY, 2005).

Lucco 1983
Lucco, Mauro, "Venezia fra Quattro e Cinquecento,"
 in *Storia dell'arte italiana*, part II: *Dal Medioevo al*
 Novecento, Federico Zeri, ed., vol. V: *Dal Medioevo al*
 Quattrocento (Turin, 1983).

Lucco 1984
Lucco, Mauro,"Il Quattrocento," in *Le Pitture*
 del Santo di Padova, Camillo Semenzato,
 ed. (Vicenza, 1984), 119–143.

Lucco 1989–1990
Lucco, Mauro, ed., *La pittura nel Veneto. Il Quattrocento*,
 2 vols. (Milan, 1989–1990).

Lucco 2006
Lucco, Mauro, ed., *Antonello da Messina: L'opera*
 completa, exh. cat., Rome, Scuderie del Quirinale
 (Cinisello Balsamo, 2006).

Mâle 1908
Mâle, Émile, *L'Art religieux de la fin du Moyen Âge en*
 France: Étude sur l'iconographie du Moyen Âge et sur
 ses sources d'inspiration (Paris, 1908).

Mâle 1958
Mâle, Émile, *Religious Art From the Twelfth to the*
 Eighteenth Century (New York, NY, 1958).

Mâle 1972
Mâle, Emile, *L'Art Religieux de la fin du XVIe siècle,*
 du XVIIe siècle et du XVIIIe siècle: Étude sur
 l'iconographie après le Concile de Trente (Paris, 1972).

Mandylion 2004
Mandylion: Intorno al 'Sacro Volto,' da Bisanzio a
 Genova, exh. cat., Gerhard Wolf, Colette Dufour
 Bozzo and Anna Rosa Calderoni Masetti,
 eds., Genoa, Palazzo Ducale (Milan, 2004).

Mantegna 2008
Mantegna 1431–1506, exh. cat., Giovanni Agosti and
 Dominique Thiébaut, eds., Paris, Musée du Louvre
 (Paris and Milan, 2008).

Mantegna e le Arti 2006
Mantegna e le Arti a Verona. 1450–1500, exh. cat.,
 Sergio Marinelli and Paola Marini, eds., Verona,
 Palazzo della Gran Guardia (Venice, 2006).

Mantegna e Padova 2006
Mantegna e Padova, 1445–1460, exh. cat., Davide
 Banzato, Alberta De Nicolò Salmazo and Anna
 Maria Spiazzi, eds., Padua, Musei Eremitani
 (Milan, 2006).

Marcon 2007
Marcon, Susy, "Le Mariegole delle Scuole Veneziane
 del Santissimo Sacramento nei primi tre decenni
 del Cinquecento," *Rivista di Storia della Miniatura*,
 11 (2007), 279–296.

Mariani Canova 1978
Mariani Canova, Giordana, *Miniature dell'Italia*
 Settentrionale nella Fondazione Giorgio Cini, exh. cat.,
 Venice, Fondazione Giorgio Cini (Venice, 1978).

Mariani Canova 2002
Mariani Canova, Giordana, "La miniatura a Padova
 nel tempo di Iacopo Montagnana: l'attività di
 Antonio Maria da Villafora per Pietro Barozzi," in
 Jacopo da Montagnana e la pittura padovana del
 secondo Quattrocento: *Atti delle Giornate di Studio*,
 Alberta De Nicolò Salmazzo and Giuliana Ericani,
 eds. (Padua, 2002), 261–284.

Marioni and Mutinelli 1958
Marioni, Giuseppe and Carlo Mutinelli, *Guida*
 storico-artistica di Cividale (Udine, 1958).

Marks 1977
Marks, Richard, "Two Early 16th Century Boxwood
 Carvings Associated with the Glymes Family of
 Bergen op Zoom," *Oud Holland*, 71 (1977), 132–143.

Marrow 1979
Marrow, James, *Passion Iconography in Northern*
 European Art of the Late Middle Ages and the Early
 Renaissance, A Study of the Transformation of Sacred
 Metaphor into Descriptive Narrative (Kortrijk, 1979).

Martin 1998
Martin, Susanne, "Eine Zeichnung Girolamo
 Campagnas für die Engel-Pietà des Sakraments-
 altares in San Giuliano in Venedig," in *Gedenkschrift*
 für Richard Harpath, Wolfgang Liebenwein and
 Anchise Tempestini, eds. (Berlin, 1998), 263–269.

Mascherpa 1978
Mascherpa, Giorgio, "L'ancona perduta," in
 La Pala Martinengo di Lorenzo Lotto
 (Bergamo, 1978), 40–53.

Mason 1976
Mason Rinaldi, Stefania, "La Cappella del SS.
 Sacramento in San Zulian," *Atti dell'Istituto Veneto*
 di Scienze, Lettere ed Arti, 134 (1975–1976), 439–456.

Mason 1984
Mason Rinaldi, Stefania, *Palma il Giovane, L'opera*
 completa (Milan, 1984).

Mason 1990
Mason, Stefania, *Palma il Giovane, 1548–1628, Disegni*
 e dipinti, exh. cat., Venice, Museo Correr
 (Milan, 1990).

Mayor 1938
Mayor, A. Hyatt, "A Woodcut in the Style of Veronese,"
 The Metropolitan Museum of Art Bulletin,
 33, no. 5 (1938), 128–130.

Mayor 1971
Mayor, A. Hyatt, *Prints & People: A Social History of*
 Printed Pictures (New York, NY, 1971).

McCormick 1994
McCormick, Jr., Scott, *Behold the Man: Re-reading*
 Gospels, Re-humanizing Jesus (New York, NY, 1994).

McKenzie 1968
McKenzie, John, *Second Isaiah* (Garden City, NY, 1968).

McKinion 2004
McKinion, Steven, ed., *Ancient Christian Commentary*
 on Scripture: Old Testament X – Isaiah 1–39
 (Downers Grove, IL, 2004)

McNamer 2010
McNamer, Sarah, *Affective Meditation and the Invention*
 of Medieval Compassion (Philadelphia, PA, 2010).

Meier 2006
Meier, Esther, *Die Gregorsmesse: Funktionen*
 eines spätmittelalterlichen Bildtypus
 (Cologne, Weimar and Vienna, 2006).

Menato 1974–1976

Menato, Giuliano, "Niccolò da Cornedo," *Odeo Olimpico*, 11–12 (1974–1976), 161–199.

Merback 2005

Merback, Mitchell B., "Fount of Mercy, City of Blood: Cultic Anti-Judaism and the Pulkau Passion Altarpiece," *The Art Bulletin*, 87 (2005), 589–642.

Middeldorf 1976

Middeldorf, Ulrich, *Sculptures from the Samuel H. Kress Collection. European Schools, XIV–XIX Century* (London, 1976).

Middione 2001

Middione, Roberto, *Museo nazionale di San Martino: Le raccolte di scultura* (Naples, 2001).

Millet 1916

Millet, Gabriel, *Recherches sur l'iconographie de l'évangile aux XIVe, XVe et XVIe siècles d'après les monuments de Mistra, de la Macédoine et du Mont-Athos* (Paris, 1916).

Miniatura a Padova 1999

La Miniatura a Padova dal Medioevo al Settecento, exh. cat., Giordana Mariani Canova, ed., Padua, Palazzo della Ragione (Modena, 1999).

Miotto 1999

Miotto, Stefania, "'Item una pax solemnis . . .', Nicolò Lionello orefice e la committenza francescana: documenti inediti," *Arte Veneta*, 55 (1999), 138–144.

Molinier 1886

Molinier, Émile, *Les Bronzes de la Renaissance: les Plaquettes, Catalogue Raisonné* (Paris, 1886).

Morello and Wolf 2000

Morello, Giovanni and Gerhard Wolf, eds., *Il Volto di Cristo*, exh. cat., Rome, Palazzo delle Esposizioni (Milan, 2000).

Moretti 2009

Moretti, Fabrizio, *Dalla tradizione gotica al primo Rinascimento* (Florence, 2009).

Moschini 1847

Moschini, Gianantonio, *Nuova guida di Venezia . . . con emende ed aggiunte* (Venice, 1847).

Moschini Marconi 1955

Moschini Marconi, Sandra, *Gallerie dell'Accademia di Venezia*, vol. I, *Opere d'arte dei secoli XIV e XV* (Rome, 1955).

Moschini Marconi 1962

Moschini Marconi, Sandra, *Gallerie dell'Accademia di Venezia*. vol. II, *Opere d'arte del secolo XVI* (Rome, 1962).

Mostra di Tiziano 1935

Mostra di Tiziano, exh. cat., Nino Barbantini, ed., Venice, Ca' Pesaro (Venice, 1935).

Muir 1981

Muir, Edward, *Civic Ritual in Renaissance Venice* (Princeton, NJ, 1981).

Muir 2002

Muir, Bernard J., ed., *Reading Texts and Images: Essays on Medieval and Renaissance Art and Patronage* (Exeter, 2002).

Mysterium 2004–2005

Mysterium, L'Eucaristia nei capolavori dell'arte europea, exh. cat., Alessio Geretti, ed., Illegio, Casa della Esposizioni, 2004 (Milan, 2005).

Nagel 2000

Nagel, Alexander, *Michelangelo and the Reform of Art* (Cambridge, 2000).

Nagler 1966

Nagler, Georg Kaspar, *Die Monogrammisten* (Nieuwkoop, 1966).

Napione 2009

Napione, Ettore, *Le Arche Scaligere di Verona* (Venice, 2009).

National Gallery 1995–1996

The National Gallery, Complete Illustrated Catalogue (London, 1995–1996).

Neff 1999

Neff, Amy, "Byzantium Westernized, Byzantium Marginalized: Two Icons in the *Supplicationes Variae*," *Gesta*, 38 (1999), 81–102.

Nepi Scirè 2000

Nepi Scirè, Giovanna, in *Restituzioni 2000*, exh. cat., Vicenza, Palazzo Leoni Montanari (Vicenza, 2000), 166–169.

Netzer and Reinburg 1995

Netzer, Nancy and Virginia Reinburg, eds., *Memory and the Middle Ages*, exh. cat., Boston College, McMullen Museum of Art (Chestnut Hill, MA, 1995).

Netzer and Reinburg 2007

Netzer, Nancy and Virginia Reinburg, eds., *Fragmented Devotion: Medieval Objects from the Schnütgen Museum, Cologne*, exh. cat., Boston College, McMullen Museum of Art (Chicago, IL, 2007).

Neumeyer 1958

Neumeyer, Alfred, *Cézanne Drawings* (New York and London, 1958).

Nicol 1999

Nicol, Donald M., *Byzantium and Venice: A study in diplomatic and cultural relations* (Cambridge, 1999).

Niero 1961

Niero, Antonio, *I Patriarchi di Venezia, da Lorenzo Giustiniani ai nostri giorni* (Venice, 1961).

North Carolina Museum 1965

The Samuel H. Kress Collection, North Carolina Museum of Art, Raleigh (Raleigh, NC, 1965).

Old 1999

Old, Hughes Oliphant, *The Reading and Preaching of the Scriptures in the Worship of the Christian Church: Volume 3, The Medieval Church* (Grand Rapids, MI, 1999).

O'Malley 2005

O'Malley, Michelle, *The Business of Art, Contracts and the Commissioning Process in Renaissance Italy* (New Haven and London, 2005).

O'Meara 2001

O'Meara, Carra Ferguson, *Monarchy and Consent: The Coronation Book of Charles V of France, British Library MS Cotton Tiberius B.VIII* (London, 2001).

Origo 1963

Origo, Iris, *The Merchant of Prato, Francesco di Marco Datini* (Harmondsworth, 1963).

Painting and Illumination 1994

Painting and Illumination in Early Renaissance Florence 1300–1450, exh. cat., Laurence B. Kanter et al., New York, The Metropolitan Museum of Art (New York, NY, 1994).

Painting in Renaissance Siena 1988

Painting in Renaissance Siena 1420–1500, exh. cat., Keith Christiansen, Laurence B. Kanter and Carl Brandon Strehlke, New York, The Metropolitan Museum of Art (New York, NY, 1988).

Pallas 1965

Pallas, Demetrios I., *Die Passion und Bestattung Christi in Byzanz: Der Ritus – das Bild* (Munich, 1965).

Pallucchini 1962

Pallucchini, Rodolfo, *I Vivarini (Antonio, Bartolomeo, Alvise)* (Venice, 1962).

Palumbo 1973

Palumbo, Giuseppe, *Collezione Federico Mason Perkins nel Sacro Convento di San Francesco, Assisi* (Rome, 1973).

Panofsky 1927

Panofsky, Erwin, "'Imago Pietatis,' Ein Beitrag zur Typengeschichte des 'Schmerzensmanns' und der

'Maria Mediatrix,'" in *Festschrift für Max J. Friedländer zur 60. Geburtstag* (Leipzig, 1927), 261–308.

Panofsky 1955

Panofsky, Erwin, *The Life and Art of Albrecht Dürer* (1955; reprinted Princeton, NJ, 2005).

Panofsky 1956

Panofsky, Erwin, "Jean Hey's 'Ecce Homo': Speculations about its author, its donor and its iconography," *Bulletin des Musées Royaux des Beaux-Arts de Belgique*, 5, nos. 3–4 (1956), 95–138.

Paoletti 1840

Paoletti, Ermolao, *Il Fiore di Venezia ossia i quadri, i monumenti, le vedute ed i costumi veneziani* (Venice, 1840).

Paoletti 1893–1897

Paoletti, Pietro, *L'architettura e la scultura del rinascimento in Venezia; ricerche storico-artistiche*, 2 vols. (Venice, 1893–1897).

Parler und der Schöne Stil 1978

Die Parler und der Schöne Stil 1350–1400: Europäische Kunst unter den Luxemburgern, exh. cat., Anton Legner, ed., vol. 2, Cologne, Schnütgen Museum (Cologne, 1978).

Parma Baudrille 1995

Parma Baudrille, Rita, "Disegni di Battista Franco," *Arte/Documento*, 8 (1995), 89–100.

Parshall 1993

Parshall, Peter, "Imago Contrafacta: Images and Facts in the Northern Renaissance," *Art History*, 16 (1993), 554–579.

Parshall 2005

Parshall, Peter, *Origins of European Printmaking: Fifteenth-Century Woodcuts and Their Public*, exh. cat., Washington, DC, National Gallery of Art (Washington, DC, 2005).

Paulus 1922–1923

Paulus, Nikolaus, *Geschichte des Ablasses im Mittelalter vom Ursprunge bis zur Mitte des 14. Jahrhunderts*, 3 vols. (Paderborn, 1922–1923).

Pavanello and Walcher 1999

Pavanello, Giuseppe and Maria Walcher, eds., *Istria, Città Maggiori, Capodistria, Parenzo, Pirano, Pola, Opere d'arte dal Medioevo all'Ottocento* (Trieste, 1999).

Pedrocco 2001

Pedrocco, Filippo, *The Mestrovich Collection at Ca' Rezzonico* (Venice, 2001).

Penny 1993

Penny, Nicholas, *The Materials of Sculpture* (New Haven and London, 1993).

Pepper 1984

Pepper, D. Stephen, *Bob Jones University Collection of Religious Art: Italian Paintings* (Greenville, SC, 1984).

Pesenti 2006

Pesenti, Allegra, "The Use of Drawings in the Communication between Artists and Patrons in Italy during the Fifteenth and Sixteenth Centuries," Ph.D. dissertation, The Courtauld Institute of Art, University of London, 2006.

Petersen 2001

Petersen, David, *The New Interpreter's Bible VI* (Nashville, TN, 2001)

Petricioli 1956

Petricioli, Ivo, "Uno sconosciuto quadro bassanesco di Zadar," in *Venezia e l'Europa, Atti del XVIII congresso internazionale di storia dell'arte* (Venice, 1956), 289–291.

Pettenati 1978

Pettenati, Silvana, *I Vetri Dorati Graffiti e I Vetri Dipinti del Museo Civico di Torino* (Turin, 1978).

Pettenati 1986

Pettenati, Silvana, *Vetri Rinascimentali* (Florence, 1986).

Pfändtner 2006

Pfändtner, Karl-Georg, "The Influence and Spread of the Bohemian Decoration System to Fifteenth-Century Manuscript Production in Vienna and Nuremberg," *Manuscripta*, no. 2 (2006), 301–316.

Pichi 2007

Pichi, Silvia, "Scuole di devozione, Arti e mestieri in San Salvador," in *La chiesa di San Salvador: Storia, arte, teologia, Atti del convegno*, Gianmario Guidarelli, ed. (Venice, 2007), 29–65.

Pignatti 1984

Pignatti, Terisio, "Una Nuova *Pietà* di Paolo Veronese," *Arte Veneta*, 38 (1984), 146–148.

Pignatti 1996

Pignatti, Terisio, *Disegni Antichi del Museo Correr di Venezia*, vol. V (Vicenza, 1996).

Pignatti and Donahue 1979

Pignatti, Terisio and Kenneth Donahue, *The Golden Century of Venetian Painting*, exh. cat., Los Angeles County Museum of Art (Los Angeles, 1979).

Pignatti and Pedrocco 1995

Pignatti, Terisio and Filippo Pedrocco, *Veronese*, 2 vols. (Milan, 1995).

Pinacoteca civica 2003

Pinacoteca civica di Vicenza, Catalogo scientifico delle collezioni, vol. 1, *Dipinti dal XIV al XVI secolo*, Maria Elisa Avagnina, Margaret Binotto and Giovanni Carlo Federico Villa, eds. (Vicenza, 2003).

Pinacoteca civica 2005

Pinacoteca civica di Vicenza, Catalogo scientifico delle collezioni, vol. 3, *Scultura e arti applicate dal XIV al XVIII secolo*, Maria Elisa Avagnina, Margaret Binotto and Giovanni Carlo Federico Villa, eds. (Vicenza, 2005).

Pirker-Aurenhammer 2002

Pirker-Aurenhammer, Veronika, *Das Gebetbuch für Herzog Albrecht V. von Österreich (Wien, ÖNB, Cod. 2722)* (Graz, 2002).

Pope-Hennessy 1964

Pope-Hennessy, John, *Catalogue of the Italian Sculpture in the Victoria and Albert Museum* (London, 1964).

Pope-Hennessy 1965

Pope-Hennessy, John, *Renaissance Bronzes from the Samuel H. Kress Collection. Reliefs, plaquettes, utensils and mortars* (London, 1965).

Pope-Hennessy 1980

Pope-Hennessy, John, *The Study and Criticism of Italian Sculpture* (New York, NY, 1980).

Pope-Hennessy 1987

Pope-Hennessy, John, *The Robert Lehman Collection*, vol. 1, *Italian Paintings* (New York, NY and Princeton, NJ, 1987).

Pope-Hennessy and Lightbown 1964

Pope-Hennessy, John and Ronald Lightbown, *Catalogue of Italian Sculpture in the Victoria and Albert Museum*, vol. 1 (London, 1964).

Posocco and Settis 2008

Posocco, Franco and Salvatore Settis, eds., *La Scuola Grande di San Rocco a Venezia* (Modena, 2008).

Prague 2005

Prague: the Crown of Bohemia, 1347–1437, exh. cat., Barbara Drake Boehm and Jiří Fajt, eds., New York, The Metropolitan Museum of Art (New Haven and London, 2005).

Prodi 1990

Prodi, Paolo, "La Chiesa di Venezia nell'età delle riforme," in *La Chiesa di Venezia tra Riforma Protestante e Riforma Cattolica*, Giuseppe Gullino, ed. (Venice, 1990), 63–75.

Prosperi 1999

Prosperi, Adriano, *Il Concilio di Trento e la controriforma* (Trent, 1999).

Puglisi and Barcham 2006

Puglisi, Catherine and William Barcham, "Gli esordi del *Cristo passo* nell'arte veneziana e la *Pala feriale* di Paolo Veneziano," in *Cose Nuove e Cose Antiche, Scritti per Monsignor Antonio Niero e Don Bruno Bertoli*, Francesca Cavazzana Romanelli, Maria Leonardi and Stefania Rossi Minutelli, eds. (Venice, 2006), 403–429.

Puglisi and Barcham 2008

Puglisi, Catherine and William Barcham, "Bernardino da Feltre, the Monte di Pietà and the *Man of Sorrows*: Activist, Microcredit and Logo," *Artibus et Historiae*, 58 (2008), 35–63.

Quarré 1971

Quarré, Pierre, *Le Christ de Pitié, Brabant-Bourgogne autour de 1500*, exh. cat., Dijon, Musée des Beaux-Arts (Dijon, 1971).

Radcliffe 1992

Radcliffe, Anthony, "Multiple production in the fifteenth century: Florentine stucco Madonnas and the della Robbia workshop," in *The Thyssen-Bornemisza Collection. Renaissance and Later Sculpture with Works of Art in Bronze*, Anthony Radcliffe, Malcolm Baker and Michael Maek-Gérard, eds. (London, 1992), 16–23.

Ragusa and Green 1961

Ragusa, Isa and Rosalie Green, *Meditations on the Life of Christ, An Illustrated Manuscript of the Fourteenth Century, Paris, Bibliothèque Nationale, Ms. Ital. 115* (Princeton, NJ, 1961).

Ransom 2011

Ransom, Lynn, essay in the catalogue of *Renaissance Art and the Devotional Imagination: Meditations on the Life of Christ*, exh. cat., New York, Museum of Biblical Art, 2011—forthcoming.

Rearick 1958

Rearick, W. R., "Battista Franco and the Grimani Chapel," *Saggi e Memorie di Storia dell'Arte*, 2 (1958–1959), 107–139.

Rearick 1988

Rearick, W. R., *The Art of Paolo Veronese: 1528–1588*, exh. cat., Washington, DC, National Gallery of Art (Cambridge, 1988).

Reed and Wallace 1989

Reed, Sue Welsh and Richard Wallace, *Italian Etchers of the Renaissance and Baroque*, exh. cat. Boston, Museum of Fine Arts (Boston, MA, 1989).

Reff and Shoemaker 1989

Reff, Theodore and Innis H. Shoemaker, *Paul Cézanne, Two Sketchbooks: the Gift of Mr. and Mrs. Walter H. Annenberg to the Philadelphia Museum of Art*, exh. cat., Philadelphia Museum of Art (Philadelphia, PA, 1989).

Rewald 1983

Rewald, John, *Paul Cézanne: the watercolors: a catalogue raisonné* (Boston, MA, 1983).

Ricci 1931

Ricci, Seymour, *The Gustave Dreyfus Collection: Renaissance Bronzes* (Oxford, 1931).

Richardson 1980

Richardson, Francis, *Andrea Schiavone* (Oxford, 1980).

Ridderbos 1998

Ridderbos, Bernhard, "The Man of Sorrows: Pictorial Images and Metaphorical Statements," in *The Broken Body: Passion Devotion in Late-Medieval Culture*, Alasda A. MacDonald, Bernhard Ridderbos and R. M. Schlusemann, eds. (Groningen, 1998), 145–181.

Ridolfi 1837

Ridolfi, Carlo, *Le maraviglie dell'arte ovvero le vite degli illustri Pittori Veneti e dello Stato*, 2nd ed. (Padua, 1837).

Righetti 1949

Righetti, Mario, *Manuale di Storia Liturgica*, vol. 3, *L'Eucaristia* (Milan, 1949).

Rigoni 1999

Rigoni, Chiara, ed., *Scultura a Vicenza* (Milan, 1999).

Ringbom 1984

Ringbom, Sixten, *Icon to Narrative: The Rise of the Dramatic Close-up in Fifteenth-Century Devotional Painting* (Doornspijk, 1984).

Rizzi 1987

Rizzi, Alberto, *Scultura Esterna a Venezia, Corpus delle Sculture Erratiche all'aperto di Venezia e della sua Laguna* (Venice, 1987).

Roest 2004

Roest, Bert, *Franciscan Literature of Religious Instruction Before the Council of Trent* (Boston, MA, 2004).

Rognini 1985

Rognini, Luciano, "Il reliquiario della pieve di Arbizzano," in *La Valpolicella dal Duecento al Quattrocento*, Gian Maria Varanini, ed. (Verona, 1985).

Rosand and Muraro 1976

Rosand, David and Michelangelo Muraro, *Titian and the Venetian Woodcut*, exh. cat., Washington, DC, National Gallery of Art (Washington, DC, 1976).

Rosenauer 1993

Rosenauer, Artur, *Donatello* (Milan, 1993).

Rosenstein 2001

Rosenstein, Stefania, "Bodies of Heaven and Earth: Christ and the Saints in Medieval Art and Devotion," in *Pious Journeys: Christian Devotional Art and Practice in the Later Middle Ages and Renaissance*, exh. cat., Linda Seidel, ed., Chicago, IL, David and Alfred Smart Museum, University of Chicago (Chicago, IL, 2001), 21–41.

Rossi 1974

Rossi, Francesco, ed., *Placchette Sec. XV–XIX* (Vicenza, 1974).

Rossi 1988

Rossi, Francesco, *Accademia Carrara*, vol. I, *Catalogo dei dipinti, sec. XV–XVI* (Bergamo, 1988).

Rossi 1995 – see Rossi, M.

Rossi 2006

Rossi, Francesco, ed., *Placchette e rilievi di bronzo nell'età del Mantegna*, exh. cat., Mantua, Museo della Città di Palazzo San Sebastiano (Vicenza, 2006).

Rossi, M. 1995

Rossi, Massimiliano, *La Poesia Scolpita. Danese Cataneo nella Venezia del Cinquecento* Lucca, 1995).

Rubin 1991

Rubin, Miri, *Corpus Christi, The Eucharist in Late Medieval Culture* (Cambridge, 1991).

Ruggeri 1993

Ruggeri, Ugo, "Una 'Imago Pietatis' di Bartolomeo Vivarini," *Antichità Viva*, 32 (1993), 51–53.

Rye-Clausen 1981

Rye-Clausen, H., *Die Hostienmühlenbilder im Lichte mittelalterlicher Frömmigkeit* (Stein am Rhein, 1981).

Saff and Sacilotto 1978

Saff, Donald and Deli Sacilotto, *Printmaking: A History and Process* (New York, NY, 1978).

Salomon 2009

Salomon, Xavier F., ed., *Paolo Veronese: The Petrobelli Altarpiece*, exh. cat., London, Dulwich Picture Gallery; Ottawa, National Gallery of Canada; and Austin TX, Blanton Museum of Art (Cinisello Balsamo, 2009).

Salvi 1910

Salvi, Guglielmo, *Il santuario di Nostra Signora in Finalpia su documenti inediti* (Subiaco, 1910).

San Martino de Geminis 2004
San Martino de Geminis, anonymous guidebook (Venice, 2004).

Sanvito 2009
Sanvito, Paolo, *Imitatio: L'amore dell'immagine sacra* (Città di Castello, 2009).

Sarchi 2008
Sarchi, Alessandra, *Antonio Lombardo* (Venice, 2008).

Sawyer 1996
Sawyer, John F. A., *The Fifth Gospel, Isaiah in the History of Christianity* (Cambridge, 1996).

Sawyer 2010
Sawyer, John F. A., "Van Dyck's 'Ecce Homo' in the Barber Institute," in *Bible, Art, Gallery*, Martin O'Kane, ed. (Sheffield, 2010).

Scaglietti Kelescian 1999
Scaglietti Kelescian, Daniela, *Alessandro Turchi detto l'Orbetto 1578–1649*, exh. cat., Verona, Museo di Castelvecchio (Milan, 1999).

Schiller 1968
Schiller, Gertrud, *Iconography of Christian Art*, vol. 2 (New York and Greenwich, CT, 1968).

Schmidt 1977
Schmidt, Gerhard, "Bohemian Painting up to 1450," in *Gothic Art in Bohemia: Architecture, Sculpture, and Painting,* Ferdinand Seibt and Erich Bachmann, eds. (New York, NY, 1977), 41–68.

Scholz 1976
Italian Master Drawings, 1350–1800 from the Janos Scholz Collection (New York, 1976).

Scholz 1980
Janos Scholz, Musician and Collector, exh. cat., South Bend, IN, University of Notre Dame, The Snite Museum of Art (Notre Dame, IN, 1980).

Schulz 1983a
Schulz, Anne Markham, "Giovanni Buora lapicida," *Arte Lombarda*, 65 (1983), 49–72.

Schulz 1983b
Schulz, Anne Markham, *Antonio Rizzo, Sculptor and Architect* (Princeton, NJ, 1983).

Schulz 1988–1989
Schulz, Anne Markham, "Cristoforo Solari at Venice: Facts and Suppositions," *Prospettiva*, 53–56 (1988–1989), 309–316.

Schulz 1991
Schulz, Anne Markham, *Giambattista and Lorenzo Bregno* (Cambridge, 1991).

Schulz 2004a

Schulz, Anne Markham, "A newly discovered work by Giammaria Mosca," *The Burlington Magazine*, 146 (2004), 656–664.

Schulz 2004b
Schulz, Anne Markham, "Antonio Bonvicino and Venetian Crucifixes of the Early Quattrocento," *Mitteilungen des Kunsthistorischen Instituts in Florenz*, 48 (2004), 292–332.

Scultura in cartapesta 2008
La scultura in cartapesta: Sansovino, Bernini e i maestri leccesi tra tecnica e artificio, exh. cat., Milan, Museo Diocesano (Cinisello Balsamo, 2008).

Seidel 2005
Seidel, Max, "The Sculpted Image, Tino di Camaino measures up to Simone Martini," in *Italian Art of the Middle Ages and the Renaissance*, vol. 2: *Architecture and Sculpture* (Venice, 2005).

Seifert 1991
Seifert, Oliver, "Tüchleinmalerei: Funktionswandel eines Bildträgers," M.A. dissertation, Kunst-historisches Institut der Ludwig-Maximilians-Universität, Munich, 1991.

Sensi 2000
Sensi, Mario, "Dall'*Imago Pietatis* alle cappelle gregoriane. Immagini, racconti e devozioni per la 'visione' e la Cristomimesi," *Collectanea Franciscana*, 70 (2000), 79–148.

Sensi 2008
Sensi, Mario, "Le forme dell'adorazione e della pietà eucaristica," *Lateranum*, 74 (2008/2), 275–318.

Serenissima 2000
Serenissima, Swiatło Wenecji, exh. cat., Grażyna Bastek and Grzegorz Janczarski, eds., Posnan and Wrocław, 2000 (Posnan and Wrocław, 2000).

Sgarbi 2006
Sgarbi, Vittorio, ed., *La scultura al tempo di Andrea Mantegna tra classicismo e naturalismo*, exh. cat., Mantua, Castello di San Giorgio (Milan, 2006).

Shapley 1966
Shapley, Fern Rusk, *Paintings from the Samuel H. Kress Collection, Italian Schools XIII–XV Century* (London, 1966).

Sheppard 1981
Sheppard, Jennifer M, "The Inscription in Manet's 'The Dead Christ with Angels,'" *The Metropolitan Museum Journal*, 16 (1981), 199–200.

Sinding-Larsen 1974
Sinding-Larsen, Staale, *Christ in the Council Hall, Studies in the Religious Iconography of the Venetian Republic* (Rome, 1974).

Smith 1989
Smith, Ruth, "The Achievements of Charles Jennens (1700–1773)," *Music and Letters*, 70 (1989), 161–190.

Smith 1995
Smith, Ruth, *Handel's Oratorios and Eighteenth-Century Thought* (Cambridge, MA, 1995).

Smyth 2007
Smyth, Carolyn, "Insiders and Outsiders: Titian, Pordenone and Broccardo Malchiostro's Chapel in Treviso Cathedral," *Studi Tizianeschi*, 5 (2007), 32–75.

Soards 2000
Soards, Marion, ed., *The New Interpreter's Bible XI* (Nashville, TN, 2000).

Sorelli 1984
Sorelli, Fernanda, "Per la storia religiosa di Venezia nella prima metà del Quattrocento: Inizi e sviluppi del terz'ordine domenicano," in *Viridarium Floridum: Studi di Storia Veneta offerti dagli allievi a Paolo Sambin* (Padua, 1984), 89–113.

Spiazzi 2004
Spiazzi, Anna Maria, *Oreficeria Sacra in Veneto*, vol. I, *Secoli VI–XV* (Cittadella, 2004).

Stabenow 2006
Stabenow, Jörg, ed., *Lo Spazio e il Culto: Relazioni tra edificio ecclesiale e uso liturgico dal XV al XVI secolo* (Venice, 2006).

Stadlhuber 1950
Stadlhuber, Josef, "Das Laienstundengebet vom Leiden Christi in seinem mittelalterlichen Fortleben," *Zeitschrift für katholische Theologie*, 72 (1950), 282–325.

Stechow 1967
Stechow, Wolfgang, *Catalogue of European and American Paintings and Sculpture in the Allen Memorial Art Museum, Oberlin College* (Oberlin, OH, 1967).

Steer 1982
Steer, John, *Alvise Vivarini, his art and influence* (Cambridge, 1982).

Steinberg 1966
Steinberg, S. H., *Five Hundred Years of Printing*, revised by John Trevitt (London and New Castle, DE, 1966).

Strehlke 2004
Strehlke, Carl Brandon, *Italian Paintings 1250–1450 in the John G. Johnson Collection and the Philadelphia Museum of Art* (Philadelphia, PA, 2004).

Suppellettile 1988

Suppellettile ecclesiastica, Benedetta Montevecchi and
 Sandra Vasco Rocca, eds. (Florence, 1988).

Swarzenski 1940

Swarzenski, Georg, "The Localization of Medieval
 Verre Eglomisé in the Walters Collection," *Journal
 of the Walters Art Gallery*, 3 (1940), 54–69.

Szépe 2004

Szépe, Helena, "Isabella Stewart Gardner's Venetian
 Manuscripts," in *Gondola Days: Isabella Stewart
 Gardner and the Palazzo Barbaro Circle*,
 exh. cat., Elizabeth A. McCauley, Alan Chong,
 Rosella M. Zorzi and Richard Lingner, eds.,
 Boston, Isabella Stewart Gardner Museum
 (Boston, MA, 2004), 233–234.

Tanner 1990

Tanner, Norman P., *Decrees of the Ecumenical Councils*
 (London and Washington, DC, 1990).

Tesoro di San Marco 1971

Il Tesoro di S. Marco, Il Tesoro e il Museo,
 H. R. Hahnloser, ed. (Florence, 1971).

Theoderich 1986

Theoderich, *Guide to the Holy Land*, trans. Aubrey
 Stewart (New York, NY, 1986).

Thornton 1991

Thornton, Peter, *The Italian Renaissance Interior
 1400–1600* (New York, NY, 1991).

Tietze 1948

Tietze, Hans, "Nuovi Disegni Veneti del Cinquecento in
 Collezioni Americane," *Arte Veneta*, 2 (1948), 56–66.

Timofiewitsch 1972

Timofiewitsch, Wladimir, *Girolamo Campagna*
 (Munich, 1972).

Toderi 1996

Toderi, Giuseppe and Fiorenza Vannel Toderi,
 *Placchette, secoli XV–XVIII nel Museo Nazionale del
 Bargello* (Florence, 1996).

Ton 2007

Ton, Denis, "Per la fortuna delle 'Nozze di Cana' di
 Paolo Veronese," in *Il Miracolo di Cana: l'originalità
 della riproduzione: storia, creazione e riproposizione
 delle 'Nozze di Cana' di Paolo Veronese per il
 refettorio palladiano di San Giorgio Maggiore*, exh.
 cat., Giuseppe Pavanello, ed., Venice, Fondazione
 Giorgio Cini (Verona, 2007), 49–92.

Tramontin 1967

Tramontin, Silvio, "La Visita Apostolica del 1581 a
 Venezia," *Studi veneziani*, IX (1967), 453–533.

Tramonto del medioevo 1987

*Il tramonto del medioevo a Bologna: il Cantiere di San
 Petronio*, Rosalba D'Amico, Renzo Grandi, Jacques
 le Goff, exh. cat., Bologna, Pinacoteca Nazionale
 and Museo Civico Medievale (Bologna, 1987).

Treasures of the Fitzwilliam 2005

Treasures of the Fitzwilliam Museum (London, 2005).

Tuchman 1978

Tuchman, Barbara, *A Distant Mirror: The Calamitous
 14th Century* (New York, NY, 1978).

Twilight 1974

*The Twilight of the Medici: Late Baroque Art in Florence,
 1670–1743*, exh. cat., Jennifer Montagu and Klaus
 Lankheit et al., Detroit Institute of Arts
 (Detroit, MI, 1974).

Van Ausdall 1994

Van Ausdall, Kristen, "Tabernacles and the Sacrament:
 Eucharistic Imagery and Classicism in the
 Early Renaissance," Ph.D. dissertation, Rutgers
 University, 1994.

Van de Sman 1995

Van der Sman, Gert Jan, "Il percorso stilistico di
 Battista Franco incisore: elementi per una
 ricostruzione," *Arte/Documento*, 8 (1995), 101–114.

Van de Sman 2000

Van der Sman, Gert Jan, "Battista Franco: studi di figura
 per dipinti e incisioni," *Prospettiva*, 97 (2000), 63–72.

Van de Sman 2003

Van der Sman, Gert Jan, *Le Siècle de Titien: Gravures
 vénitiennes de la Renaissance*, exh. cat., Maastricht,
 Bonnefantenmuseum and Bruges, Musée
 Groeninge (Zwolle, 2003).

Van Os 1989

Van Os, Henk W., "Painting in a House of Glass: the
 Altarpieces of Pienza," in *Italian Church Decoration
 of the Middle Ages and Early Renaissance: functions,
 forms and regional traditions*, William Tronzo,
 ed., Florence, Villa Spelman Colloquium
 (Bologna, 1989), 195–215.

Van Os 1994

Van Os, Henk W., *The Art of Devotion in the Late Middle
 Ages in Europe, 1300–1500* (Princeton, NJ, 1994).

Vanin and Eleuteri 2007

Vanin, Barbara and Paolo Eleuteri, *Le mariegole della
 Biblioteca del Museo Correr* (Venice, 2007).

Varick Lauder 2004

Varick Lauder, Anne, "Battista Franco *c.*1510–1561. His
 Life and Work with Catalogue Raisonné," 4 vols.,
 Ph.D. dissertation, University of Cambridge, 2004.

Varick Lauder 2009

Varick Lauder, Anne, *Battista Franco*, Inventaire
 Général des Dessins Italiens, VIII, Département des
 Arts Graphiques, Musée du Louvre (Paris, 2009).

Vasari 1984

Vasari, Giorgio, *Le vite de' più eccellenti pittori,
 scultori e architettori, nelle redazioni del 1550 e 1568*,
 Rosanna Bettarini and Paola Barocchi, eds., vol. 5
 (Florence, 1984).

Vassilaki 2009

Vassilaki, Maria, *The Painter Angelos and Icon-Painting
 in Venetian Crete* (Farnham and Burlington, VT,
 2009).

Vecellio 2008

Vecellio, Cesare, *The Clothing of the Renaissance World:
 Europe, Asia, Africa, the Americas: Cesare Vecellio's
 'Habiti Antichi et Moderni,'* eds. and trans., Margaret
 F. Rosenthal and Ann Rosalind Jones (London,
 2008).

Vellekoop and Alvarez 1978

Vellekoop, Kees and Manuel Fernández Alvarez, *Dies
 ire dies illa. Studien zur Fruhgeschichte einer Sequenz*
 (Bilthoven, 1978).

Venezia e Creta 1998

*Venezia e Creta, Atti del Convegno internazionale di
 studi*, Gherardo Ortalli, ed. (Venice, 1998).

Verdi 2002

Verdi, Richard, *Anthony van Dyck (1599–1641),
 'Ecce Homo' and 'The Mocking of Christ,'* exh. cat.,
 Princeton University Art Museum and the Barber
 Institute of Fine Arts, University of Birmingham
 (Birmingham, 2002).

Vio 2004

Vio, Gastone, *Le Scuole Piccole nella Venezia dei Dogi*
 (Costabissara, 2004).

Vitolo 2008

Vitolo, Paola, *La chiesa della Regina: L'Incoronata di
 Napoli, Giovanna I d'Angiò e Roberto di Oderisio*
 (Rome, 2008).

von Dobschütz 1899

von Dobschütz, Ernst, *Christusbilder: Untersuchungen
 zur christlichen Legende. Texte und Untersuchungen
 zur Geschichte der altchristlichen Literatur*, 3 vols.
 (Leipzig, 1899).

Walcher 2006

Walcher, Maria, "Venezia e l'Istria," *Saggi e Memorie di
 Storia dell'Arte*, 30 (2006), 135–162.

Walsh 2003

Walsh, John, ed., *Bill Viola: The Passions*, exh. cat., Los Angeles, The J. Paul Getty Museum (Los Angeles and London, 2003).

Wardropt 1963

Wardropt, James, *The Script of Humanism, Some Aspects of Humanistic Script 1460–1560* (Oxford, 1963).

Weisberg 1985

Weisberg, Gabriel, "From the Real to the Unreal: Religious Painting and Photography at the Salons of the Third Republic," *Arts Magazine*, 60, no. 4 (1985), 58–63.

Welch 1997

Welch, Evelyn, *Art and Society in Italy, 1300–1500* (Oxford, 1997).

Werness 2004

Werness, Hope B., *The Continuum Encyclopedia of Animal Symbolism in Art* (New York and London, 2004).

Westermann 1969

Westermann, Claus, *Isaiah 40–66: A Commentary* (Philadelphia, PA, 1969).

Westfehling 1982

Westfehling, Uwe, *Die Messe Gregors des Grossen: Vision, Kunst, Realität: Katalog und Führer zu einer Ausstellung im Schnütgen-Museum der Stadt Köln*, exh. cat., Cologne, Schnütgen Museum (Cologne, 1982).

Wethey 1955

Wethey, Harold E, *Alonso Cano: Painter, Sculptor, Architect* (Princeton, 1955).

Wieck 1988

Wieck, Roger, *The Book of Hours in Medieval Art and Life* (New York, NY, 1988).

Wildenstein 1992

Wildenstein, Alec, *Odilon Redon. Catalogue Raisonné*, 4 vols. (Paris, 1992–1998).

Wilken 2007

Wilken, Robert Louis, ed., *Isaiah Interpreted by Early Christian and Medieval Commentators* (Grand Rapids, MI, 2007).

Williamson 2008

Williamson, Beth, *The Madonna of Humility: Development, Dissemination and Reception, c.1340–1400* (Woodbridge, 2008).

Wilson 1996

Wilson, Carolyn C., *Italian Paintings: XIV–XVI Centuries in the Museum of Fine Arts, Houston* (Houston, TX, 1996).

Wixom 1983

Wixom, William D., Carmen Gómez-Moreno, Timothy Husband and Katharine R. Brown, *Notable Acquisitions 1982–1983*, New York, The Metropolitan Museum of Art (New York, NY, 1983).

Wixom 1999

Wixom, William D., ed., *Mirror of the Medieval World*, exh. cat., New York, The Metropolitan Museum of Art (New York, NY, 1999).

Wolfthal 1989

Wolfthal, Diane, *The Beginnings of Netherlandish Canvas Painting, 1400–1530* (New York, NY, 1989).

Wolters 1976

Wolters, Wolfgang, *La Scultura Veneziana Gotica (1300–1460)* (Venice, 1976).

Worthen 1996

Worthen, Thomas, "Tintoretto's Paintings for the Banco del Sacramento in S. Margherita," *The Art Bulletin*, 78 (1996), 707–732.

Zanetti 1834

Zanetti, Alessandro, *A quelli che amarono e stimarono Leopoldo Cicognara ed onorano la sua memoria* (Venice, 1834); in French: *Le Premier Siècle de la Calcographie ou Catalogue Raisonné des Estampes du Cabinet de feu M. le Comte Léopold Cicognara, avec un appendice sur les nielles du même cabinet* (Venice, 1837).

Zanetti 1866

Zanetti, Vincenzo, *Guida di Murano e delle celebri sue fornaci vetrarie* (Venice, 1866).

Zava Boccazzi 1965

Zava Boccazzi, Franca, *La Basilica dei Santi Giovanni e Paolo in Venezia* (Padua, 1965).

Zerner 1965

Zerner, Henri, "Giuseppe Scolari," *L'Oeil*, 121 (1965), 25–29.

Zerner 1979

Zerner, Henri, *The Illustrated Bartsch*, 32 (New York, NY, 1979).

Zeri 1986

Zeri, Federico, *Italian Paintings: A Catalogue of the Collection of the Metropolitan Museum of Art* (New York, NY, 1986).

Zorzi 1977

Zorzi, Alvise, *Venezia Scomparsa*, 2 vols. (Milan, 1977).

Photography credits

Cover: Photo © NGC

Art Resource, NY:
Alinari/Art Resource, NY (Page 23)
Bildarchiv Preussischer Kulturbesitz/ Art Resource, NY (Page 13)
Scala/Art Resource (Page 14, 24)
Scala/Ministero per I Beni e le Attività culturali/ Art Resource, NY (Page 16)
© The Metropolitan Museum of Art/Art Resource, NY Metropolitan Museum of Art, New York, NY, USA (Page 31, 45, 47, 53, 93, 97, 124, 131, 137, 141)
© National Gallery, London/Art Resource, NY (Page 38, 97)

Allen Memorial Art Museum, Oberlin: Courtesy of the Allen Memorial Art Museum, Oberlin College, Ohio (Page 105, 148)

Bernenson Collection, Florence: Reproduced by permission of the President and Fellows of Harvard College (Page 18)

Biblioteca Civica, Padua: Photographic rights are given on kind concession of the Comune di Padova-Department of Culture (Page 67)

Bill Viola Studio, LLC: Courtesy of Bill Viola Studio, LLC (Page 25, 159)

Bob Jones University: From the Bob Jones University Collection (page 77)

Denver Art Museum, Denver: Courtesy of the Denver Art Museum (page 51)

Fine Arts Museum, San Francisco: Courtesy of Fine Arts Museum San Francisco, Gift of Albert C. Hooper, 41751 (Page 103)

Fondazione Musei Civici, Museo Correr, Venice: Courtesy of Fondazione Musei Civici, Museo Correr (Page 143)

Giorgio Deganello, Padua: Courtesy of Giorgio Deganello (Page 23)

Isabella Stewart Gardner Museum, Boston: Courtesy of the Isabella Stewart Gardner Museum, Boston (Page 109)

Minneapolis Institute of Arts, Minneapolis: Courtesy of Minneapolis Institute of Art, The Ethel Morrison Van Derlip Fund (Page 147)

Museum of Art and Archeology, Columbia: Museum of Art and Archaeology, University of Missouri, Columbia, MO, inv. 61.75 Samuel H. Kress Collection, K461 (Page 79)

Museum of Biblical Art, New York: Courtesy of the Museum of Biblical Art, New York; Photo by Gina Fuentes Walker (Page 35, 37)

Museum of Fine Arts, Boston: Photograph © 2010 Museum of Fine Arts, Boston (Page 133)

Museum of Fine Arts, Houston: Courtesy of the Museum of Fine Arts, Houston; Gift of Mr. and Mrs. Isaac Anold, Jr. in memory of Hugh Roy and Lillie Cullen (Page 135)

Museo d'Arte Medioevale e Moderna, Padua: Photographic rights are given on kind concession of the Comune di Padova-Department of Culture (page 69)

National Gallery of Canada, Ottawa: Photo © NGC (Page 128, 129)

National Gallery of Ireland, Dublin: Photo © National Gallery of Ireland (Page 81)

National Gallery of Art, Washington: Image Courtesy of the Board of Trustees, National Gallery of Art, Washington (Page 71, 85, 93, 99, 101, 139, 155)

National Portrait Gallery, London: Courtesy of the National Portrait Gallery, London (Page 152)

North Carolina Museum of Art, Raleigh: Courtesy of the North Carolina Museum of Art, Gift of Samuel H. Kress Foundation (Page 121)

Philadelphia Museum of Art, Philadelphia: Images © Philadelphia Museum of Art (Page 75, 157)

Princeton University Art Museum, Princeton:
Courtesy of Princeton University Art Museum, Gift of Frank Jewett Mather, Jr.; Photo by John Blazejewski (Page 20)
Courtesy of Princeton University Art Museum, Bequest of Dan Fellows Platt, Class of 1895; Photo by Bruce M. White (Page 73)
Courtesy of Princeton University Art Museum, Gift of Frank Jewett Mather, Jr.; Photo by Bruce M. White (Page 110–111)
Courtesy of Princeton University Art Museum, Museum Purchase, Laura P. Hall Memorial Fund (Page 123)

Private Collection, New York: (Page 87)

Private Collections: (Page 43, 91, 107, 127, 151)

Renée Roberts: Map by Renée Roberts (www. reneeroberts.net) (Page 9)

Scuola Grande Arciconfraternità di San Rocco, Venice: Courtesy of Scuola Grande Arciconfraternità di San Rocco, Venice (page 119)

Statens Museum for Kunst, Copenhagen: © SMK Foto (Page 25)

Syracuse University Library, Syracuse: Photo of Books of Hours courtesy of Special Collections Research Center, Syracuse University Library (Page 59)

The David and Alfred Smart Museum of Art, Chicago: Image © 2010 courtesy of The David and Alfred Smart Museum of Art, The University of Chicago (Page 95, 125)

The Dayton Art Institute, Dayton: The Dayton Art Institute, Museum purchase with funds provided by the 1971 Associate Board Art Ball and the Virginia V. Blackeney Endowment, 1970.29 (Page 89)

The Cleveland Museum of Art: Courtesy of The Cleveland Museum of Art, Holden Collection 1916.806 (Page 145)

The Free Library, Philadelphia: Used by permission of the Rare Book Department, Free Library of Philadelphia (Page 49, 61)

The Getty Research Institute, Los Angeles: Courtesy of the Research Library, The Getty Research Institute, Los Angeles, California (Page 65)

The Morgan Library and Museum, New York: Courtesy of The Morgan Library and Museum, New York (Page 41, 55, 153)

Wellesley College Library, Wellesley: Courtesy of Wellesley College Library, Special Collections (Page 57)

Page 10: After Helen C. Evans, *Byzantium, Faith and Power (1261-1557)*, exh. cat., Metropolitan Museum of Art, New York 2004 (New York, New Haven and London, 2004), pp. 221–223, cat. 131

Page 11, 17, 19, 20–22, 49, 82, 83, 115, 117: Courtesy of William Barcham and Catherine Puglisi

Index

DATE DUE

The Library Store #47-0103